The Artist Grows Old

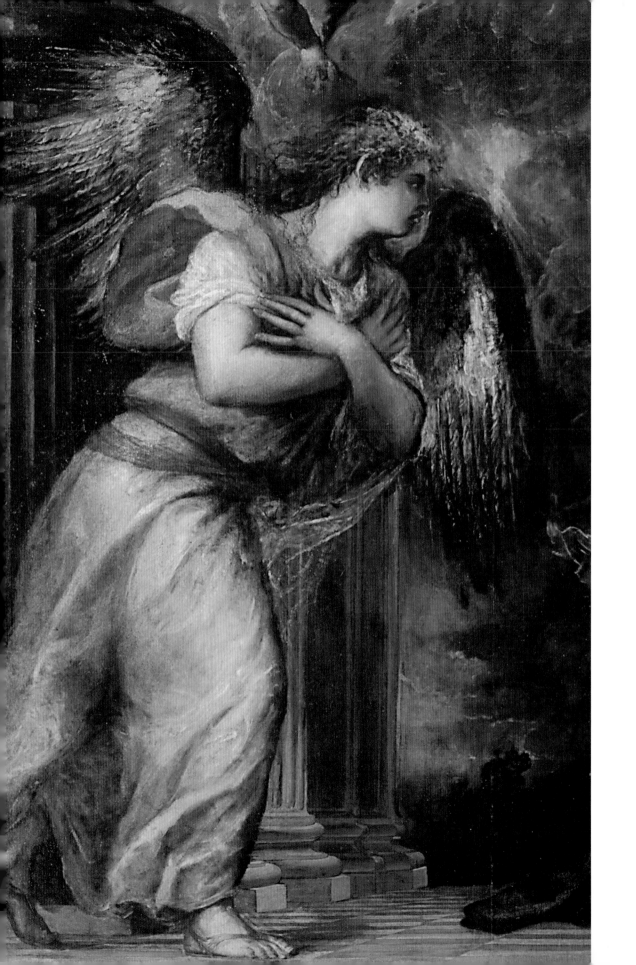

The Artist Grows Old

The Aging of Art and Artists in Italy, 1500–1800

Philip Sohm

Yale University Press

New Haven and London

Designed by Sarah Faulks

Printed in China

Library of Congress Cataloging-in-Publication Data

Sohm, Philip L. (Philip Lindsay), 1951–
 The artist grows old : the aging of art and artists in Italy 1500–1800 / Philip Sohm.
 p. cm.
 Includes bibliographical references and index.
 ISBN 978-0-300-12123-0 (cl : alk. paper)
 1. Old artists–Italy–Biography–History and criticism. 2. Art, Italian–16th and 17th century.
 3. Art criticism–Italy–History–16th century. 4. Art criticism–Italy–History–17th century.
 5. Ageism–Italy. I. Title.

N6915.S644 2007
709.45'03--dc22

 2006100421

A catalogue record for this book is available from The British Library

Frontispiece: Titian, *Annunciation*, detail of pl. 27

For my mother,
Myra Lindsay Sohm

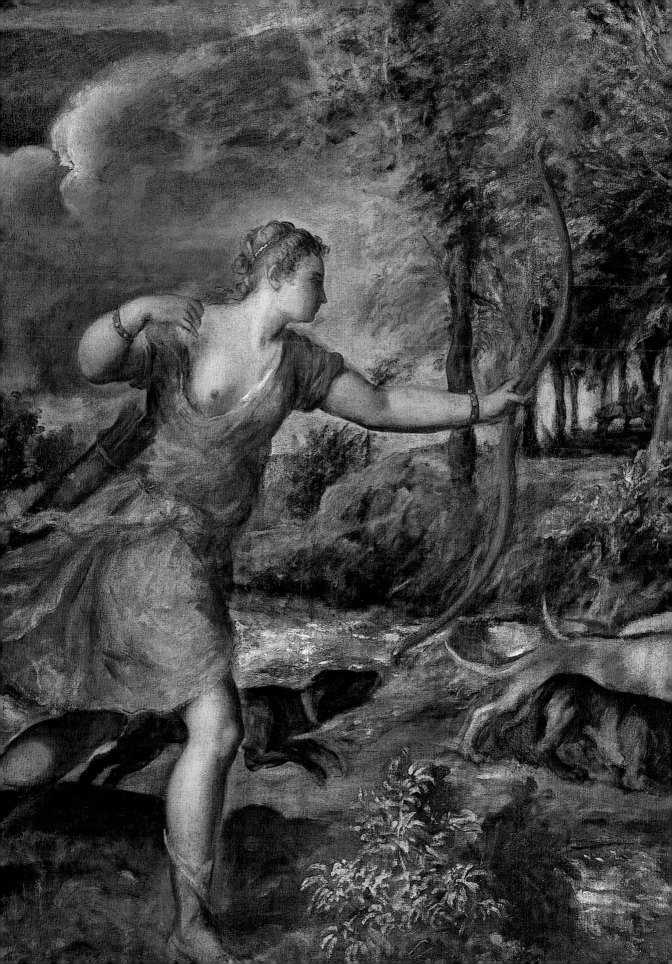

Contents

Facing page: Titian, *Death of Actaeon*, detail of pl. 29

Preface

In 1972 at Oberlin College Wolfgang Stechow gave the Baldwin Seminar on the aging Rembrandt, his last teaching at Oberlin after 32 years. Listening to the seminar today, an audience might find it methodologically naïve, where old Rembrandt and his paintings are made to perform the traditional elderly roles of quiet spirituality and heroic confrontation of a material world slowly dissolving and fading away. As Kenneth Clark put it in a booklet published in the same year as part of the Rede Lectures at Cambridge, *The Artist Grows Old*, great old artists (and only great artists were honored with an old-age style) shared "a sense of isolation, a feeling of holy rage, developing into what I have called transcendental pessimism; a mistrust of reason, a belief in instinct." Befitting a grand master of great narratives, Clark swept through history (1400–1950) in one hour and found an essential similarity in the works by old masters. Compared with Clark's empyrean perspective, Stechow dared to speak empathically and thereby made Rembrandt's old age resonate with the complicated truths of lived realities. He was 76 years old when he gave the Baldwin Seminar, venerably old from my perspective, a callow undergraduate living in a protest culture that proclaimed "Trust no one over thirty." I trusted him, however, almost as a mythic figure – World War II refugee, acclaimed scholar and accomplished musician – younger in spirit than most of my classmates.

The seeds that Stechow planted at Oberlin germinated as soon as I started teaching Titian and Michelangelo six years later. It became one of my favorite hobby horses and inspired a Toronto undergraduate, Erin Campbell, to write a PhD dissertation with me on old age. She has since published three articles and edited a volume of essays on the subject. The book at hand was originally intended as part of a larger book, to be co-authored with Erin. Our approaches complemented each other (Erin explored artistic representations of the elderly, while the aging artist concerned me) as did our interests in the multi-faceted beliefs about aging (Erin was drawn to the transcendence of old age; the descent into old age fascinated me). Real life intervened, however, and Erin is now writing her own book, optimistic and platonic, leaving mine riven with gerontophobia.

Gerontophobia is only one of several psychological categories that characterize how I think of old age. As a young teacher, when old age was a distant fiction, I took Stechow's ennobled view as my own. Now, as a scholar deep into middle age, my views turned more pessimistic regarding old age. This book is a response to that change in perspective. It confronts the dread of physical and mental decay that awaits all of us, if we are lucky enough to live so long. Art history became psychotherapy. And it almost worked! Now that the book is finished, the corporeal realities of aging seem no more important than the liberating subjectivities that age can bring.

Many people have contributed to this book. In conversation and correspondence, and from questions after lectures, I have had ideas challenged and evidence supplemented by Leonard Barkan, Paul Barlosky, Olivier Bonfait, Patricia Fortini Brown, Tracy Cooper, Elizabeth Cropper, Una Romano D'Elia, Charles Dempsey, Anne Dunlop, David Freedberg, Charles Hope, Evonne Levy, Peter Lukehart, Alexander Nagel, Alina Payne, David Quint, Sebastian Schütze, Athena Tacha, Paul Taylor, Robert Williams, Christopher Wood, Ariel Zielinsky, and many talented graduate students at the University of Toronto, Columbia University and Yale University, too many to list here. William Barcham, Catherine Puglisi, Eike Schmidt and Nicola Sutor read the typescript at various stages in its life and gave me much important encouragement and advice. When Deborah Howard and Maria Loh read the final version (or what I thought would be the final version until hearing from them), they responded with detailed corrections, thoughtful critiques, and playful comments. And finally I owe a special debt of gratitude to Richard Spear, who not only read the typescript twice, sustaining interest and attention when others would tune out, but responded with comments that were complexly varied: probative, provocative, and precise.

Maria Rosaria De' Georgi and Claudia Bovis made heroic efforts to obtain photographs at the last minute; Alex Hoare and Delia Gaze proof-read and edited in exemplary fashion, as did Sarah Faulks as she saw it through production. Gillian Malpass, editor at Yale (London), deserves special recognition for her faith in this project and her unwavering encouragement. Without the generous financial support of the Social Sciences and Research Council of Canada, I would have been old indeed before this book was finished. And finally my wife, Janet Stanton, selflessly gave me the time and emotional support that made this book possible in the first place.

This book is dedicated with love to my mother who, in her life, has shown me and continues to show me how to age gracefully.

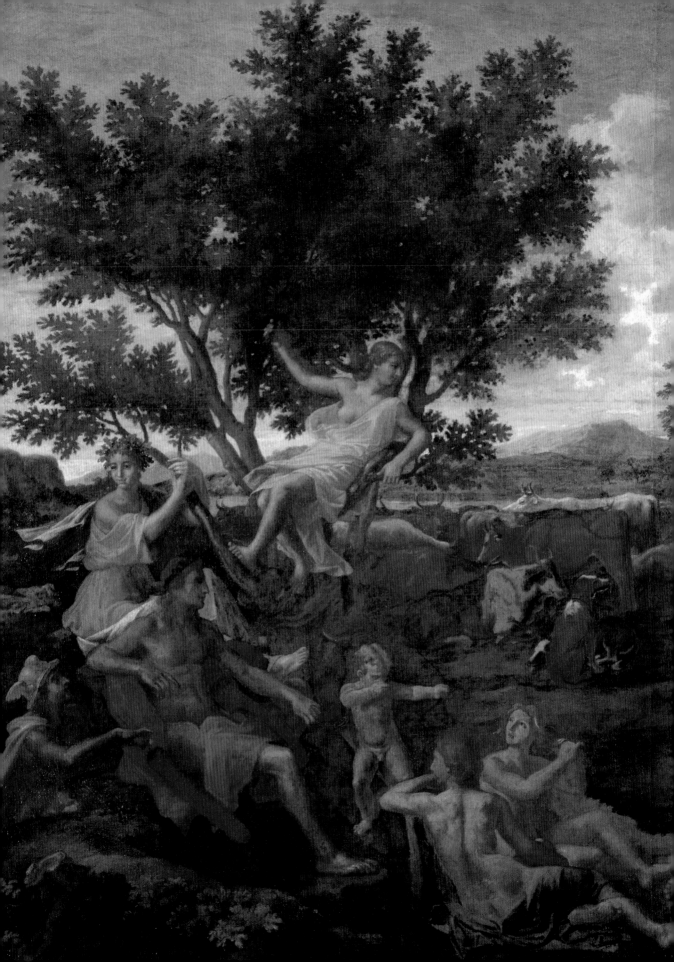

Introduction

This book is a history of prejudices about old age. It asks what fate old painters suffered at the hands of Renaissance and Baroque art critics, collectors, biographers, and fellow artists; what mental landscapes preconditioned the responses to art produced by the elderly; and how biology and psychology were co-opted to explain the imprint that artists left on their art. Everyone's old age is different and ultimately unknowable, especially as the passing centuries erase most evidence. How, then, can a corporeal and psychological experience as elusive as aging be reconstructed for early modern artists? Mostly we lack the evidence to write biographies that do anything but flatten out and simplify the manifold complexities of aging. And where we do have abundant primary evidence – the paintings themselves – we are faced with the dilemma of extracting symptoms of old age from the paintings' circumstances of production (patron, subject, site, studio involvement, and the acculturated language of style). Instead of resisting the ineffability of knowing someone's old age, I propose that a history of prejudice can help reconstruct certain preconditions of aging. It helps us to understand how artists experienced their aging bodies and selves. Prejudices, like proverbs, can be banal, distasteful, or even comic in their reductive views, often driven by fears of loss and difference, always dictating moral certainties. Yet such bromides can distil common denominators that were believed to transcend the individual. That these commonalities are most glaringly expressed as stereotypes, metaphors, and other imagined categories should discredit them as diagnostic tools. And yet they tell us about one essential thing: the internalized values shared by a society.

Belief systems can shape realities. They filter out discordant evidence, all of the ephemeral fragments that drift through our lives, and preconfigure our responses to life experiences. The biographic, medical, and anthropological sources for this book include, often on the same page, fictional narratives, invented dicta, and projections of authorial anxieties, all intermingled with facts. Biographies tell us about actual lives, and at the same time they tell us how we should (or shouldn't) live our own lives. As exempla, they bend and shape the awkward complexities of anyone's life to fit the message. By excavating the fictions of biography, I hope to discover how artists explained their old age to themselves and how others viewed the work they produced.

"Beliefs create realities" is not some philosophic fantasy, but a premise proven in scientific gerontological studies. In a series of experiments at Yale University, Becca Levy demonstrated a correlation between memory function and self-stereotyping by the elderly.[1] What effects, Levy asked, did preconceptions about memory loss have on the actual memory functions of the old? Based on a broad epidemiological survey, she showed how a negative attitude toward old age

can actually accelerate aging and shorten life by more than seven years when all other medical and social factors are equal. A related effect had been previously established experimentally. Two groups read two kinds of gerontological literature, one about old age as dotage, the other describing old age as the "golden years." Memory was tested before and after the readings. Those who read about senility, depression, and physical incapacities suffered a loss of memory function; those who read more optimistic accounts of aging found that their memory tests improved. In an even more remarkable experiment, Levy asked whether self-stereotyping could affect behavior that is generally assumed to operate beyond conscious control.[2] Handwriting (or, for the painter, drawn lines or brushwork) is conventionally believed to deteriorate with age, and, as we will see in later chapters, the elderly Michelangelo, Titian, and Poussin did lose some control over their fine motor skills. This was certainly a neurological fact, but as Levy shows, it could be exaggerated by expectations that hands become shakier in old age. Levy asked two groups for handwriting samples. The first group was then asked to read about old age presented optimistically, the second group submitted to some negative stereotyping. Afterwards, readers then compared the handwriting samples in a blind submission and found that the writing improved for the first group and deteriorated for the second.

Gerontologists are proving today what novelists and philosophers knew long ago: in the course of our lives, we follow a shadowy map of beliefs. Our lives embody the power of self-fulfilling expectations. Modern pop psychologists have rendered the power-of-belief mantra into a caricature of itself. Deepak Chopra, prophet of New Age narcissism and personal guru to Hollywood stars, flatters his followers that they can control their aging, that "people grow old and die because they have seen other people grow old and die. Aging is simply learned behavior." The actress Demi Moore thinks she might reach the age of 130 by unlearning old-age beliefs.

If self-actualization sounds dubiously modern, consider the story told by Antonio Manetti and Giorgio Vasari in which Brunelleschi and some friends devise an elaborate existential joke for a woodcutter, Manetto di Jacopo Ammannatini. They rearrange all his furniture and tell Manetto that he is not who he thinks he is but someone else. After an initial resistance, Manetto comes to believe them and begins to defend his new, illusory identity. This story has been read as an apologue exemplifying the procreative power of the artist (Brunelleschi), but when reversed and viewed from Manetto's perspective, it also tells us about the power of social conformity in identity formation. The Manetto-effect can be taken as paradigmatic of old-age concepts and how they shape the realities of the old and those thinking about the old.

Social expectations, according to the disappointed and alienated painter Giovan Battista Armenini, misled late sixteenth-century artists into adopting fashionable psychological disorders. This suggests that artistic identity is malleable and lies somewhere between a natural and an artificial phenomenon. Some artists' temperaments were truly given to "madness, uncouthness, and extravagance," and, because the tug of conformity is so powerful, "ignorant artists" decided to be fashionable "by affecting melancholy and eccentricity."[3] Armenini considered temperament to be a marketing device, adopted to become "great and famous," and played out for public consumption. He did not mention old artists, but since the elderly, like artists, were thought to be prone to "whims and oddities," it is possible that an analogous phenomenon occurred. If we accept the power of prejudice, then old artists start to act old not just because

their aging bodies and minds dictate this but because the artists enact the roles that society expects of them. This can happen without their knowledge – the Manetto-effect – or, as Armenini would have it, as a self-conscious fashioning, or (more likely) some combination of the two.

That many people, as they age, adopt the roles that society expects of them explains the self-conscious resistance of early modern writers to accept the conventional role. Petrarch refused a numerical answer to the question "when are you old?," responding instead: "When you feel that you are old, then and no sooner will you declare your old age."[4] Old age is a personal choice. Francesco Albani lived this optimistic credo. He also had the good fortune to be a durable physical specimen, painting without glasses and with barely diminished productivity into his eighties.[5] He understood that the most dangerous aspect of old age was not physical decline but an acceptance of cultural expectations. You, not your body, make yourself irresolute and debilitated.

If, as Petrarch claimed, you are as old as you feel, then Michelangelo, the Dante of painting, was a young fogy. Others called him "divine," but the ever hypochondriacal Michelangelo saw in himself the ravages of senescence by the age of 42.[6] Old age did not have fixed numerical standards during the sixteenth century, and even when the odd exceptions are removed, old age could still start as early as 50 years but more commonly at age 60.[7] Some early modern art historians and critics thought that incipient old age began at 50, but most set the entry at 60.[8] The Venetian republic in its civic practice set old age between 50 and 60 for their census collectors.[9] The state's official designation for the elderly was idle or useless people (*persone inutili*), and in that spirit the Scuola Grande della Misericordia exempted members over 60 from self-flagellation, a core religious and ceremonial practice for the Venetian *scuole grandi*.[10] Thus, by these conventional standards, Michelangelo at 42 years was anomalously young to enroll himself in old age, anticipating by nearly two decades the most common marker of 60 years. In his late forties and into his fifties, Michelangelo frequently described himself as old,[11] and by the time he actually reached old age by more traditional standards, he could barely write a letter without some pathos-inducing reference to his age:

I am an old man and death has robbed me of the dreams of youth – may those who do not know what old age means bear it with what patience they may when they reach it, because it cannot be imagined beforehand.
[Letter to Luca Martini, 1547]

I've many bodily disabilities which make me feel that death is not far off, so that I should be glad if you would come here this September, if I'm alive, in order to settle my affairs and ours.
[Letter to Lionardo Buonarroti, May 1557]

My brain and my memory have gone to await me elsewhere.
[Letter to Giorgio Vasari, 1557]

I'm all yours, old, blind, deaf, and inept in hands and in body.
[Letter to Bartolomeo Ammannati, 1559]

He died in 1564 at age 89, still an inventive and productive artist. His biographers chose for him a transcendental old age, but when Michelangelo addressed his friends he most often adopted senility as his defining attribute. Whether this was an indulgence, an affectation, an affect intended to manipulate, or an expression of melancholy and fatigue, it was most certainly characteristic of his hypochondriac self-image. The role suited him, weighed down by his own divinity.

Most early modern art biographers held equally pessimistic views for their subjects, as the first chapter of this book graphically illustrates. Ironically, it was the self-suffering Michelangelo who provided the exceptional example of an old artist transcending the effects of age. Most others, however, slipped into categories of loss: diminishing strength, coordination, and eyesight. Biographers thought of old age first as a biological and then as a social or psychological category. "After he had grown old and useless," Vasari wrote of Botticelli, "unable to stand upright and moving about with the help of crutches, he died, ill and decrepit at the age of 78. . . ."[12] "Useless" being the administrative category used by the Venetian census to designate elderly residents, we should read Vasari's phrase "old and useless" as a redundancy used for emphasis. Old age blurred into other physical and psychological pathologies that became particularly artistic: suicides (Rosso Fiorentino, Francesco Bassano, Borromini, Pietro Testa, Marco Ricci), schizophrenia (Mastelletta), fear of poisoning (Domenichino), hygiene obsession (Cappellino), fear of old women (Guido Reni), frequent nightmares (Barocci), and rampant phobias (Piero di Cosimo and Pontormo).

If beliefs create realities, readers of this book may want to enquire what beliefs about old age its author brings to his work. My prejudices lean toward the gerontophobic. At age 55, with old age just appearing on the horizon of my life, I fear what comes next. Hence my studies cover such topics as gerontophobia and the anxiety of obsolescence (chapter 1), narcissism (chapter 2), dysfunctional bodies (chapter 3), the family of phobias that haunted Pontormo's old age (chapter 5), and Mannerism as a senile style (chapter 6). I leave the more optimistic topics to other writers: how old age can bring transcendence; how elderly artists become wiser, reducing their art to its essentials; and how they liberate themselves from youthful preconceptions.

* * *

While prejudices can shape one's sunset years, old age is also a discomforting and constant biological fact. Despite current revisionisms in gerontology and the self-help guides to prolongevity, and until gene therapy renders old age obsolete, it remains an inescapable corporeal reality. Physical and psychological regimens can stave off deterioration, but we cannot escape the inevitable shortening of our telomeres or, to use an equivalent Renaissance metaphor, the unwinding of our biological clock. The taut muscles and flesh of youth do eventually slacken like the spring of a clock. Art biographers of elderly artists repeated the same story, dismal in its sameness: eyesight fades; reflexes and coordination slacken; the hand trembles. They saw old age mainly as a physical problem. Chapter 3 tells two stories about these common degenerative conditions, using Poussin's shaky hands and Titian's dimming eyesight as exemplary

models. However, in the fearsome loss of control that palsy and incipient blindness hold, it is dangerous to assume that paintings and drawings by old artists are merely passive reflections of their physical conditions, as if they were ECG lines. Even where biographical and visual evidence intersect – Poussin's tremors and his shaky lines, or Titian's blurred eyesight and his puckered pigment and mellow monochromes – we cannot always separate involuntary responses to physical and psychic aging from cunning references by artists to their old age. Complicating any interpretation of the artist's body is the partial control they exercised over self-presentation, a topic explored in chapter 4.

While representations of the body in early modern art continue to excite new research, the artist's own body remains comparatively marginalized, and for good reason: the artist's body can never be exposed to us so completely as bodies or "figures" in paintings. Corporeal sensoriality, or how we experience ourselves and the world through our bodies, lies at the heart of old-age biological determinism. Painters express themselves through the body (sight and gesture), and what they want to express changes with age as their senses reshape their experience of life. Psychosomatic methodologies such as humoral psychology and physiognomy took the body as a diagnostic map for the soul, psyche, and emotions. The physician and art collector Giulio Mancini (1558–1630), for example, used physiology and humoral psychology to explain the aesthetic inclinations of different nations.[13] Blue-eyed northerners have a cooler cranial temperature and cooler temperaments, and hence he adduces that they prefer cool colors and weak tonal contrasts. Dark-eyed Italians are hot-tempered and consequently prefer strong contrasts of light and dark. He did not, however, draw the obvious conclusion that physiologies also change with age, becoming cooler, dryer, and sluggish; that in their rancid, crapulent phase of life, artists' skin begins to resemble old paper and paintings, withered, parched, yellowed, and wan. Interwoven into these innate conditions were the temporal "accidents" of life – diet, disease, work, etc. – each interacting with the body's constitution in different ways.

Like the artist's body, the artist's corpus (its style or characteristic visible form) was read as a dependent form of the artist's mind and soul. Early modern critics deduced the creative characteristics of artists by corporeal autopsy: physiognomy, pathognomy, and physiology. Related procedures – graphology and stylistic analysis – enabled critics to deduce the physical and psychological conditions of painters from the body of their works (their corpus). Because critics cannot live inside the artist's body, they engaged metaphoric parallels to explain how the artist's life is manifested pictorially. The angelic virgin Guido Reni paints with heavenly grace. Swarthy and murderous Caravaggio invents tenebrism.

More so than any other biographer, Vasari was (and is) blamed for this kind of psychostylistics. When scholars impugn him as a fabulist, an unreliable historian, and a biased critic, they sometimes overlook the remarkable originality of his biographical epistemology of art. The concept of artistic self-expression pre-dates Vasari – taking precedence would be Alberti's claim for Narcissus as the first painter, for example, and the resulting Florentine proverb that "every painter paints himself" – but its extended application to historiography and biography was unprecedented. Stories like Andrea del Castagno's murder of Domenico Veneziano or Parri Spinelli's traumatic mugging were thought to be romanticized storytelling and hence art history at its worst. Castagno did not murder Veneziano, but mere factual truth is trumped by a need

to animate the rivalries between Florence and Venice, between design and coloring, between the cunning and the innocent. The murder reveals Castagno's pictorial style: sharp, cutting, and harsh. His first drawing instrument was a knife. Parri Spinelli may or may not have been mugged by two armed kinsmen, but Vasari was looking for a way to explain the Gothic curves of his figures: "the fear he felt thereafter was the reason that his figures lean to one side as if they were frightened."[14]

Vincenzio Borghini (1515–1580), philologist and cultural power-broker for Cosimo 1 de' Medici, worried about the consequences of Vasari's psychology of narcissine creativity. He wished that Vasari had written a book about art and not about the less worthy subject of artists, in other words, a book more like Alberti's *De pictura* (1435) than the seminal *Vite* that he knew Vasari to be reworking:

> The PURPOSE of your work is not to write the lives of painters, nor whose sons they were, nor what their typical actions were, but only about their WORKS as painters, sculptors, and architects. It is of little importance for us to know about the lives of Baccio d'Agnolo or of Pontormo. The writing of lives is suitable only for princes and men who have practiced princely things and not of low people, but here you have only as your end the art and the works by their hand.[15]

Therefore, according to Borghini, saints, poets, princes, and philosophers deserve biographies, not artists. We can only imagine the disapproval that Borghini felt concerning the autobiography of Benvenuto Cellini, self-puffing an ego already inflated past safety.[16] Vasari ignored Borghini's advice, obviously, coming fourteen years after the Torrentino edition of 1550 and just four years before the Giuntina of 1568. He also ignored the spirit of Borghini's advice, claiming the primacy of artists over works of art, the creators over their creations. Set aside the lives of artists! Borghini understood Vasari's intent of interpreting art through the artist's life. As he wrote elsewhere, one should never confuse art ("that which has essence") with the artist, who gives only incidental expression to that art.[17]

By citing Baccio d'Agnolo and Jacopo Pontormo to prove that "it is of little importance for us to know about the lives" of artists, Borghini turned to two compelling cases, the first already published in the Torrentino edition, the second in preparation for the Giuntina. They were artists whose lives carried vital meanings to their art. We do not usually think of Baccio and Pontormo paired in this or any other way, one a Renaissance architect (1462–1543) and the other a Mannerist painter (1494–1556), but they did share conspicuous public failures that finished their careers in disrepute. Both died bitter old men because they aimed high (Brunelleschi for Baccio, and Michelangelo for Pontormo), and knew or were made to know that they failed. For Baccio, it was the commission to complete the gallery around Brunelleschi's cupola for Florence Cathedral, not by following Brunelleschi's designs (which apparently were lost by then) but with designs of his own invention. When Michelangelo saw the work that had been finished on one side, he complained loudly that it looked like "a cage for crickets" and that the dome needed something much grander.[18] An outcry ensued, work was stopped, and Baccio became a pavement specialist starting with the Duomo floor. Like Icarus, he aimed high, aspiring to equal Brunelleschi, but was struck down to earth for his hubris. The case against Pon-

tormo, who fashioned himself as a new Michelangelo and failed with his last work, the choir of San Lorenzo, will be presented in chapter 5.

If art reflects its creator, as Narcissus' reflection captured a cunning self-portrait, then an old artist will paint differently from a young one, in ways characteristic of his years. "Every painter paints himself" articulates a fluid and ambiguous semiology that enabled artists to communicate with the viewer. One reading of the proverb holds that a painting passively reflects the appearance and character of an artist, much as facial features reveal physiognomic signs of a person's character. We look at a painting but see the painter; or as Anton Raphael Mengs lamented when looking at a *Virgin and Child* by Annibale Carracci: "I can only see Annibale." According to another reading, however, what Mengs took to be a transparent relationship between art and artist could also be a constructed one where the artist paints in ways that seem appropriate to his character. According to this model, the artist can act like a courtier and manipulate his performance for particular effects.

Artists who read Vasari's *Vite* and its progeny became more self-conscious about how their styles would be interpreted, what psychological attributes would accrue to them, and what place in history they might occupy. But why leave it to the next Vasari? Why not mythologize yourself? This is obviously a complex subject with many different roles available to artists: the artist as courtier, as humanist, as technician, as scientist, as melancholic seer, as rebel, or some combination of them. As the idea of painting oneself became a proverbial truth during the late sixteenth and seventeenth centuries, artists could begin to manipulate receptive audiences in more subtle ways. The dominant myth of self-reflective art meant that artists could expect their audiences to perform certain kinds of stylistic analysis based on the expectation that non-artistic actions reveal the creative mind. How artists dressed, what they ate, how they spoke, became signs of their identity, signs that led critics and collectors to look at their paintings in particular ways. Facial hair, bewigged or not, their carriage and servants (should they be so lucky), their gait or posture, all belonged to a social code that changed with time, place, and class.

* * *

Old age has a history, one that revolves around two incompatible views: one of physical, mental, and psychological decline; the other of a spiritual liberation from our corporeal limitations.[19] Like old age, old artists have a history. It started with sixteenth-century biographies, predominantly *Le vite de' più eccellenti pittori scultori e architettori* (Florence, 1550 and 1568). Giorgio Vasari, like the biographical tradition he spawned, described aging artists most often in Aristotelian terms of physical and psychological deficits: failing eyesight, uncontrollable hands, melancholic solitude, various phobias, and bitter nostalgia. Instances of Platonic old age – prudent, peaceful, and pious – are fewer. From the historical record of Vasari's *Vite*, Raffaello Borghini drew a universal conclusion in *Il riposo in cui della pittura e della scultura si favella* (Florence, 1584): because artists generally decline with old age, they should accept this unwelcome truth and act accordingly by abandoning the practice of painting in favor of theory and instruction.

Between 1584 and 1590 old artists became a subject of analysis, instruction, and moralizing. The topic arrived on the scene just as a critical consensus emerged that modern art had suffered a terrible decline. It is not coincidental that the treatises where old age first appeared as a subject of art theory were written by those who subscribed to the belief of modern cultural degradation: Giovan Battista Armenini (*De' veri precetti della pittura*, Ravenna, 1586), Giampolo Lomazzo (*Idea del tempio della pittura*, Milan, 1590), and Raffaello Borghini. All three contributed to a gathering consensus that contemporary art had worsened and might possibly enter a new dark age. As the final section ("Historiography") of this book shows, they used old age to explain the failure of individual artists and the decline of art in general. Two of them – Armenini and Lomazzo – were failed artists writing at a time when they no longer could paint or wanted to paint. For Lomazzo, a painter whose enveloping blindness made him uniquely sensitive to the corporeal limitations of making art, the epistemology of art was partly physiological. Old artists, he thought, manifest their age physically; even the divine Michelangelo in his third, last, and worst style did so.[20]

The invention of a universal "late style," one whose characteristics transcended any individual's style, came later with Roger de Piles' *Abrégé de la vie des peintres* (Paris, 1699). Lomazzo had explored this terrain previously and classified Michelangelo's work in three sequential styles with the worst coming in old age, but he never generalized the attributes of a universal old-age style; like Vasari, he limited late styles to individual artists. De Piles, however, developed Baldinucci's definition of individual style and mannered style (*maniera* and *ammanierato*) by mapping out three stages that applied to all artists: the first style of youth, where artists follow their masters; the second style of maturity, where they become truly themselves; and the third style of old age, when they become mannered or caricatures of themselves.[21] The late style, exemplified by Titian, is when an artist "degenerates into habit." De Piles' universal staging of artistic styles had practical effects on how critics and collectors looked at paintings by old artists. For example, Ferdinando de' Medici remarked in 1703 how the landscapes by Francesco Bassi, painted at the age of 63, were labored and weak, and, "appear to be copies by a feeble student rather than originals by a noted master."[22] Bassi had become unlike himself and reverted to student status, now copying himself in a second childhood.

Most of the ingredients for our understanding of late style are present in these early modern writings, including the beliefs that style changes with age and that a unique relationship existed between artistic psychology and works of art.

Old-age style is usually seen as a German invention and hence first named in German (*Altersstil*). Goethe is often cited as the progenitor of an old-age style as a positive phenomenon, one involving "a gradual withdrawal from appearances" and a consequent approach to the infinite and mystical.[23] Albert Erich Brinckmann in *Spätwerke grosser Meister* (Berlin, 1925) is credited as the first art historian to posit it as a recurring phenomenon,[24] even though, as I mentioned before, this honor actually goes to Roger de Piles. The attributes that Brinckmann assigned – *non-finito*, subjectivity, and a blending of these formal and expressive elements (*Verschmolzenheit*) – derive from German Expressionism (as well as Goethe),[25] and, despite their historical origin, they remain embedded in art historical writing today. Because the craft of art is still valued less than its ideation (our Renaissance heritage), old artists, or at least the great

ones, were exempted from the physical effects of old age.[26] Instead, old age became spiritual-ized. In a classic article by Walter Friedlaender on "Poussin's Old Age," he described and sub-scribed to the traditional view:

> It is a remarkable and often discussed phenomenon that great artists develop in the last years of their lives a sublime style which differs symptomatically from the style of their youth and maturity. The works of the late or "old age" style of Titian, Rubens, Rembrandt and others display a deepening and broadening of imagination in form and idea that compensates for the natural uncertainty of vision caused by the decay of bodily forces.[27]

Two features are noteworthy about Friedlaender's concept of sublime senescence. First, he reserved sublimity for "great artists" (Poussin, Titian, Rubens, and Rembrandt), those whose talent and imagination can overcome physical frailties. By defining old-age style as exceptional, Friedlaender and Brinckmann encouraged scholars working on any old artist to apply these attributes whether or not they are appropriate. The reasoning could go like this: if "my" artist is "great" (and who wants to admit to working on a mediocrity?), then by definition "my" artist will manifest these signs of old age. Second, Friedlaender adopted a medicalized vocabu-lary ("symptomatically"), and the notion of compensation, where physical deficits bring bene-fits of mind, is representative of this view. The symptoms of old age are displaced from the artist's body to his figures. In *Apollo and Daphne* (pl. 1), Poussin's last painting, Friedlaender finds an "immobile tranquility" in pose and mood.[28] In the later version of *Achilles and the Daughters of Lycomedes* (Richmond, Virginia Museum of Fine Arts), he found Poussin moving from an expressive extroversion toward "a quiet and almost lonely repose" where the figures "hardly seem to react to one another." And finally, Friedlaender rendered Poussin's late style autobiographical. In the *Apollo and Daphne*, Poussin "renders an atmosphere full of peace and happiness that is nevertheless impregnated with forebodings of catastrophe . . . [I]n the midst of ideal beauty is the premonition of tragedy." What we see on the surface may be peaceful, but growing underneath, "impregnated" as it were, is a catastrophe. With these contradictory statements, Friedlaender compliments himself in diagnosing future life events from artistic forms. He also demonstrates, perhaps unintentionally, that old-age styles are paradoxical.

Hoping to extricate art history from some of its inheritance, David Rosand posed a series of challenging questions in his preface to the *Art Journal* issue of 1987 devoted to "Style and the Aging Artist":

> Can we, drawing the analogy between biography and stylistic evolution, talk of a life-cycle of style? What, indeed, is the relation of the life of an artist to his art, the correlation between age and style? What should or can we know about the body as well as the mind of the artist? What other determinants act to shape the late style of an artist – medium, conventions, tra-ditions, social forces?[29]

Rosand's questions are fraught with expectations, first and foremost, that such a thing as a "late style" exists, as he posited in the final question. Yes, we can talk of a "life-cycle of style," but not in a way that gives it general legitimacy, as Rosand is angling, but only (I will contend) as

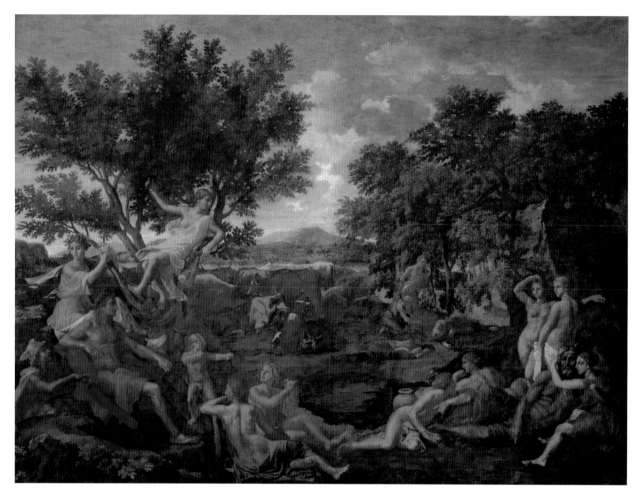

1 Nicolas Poussin, *Apollo and Daphne* (Paris, Louvre)

a historicist construct. Despite the methodological doubts that Rosand wanted to inject by asking about art as autobiography and about life cycles of style, art historians continue to adhere to the symptoms discussed by Brinckmann and Friedlaender. For example, according to Roger Rearick, Paolo Veronese's late drawings "grew more ethereal," and in Jacopo Bassano's *Susanna and the Elders* (Nîmes, Musée des Beaux-Arts), he finds that "a ghostly deer stares in from the right, and the anatomy of the central elder has lost corporeal legibility."[30] And, in a final example (of what could be an endless series), Nicola Spinosa gives us a highly subjective reading of Jusepe de Ribera's late style, one that projects biography literally into his paintings (pl. 2):

The last years of Ribera's life were made sad and difficult by poor health, vicissitudes of family life, and financial difficulties – elements that made the aged master increasingly sensitive to the human condition and responsive to familial intimacy. In the *Adoration of the*

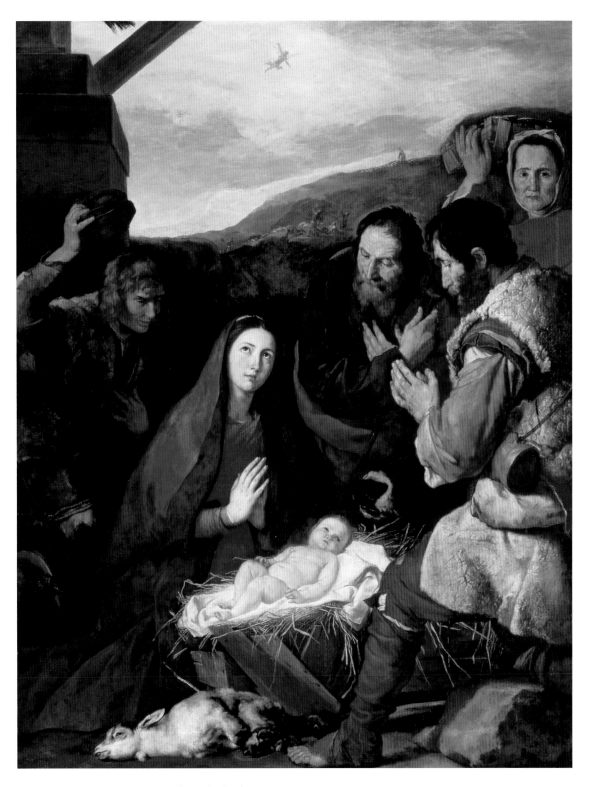

2 Jusepe de Ribera, *Adoration of the Shepherds* (Paris, Louvre)

Shepherds in the Louvre of 1650, the pleasant tone of his earlier treatments has become a touching evocation of domestic affections and those common bonds of everyday miseries that are confronted with dignity and Christian resignation, without bitterness or rancor.[31]

Looking at this painting without the framing of biography, one could just as easily find a dulled sensibility instead of Spinosa's resignation.

With B-team artists, even in recent revisionist accounts of their work, more frequently we find the weaknesses of old age openly discussed. Antonio Zanchi enters "a long and decadent old age" painting "without strength or muscle"; and Donato Creti's late work is "weary with the artist's old age." Even art historians who resist this typecasting can reluctantly admit that the rehabilitation of their artist cannot be sustained into old age:

> Many writers have found the works of Ludovico [Carracci]'s last years disappointing. . . . [It] is undeniable that the surface of objects is less forcefully and attractively presented in the late than in the early work. . . . At times the late work can seem drained of energy, action, and vitality. Though early critics like Malvasia admired Ludovico's late work, few modern writers have found any virtues in it. They have assumed that the aging artist's creative powers had faded. . . . [It] is taken for granted that he would have painted in his former manner if he were able, and thus Ludovico must have experienced an involuntary loss of artistic prowess.[32]

Despite Gail Feigenbaum's noble efforts to find a profound "iconographic complexity" and "theological and moral lessons" in Ludovico's late work, can we really believe his *San Carlo Baptizing during the Plague* (Nonantola, Chiesa Abbaziale) or his *Adoration of the Magi* (pl. 3) to be a "meditation" when even she describes them as possessing "a curious sluggishness"? Or when she so vividly captures the effects of his old age in these terms: "Actors move languidly in a thick atmosphere, as if under water. The fog, slow motion, the dullness of the physical responses of the actors, have the effect of conjuring an image as it coalesces dimly in the mind, half obscure."

* * *

By accident more than design, this book has three thematic sections:

1) "Psychology" studies the cultural beliefs about how character and intellect changed in old age, and how those changes affected (or were thought to affect) the artist's work.
2) "Making Art in Old Age" takes three artists – Pontormo, Titian, and Poussin – who exemplify (or were made to exemplify) body, mind, and psyche issues.
3) "Historiography" looks at early modern inventions of senescent Mannerist and Baroque styles, and poses the question: How did the first art historians attribute to history itself the worst aspects of old age?

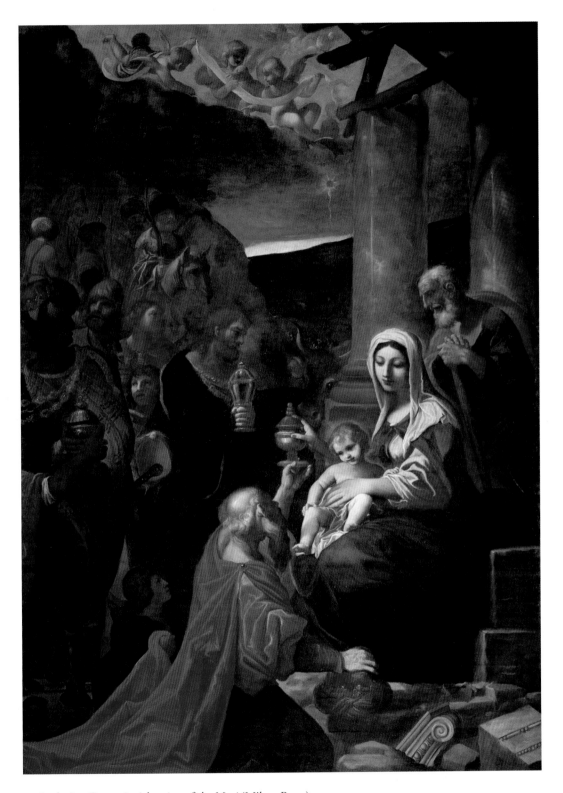

3 Ludovico Carracci, *Adoration of the Magi* (Milan, Brera)

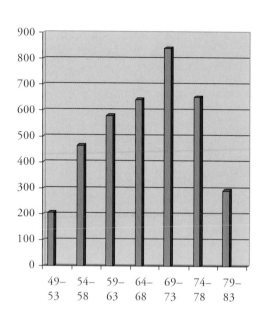

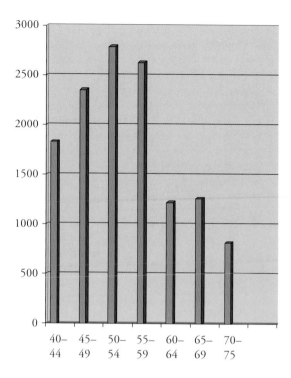

Graph 1 Paolo Farinati (1524–1606): annual income (in ducats) in five-year averages (based on data from Paolo Farinati, *Giornale, 1573–1606*, ed. L. Puppi, Florence, 1968)

Graph 2 Guercino (1591–1666): annual income (in ducats) in five-year averages (based on data from Guercino, *Il libro dei conti del Guercino, 1629–1666*, ed. B. Ghelfi, Bologna, 1997)

There could have been many more than these three sections, covering such important topics as the pictorial techniques of old age (using or initiating conservation laboratory studies), or the spirituality of old age, or the iconography of old age. In my current research on the economic lives of Baroque painters, I ask how an artist's earning power changes over his or her lifetime. It is not a question that I would have posed before writing the present book. The preliminary results are suggestive. An artist's lifetime earnings often follow a bell curve, with income declining in old age. The two most complete account books by seventeenth-century painters who reached old age – Paolo Farinati and Guercino – clearly demonstrate this pattern. (I have tabulated the results in Graphs 1 and 2, averaging their incomes into five-year composites.) Declining income in old age can be precipitated by various factors: lower productivity, because the elderly painter thinks and moves more slowly; diminishing demand as patrons exercise their prejudices about old age and turn to younger, possibly more fashionable artists; an increased reliance on assistants with a consequent loss of artistic and economic value; and a gradual withdrawal into voluntary retirement.

What makes old age so compelling as a field of enquiry in art history is its openness. The vista is uncluttered by thickets of scholarship, much like gender studies in the 1960s. In one sense, every scholar working on an artist who lived past 60 studies old age. And there

Graph 3 Age of painters at death. (Vertical axis = number of painters; horizontal axis = age at death)

were many old painters, nearly two-thirds of all painters as the longevity data in Graph 3 shows (based on 975 Italian painters with known birth and death dates between 1500 and 1700).

However many opportunities there are, and as this graph shows there are many, and no matter how often art historians write about artists who happen to be old, the "problem" of old age remains secondary to their other concerns, if it enters the discussion at all. I hope this book will open new sensibilities and new questions about what it meant to be an old artist and to look at art by an old master.

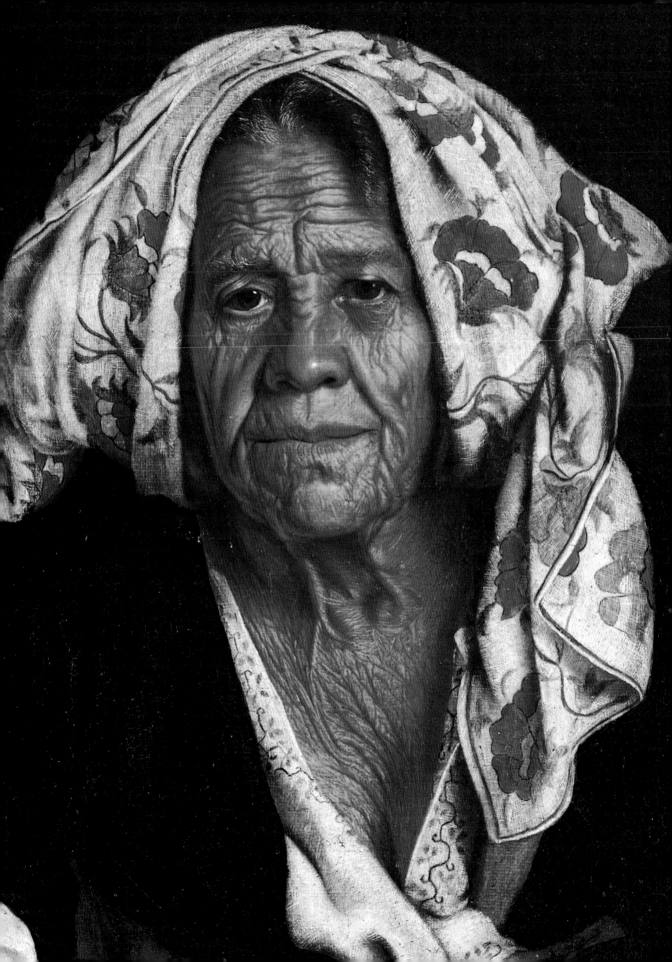

I Psychology

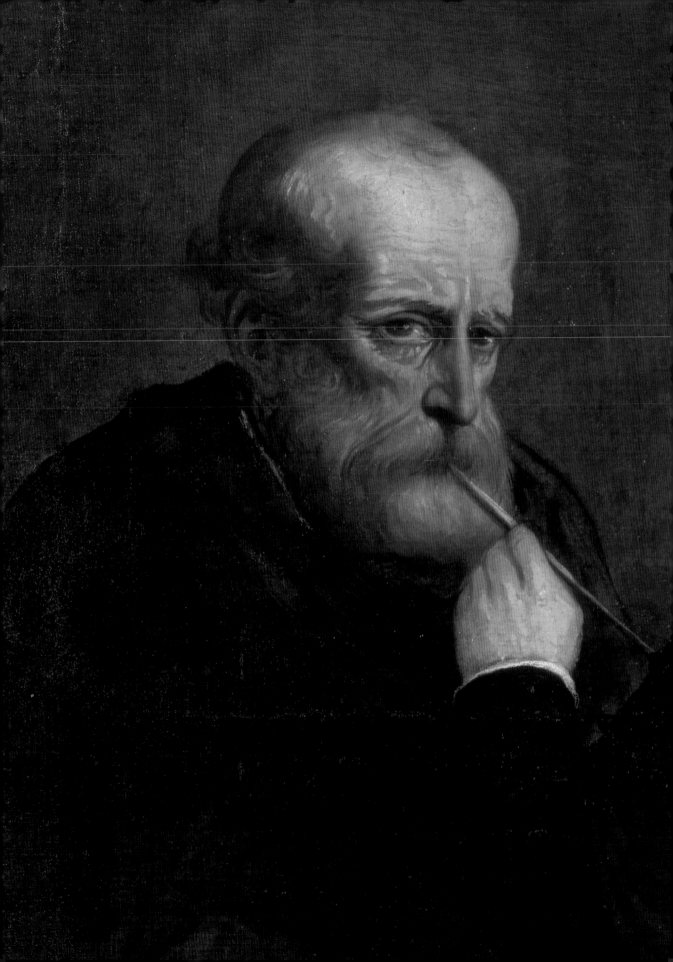

1 Gerontophobia and the Anxiety of Obsolescence

As Western postmodern society labors to free itself from destructive biases such as racism and sexism, anxieties about corporeal decline and death continue to fuel a flaming gerontophobia that may be more resistant to suppression than gender and racial prejudices. Gerontophobia is an emotional reality – some psychologists say that it is an enduring cross-cultural phenomenon – that resists not only "right thinking" but even the powers embedded in political and economic gerontocracies. Modern geriatric liberators take the optimistic view that old age can be freed from the stigmas of typecasting. Because ageism, racism, and sexism operate on the basis of visible and physical appearances, sometimes just skin-deep, they can be easily discredited as superficial misconceptions. They are cultural prejudices, not exclusively biological realities as once thought. Despite these similarities, ageism functions differently from racism and sexism at least in one respect. Unlike race and gender, which are assigned at birth and differentiate us for life from the other gender and races, with age we eventually become the "other." "What I was once, I am not: the best has perished," wrote Maximianus in his *Elegies on Old Age* (I. 5). In old age the Neapolitan painter Giuseppe Marullo (d. 1685) discovered that his hand had ossified and that he could no longer recapture his youthful, pliable style of painting. Looking at one of his early works, he lamented: "here I am as a youth, having painted these great works, and now as an aged man I don't know how I did it."[1] We accumulate our prejudices about bodies – gender, race, age – when we are young, when negative stereotypes of the elderly help us to form our emerging identities, but unlike racists and sexists, every ageist turns into the object he fears, should he be lucky enough to live so long. A recent survey of more than 17,000 people shows a dramatic drop in self-esteem in old age.[2] Age turns us against ourselves.

Aging poses an existential crisis. As we grow old, we look less and less like ourselves; we move and feel unlike ourselves. We lose parts of our individuality, our identity, and acquire attributes shared by every other old person:

> Deformed and ugly face
> Unlike its former self, a wrinkled hide
> Instead of skin, the hanging cheeks, the grooves
> Like those an old baboon carves on her jowls
> Deep in the shaded jungle of Africa.
> Young men differ in so many ways . . .
> Old men have one appearance only.[3]

Facing page: Luca Cambiaso, *Self-Portrait*, detail of pl. 8

A modern-day Juvenal, the personal essayist Phillip Lopate, also shuddered at the anonymity and uniformity of the elderly: "Old age is a great leveller: the frailer elderly all come to resemble turtles trapped in curved shells – shrinking, wrinkled, and immobile – so that in a roomful, a terrarium, of the old, it is hard to disentangle one solitary individual's karma from the mass fate of aging."[4]

Our self-image resists the physical changes of our shell. We want to believe, like Michelangelo and other Neoplatonists, that our body is just a skin that can be sloughed like a snake or St. Bartholomew, but like Juvenal we fear that we have become merely "a wrinkled hide." In pre-modern times, literature captured the anxieties about old age more effectively than philosophy or medicine. When the attributes of old age in Greek and Roman literature are collected and arranged by frequency of use, a remarkable picture emerges of old age as primarily a dreadful corporeal decline: "dirty; sallow complexion; stinking breath, smelling like a goat; grey-haired, pot-bellied, slanting-jawed, flat-footed; untidy; shabby; sickly; ragged and aged; bent-double, shaky, loose-lipped; groaning and of damnable shape . . . ugly old thing; a withered, worn-out, flabby old man; the old fossil; decrepit old frame and stupid old chatterbox."[5] From literary and biographical perspectives, which became part of the foundation of early modern art biographies, old age is a fallow, putrefying terrain. The aging body returns to its inherent materiality, revealing itself for what it is – a fragile and shabby vessel. The great Renaissance chronicler of aging, Gabriele Zerbi, borrowed Aristotle's metaphor of decay when he evoked "the senile body as almost like a ruined and broken building."[6] Rosalba Carriera (1675–1757), the famed pastelist whose cosmeticized portraits seem touched by her own fragrant beauty, needed reassurance in her old age, just as she was turning 70, and received it from her loyal friend and correspondent Antonio dall'Agata. The beauty of her work resides not in her own legendary beauty so much as in her character (*disposizione*), he wrote to her, and so her pastels will only improve with age, "even to one hundred years."[7] This must have been particularly reassuring for a woman in an art world where artistic and female beauty were so closely entwined,[8] and where her own beauty could be taken as a sign of her art, as Giulio Mancini did for Lavinia Fontana: "Do not wonder that she paints so beautifully because she paints herself."[9] Still, following this upbeat message, Dall'Agata acknowledged in 1744 the source of Rosalba's anxiety and the power of prejudice she was struggling with:

> It is true that many artists, even most of the best ones, when they recognize the advancing years find not only that they have made a glorious reputation for themselves but also that their work has begun to decline from the first beautiful way of painting. More and more they can no longer recognize their work as their own, but one cannot say the same of the great lady Rosalba . . .[10]

Art critics also found aged artists to be uncharacteristic and unlike themselves: Domenico Passignano (1559–1638) became "inferior to himself," and, according to Ferdinando de' Medici, the 63-year-old landscapist Francesco Bassi (1640–1703) produced paintings that "appear to be copies by a feeble student rather than originals by a noted master."[11] Paintings by Domenico Parodi (1668–1740) "no longer resemble the hand of their youth . . . they show so little knowledge of himself that it becomes difficult to believe that he made them."[12] Parodi's friend and

biographer, Carlo Ratti, blamed old age – "This is completely the fault of old age which cools the imagination, dims the vision, makes the hand waver, and extinguishes his former brio" – but he could not resist mentioning the general belief that Parodi died from "the immoderate use of chocolate," his sole sustenance in old age. His death-by-chocolate, like so much in old age, shows how the ridiculous often lurks behind the tragic. Mattia Preti (1613–1699) gave up painting not for reasons of physical disability but in order to contemplate eternity – one of those exceptional artists who remained strong and active even into his eighties – and how did he die? from facial gangrene caused by a cut that an aged and shaky barber had inflicted on him.[13]

Old age was an abject and humiliated state, a fallen state of lost grace, beauty, and power. Old women were particularly vulnerable to what Susan Sontag called, "the double standard of aging."[14] In one of his parables Leonardo writes of "Helen, looking at herself in the mirror, seeing the wrinkles in her face made by old age, weeps and asks herself why she was twice raped."[15] And in his advice on "How old women should be represented," we find no examples of dignified aging (such as Mary Magdalene) but only of "infernal furies": "Old women should be represented as shrewlike and eager . . ."[16] Ruzante, the social satirist from Padua, compared youth to "a lovely flowery bush where all the birds flock to sing" and old age to "a skinny dog pursued by swarms of flies who devour his ears."[17] In his lost fresco cycle at the Palazzo Ducale in Sassuolo, dated 1657, Giovanni Boulanger concluded his history of ancient art in the Room of Painting, mostly potboilers from Pliny, with the *Death of Zeuxis*, where poor Zeuxis "dies laughing after painting a ridiculous old woman," an invention derived from the Roman grammarian Marcus Verrius Flaccus.[18] Many early modern paintings of old women are suspended between parody, dignity, and tragedy – Quinten Metsys's *A Grotesque Old Woman* of *circa* 1525–30 (London, National Gallery) or Pietro Bellotti's *Fate Lachesis* (pl. 4) – because the deformity of old age poignantly recalls the beauty of lost youth. Wrinkles in these paintings take on an iconic status, transforming soft flesh into dried and cracked mud riven with fissures.[19] In *La Vecchiaia* or *Col tempo* (pl. 5), Giorgione evokes old age as a time of poverty and, in the subject's servile pleading, as a time of subjugation. Like Leonardo's Helen, physical appearance defines her age. Helen sees herself and cries; Giorgione's old woman submits herself to the viewer's gaze and seeks our pity. Time may erode our appearances gradually, hinting at the arrival of old age, but the recognition of our own age can be sudden and shocking. Like Leonardo's Helen, Tomaso Garzoni in the oft-published *L'hospidale de' pazzi incurabili* (Hospital for the incurably insane) tells the case of Acco, an old woman who discovers her "deformed old age" when looking in a mirror.[20] Unable to believe this ruined image to be herself, she took refuge in madness and spent her last days laughing and arguing with herself. In another bit of misogyny, François Bruys in *The Art of Knowing Women; or, The Female Sex Dissected* (London, 1730) discusses "the Deformities of Old Age" that women try to conceal "with all the deceitful Powers of Cosmetics," trying to cover "the hideous Ruins" of their beauty instead of frightening themselves in the mirror.[21] Which is worse, he asks, to appear ridiculous or old? For women, apparently, other options did not exist. Why old women? In part because beauty conventionally resided in women, and hence too its ugly counterpart. *Formoso* and *deformo* mirrored each other. Instead of the purity and clarity of youth, the repulsive elderly are, again in the words of Ruzante, "a

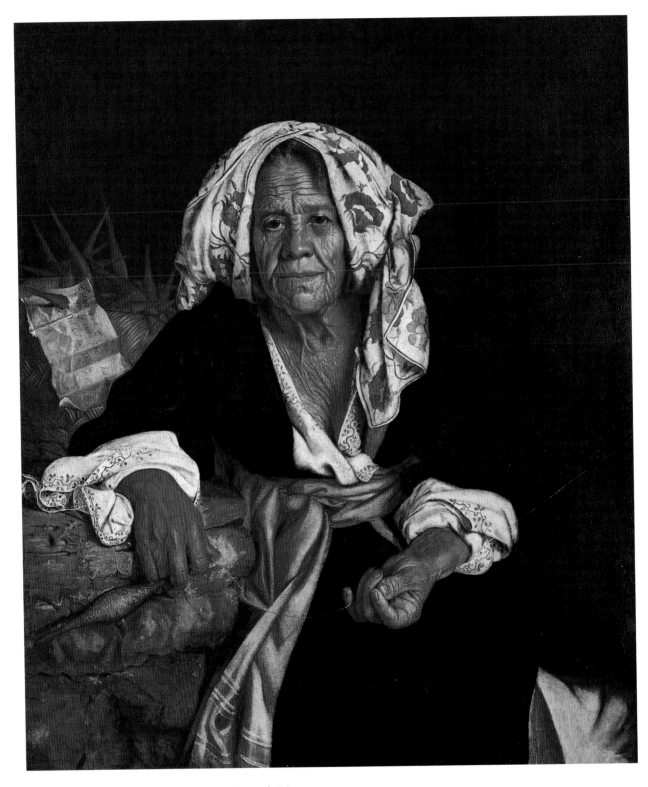

4 Pietro Bellotti, *Fate Lachesis* (Stuttgart, Staatsgalerie)

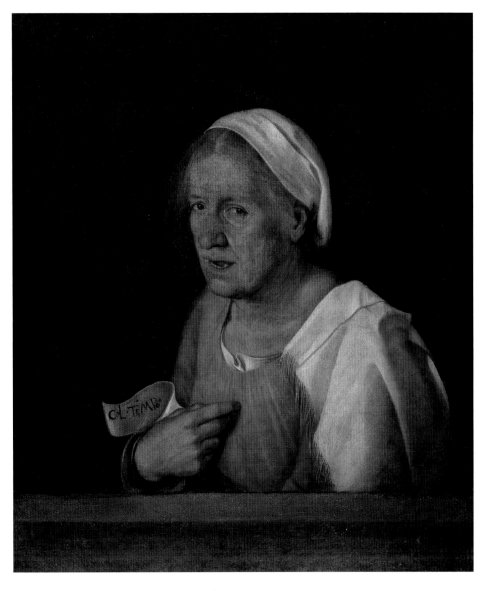

5 Giorgione, *La Vecchiaia* (Venice, Accademia)

swamp where every sort of unhealthy water gathers." Most witches were old women, either sin-
ister and dangerous, or just repulsive. Out of the "toothless mouth" of an old woman comes "a
putrid smell which makes the cats sneeze" (François de Maynard).[22]

Irrespective of gender, however, old bodies were generally sites of decay and deformity, "a
breathing mummy," according to Ronsard, "colorless carrion, tomb's plunder, disinterred
carcass, crow's prey." The physician and art critic Francesco Scannelli called the old body a
"monstrosity."[23] And when Gabriele Paleotti, Archbishop of Bologna and author of an influ-
ential treatise on art, tried to rescue old age from its reputation in *De bono senectutis* (Bologna,

1595), a book full of hopeful bromides, even he thought his book's frontispiece should include an image of something "horrible and deformed," if only to demonstrate (perversely) the hidden beauty of the soul.[24] In modern psychological parlance, "because of their frailty, the aged are moving into the country of the dead; they take on some of the fearsome aura of the corpse that they will soon become."[25]

* * *

Artists were particularly susceptible to gerontophobia. Old age for painters, according to the biographer and failed painter Carlo Ridolfi (1594–1658), was a time "that brings great annoyance and infirmity and that is unsuitable for working."[26] Having read in biographies about the decline of even great artists, and having witnessed it first hand within the local community, many of them might have agreed with Lione Pascoli's dismal claim that "those who live long are ill-advised!"[27] In 1639 Guido Reni (1575–1642) told a prospective patron, Ferrante Trotti, that he felt himself growing old and burdened, less vigorous, and so "I even have begun not to like myself."[28] Reni suffered from shame and perhaps even self-loathing throughout his life, but at age 64 he identified the cause with old age. Ludovico Carracci (1555–1619) was also 64 when, in an apocryphal and moralizing account, he distorted the foreshortening of an angel's foot in his supposed last work, an *Annunciation* (pl. 6). Malvasia ascribed the error to the painter's

6 Ludovico Carracci, *Annunciation*, (Bologna, San Pietro)

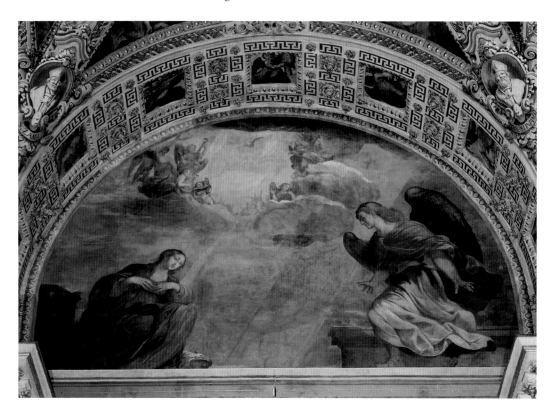

failing eyesight ("he could not see well, his sight being impaired by age").[29] When the fresco was unveiled, "the public outcry and the many complaints" made Ludovico determined to correct it, but the church's overseers would not allow new scaffolding to be constructed, thus making Ludovico "so distressed and overcome with sorrow that he took to his bed and died within a few days." "Only the fortunate few, but very few, are not abandoned by fortune in old age," Pascoli warned his readers before revealing that Giovanni Battista Gaulli (1639–1709) was not one of them. Neither was Reni, as we will see in chapter 7. Pascoli (1674–1744), on the cusp of old age himself when he wrote this, opined that "how much more glorious would be the dead if they hadn't lived so long." Giovanni Stefano Robatto (1649–1733), true to his name (*arrobatto* in the Genoan dialect means to make something less), precipitated a decline to his already meager reputation by continuing to paint in old age.[30]

The advice, freely given by Raffaelo Borghini, a nonpractioner, that painters should retire in old age instead of facing the inevitability of decline, was usually followed only when the artist became physically incapacitated. Twenty years before Borghini recommended voluntary retirement for old painters whose talent was slipping, Vasari had helped to plan the first dedicated nursing home for artists: "and for the old artists who are past the period of labor, his Excellency has (for the benefit and honor of us all, and to his own immortal memory in this world) provided an infirmary, where they may in retirement cultivate divine knowledge, to the end that they may live like Christians, and among them do many acts of charity til they fall into the grave."[31] Many artists, even successful ones like Francesco Albani (1578–1660), were forced by financial exigency to continue painting long after old age had sapped their creative spirit. In his old age Albani labored into the early hours, his friend and biographer Carlo Cesare Malvasia wrote,

> and it was then precisely, that working more out of necessity than from sincere inclination, more out of utility than for glory, he began to weaken in his works, the quickness of his spirits also unfortunately aggravated by the weight of his already weary state; wherefore interested amateurs may observe and find much difference in his pictures from that period on.[32]

Voluntary, happy retirements are rarities in art biography. Lazzaro Tavarone (1556–1641) was one, but in his case he simply became tired of painting, especially of the physical demands of frescoes. Having achieved financial success, a pleasant home, and beautiful possessions, Tavarone decided that it would be more pleasing to stay at home and enjoy his collection of 2,000 drawings.[33] Viewing became a satisfying substitute for painting. Few other artists had this fortunate combination of opportunity and temperament to make retirement a viable option. Arrigo Fiammingo (*fl.* 1561–90) continued painting into his seventies, wrote Giovanni Baglione, not because he wanted to but because he had to.[34] The physician Giulio Mancini knew that many celebrated artists did not work as well in old age as in youth, although (alas) he does render a medical opinion about the causes. Artists should follow Michelangelo's example, who, Mancini thought, abandoned painting and sculpture in order to stop his hands from "making a mess" and adopted architecture instead because it required judgment alone. Mancini corrected Vasari in great detail, showing himself to be a dedicated empirical historian, but in the case of

Michelangelo's career he invented a history that conformed to his ideas on old age and that fit comfortably within his subject's famous judiciousness.

Some artists amassed impressive estates (the two largest estates being those of Michelangelo and Bernini, the new Michelangelo), but most artists faced old age without the financial cushion of their few rich and famous colleagues. Poverty and old age were linked even more than they are today. Artists, anticipating a time when corporeal decay would disable them, strove to maximize profits in order to save for that dreaded time. The cost to their art, where increased production led to diminished quality, became a biographical motif.[35] For Salvator Rosa (1615–1673), artists on the cusp of old age "see themselves between prison and hospital notwithstanding their reputation and genius."[36] Economic data confirm artists' expectations that they would sink into poverty or at least suffer a painfully diminished income in their old age.[37] The account books of two artists who reached old age – Paolo Farinati and Guercino – demonstrate this phenomenon in detail and even suggest causes: declining productivity and declining prices (see Graphs 1 and 2, p. 14).

* * *

Exceptionalism is the masked twin of gerontophobia, the twin of denial and hope that tries to rescue old artists from a conventionally predicated decline. Because critics thought of old age mostly as a corporeal deprivation evident in an artist's technique, exceptions were important in demonstrating that art was more than technique, more than a craft. Exceptions to the norm suggest a resistance to the acknowledged physical realities; they predicate art as something that transcends materials and actions, something conceptual and spiritual. However, by exempting great masters from the deleterious effects of age, they confirm popular expectations. Exceptions reinforce the inevitable downward trajectory of old age. Giovanni Pietro Bellori (1613–1696) resorted to this trope when he defended his friend and adviser Carlo Maratta (1625–1713):

> It is remarkable for anyone who looks at his work that, whereas other painters (no matter how excellent) become feeble as they grow old, Carlo on the contrary improves with the years, always stronger so that his last works are his best. For no other reason than his age, one can expect his work to decline, but he is so assured that he never succumbed to inconstant practice or to a habituated talent. Instead of losing the force of his natural talent, which normally grows cold with age, he became stronger . . .[38]

Two types of exceptionalism can be identified: the painter maintains his earlier quality – stasis, not progress, is the most that the elderly could aspire to; and the critic adopts a form of relativism similar to discussions of the "primitives" (pre-Raphael) whose paintings were judged within a framework of reduced expectations. The first type was the most common. Antonio Balestra (1660–1740) at age 64 showed "no loss of his great understanding despite his advanced years, something that is rarely, or possibly never, seen."[39] Approaching 80, Carlo Cignani (1628–1719) finished the cupola fresco in Forlì Cathedral, whose physical demands alone prompted admiration, and even in less taxing work he never lost his "ready and resolute" style.[40] Francesco Albani (1578–1660) at age 81 – although he thought of himself as 84 – could no long-

er finish his work with the same "delicacy," according to the Bolognese senator Ferdinando Cospi, writing in 1659, yet his spirit remained untouched.[41] Bartolomeo del Bimbo (1648–1729), "in his decrepit years of over 80 . . . amazingly weak and emaciated," could still paint "very well indeed"; and Ferraù Fenzoni (1562–1645) lived and worked well "almost for a whole century."[42]

The most exceptional old artist was Michelangelo (1475–1564). Vasari's agenda for Michelangelo involved transcendence, an artist who overcame suffering for his art, an artist whose creativity and spirituality overcame physical discomfort and inoculated him against the effects of old age. Although he "could no longer draw clear lines" in old age, when "his flesh betrayed his spirit," he still managed to design the cupola of St. Peter's, the Porta Pia, and Santa Maria degli Angeli. He embodied the senescent ideal expressed by Stefano Guazzo in his popular etiquette manual of 1574: "Age is undoubtedly the seasoning of prudence; when the body begins to wither, it is then that the mind's eye begins to flourish."[43] Michelangelo was exempted from the more humiliating effects of old age assigned to many others, and his old age came as final proof of his divine art, much like his fragrant, immaculate corpse. He was not only eternal before death, and hence worthy as the sole living artist for inclusion in the first edition of Vasari's *Vite*, but his saintly corpse was discovered to be eternal after death, emitting only the smell of flowers and with no signs of physical decay when his coffin was opened more than three weeks after his temporary entombment in Rome. Condivi tells us that Michelangelo wanted his body to be embalmed so that it would remain eternal, like his art, which would make his sweet-smelling corpse his final act of self-fashioning, even though Vasari presents it as a supernatural event.

The second type of exceptionalism, more sympathetic and tolerant than the first, but also less common, held that "one must excuse him if one sees it painted in a weak style because it was made by an old man, now octogenarian."[44] Or, according to the forgiving Bernardo de' Dominici,

> one must excuse the weakness of these and other [paintings] that Andrea Vaccaro made in old age since the early vigor of an artist's spirits flag with the weight of years, and as a consequence the fervor of imagination starts to weaken as does the sharpness of the senses which is so necessary for working.[45]

Usually critics were not so tolerant, and even de' Dominici immediately turned to three "famous painters from our time" who being greater fell further in old age (Mattia Preti, Carlo Maratta, and Francesco Solimena). When Solimena (1657–1747) sent some paintings to Venice in 1735 at age 78, the Venetian collector Antonio Widmann reported back to Naples that they were met "with little praise, lots of blame, and some compassion because of his advanced age."[46] Venetians had some knowledge of Solimena's earlier, "better" paintings – de' Dominici lists ten in Venetian collections[47] – but the general condemnation was probably not based on a comparative analysis so much as an application of age prejudice. Solimena's painting arrived in Venice at just the wrong time. Late in life, he began to return to the style of his youth – a retrospective move that we will meet later with Titian, Michelangelo, and others – and this neo-Baroque style did not suit the lighter neo-Veronesian style then being introduced in Venice by

Giambattista Tiepolo.[48] Widmann showed more "compassion" than those who heaped "lots of blame" on this late work, possibly because he was a compassionate man, but just as likely because his taste in painting tended toward the Baroque.[49] For other Venetians, however, anticipating the "renaissance" described by Vincenzo da Canal and Anton Maria Zanetti in the early 1730s, Solimena's age provided a ready excuse to condemn a painting that they found objectionable for other reasons.

In conclusion, the possibility of a third type of exceptionalism should be acknowledged, one that finds artistic progress in old age. However, the only two examples that I could find are compromised by the circumstances of their articulation: "One can say," Duke Francesco Maria II delle Rovere wrote to Federico Zuccaro in 1603, "that one finds your work always growing and improving with the years so that in this, your mature age . . . you have in some way surpassed yourself."[50] Was this flattery or a frank opinion based on an examination of Zuccaro's paintings? Zuccaro was 63 at the time and suffering in Venice from some public humiliations involving his *Submission of Emperor Federico Barbarossa to Pope Alexander III* (Venice, Palazzo Ducale).[51] Zuccaro had sent a *Paradise* to the Duke of Urbino, possibly one of his losing oil sketches for the Palazzo Ducale competitions that he twice lost out to Tintoretto, thus evoking earlier humiliations in Venice. Duke Francesco Maria appreciated Zuccaro's precarious position – rejected and desperate to collect the outlandish sum of 1,000 ducats from the Signoria – and, perhaps sensing a need for reassurance, he turned to the question of age prejudice. Your painting is not deteriorating, he seems to say, but ever improving. It sounds like sympathetic spin. The second example comes from the painter, forger, and theorist Giovanni Battista Volpato (1633–1706), who made an exception for "great masters": "The more advanced in years they [the great masters] become the more perfectly they paint."[52]

<center>* * *</center>

One consequence of gerontophobia, when it is internalized by artists, is a fear of obsolescence. The "anxiety of influence" existed long before Harold Bloom immortalized the sentiment that "You will not surpass the one whose footsteps you follow." In saying this, Michelangelo himself was following a long trail of similar or identical dicta stretching back to antiquity. Many became mired in his huge footprints. As we will see in chapter 5, Pontormo suffered from epigonism.[53] His strategy for artistic success – emulation of Michelangelo – proved to be a cause for failure in posterity's judgment. By hoping "to surpass all the paintings there are, he did not even match to any extent his own pictures"; he imagined that "he must surpass all the other painters, and, it was said, even Michelangelo." By trying to be better than Michelangelo, he became less than himself. Pontormo's reputation sank after his death, despite his standing as founder of the Bronzino-Allori dynasty. Wedged into a dual role as dutiful follower (Michelangelo's amanuensis) and progenitor of followers (Bronzino, Alessandro Allori, Cristofano Allori, Cesare Dandini, etc.), he represented "slavish imitation," both its cause and its practitioner. The Pontormo-Bronzino-Allori dynasty may have proved a stable style that became a Medici trademark signifying the continuity and stability of governance,[54] but from the critics' point of view it brought only stagnation, introversion, and automimetic decline.

If the anxiety of influence initially afflicted artists in their youth facing a canon of immortalized old masters, its mirrored counterpart – the anxiety of obsolescence – was a senescent phenomenon. Paolo Giovio told the story first and best:

> But then the stars of a perfect art called Leonardo, Michelangelo, and Raphael who suddenly stepped out of the shadows of that age. . . . Perugino, emulating and imitating his betters, strove to maintain his standing, now overtaken, but all in vain because his imagination dried up and constrained him always to return to the mawkish faces developed and set in his youth, so much so that his modest soul bore the shame with difficulty while those great artists represented grand nude figures with amazing variety in every type of subject.[55]

Frozen into the facial types he developed in his youth, Pietro Perugino (*circa* 1450–1523) was condemned to repeating himself in old age. Vasari called this flaw *di maniera*, meaning a formula inappropriately and endlessly repeated.[56] Florentines confronted Perugino with this practice of repeating himself after they saw his *Assumption of the Virgin* for the Santissima Annunziata (1507): "it was severely censured by all the new artists, and particularly because Pietro had employed the same figures he used for his works at other times."[57] Even his friends suggested to him that he had fallen prey to greed or laziness. Poor Perugino failed to understand, answering them pathetically: "In this work I have used figures which you've praised at other times, and which have pleased you beyond words. If they now displease you and earn no praise, what can I do?" The insults continued, "so then, though now an old man, Pietro left Florence and returned to Perugia . . ." Vasari's Perugino is defensive, like an old man who fails to understand why others cease to enjoy hearing the same story as often as he enjoys telling it. Those who were "lambasting him with open insults" were young, the "new artists." Like Aristotle's old men who "live in memory more than in hope . . . the cause of their garrulity, for they keep talking about things that have passed."[58] Perugino seems unaware that he has become a stereotype. His incomprehension recalls Giovan Battista Gelli's famous dialogue, *I capricci del bottaio* (Florence, 1549), where the wise "Animo" counsels the despairing "Giusto" that there is hope since the flaws of old age often originate "in those who do not know themselves well." Vasari's Perugino seems to have this blind spot.

 Giovio's Perugino, however, is miserably self-conscious, "shamed" by his inability to change. He sounds more like Ovid, who regretfully accepted the reason why he was ignored in old age: "I write so often of the same things that scarce any listen . . ."[59] What made Perugino and his friends aware of his limitations was the "amazing variety" of Leonardo, Michelangelo, and Raphael. Similarly, Vasari used the pejorative phrase *di maniera* (in distinction to the desirable grace and beauty of *maniera*) for antiquated styles like Byzantine mosaics, where time and changing taste reveal the formulae that are behind most styles.[60] Ludovico Dolce tried to make Michelangelo sound similarly old-fashioned by calling his works *di maniera* – "if you've seen one, you've seen them all" – and giving him Quattrocento attributes that also happen to be old-age attributes (hard and dry). Vasari responded that Michelangelo never forgot a figure (certainly not a forgetful senior!) and never repeated one either, a rebuttal that did not have the posthumous success of Dolce's initial charge. As for Perugino, Vasari does not say why he lapsed into *di maniera* painting, but since the comment applied to Perugino's late work, we can assume

that he associated it with senescence. Giovio was also indirect, but by referencing a common attribute of old age – the "dried up" imagination – he makes it clear that Perugino's was a problem of age. The fecundity of his juniors made Perugino's sterility all the more apparent. By returning Perugino to the "shadows," Giovio evokes the old-age images of entombment and blindness.

The difficulty of stepping out of Perugino's "shadow," to continue with Giovio's metaphor, became evidence of Raphael's genius. Perugino's formulae not only trapped himself, but "many masters he made in his own kind of style." Raphael, however, broke free after a heroic struggle. Perugino was an infinitely proud man and shamelessly open in professing his own superiority: "Even were the art of painting to have become lost, here by the distinguished Pietro of Perugia was it restored; had it nowhere yet been devised, at this level he gave it to us."[61] These words were not penned by some addled hagiographer but by Perugino himself! To show everyone what this genius looked like, he painted his self-portrait glaring out at the viewer above the inscription (pl. 7). This is how he saw himself, then, or at least how he wanted others to see him, in 1500, when, by Vasari's count, he was 54 years old. It was just then that Perugino decided to see the work of Michelangelo, who "had already come to the fore at this time." Vain Perugino heard of Michelangelo's fame and "seeing that the greatness of his own name . . . was being obscured, he was always trying to insult his fellow workers with biting words." Michelangelo insulted him in return, deservedly so according to Vasari, but "as Pietro could not bear such ignominy, both of them appeared before the Tribunal of Eight, where Pietro came off with very little honor."

Acknowledgments of superannuation are generally psychologically fraught. When Verrocchio saw the angel painted in the *Baptism* (Florence, Uffizi) by his assistant Leonardo, he gave up painting. When Francesco Francia saw Raphael's *St. Cecilia* altarpiece (Bologna, Pinacoteca), he died of envy. Neither tale is true. Less fabulous and more typical are the stories told by Armenini and Vasari of the aging Perino del Vaga (1501–1547): "One can say that Perino in his day was the most beautiful and universal painter above all others, so that, seeing the success of that crowd of masters (whose success had been predicted), he sank into a fear of unemployment. . . ."[62] And, according to Vasari, "because it annoyed [Perino] greatly to see ambitious young men coming forward, he sought to hire them all himself so that they would not get in his way." Armenini, writing at age 54 in monastic seclusion after abandoning painting (forced out by the market realities he lamented with reference to Perino), seemed especially sensitive to aging obsolescence. He transformed the motivations attributed by Vasari for Sebastiano del Piombo's dwindling production during his later years (laziness and financial comfort) into a generational struggle. Sebastiano del Piombo (*circa* 1485–1547), according to Armenini's supposed first-hand account ("I am using his own words"), retired gracefully instead of facing the hordes of younger, more fecund painters:

Many tried to persuade him not to abandon the art of painting in which he so excelled. He would answer by saying that since he had the means to live comfortably, he did not want to bow out clumsily – I am using his own words – for, he claimed, some new talents had arrived on the scene who were able to do in two months what he was used to doing in two years. . . .

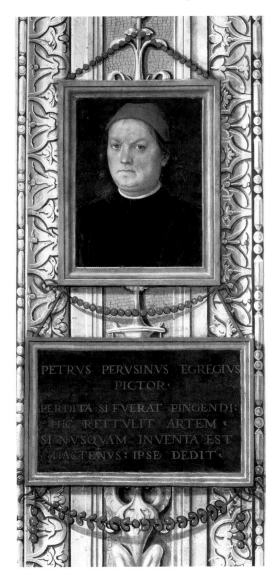

7 Pietro Perugino, detail of *Self-Portrait* (Perugia, Palazzo dei Priori, Collegio di Cambi)

Another tale of aging obsolescence, also based partially on Vasari, was told by Bernardo de' Dominici of the Neapolitan painter Belisario Corenzio (*circa* 1560–*circa* 1640).[63] When Corenzio was old, he mingled in a crowd of painters and the general public to hear what they were saying about the newly unveiled frescoes in the Carmine by his former pupil Rodrigo. He heard fulsome praise, but more disturbing was the opinion that Rodrigo had surpassed him both as a gentleman and as an artist. So highly did they praise Rodrigo that the "invidious Corenzio" forgot that he was old and a Christian. He decided to kill the young painter. To this end he feigned friendship, went out eating and drinking with Rodrigo, just as Andrea del Castagno supposedly did with Domenico Veneziano before murdering him. One day he gave Rodrigo a slow but effective poison. The wicked, envious, malignant old man did not go long unpunished for his misdeed. Before dying, he disgraced himself by trying to correct some old errors in his paintings in San Severino, which he had heard criticized by Massimo Stanzione and others. While on the scaffolding, he lost his footing, fell, and died shortly after giving confession. Because these reactions are so extreme, and because other historical evidence contradicts them, we may want to relegate these stories to the realm of myth. Like all good myths, however, they tell us something important and enduring about being human. They may not describe what actually happened, but they do accurately portray the psychological realities that many artists lived in. Luigi Lanzi's explanation of Pontormo's failure at San Lorenzo draws on a similar role performed by the elderly. Pontormo, Lanzi wrote, wanted to present a new anatomical style, taking Michelangelo further, but instead gave Florence an unintended lesson that "old painters should never run after new fashions."[64] The frescoes, he notes, were recently "whitewashed with no complaints from painters." Pontormo tried too hard. His ambition defeated him. Perhaps like other old artists, he feared a loss of reputation and descent into obscurity. Late in life, Bronzino saw (or thought he saw) the value of his own drawings reduced to mere paper. In his late lament

on the decline of art, "Dell'esser chiaro," he complained that his drawings were being used as packing paper:

> Ah, no Muse, ah no, while I am speaking about being famous, don't place before me bothersome things which should be disdained! O noble art, once so esteemed, where are your studies? Where is the road where one always went forward accompanied by truth? What forest is this? And into what strange land do rashness, envy, and avarice lead you, so that you always lose yourself and fall?[65]

<p style="text-align:center">* * *</p>

If the anxiety of belatedness feels like living "in the shadow of the father," then the anxiety of obsolescence comes from living in the shadow of your son. Both speak to a generational struggle. Generational stories are a staple of early modern art biography. When Philip II of Spain chose to buy a painting by Titian instead of one by Joos van Cleve, the young Flemish painter transformed himself into an old masterpiece by varnishing his body and parading around the street, a bizarre parody of the Renaissance proverb "every painter paints himself" and an uncanny prefiguration of modern body and performance art.[66] In 1513, two years before Giovanni Bellini died at the age of 84, Titian asked the Signoria of Venice for his former master's position, the lucrative *sansaria*, "when it becomes available," Titian adds. He expected Bellini's death to be imminent, but his premature eagerness in petitioning sounds a bit ghoulish. With the *sansaria*, Titian would attach himself to the Bellini lineage and ensure a steady income. To convince the Signoria, he offered to paint a battle scene for the Doge's Palace (the *Battle of Agnadello*) that had defeated other artists: "no man until this one," Titian wrote of himself, "has wished to undertake such a feat."[67] He would succeed where other, older artists had failed. Making your reputation by exploiting a failed project by an older artist was exactly Michelangelo's ploy about a decade earlier, when he transformed *Il gigante* into *David*.[68] Unlike Michelangelo, however, once receiving the *sansaria* and the commission to paint the *Battle of Agnadello*, Titian procrastinated for twenty-five years before completing it, apparently unafraid of possible rumors that he too was defeated by the scale and difficulty of his subject.

Two other episodes are pertinent here. Both involve crucial figures in the Accademia del Disegno in Florence and the Accademia di San Luca in Rome – Giorgio Vasari (1511–1574) and Federico Zuccaro (1540–1609) – and both highlight the inherent tensions of a gerontocracy like the art academy, where the younger and avowedly more creative members are governed by their old-fashioned elders. In 1562, when Vasari was prepared to draft the Accademia's constitution, he proposed the following committee to Cosimo I de' Medici: Montorsoli (1506–1563), Agnolo Bronzino (1502–1572), Francesco da Sangallo (1494–1576), Michele di Ridolfo (1503–1577), Ghirlandaio Tosini (1503–1577), and PierFrancesco di Iacopo di Sandro Foschi (1502–1567).[69] At age 51, Vasari was the youngest; the others ranged between 55 and 68. Soon after the committee was appointed, a disgruntled group of "six immature boys" signed a letter of complaint to Cosimo I. Why, they asked, was Jacopo Zucchi appointed as academician at age 22, in violation of the minimum age requirement, when other young artists (such as themselves) were

not. In his response to Cosimo I, Vincenzio Borghini explained that "these six immature boys have vaunted themselves with little prudence and with less reason" and that "these outbursts of children" were inconsequential. Karen-edis Barzman calls this generation struggle "a process of infantilization" because the "immature boys" were mostly middle-aged.[70] Academies were not always seen as gerontocracies. In the mid-eighteenth century Natale dalle Laste anticipated that older artists would resent the new art academy established in Venice by Filippo Farsetti because it would undermine their authority by turning young painters back to the ancients:

> For it must be admitted that old age loses some of its natural modesty which it has learned while young and has the tendency to return from the goal back to the start, especially when there is no lack of reputation and some of their pictures stand at a good price. We should not envy the enterprising men their little profit, neither their glory. But may they themselves not envy the young beginning artists the best kind of instruction established for them by Farsetti's generosity.[71]

The second episode involves Federico Zuccaro in 1600, when he was President (*principe*) of the Accademia di San Luca in Rome. Caravaggio's first public paintings had just been unveiled in the Contarelli Chapel in the Roman church of San Luigi de' Francesi to an enthusiastic reception. Zuccaro, aged 60, was predictably disappointed with the upstart's work: "I don't see what all the fuss is about. . . . I see nothing but the style of Giorgione."[72] "And then," Baglione writes, "sneering, astonished by the commotion, he turned his back and left." As Zuccaro knew as well as we do today, Caravaggio marketed himself as a rebel and outsider, painting in "a never-seen-before style." Hence by calling him a rehashed Giorgione, Zuccaro was attacking the center of his persona by exploiting superficial similarities between their styles: naturalist, dark, and Venetian (in Bellori's account, Caravaggio discovered his true style on a visit to Venice).

Lurking under this obvious generational struggle might be a deeper one that involved Annibale Carracci, newly arrived in Rome in 1595 at age 35, and poised to become a new Raphael. The need for Annibale and Caravaggio to save art from its decline had become common wisdom by the mid-seventeenth century, but in 1600 a new Giorgione and a new Raphael could threaten Zuccaro, who was carrying forward the tradition of his elder brother, Taddeo. Revivals and saviors speak of a decadent condition that needs saving. Was Zuccaro obsolete? No, he tells his public through Baglione, it is Caravaggio who is old-fashioned, as if to say "I am the modern." In telling this story, Giovanni Baglione had his own agenda – revenge for Caravaggio's earlier defamation of character – and he deftly puts Caravaggio's popularity in its place within the twin conventions of the public's stupidity and its craving for novelty. Was Baglione using Zuccaro as a front to mask his own dislike, which he could not expose without ridicule, given his history with Caravaggio? Possibly he included this anecdote in the *Vite* for personal reasons, but Zuccaro's antipathy toward Caravaggio can be authenticated: "I do not wonder," he wrote to Monsignor Cesarini, "why Caravaggio has so many fans and protectors since the extravagance of his character and painting is more than enough to nurture this result. And our gentlemen believing themselves to be more refined connoisseurs because of their wealth and social status

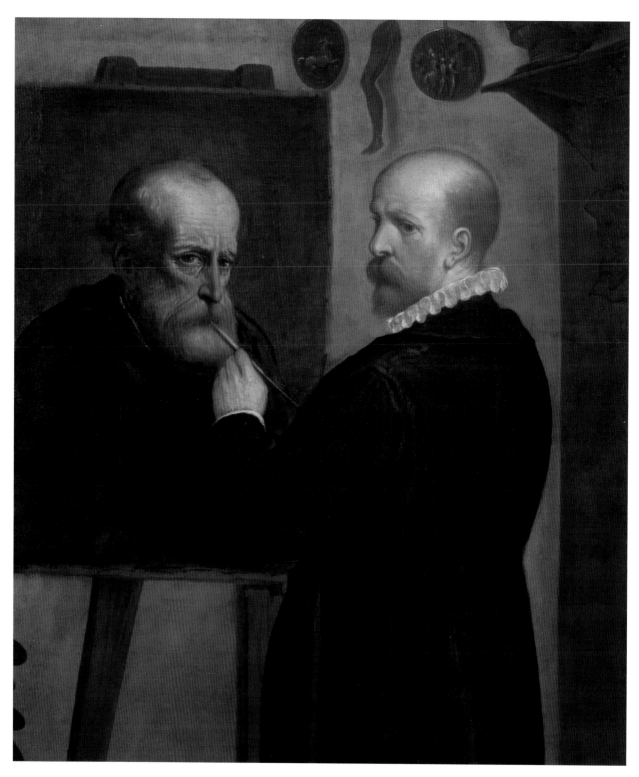

8 Luca Cambiaso, *Self-Portrait* (Genoa, Museo di Palazzo Bianco)

judge beauty only by its air of novelty and ability to surprise."[73] Caravaggio was involved in other generational struggles, including the reported (but fictional) murder of his former employer, Cavaliere Giuseppe Cesari d'Arpino, a story that will be analyzed in chapter 7.

Of course, generations were not always pitted against each other. Indeed the seventeenth and eighteenth centuries were more often characterized by ancestor worship. The Pontormo-Bronzino-Allori dynasty, part artistic and part family lineage, was not uncommon, especially in Venice with its da Ponte, Vecellio, Robusti, and Caliari dynasties. The teacher-as-father initiated name adoptions (by Jacopo Sansovino and Giuseppe Salviati, for example) and avowals of filial devotion (Cesare Nebbia: "I loved him in life as my father and in death as my master").[74] In his *Self-Portrait* of *circa* 1625 (Padua, Museo Civico), Alessandro Varotari (1590–1650), known as Padovanino, shows himself with the bust of Titian. Palma Giovane's tomb in Santi Giovanni e Paolo, Venice, includes busts of his uncle Palma Vecchio and his teacher, Titian.[75] Luca Cambiaso (1527–1585), in his *Self-Portrait* (pl. 8), shows himself painting a portrait of his father on an easel, with his brush poised to paint his father's mouth, a touching mirror display where the father who begat his son is seen created by his son. The strong familial resemblance between son and father speaks eloquently of the passage of time, a kind of double self-portrait of the young artist as an old man. Luigi Crespi (*circa* 1709–1779) also portrayed himself in the presence of his more famous father, Giuseppe Maria. In his *Self-Portrait* (Venice, Accademia), Luigi is painting the figure of Virtue that had, in fact, been painted earlier by his father. Virtue reaches out as if to crown Luigi with laurel in a gesture of imagined paternal blessing.

The consequence of ancestor worship, according to some early modern culture critics, was cultural decline, where Italy became a museum of dead antiquities instead of fertile ground for new creations. Nostalgia for the past stultified any progress into the future. Italy became old and, like the elderly who "live in memory more than in hope," turned inward. The pictorial style of senescence was called Mannerism, the topic of chapter 6.

2 Narcissus Grows Old

Narcissus grows old? That superficial, self-infatuated pretty boy, youth personified and made eternally youthful by his early death and annual reincarnation as a flower, how can he grow old? He didn't, but Narcissus in his role as the first painter came to represent a profession whose members and whose art could and did grow old. Senescence is not just for the elderly. It shadows us in youth, and those shadows deepen in middle age. In *Socrates Instructing the Young on Self-Knowledge* (*Nosce te*) (pl. 9), Pier Francesco Mola (1612–1666) represented Socrates revealing to a group of youths the truth about themselves. One who wants to confirm the truth, much like Narcissus, reaches out to touch his mirrored image. Mola's contrast of a wise old man and gulled youths fits the moralizing framework of many Narcissus commentaries from antiquity to the Renaissance: youth suffered narcissine folly; the sage elder knows better. Nevertheless, embedded in the myth of Narcissus were attributes of old age. Physically, Narcissus wasted away and became a "shadow" of himself, prematurely aged. Psychologically, his lapse into interiority, the exclusion of the world around him, and the loss of reality itself prefigured the predations of time. For Aristotle, the elderly are selfish, inward-looking, uninterested in friendship, and incapable of love except as an outward habit manifested after many years of practice: "And they are more fond of themselves than is right; for this is also a form of small-mindedness."[1] The old and powerful, noted one seventeenth-century polemicist, are "Narcissi unto themselves."[2]

Young Narcissus' languishing death, in Ovid's rendition, starts when he stumbles upon a pool in a cool and sunless spot, an eternally shadowy place. The stillness is a narrative pragmatic to explain the persistence of Narcissus' reflection, never changing with the passage of the sun, but its function is also dramatic and metaphoric. The vale of eternal shadows is where Narcissus meets his own shadow. It is an old place – dim, silent, abandoned, and lifeless – and hence an inversion of the *locus amoenus* where pastoral youth usually congregate. It is a disorienting place, *fons erat inlimis*, askew and aslant, where one cannot see straight, where one's vision becomes untrustworthy like an old man's. When Narcissus first catches sight of his image in the pool, he experiences a suspension of time: "He looks in speechless wonder at himself and hangs there motionless in the same expression, like a statue carved from Parian marble."[3] At this point in the story Ovid is describing Narcissus' reflection as if it were a painting. The action and plot are suspended momentarily so that we can watch as Narcissus gapes at himself. The other two important accounts of the Narcissus myth from antiquity – Philostratus' *Imagines* and Callistratus' *Descriptions* – actually are ecphrases. Callistratus made Narcissus into a statue (one that Marino "attributed" to Michelangelo). And Philostratus plays with the idea

9 Pier Francesco Mola, *Socrates Instructing the Young on Self-Knowledge (Nosce te)* (Lugano, Museo Civico di Belle Arti)

of painting as a frozen action: a stunned Narcissus becomes immobilized forever in his word-painting.

To describe these first moments of wonder, Ovid, Philostratus, and Callistratus transformed Narcissus into an art object and viewer of art. Leon Battista Alberti deferred to them (without naming them) when he took the final step and made Narcissus the inventor of painting: "I used to tell my friends that the inventor of painting, according to the poets, was Narcissus. . . . What is painting but the act of embracing, by means of art, the surface of the pool?"[4] What a great art myth! Imbricated in one person are the roles of artist (creator of an image), model (the object of reflection), art work (a statue of Parian marble), and viewer. Narcissus the artist creates an image of himself that Narcissus the viewer finds irresistible. He enslaves himself (the viewer) by his success as an artist and model. Even stated this way, in its simplest form, it is obvious why the myth of Narcissus has recently inspired some remarkable studies by art historians and others.[5] Their contributions are much too complex to summarize here, much less adjudicate between them, but one topic that they pass over needs to be mentioned: the aging of Narcissus. In the Narcissus narratives, the early moments of discovery tend to be blooming metaphorically with youthful ardor and potency. The story, however, did not end there. Slowly Narcissus loses his youthful vitality. As his will to live erodes, his body rapidly ages, a ripening fruit, before dissolving or melting "as the yellow wax melts before a gentle heat, as hoar frost melts before the warm morning sun. . . . No longer has he that ruddy color mingling with the white, no longer that strength and vigour" (III, 486–92). He is transformed, metaphorically and perhaps corporeally, into liquid (*sic attenuatus amore/liquitur*) and joins his beloved in the water of the pool. Ovid's language of dissolving links Narcissus to the dissolution of old age. In his commentary on Ovid, Lattanzius Placidus described it as *tabes* (*tabuit*) or a decay, a wasting away, or putrification.[6] According to Lucretius, melting and liquefying are forms of senescence: "I will explain the motion by which the generative bodies of matter give birth to various things, and, after they are born, dissolve them once more. . . . For we see that everything grows less and seems to melt away with the lapse of time and withdraw its old age from our eyes."[7] The flowering youth fades like a wilting flower and in so doing experiences premature old age before dying.

Precarious beauty, fleeting youth, and lurking death became common themes in many Renaissance renditions of the myth.[8] For Alciati in *Emblematum liber* (Augsburg, 1531), Narcissus represented the "death and decay of genius."[9] His reflection foreshadows his death. Ovid called the reflection both *imago* and *umbra*. His spurned suitor, Echo, suffered an early senescence, mirroring Narcissus, except that she hardens and dries up instead of melting: "She becomes gaunt and wrinkled and all moisture fades from her body into the air. Only her voice and her bones remain."

Transfixed by his reflection, Narcissus entered a tranced delusion much like a dream. In *De somniis* Aristotle explained dreams with a narcissine image: "As in a liquid whose surface is moving, one cannot see any image or if an image does appear it is completely distorted. . . . [but] if the surface of the water is quiet, the image will appear clearly defined." Narcissus' pool, says Ovid, was still. The elderly were especially sensitive to dreams because "the surface of [their] water is quiet." As the cardio-pulmonary system weakens, the imagination can receive

sensory impressions from the body more clearly during sleep. Concurrently their senses weaken – dulled eyesight, hearing loss, bland flavors, etc. – loosening them from the natural world around them. As a result, dreams of the elderly were thought to become more vivid, and their waking life to become more like a dream. (Dreams, it will become clear later, caused painters to "paint themselves," according to the physician, connoisseur, and art collector Giulio Mancini.)

The pharmacology of the narcissus flower reproduces dream states and resembles the experience of its namesake. Galen, Pliny, and others thought the etymology of narcissus, the flower, was *narkê* (numbness, deadening) and *narkân* (to narcotize).[10] Its effects are torpor, numbness, dizziness, and even delirium. Not only does it make one like Narcissus, but its soporific and disorienting effects render one senile. Not only does Narcissus grow old when he is trapped by his image, but ingesting the narcissus mimics old age. Because the narcissus flower produced tranced hallucinations, classicists from Pausanius onwards have argued (mostly on the chronology of texts) that Narcissus took his name from the flower. He performs the role of his flower, or, might we say in anticipation of Pontormo's narcissism (chapter 5), you are what you eat. Modern science has tested some of these effects. Dutch botanists discovered that putting the narcissus with tulips in the same vase will prematurely wither the tulips.[11] The narcissus, however, does not always act with such poetic truth. In a curious reversal, which sounds too good to be true, Shire Pharmaceuticals is presently testing the alkaloid-rich narcissus as a treatment for Alzheimer's.[12] And in another ironic twist, one compound of the narcissus flower, galanthamine, is now used to treat schizophrenia.

Every Painter Paints Himself

The myth of Narcissus and the proverb "Every painter paints himself" help to explain how artists and their biographers understood the relation of art and life, and, more particularly, why they were inclined to find symptoms of old age in the art of elderly artists. If, as this book claims, artists and biographers found symptoms of old age in the paintings of elderly artists, what supporting beliefs upheld this mirrored relationship of art and life? If the corporeal or psychological facts of life are transmuted into art, how then were the symptoms of old age manifested in their late works, embedded in the tone and texture of pigment, in the figures' poses and expressivity? How did art biographers manifest the symptoms of old age in the old artist paintings? In order to answer these questions which occupy the following three chapters, a few early modern beliefs about artistic self-expression need to be introduced.

Narcissus as the inventor of painting was Alberti's invention, although he deferred it to "poets," possibly Philostratus,[13] who drew similarities between reflections and paintings but never actually drew the conclusion that therefore Narcissus was the first painter. Alberti's choice was an odd one since Narcissus was then a morally tainted figure. Deluded by his senses, lacking any basic knowledge of himself, self-absorbed, a pretty package void of content, poor Narcissus looked at his mirrored reflection and mistook image for reality. He may be a perfect, if passive and accidental, painter in creating such a strong illusion, but as a viewer he failed the most

basic test of knowing what he saw. The first painting by Alberti's account was a self-portrait whose creator did not recognize it as an image of himself. Narcissus' failings as a man, particularly his inability to distinguish himself from the world, where the world is simply an extension of himself, became a recognized threat to good painting. Painters should aspire to the mimetic ideal represented in Narcissus' reflection. They should imitate the image, but not the young deluded "painter" who came to represent the perils of self-imitation. By not knowing what he "painted," Narcissus was a most imperfect artist.

Narcissus as a figure of artistic self-projection did not interest Alberti. However, by inserting Narcissus into art theory, he did prepare a later generation, including Cosimo de' Medici (il Vecchio) and Leonardo da Vinci, to consider the psychology of narcissine creativity. Their conclusion became distilled into a proverb: "Every painter paints himself." Angelo Poliziano first recorded it in the late 1470s, crediting its invention to Cosimo de' Medici.[14] Both Cosimo and Poliziano knew Alberti's *De pictura*, still at that time the most recent and sophisticated theory of art, and could well have used Alberti's origin story to craft the aphorism that makes painters into solipsists. Poliziano's dictum, unlike Alberti's Narcissus, involved psychological rather than physical resemblances: "Cosimo said, that one would rather forget a hundred charities than one insult and that the offender never forgives and that every painter paints himself."[15] Psychologists call this form of behavior "projection." The "offender" forms his world view around the exceptional (one insult) rather than the typical (one hundred kindnesses) because it matches his character. The "offender" portrays others as he sees himself, and his opinion of others reveals his true self, just as painters do in their pictures. Although Poliziano attributed the dictum to Cosimo de' Medici – his own clever bit of projective flattery – it was a topic of great interest to him. In addressing the question of imitation – who should a poet imitate – he sidesteps the usual options in favor of himself. When accused that he does not portray or follow (*exprimis*) Cicero in his style (*stylo*), he responds: "Why should I? I am not Cicero; I portray myself."[16] Painters are evoked not as "offenders" but as a group whose claims do not match their actions, whose true selves are unwittingly expressed in all their work. Painters profess to record mundane and divine realities, but what they actually record are their own subjectivities.

Whether or not "Every painter paints himself" had folk or humanist origins, it was later designated as a proverb and, because of its semantic flexibility, thrived for more than two centuries. Savonarola twisted it to suit his purposes, a wonderful case of every writer writing himself, and by the mid-sixteenth century it was circulating widely in Florence with Lodovico Domenichi, Anton Francesco Doni, Matteo Franco, and Giovan Maria Cecchi calling it a "saying" (*motto*); and, finally, by 1603 it attained "proverbial" status.[17] As folk wisdom, it became the subject of jokes, first by early modern artists, and later by art historians wanting to debunk the kind of art history Vasari helped to initiate. When a painter showed Michelangelo his picture of a bull, Michelangelo responded: "Every painter paints himself well."[18] Salvator Rosa recycled Michelangelo's wit in his *Satire on Painting* by targeting genre and still-life painters: "Others only study how to make animals and, without even looking in the mirror, they portray them truly and naturally."[19] Giovanni Battista Passeri played ironically on Guercino's physiognomy and moniker (Little Squinty) by having him draw an eye over and over again until it no longer

resembled his own wayward eye.[20] Pieter van Laer (1592/5–1642) looked like and painted his figures like his nickname, Il Bamboccio (a rag doll).[21] The weirdest play on the proverb, also from the seventeenth century, concerns Girolamo Curti (1570/75–1632), who developed a large boil or some other growth on his knee. He refused to have it lanced, choosing instead to paint a face on it and calling it his "comrade." When the liquid leaked out of his comrade, Curti also died.[22]

Proverbs identify stable and enduring beliefs frozen into their unchanging structure.[23] "Every painter paints himself" not only conveyed an essential condition of painting but packaged it for non-specialists. Its proverbial status gave it access to literary critics and others wanting to explain the relationships between art and life: "Painters by an instinct of nature, drawing and coloring figures, drawing and coloring without due diligence or counsel, so that the figures or, at least, most of them, resemble the painters themselves. . . . Guido Reni, having the body and soul of an angel, paints angelic figures."[24]

* * *

Leonardo grappled more systematically than others with the proverbial implications of painters painting themselves. In earlier notes, he restricted the problem of self-imitation to outer appearance alone:

> A painter who has clumsy hands will paint similar hands in his works, and the same will occur with any limb, unless long study has taught him to avoid it. Therefore, O Painter, look carefully what part is most ill-favoured in your own person and take particular pains to correct it in your studies.[25]

Beautiful painters can imitate themselves without great damage, which may be why Gaspare Visconti in a sonnet of 1497–99 excused Leonardo for doing so: "There is one [painter] nowadays who has so fixed / in his conception the image of himself / that when he wishes to paint someone else / he often paints not the subject but himself."[26]

Leonardo's legendary beauty, so magnificent that "it brought comfort to the most troubled souls," protected him. Ugly painters, however, should rely on a consensual, public view of beauty or else "you might deceive yourself and choose faces which conform to your own, for often, it seems, such conformities please us."[27] In a fuller, later rendition of these notes, Leonardo required artists to know themselves both physically and psychologically:

> It is a fault in the extreme of painters to repeat the same movements, the same faces and the same style of drapery in one and the same narrative painting and to make most of the faces resemble their master, which is a thing I have often wondered at, for I have known some who, in all their figures seem to have portrayed themselves from the life, and in them one may recognise the attitudes and manners of their maker. If he is quick of speech and movement his figures are similar in their quickness, and if the master is devout his figures are the same with their necks bent, and if the master is a good-for-nothing his figures seem laziness itself portrayed from the life. If the master is badly proportioned, his figures are the same.

And if he is mad, his narrative will show irrational figures, not attending to what they are doing, who rather look about themselves, some this way and some that, as if in a dream. And thus each peculiarity in a painting has its prototype in the painter's own peculiarity. I have often pondered the cause of this defect and it seems to me that we may conclude that the very soul which rules and governs each body directs our judgement before it is our own. Therefore it has completed the figure of a man in a way that it has judged looks good, be it long, short or snub-nosed. And in this way its height and shape are determined, and this judgement is powerful enough to move the arm of the painter and makes him repeat himself and it seems to this soul that this is the true way of representing a man and that those who do not do as it does commit an error. If it finds someone who resembles the body it has composed, it delights in it and often falls in love with it. And for this reason many fall in love with and marry women who resemble them, and often the children that are born to such people look like their parents.[28]

The interplay of love-making and art-making, and the blinding effects of self-love, may be a recollection of Narcissus and reminds us of Dante's theory of love as a kind of optical narcissism: "We love those who look like ourselves."[29] Having composed a painting that resembles himself, "a painter delights in it and often falls in love with it." The idea pre-dates Dante – Cicero wrote that "when a man thinks of a true friend he is looking at himself in a mirror," and Aristotle claimed that "like is always attracted to like" – and thrived through the Renaissance in Marsilio Ficino and others.[30] The Narcissus myth, according to Ficino, is an extreme demonstration of this tendency to love those like ourselves: the lover who desires the body without knowledge of the soul is "like Narcissus, desires its own sort, enticed by the bodily form that is the image of its own sort."[31] Sperone Speroni has the courtesan Tullia d'Aragona declare: "the lover . . . is properly a portrait of that which he loves. . . . As the painter portrays the person's appearance with colors and with his artifice . . . so the thing that is loved by means of love's stylus, portrays itself and all that belongs to it, soul and body, in the lover's face and in his heart."[32]

Because self-imitation was a natural function, often as inevitable as falling in love, artists should guard against the phenomenon by self-examination. Unselfconscious artists were doomed to self-portraiture. "Painters," wrote Claudio Achillini in 1633, "draw and color their figures by instinct, drawing or painting them like themselves and without conscious effort or counsel, or at least with most of the figures resembling themselves."[33] Charles Alphonse du Fresnoy called this unconscious self-representation an "instinctive law": "Even artists bound by her instinctive law, /In all their works their own resemblance draw: / Learn then 'to know thyself,' that precept sage / Shall best allay luxuriant fancy's rage. . . ."[34] Du Fresnoy, a careful reader of Lomazzo, probably quoted the Socratic imperative to "Know thyself" after consulting the *Trattato dell'arte de la pittura* (Milan, 1584), where Lomazzo gave the prophylactic advice – "conoscere se stesso" – as a defense against self-infatuation and automimesis.[35] This type of autonomic self-imitation or vicarious self-portraiture does not exactly reproduce the artist's appearance but results in a resemblance that is more familial than precise. Perugino, for example, populated his paintings with pie-faced figures much like (but not iden-

10 Pietro Perugino, *St. Michael* (London, National Gallery)

tical to) his own (pls. 7 and 10). And Titian, after he painted and publicized his late *Self-Portrait* (Madrid, Prado), began painting similar figures, gaunt, skull-capped, bearded, and with an aquiline nose. Variety exists in family resemblances, but, as Leonardo insists, repetition more than variety will result when the painter abdicates control by the intellect in favor of the heart.

Painters painting themselves brought interpretive consequences and responsibilities for the viewer. Ancient and Renaissance Neoplatonists easily grasped the notion of the artist in the artwork because it coincided with their epistemological relation of spirit (the artist) and body (his corpus). Philo Judaeus, a Neoplatonist (active first century BC–first century AD) wrote: "Unfailingly, works of art make known their creator, for who, as he looks at statues and pictures, does not immediately form an idea about the sculptor and the painter?"[36] And Renaissance Neoplatonists found the same:

In paintings and buildings the skill of the artist shines forth. Moreover, we can see in them, the attitude and the image, as it were, of his mind; for in these works the mind expresses and reflects itself not otherwise than a mirror reflects the face of a man who looks into it.[37]

Michelangelo's diagnostic ability in this area was legendary: "When he was shown a work by a good painter, he used to say, 'This is by a rogue, a real wretch,' but about those of the mediocre, 'This is by a good fellow who will give no one any trouble'." As Vasari's account of Michelangelo's visual divination suggests, by the mid-sixteenth century one way of looking at paintings involved a discovery of the artist's character, a trend that Borghini wanted Vasari to resist. Whereas Borghini wanted art to be pure, disembodied, and depersonalized, with the work speaking for itself, art biographers welcomed this contamination for the interpretive opportunities it afforded. Carlo Cesare Malvasia knew Alessandro Tiarini (1577–1668) person-

ally and found his melancholy portrayed in his paintings. "Every painter portrays himself," he concluded before jumping to Correggio, Tiarini's "opposite" because his figures are "always laughing, crying, and adoring."[38] Malvasia did not know Correggio to be as extrovert as his paintings, nor do we, but the conclusion was a natural extension of his premise.

* * *

One final topic of narcissine distortion and the effects of every painter painting himself involves the bent reality of dreams. As a physician, Giulio Mancini introduced a new medical explanation for why every painter paints himself:

> . . . this or that artist has their own individual characteristic, beyond the common characteristics of the age. Even though the artist has made ever determined efforts to imitate the things of his master . . . it should be said that this individual property, like that of the artist's own constitution and conception, remains his own in the way of working. And what is more, the artist in painting makes things similar to himself, as, for example, painting a beautiful face or hand he will make the figure with a beautiful face or hand like his own, and it is the same for the other parts of the body because our actions originate in the soul and the soul is guided by impressions which it holds within itself from the imagination. The soul cannot doubt it that a better image can be made than the one from the impression of the body where it continually resides, and thus it will work according to the characteristics of its body. Hippocrates explained this insight in his book *De somnijs* when he said that while the body sleeps the soul goes wandering and considering the body, thus forming this impression and giving the artist this [characteristic] expression and way of working.[39]

Citing Hippocrates' theory of dreams, he states that artists are most familiar with their own bodies and temperament (*constitution*) because during sleep the soul roams the body and forms a self-image. When awake, Mancini read in Hippocrates, the soul is the body's "servant"; when asleep, however, "the soul administers her own household . . . and performs all the acts of the body. For the body when asleep has no perception; but the soul when awake has cognizance of all things – sees what is visible, hears what is audible, walks, touches, feels pain, ponders."[40]

Mancini took Hippocrates' vagrant soul as the means by which artists know the world through themselves. Automimesis results from a wayward exercise of the imagination, uncontrolled by reason or judgment. Paintings reveal their creator because mimesis is not a neutral record of nature or art, but a vision colored by the artist's corporeal self. Mancini concluded his observations on dreams and automimesis with an analogy drawn from the new science of graphology: "For this reason, I believe, various talented writers of our age have written and wanted to give rules of recognizing the intellect and talent of others by means of the way of writing or handwriting of this or that man." Mancini acknowledged that a "little book which is being passed from hand to hand" had inspired him to explore the relation of script to the

"temperature and habits of the writer," that is, to character or temperament.[41] He was proba-
bly referring to one of the first two treatises ever written on graphology – either Camillo Baldi's
Trattato come da una lettera missiva si conoscano la natura e qualità dello scrivere or Marco Aurelio
Severino's *Vaticinator, sive tractatus de divinatione litterali* – both of which were available only
in manuscript at the time of his writing, hence needing to be passed "from hand to hand."[42]
By studying the after-effects – the "writing and handwriting" by which Mancini meant the
content, expression, and brushwork – we will be able to understand the artist, his soul and
embodied imagination.

Painting-as-dreaming implies that an artist's work will be a distinctive variant of the world
around him. By asking what kind of distortions dreams bring, we can approach the narcissine
distortions inherent to making art. Dreams could be true, beautiful, and prognostic, as Anton
Francesco Doni noted in citing such Renaissance dream literature as Dante's *Commedia divina*
and Jacopo Sannazzaro's *Arcadia*.[43] Even painters, he added, "to come down" to a lesser
art, dream of "abstract things" and can paint places never seen before like Parnassus. More often
for Doni, however, dreams were like grotesques, figures in clouds, and stains (*macchie*).[44]
He put this observation into the mouth of the painter Paolo Pino, but registers his approval.
Grotesques may be, he says, "vain appearances like the dreams of a sick man," but unlike
Horace, whose opinion he quotes, Doni is thrilled with the multivalent fluidity of dreams.
He liked them because they introduce us to an alternate reality. For this view of dreams, Doni
was drawing on the most authoritative source, Aristotle's *De somniis*. A dream, wrote Aristotle,
is a *phàntasma* and a feeling (*pàthos*) of the common sense.[45] During the day, sensory experi-
ences embed themselves in our bodies, leaving a residue that can be seen and heard only
after the daytime clatter subsides into the silence of sleep. Without new sensory input,
these residues emerge as dreams. They are often indistinct – Aristotle likens them to shapes in
a cloud – and in flux. As noted at the beginning of this chapter, Aristotle used a narcissine
image to explain what dreams look like: "As in a liquid whose surface is moving, one cannot
see any image or if an image does appear it is completely distorted. . . . [but] if the surface of
the water is quiet, the image will appear clearly defined." Narcissus' pool, says Ovid, was still.
His trance, detached from the world around him, gazing at the stilled water, does indeed resem-
ble a dream.

Mancini's Hippocratic version of "Every painter paints himself" takes self-imitation as an
inevitable and natural process, one that binds body and soul with the imagination mediating
between the two. It tells us that we understand the world through our bodies and senses, that
these are personal and somewhat unreliable but always entrancing. We are captivated by our-
selves, looking at an unstable reflection of reality (ourselves) but believing it to be the world
around us. Dreams are the body's narcissism, and the elderly (as noted above) were particularly
sensitive to dreams.

* * *

Old Narcissists

> Trembling, doubtful, the old man is expectant
> Of ill, dreads foolishly his every act.
> He praises the past, despises the present years,
> Thinks only that is right wherein he is wise,
> That only he is learned, he is skilled,
> And, because he is wise, he grows more foolish still.[46]

Narcissus looks in the pool and finds a beautiful adolescent. Old narcissists look at modern youth and find only degraded adolescents. Traditionally, the elderly were thought to be narcissistic in their tenacious hold on their own past as a standard to judge the present. "Most of us lament," old Cephalus tells a group of aged companions, "longing for the lost joys of youth and recalling to mind the pleasures of wine, women, and feasts."[47] According to Aristotle, the elderly are "more fond of themselves than is right."[48] They are distrustful and doubtful: "since most things turn out badly, they assert nothing with certainty and all things with less assurance than is needed."[49] They are cynical, "for a cynical disposition supposes everything is for the worse. Further they are suspicious because of their distrust and distrustful because of experience." They are "cowardly and fearful ahead of time about everything . . . for fear is a kind of chilling." And they are self-involved, "more fond of themselves than is right; for this is also a form of small-mindedness," and nostalgic, living more in their past than in the present:

> They live in memory more than in hope; for what is left of life is short, what is past is long, and hope is for the future, memory for what is gone. This is the cause of their garrulity; for they keep talking about things that have passed; for they take pleasure in reminiscence.[50]

"Self-involved in calamities and ruin" is how Petrarch interpreted Cicero on old age.[51] Loquacious and repetitive, even when they recognized these bad habits, old people facilitate their own marginalization: "I write so often of the same things that scarce any listen."[52] Gerontologists today think of this tendency as a form of life review, "a naturally occurring, universal mental process characterized by the progressive return to consciousness of past experiences, and, particularly, the resurgence of unresolved conflicts."[53]

A convenient mid-sixteenth-century review of old-age psychology can be found in Alessandro Piccolomini's *Della institution morale* (Venice, 1560). Best known to art historians as author of the *Dialogo della bella creanza delle donne*, popularly known as *La Raffaella*, the Sienese humanist and comedic playwright, epigrapher to Aristotle and friend of Pietro Aretino, Piccolomini (1508–1579) had a wide set of entwined interests gravitating toward ethics, love, rhetoric, and aesthetics.[54] *Della institution morale* summarizes the reasons why old critics disparaged modernity and adulated a lost past.[55] Writing at the age of 52, just two years after he thought old age began, Piccolomini claimed that by this time in life people become more easily deceived by the world around them. Having been disappointed so often, he says, they become bitter, timid,

and unhappy. They start to love only themselves, knowing that they cannot trust anyone else. Living in what seems to be an unreliable and degraded present, they turn nostalgically to their youths when, in the glow of hindsight, things were better. They begin living more in the past than the present, anticipating that the future will resemble the past. In other words, they act like Poliziano's "painters" who project their own past experiences of the world onto every new situation, no matter how the particular conditions of the present differ from those of the past. The past, lost forever and growing more distant with the accretions of time, becomes a cause of pessimism for the future. By looking at the present through the past, nostalgic critics distort or disregard the realities of the world around them. Just like Narcissus, I might add. Piccolomini gave all of the attributes but not the name of Narcissus. He anticipated that old folk would be the harshest critics of his early play, *L'Alessandro* (1544), where old characters are either dupes (Gostanza) or querulous (Vincenzio):

> Please, don't allow yourselves to be deceived by those know-it-alls (*salamonissimi*)! Do you realize what sort of people they are? They are prating oracles, sanctimonious sages who overflow with ignorance and ill-will, trusting, in their old age, to the respect inspired by their white beards. They busy themselves all day with maligning this person and that one at the drapers' and in the streets.[56]

Baldassare Castiglione also framed old age within narcissine terms. He opened the second book of *Il libro del cortegiano* (Venice, 1528) with a critique of senescent nostalgia – "they nearly all praise bygone times and denounce the present, railing against our doings and our ways and at everything that they, in their youth, did not do" – and then ascribed their skewed judgment to the body's degradation:

> For the senses of our body are so deceitful that they often beguile the judgment of our minds as well. Hence, it seems to me that old people in their situation resemble people who, as they sail out of the port, keep their eyes fixed upon the shore and think that their ship is standing still and that the shore is receding, although it is the other way round. . . ."[57]

Castiglione's language – judgment beguiled by deceitful senses – and his powerful image of the receding shoreline recall Narcissus. In a mirror inversion of reality – "it is the other way round" – the elderly believe themselves to be a fixed point; only the world around them moves. Caught in this delusional trap, "they say that everything is the reverse these days." Their senses have become "insipid and cold," but instead of finding this to be a condition of their age, Castiglione continues, the elderly attribute their "spoiled palate" to the food and drink themselves. The problem, according to Giovan Battista Gelli, is that the elderly "do not know themselves well," not all but a common enough "defect and deficiency."[58] They have a blind spot for their own shortcomings and, self-deluded, they heap lavish criticism on others.

* * *

Art critics, artists, and patrons became old narcissists. Not everyone became more narcissistic, and not in the same ways, always nuanced by their own clusters of attendant psychological weaknesses, but before more individuated cases can be presented in the following chapters, a brief summary may be useful.

1 *Art critics* The Venetian painter Sebastiano Ricci (1659–1734), according to his first biographer Lione Pascoli, became a harsh critic of modern culture when he reached old age because "like most old people" he detested the young, "either from envy or from impotence or from a natural aversion for any other way of living."[59] Old age, by the conventional marker of 65, arrived for Ricci in 1725 soon after a new generation of artistic renovators arrived on the scene, including Tiepolo, Piazzetta, and Pellegrini. Ricci valiantly adapted his style to the new, lighter manner, but slowed by habit, obesity, and gout he could have felt his range of movement, both physical and artistic, shrinking year by year. His glory days of prestige travel and commissions from European nobility were now in the past. Settled back in Venice, the senescent role assigned by Pascoli to Ricci as nostalgic critic sounds plausible.

What, then, about the stereotype that pitted a lost golden youth against a degraded present? How true was it? There are at least two ways of answering this question. One would be anecdotal, using representative examples, maybe even ones that thematize old age, an example like this: late in life, Benvenuto Cellini (1500–1571) lamented the time he had squandered composing "my rustic poetry."[60] His gravest regrets are reserved for contemporary art. Writing a poetic "dream" in 1560 at age 60, he appeals to Hercules to save painting from its disastrous decline. Wandering around "lost and bewildered in these new grottos [of painting], I feel like crying as soon as I start thinking [about] . . . those extinguished lights and the great roads broken." The arts appeal to Hercules, but alas this *Hercules* (the infamous pendant to Michelangelo's *David*) was made by Baccio Bandinelli (1488–1560), and he is immobilized with fear: "How can I enter such a dark place? . . . I was made by Bandinelli and so I feel disoriented." The arts respond: "Now we are lost without anyone to save us."[61] Bandinelli's *Hercules* acts old (fearful and disoriented), older than its maker (then 46 years old). Cellini's remaining hope for art, Michelangelo, then aged 85, was (Cellini thought) too old to perform his traditional role as savior. And finally Cellini himself at 60 acts old, weepy, and bewildered.

The second way of answering would be a comparative historical analysis. Table 1 lists those critics featured in this book who expressed opinions about a global (rather than an individual) decline, and their ages when they voiced those views. From this straw poll it seems that those who lament the decline of contemporary art tend to be old. The median age is 58. The average age is 56. However, when these figures are compared with a control group of art writers who were either noncommittal or optimistic about the state of contemporary art (Table 2), it appears that the age factor applies to writing about art more than any particular views about artistic decline or progress. The median age is 58, exactly the same age as group 1. The average age is 55, or one year younger than group 1. Statistically it is a draw.

Table 1: Writer and age at time of writing (pessimists)
(N.B. Some writers appear more than once if they wrote at significantly different times.)

Giovanni Pietro Zanotti (1674–1765)[62]	29
Giovanni Andrea Gilio da Fabriano (d. 1584)	34
Francesco Scannelli (1616–1663)	40
Carlo Dati (1619–1675)[63]	42
Pier Jacopo Martello (1665–1727)	45
Raffaello Borghini (1541–1588)	45
Giovanni Pietro Bellori (1613–1696)	47
Salvator Rosa (1615–1673)	49
Giovanni Paolo Gallucci (1538–1621)	53
Giovan Battista Armenini (1533–1609)	54
Carlo Ridolfi (1594–1658)	54
Gabriele Paleotti (1524–1597)	58
Giovanni Pietro Bellori (1613–1696)	59
Federico Zuccaro (1542–1609)	60 and 64
Benvenuto Cellini (1500–1571)	60
Federico Borromeo (1564–1631)	61
Giampolo Lomazzo (1538–1600)	63
Antonio Balestra (1660–1740)	64 and 67
Giovanni Pietro Zanotti (1674–1765)	65
Nicolas Vleugels (1668–1737)[64]	67
Giovanni Pietro Bellori (1613–1696)	69
Giovanni Battista Passeri (*circa* 1610–1679)[65]	69
Antonio Franchi (1634–1709)	75
Giovanni Pietro Zanotti (1674–1765)	82

Table 2: Writer and age at time of writing (optimists or agnostics)
(N.B. Some writers appear more than once if they wrote at significantly different times.)

Anton Maria Zanetti (1706–1778)	1733	27
Carlo Ratti (1737–1795)	1768	31
Giorgio Vasari (1511–1574)	1550	39
Marco Boschini (1613–1678)	1660	47
Ludovico Dolce (1508–1568)	1557	49
Sebastiano Mazzoni (*circa* 1611–1678)	1661	50
Giovanni Battista Volpato (1633–1706)	1685	52
Pietro da Cortona (1597–1669)	1652	55
Giorgio Vasari (1511–1574)	1568	57
Luigi Scaramuccia (1616–1680)	1674	58
Lione Pascoli (1674–1744)	1730	58
Bernardo de' Dominici (1683–1759)	1742	59
Marco Boschini (1613–1678)	1673	60

Raffaelle Soprani (1612–1672)	1674	60
Carlo Cesare Malvasia (1616–1693)	1678	62
Filippo Baldinucci (1625–1696)	1681–96	56–71
Lione Pascoli (1674–1744)	1736	64
Giovan Maria Ciocchi (1658–1725)	1725	67
Giovanni Baglione (1571–1644)	1642	71
Sebastiano Resta (1635–1714)	1707	72

2 *Artists* Psychologists have applied empirical tests of a different sort to old artists.[66] In their pursuit of scientific proofs, these psychologists adopt a wildly mistaken premise that equates productivity and creativity: if artists become less productive in old age, then they are less creative. Perhaps the psychologists have spent too much time with lab rats, or perhaps they failed to grasp how personal and elusive creativity really is (they criticize art historians for taking the individual artist as the only acceptable unit to study creativity), but they want to reduce the question to materialist, measurable parts. Even if their premise were acceptable, their means of measuring productivity are not. For them, any painting is a unit of production. It does not matter whether it is large or small, finely or loosely painted, in oil or fresco, produced with assistants or alone. A painting is a painting.

Another slippery quantitative approach, not ventured in these psychological studies, takes the frequency of repetition in general as a measure of creativity and, in particular, how often old artists return nostalgically to subjects of their youth. Did old artists act nostalgically? Did they revisit earlier compositions, subjects, or styles that they left untouched in middle age? Did they begin to repeat themselves? The problem here again is how to measure repetition. What degree of similarity is required to justify the label "revisit"? And were the motivations artistic and psychological, or were they mitigated by such factors as market demand and financial need (or perceived need)?

Having the questions and answering them, alas, are two different things. Most artists lack the biographical, epistolary, and archival information to weigh the various factors that contribute to old-age attributes such as nostalgia, repetition, and speedy or sloppy execution; and when the evidence does exist, we are missing interested and subtle interpreters. A significant exception is Richard Spear's *The "Divine" Guido: Religion, Sex, Money, and Art in the World of Guido Reni*. Beyond the example of Reni, however, an anecdotal approach can at least identify the possibilities available to early modern biographers. First, and most importantly, we can affirm that biographers took nostalgia to be a common phenomenon. According to Malvasia, as artists grow old, "they often gaze again at their earlier beautiful paintings."[67] Lione Pascoli attributed the decline of Giovanni Battista Gaulli's paintings in old age not to Bernini's death, as others cynically claimed (many thought that Gaulli's success depended largely on Bernini's help), but to the fact that he began to imitate his earlier work.[68] Gaulli scholars disagree both with the cause and effect observed by Pascoli. In other cases, however, art historians today, with no discernible agenda on age one way or the other, identify retrospective performances in old age. Salvator Rosa's late etching of *Jason* reverts to his earliest large etching,

the *Albert*; both have a "savage romanticism" expressed with angular forms and rough etching techniques.[69] For Rosa, this retrospective review is consistent with his narcissist inclinations, always vigilant about his body and how the public judged his paintings; his paintings were personal. In other cases, scholars with no old-age agenda have reasonably identified artists whose creative juices dried up. For example, Giacomo Cavedone (1577–1660), from his mid-fifties until his death at age 83, entered a "long senile period" spent mainly in repeating earlier works.[70]

Related to the retrospective practice of old narcissists reviewing and repeating their pasts is the invention of failed old-age mannerism. Filippo Baldinucci blamed this degradation and "vice" of style (*maniera*) on old age and narcissist behavior. In the *Vocabolario toscano dell'arte del disegno* (Florence, 1681), where Baldinucci defined the terms he would employ in the exhaustive *Notizie de' professori del disegno da Cimabue in qua* (Florence, 1681–1728), he coined and defined *ammanierato* as an excess of style, when an artist "draws entirely upon his own style."[71] This imitation of oneself was a nearly universal vice, Baldinucci declares in the *Vocabolario*, but in practice in the *Notizie* it was a problem particularly associated with old artists:

> It is certainly true that at the end of Pietro Liberi's life, this happened to him, as it does even with most of the best masters, who, in the long run, loving their own way of painting, fall into the mannered and abandon obedience to nature and perfect designing.[72]

> Following the style of his twin brother, Francesco Vanni, Ventura Salimbeni made his graceful and gave his figures a beautiful ease, but he didn't give them as much relief or truth as he could because, being a man much inclined to pastimes and being too quickly contented with himself and his own style, he was more inclined to recreation than study. . . . And so it was then no surprise that many paintings left his hand, especially in his last years, that were somewhat dry, too emphatically contoured, especially in the drapery, and very mannered, and in general very different from the good qualities that could be seen from his brush during his youth.[73]

> It is certain that if [Mario Balassi] were not so much in love with his own style (a vice that steals the value of most good painters), his paintings would have been as worthy [in his last years] as they were for most of his life; he could have been paid in some other way than with manna ash, whereas having given his work much of the mannered, some of them lost value after his death.[74]

In each case, narcissism causes old-age mannered styles. Old Salimbeni was "too contented with himself"; old Balassi was "too much in love with his own style"; and old Ricchi and other old artists fell to "loving their own way of painting." Baldinucci's *ammanierato* may be a new term, but it relied on earlier beliefs about art imitating art as inbred. It produces "bastards" (Leonardo) and "nephews" (Bellori). It succumbs to the "photocopier effect," growing evermore distant from nature, the true source of art. Self-complacency, rutted habits, imaginative fatigue, and, paradoxically, rampant fantasies are amongst the causes of old-age mannerism. Colors, forms, and poses that are chilled and enfeebled are amongst the symptoms.

Lacombe, using Baldinucci's *Vocabolario* for his own dictionary of 1758, wrote that Mannerists "continually copy themselves in their figures, poses, and expressions," referring both to the auto-mimetic trap of body reproduction and to solipsistic Mannerism as an old-age period style.[75]

3 *Patrons* Because this book tries to unravel the questions about how artists age and how their aging was given meaning by their biographers and critics, patrons play only bit parts. Another book could be written on old patrons and how their taste, collecting patterns, and modes of exhibition change with time. This is not that book. Instead, here is just a single curious case of a patron's old-age narcissism: Tommaso Rangone (*circa* 1493–*circa* 1577). At least two unusual, overlapping interests distinguished this physician, philosopher, and astrologer (pl. 11). First, he had a tenacious medical interest in longevity. He wrote two health manuals, including advice on nutrition and the salutary effects of the Venetian climate: *De vita hom-*

11 Jacopo Sansovino, *Tommaso Rangone* (Venice, San Giuliano)

inis ultra CXX annos protrahenda (Venice, 1550) and *Come l'huomo può vivere più de CXX anni*
(Venice, 1557). Venice was renowned as a city of the old, not just being a gerontocracy but as
a demographic reality. According to Francesco Sansovino, foreigners often commented
on the number of healthy senior citizens living in Venice.[76] At the end of his life, Rangone
wrote two books about the political consequences of medical history, odd fragments of med-
ical esoterica and Venetian history: *Come la duchessa et i Venetiani possano vivere sempre sani*
(Venice, 1570) and *Come il serenissimo doge di Vinegia il s. Sebastian Veniero, et li Venetiani*
possano viver sempre sani (Venice, 1577).[77] He never reached his full Venetian potential of 120
years but managed the impressive age of 84 nevertheless, a living monument to health manuals
and the Venetian climate. Second, Rangone had an obsessive drive to be portrayed. He invested
his considerable wealth to attain social honors that would enable or justify having himself
portrayed. He contributed significant sums to restore or rebuild whole churches just
for the chance to have his portrait hung prominently in a public place. His activity as an art
patron of Jacopo Sansovino, Jacopo Tintoretto, Andrea Schiavone, Alessandro Vittoria,
and others mostly involved portraits of himself. Rangone still lives in the many medals,
various busts and paintings, and one statue – just the legacy he planned, having devoted so
much time and expense in having himself portrayed above church, convent, and confraternity
portals.

Two years before the publication of *De vita hominis* (1550), as he was researching and writing
this, his first book on longevity, Rangone made the first of seven public art appearances. Seeing
Rangone praying in the corner of Tintoretto's *St. Mark Saving the Slave* (Venice, Accademia;
dated 1548), so modest and traditional, one would never guess what delusions of public display
would soon follow. Rangone started here at the Scuola di San Marco, age 55, a sustained rela-
tionship with this wealthy and powerful confraternity. Fourteen years later, in his capacity as
Guardian Grande of the Scuola, Rangone commissioned three other paintings from Tintoretto
for the Scuola and had himself inserted as *dramatis persona* instead of merely as a witness. In
the *Discovery of the Body of St. Mark* (Milan, Pinacoteca Brera) he kneels in wonder at center
stage; in the *Saving of the Body of St. Mark* (pl. 12), he helps to carry Mark's body; and in *St.*
Mark Saving the Saracens (Venice, Accademia), he helps Mark with his rescue by pulling one
of the Saracens from the stormy sea. In the same year, 1562, he proposed that a sculpted life-
size and standing portrait of himself be placed on the façade of the Scuola facing the *campo* of
Venice's ducal pantheon, Santi Giovanni e Paolo:

> Let it be praised that I place myself, Tomasso Ravenna, Dr. Cavalier Guardian Grande of
> our perfect confraternity, with your permission, a life-size standing figure of myself in stone
> or bronze, at my expense and with the specifications I will give, under the niche with a lion
> on the façade of our aforementioned scuola in the Campo of San Giovanni e Paolo to stay
> there forever with this inscription: THOMAS PHILOLOGVS RAVENAS PHYSICVS EQVES G. MAG.
> ANNO MDLXII.[78]

The Chapter General voted in favor (31 pro, 24 con), but sometime soon thereafter the decision
was reversed without explanation, just a big NULADA written alongside. This proposal seems to

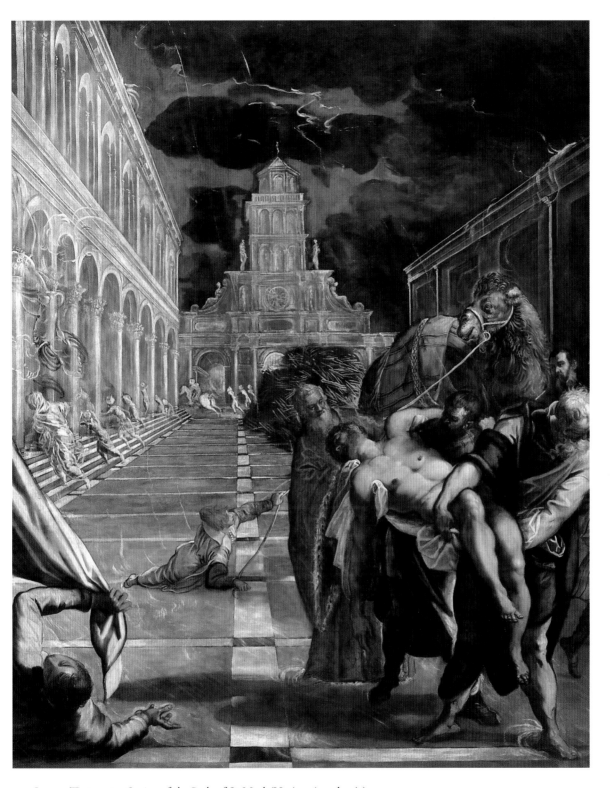

12 Jacopo Tintoretto, *Saving of the Body of St Mark* (Venice, Accademia)

have militated an anti-Rangone sentiment that culminated in 1573 when the Board of Governors passed a resolution to have Rangone's portraits removed: "to put an end to them by completely removing the figure of the Excellent Ravenna and put in their place something more suitable."[79] The paintings were first sent to Rangone's house, and then to Tintoretto's, but evidently no one wanted to obey.

Between 1548, when he made his first unassuming appearance, and 1573 with the attempted erasure of his presence from the Scuola di San Marco, Rangone had other audacious failures and successes. In 1553 or shortly before, he attempted to convince the Signoria to allow him to place a portrait of himself on the façade of San Geminiano, the church that once faced the Basilica on the Piazza di San Marco. The Signoria refused permission, just as they had in the previous century when Bartolomeo Colleoni made a very similar request. Rangone then turned to the church of San Giuliano, before later moving on (again like Colleoni) to the Campo di Santi Giovanni e Paolo. Later at San Giuliano he offered to pay for the church's reconstruction if he was granted permission to place a life-size portrait of himself "from life," standing or seated above the main portal.[80] This time the Signoria accepted. The Campo di San Giuliano, although close to the Piazza di San Marco, is a cramped, undignified space, just the opposite of the Piazza or the Campo di Santi Giovanni e Paolo. Jacopo Sansovino was commissioned to make the seated bronze figure in 1553; it was completed and installed in 1557 (pl. 11). The life-size Rangone is seated *ex cathedra* (he had been a professor at the University of Padua) between a globe on a table at one side and an astrolabe floating above a plinth on the other side.[81] His chair and the tomb that supports it project tipsily from the wall. Further disorienting is the edgy juxtaposition of scale between Rangone's head and the heavy keystone above it. In 1570, eight years after governors at the Scuola di San Marco turned him down, he initiated another attempt, this time successful, to place his portrait above the façade portal of the convent of San Sepolcro, then visible from the Grand Canal (as pointedly noted in the agreement).[82] Two years later, after years of generosity towards the church of San Geminiano, the canons gave their permission for a bronze bust of Rangone by Alessandro Vittoria; it was placed above the sacristy door and moved to the Ateneo Veneto when San Geminiano was demolished in 1807.

Two strands of thought can help to explain Rangone's persistence. First, and most obviously, there is his desire for longevity well beyond the normal human lifespan. As Alberti and many others noted, portraits keep the dead alive. They meant this figuratively. Portraits perpetuate the presence and memory of the deceased, an immortality of a kind. Rangone had eternity in mind when he proposed the life-size statue for the façade of the Scuola di San Marco. After the above-quoted inscription, his proposal to the confraternity explains that it will remain there "forever" and "perpetually." Death, as Montaigne so aptly noted, is the cruelest blow for narcissists. He imagined the elderly contemplating their pending death with resentment and incomprehension: "Should so much learning be lost, with so much damage, without the special concern of the destinies?"[83] A desire to be portrayed is not inherently narcissistic, at least not beyond many other forms of human activity, but Rangone's determined quest to be portrayed in public suggests some psychological need, complex in origins and unknowable in detail. At least in part his motivation was narcissistic, or would have been

construed as such by Gabriele Paleotti (if he could have been asked). Writing in *Discorso intorno le immagini sacre e profane* (Bologna, 1582), Paleotti speculated that the desire to be memorialized in portraits "is to be blinded by self love as the poets long ago told the story of Narcissus who was vainly charmed by his face and extinguished his own life with too much love for himself."[84]

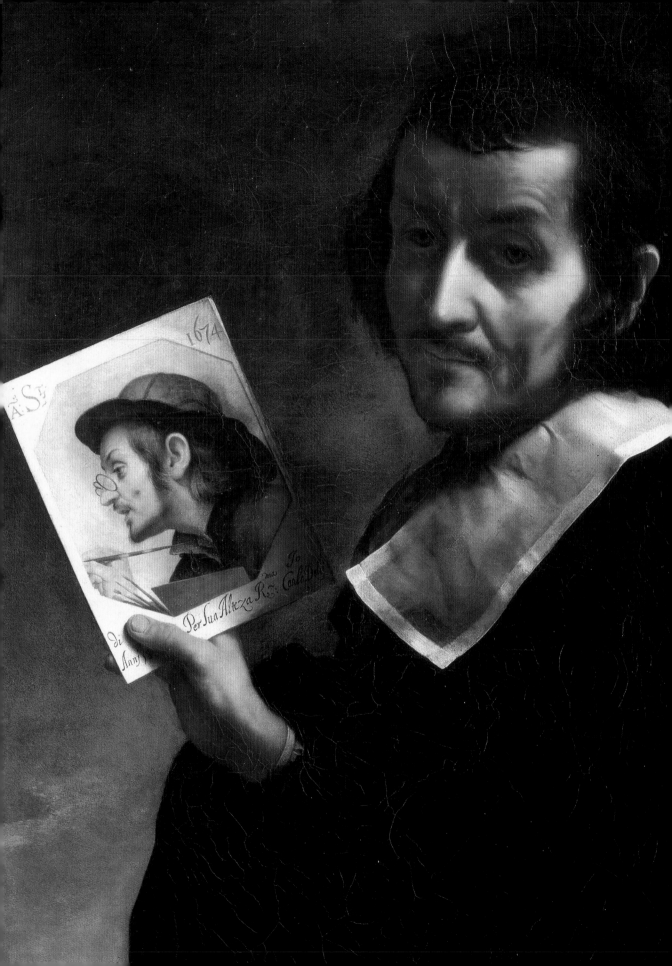

II Making Art in Old Age

3 Poussin's Hands and Titian's Eyes

Poussin's hand began shaking in his fifties. Premonitions of a neurological disorder are manifest in the *Conversion of St. Paul* of *circa* 1650.[1] By the time he reached his early sixties, when he drew *Two Hermits in a Landscape* (pl. 13), his hand trembled uncontrollably. The effects are less noticeable with the black chalk foundation, where he first sketches out a general tonality and landscape structure, than in the sharp and unforgiving pen that he used to lay in the parts.

13 Nicolas Poussin, *Two Hermits in a Landscape*, pen and ink with black chalk (St. Petersburg, The State Hermitage Museum)

Facing page: Nicolas Poussin, *Self-Portrait*, detail of pl. 17

14 Nicolas Poussin, *Landscape with Two Figures*, pen and ink (Washington, DC, National Gallery of Art, inv. 1986. 96. 2)

The outlines of the two figures jitter more nervously than elsewhere in the drawing as if his hand betrayed him wherever he aimed at precision and control. We see a similar inability to control nuanced description in the path by the pond, the trees, and the mountain silhouette of the *Landscape with Two Figures* (pl. 14).[2] In other words, in those parts of descriptive importance, Poussin slowed his hand hoping to catch the right contours. This, however, only amplified the tremor. Continuous contours skip on and off the page. Clusters of wiggles that might have been parallel hatching in earlier years swerve and tick all over the place.

It is in these jiggling lines, almost regular in their tremble, that we find a seismographic record of Poussin's hand in action. The aged hand can no longer perform the fluent *tratti* of its youth, those sweeping calligraphic flourishes of choreographed movement that can come only from steady nerves and an energetic *polso*. Curiously the most fluent lines in the Washington *Landscape* are nonmimetic. The looping filigree and two thick dashes in the sky are not clouds or anything else recognizable in nature. They are fluid and bold expressions of a hand freed from the labor of representation. But usually Poussin is reduced to short strokes, avoiding longer continuous lines that could openly fracture or stutter if his hand were to jump or spasm. The body's condition will be truthfully signed by the hand, or so Giambattista della Porta claimed with regard to signatures. On the reverse of the *Landscape* is a drafted letter that seems to confirm Della Porta's aphorism (pl. 15). Poussin labored to attain

15 Nicolas Poussin, *Draft of letter* (verso of pl. 14)

clarity, and to a remarkable degree he succeeded, but the effort is still poignantly visible.

By the end of Poussin's life, even pliant oil was beyond control. "Feebleness and tremors of the hand" prevented him from putting the "final touches" on the *Apollo and Daphne* (pls. 1 and 16).[3] "Not long before his death, he dedicated it to Cardinal Camillo Massimi, knowing it could not be brought to a greater finish." Looking at it today, can anyone resist finding, as Pliny did with the last and unfinished works of painters, "a sadness felt for a hand stilled even as it created"?[4] Like dying words or deathbed confessions, last works were often invested with a tragic nobility, truthful and transcendent.[5]

By reading *Two Hermits in a Landscape*, the *Landscape with Two Figures*, and the *Apollo and Daphne* in terms of Poussin's physical decline, I do not mean to suggest that style and artistic quality are merely consequences of neurological conditions or motor skills, even though old shaky hands do impose a similarity not only on Poussin's late drawings, but on those of Titian, Guercino, Guerrieri, and many others. Just as the elderly were thought to look alike, more like each other than themselves in youth, so too do late drawings (at least some) share an unsteady delineation or, what might be called, a neurological style. Poussin's affliction can thus be imagined as a cruel biological fact that shaped his art in ways he neither desired nor controlled. This is a view at odds with the romantic ameliorative approach still in play today, although usually without the audacity of Anthony Blunt, who read the jittery contours in *Achilles among the Daughters of Lycomedes* (pen and ink; St. Petersburg, Hermitage) as intentionally expressive forms: "the effect of surprise is vividly expressed and is perhaps even heightened by the nervous quality of the line."[6] In the course of this chapter it should

16 Nicolas Poussin, *Apollo and Daphne*, detail of pl. 1

become clear how much modern views such as Blunt's are progeny of a tradition originating with Félibien.[7] Embedded in this history is the moral that viewers of Poussin's late work should look beyond the visible form and find a better, clearer world of ideas. They should look at Poussin's drawings with the same selective and purifying mentality that Poussin brought to nature.

Poussin, unlike Félibien and Blunt, found nothing edifying about the state of his hands. In the late letters of 1664 and 1665 to Chantelou, Félibien, and the Abbé Nicaise, Poussin wrote of social alienation and physical decay, sometimes with a stoic resignation, sometimes with an abject pathos:

I am weighted with age, paralytic, full of infirmities of every kind, a foreigner without friends. . . . This is the state you find me in. . . . I have great difficulty in writing because of the terrible trembling of my hand. . . . It took me eight hours to write one pathetic letter, little by little, two or three lines at a time. . . .

I have become too infirm and paralyzed to dare to work. Also there are some times when I have abandoned my brushes, thinking of nothing other than preparing myself for death. I am a shaky body, that's me.

I am at pains to respond to you because of the debility of my trembling hand which no longer wants to obey even if I want it to . . . I have abandoned my brushes forever. There is nothing to do now but die which now seems to be the only cure for the ills that afflict me. If only God wills this to be soon because life weighs on me too heavily.[8]

Poussin's shaking hand was more than a corporeal reality. In the hands of his biographers, it became a "narrative cell" (to use the term popularized by Ernst Kris and Otto Kurz), thus taking its place amongst similar stories about old artists who were held hostage by their hands. The seventeenth-century Neapolitan painter Giuseppe Marullo, for example, made a marketing error when, in middle age, he abandoned Massimo Stanzione's style in response to the popularity of Guido Reni's light and delicate style then sweeping Italy. When in old age he realized his mistake – for his biographer, Bernardo de' Dominici, Marullo's "sin" was abandoning his native Neapolitan style – he discovered that his original pliant handling of paint could not be retrieved. In old age involuntary habits develop, and "the hand no longer obeys the intellect."[9] Raffaelle Soprani recalled visiting Giovanni Andrea de' Ferrari (1646–1724) in the dreaded Ospedale degl'Incurabili, Genoa.[10] One day Ferrari pulled his "contorted . . . twisted . . . and calcified hands" out from underneath the sheets, where they usually remained hidden, and told Soprani that even in this condition he still wanted to paint (*maneggiare il pennello*). Ferrari's nephew, Gregorio, suffered a similar fate. "Abandoned by his hands" with his desire to paint undiminished, he could make only small colored gesso figures, mere tokens that he gave as gifts to his friends.

A true story of a painter being held hostage to his hands (which is not to suggest that De' Dominici's Marullo and Soprani's Ferrari are mostly fictional) concerns Antonio Triva, an Emilian painter who left Venice in 1669 to work at the court of Bavaria. He was 43 years old at the time and at the height of his earning power: 600 florins per year plus 60 florins for every figure painted. By age 68 as his paralyzed hands hindered his painting, the stipend was cut first to 200 florins and then eliminated altogether. Triva wanted to return to Venice, but being bankrupt he could not afford the travel expenses. Abandoned in Bavaria, he died there five years later.[11]

Whatever the cause of disobedient hands, whether arthritis or Parkinson's or syphilis or sometimes just plain enervation, those artists who suffered most from a loss of manual vigor and control were those with delicate or detailed styles. Here are four sad examples. After Antonio de' Beatis, secretary to Cardinal Luigi of Aragon, visited Leonardo in 1517 at the castle of Cloux, he recorded in his diary that Leonardo was "an old man of more than seventy years of age" (Leonardo was actually 65 at the time) and that he "was overcome by a certain paralysis of his right hand, [so that] one can no longer expect fine things from him, and although messer Leonardo can no longer paint with the sweetness of style that he used to have, he can still make drawings and teach others."[12] Luis de Morales (*circa* 1500–1586), who painted hair "so finely and so delicately that it made even those who are most versed in art want to blow on it to see

it move," felt "the cruelty of Fortune" when in old age he lost his steady hand, leading his biographer, Antonio Palomino, to conclude that "his manner of painting is not meant for old people."[13] Joachim Camerarius celebrated Albrecht Dürer (1471–1528) for "the steadiness and exactitude of his hand," as if he drew with "rule, square, and compasses."[14] While Camerarius cites the performance of precise drawing, "unaided by artificial means to the great marvel of those that watched him," the results of his dexterous hand were equally visible in the precision of engraved lines and the exquisiteness of detail. For this new Apelles and Giotto whose art could be seen in a line, imagine the fear he felt when, at the age of 49, Dürer wrote to George Spalatin with touching restraint: "As I am losing my sight and freedom of hand my affairs do not look well." Willibald Pirckheimer's notation on a letter to his friend Venatorius, written six months earlier, that "Dürer is in bad shape" may not be the spiritual crisis proposed by Panofsky but something more mundane and frightening. And finally there is Gentile da Fabriano (*circa* 1370–1427), acclaimed by Michelangelo as a painter "whose hand was similar to his name" (gentle, delicate, tender) that in old age tragically "became palsied."[15]

What made Leonardo, Morales, Dürer, and Gentile such pathetic cases was their irrevocable marriage to pictorial styles that demanded a light touch and precise coordination. They lacked the formal vocabulary of a Michelangelo, who could exploit imprecision for expressive purposes, much as he had been doing with *non-finito* since his youthful *Battle of the Centaurs and Lapiths*. What would have been a deficit for others became an expressive strength for Michelangelo. Nicolas Poussin, however, represents a much sadder case. He and his biographers (early modern and modern) tried to disguise the manual perils of his old age by appealing to his noble sentiments – since concepts always surpass execution – yet an air of desperation and convenient justification lingers in their comments. It is true that we can catch Poussin's ideas somewhere in the jittery lines of his late drawings, but like a Parkinson's patient (although Poussin's symptoms might have been late-stage syphilis) who is locked inside himself, what we are most aware of is his struggle to control his hand. In the 1650s, just as his once flowing lines rigidified, his figures also started to exhibit signs of old age. No longer supple of body and flowing in movement, they suffer from an arthritic stiffness with poses that are more rigid and angular than in his youth. Friedlaender romanticized this stiffness when he described "a quiet and almost lonely repose" in Poussin's later version of *Achilles and the Daughters of Lycomedes* and the "very mysteriousness [of] these crystallized figures" in the *Apollo and Daphne* (pl. 1), but they could just as well be seen as sclerotic surrogates of the artist.

Poussin biographers do not usually dwell on their subject's body. In the quincentennial flood of Poussin publications and exhibitions of 1994, we find virtually nothing devoted to his body or character. Instead, he is a great mind (iconography and theory) and author of prestige paintings (collecting and patronage). Art historians, with some exceptions, still prefer Anthony Blunt's Poussin to Jacques Thuillier's,[16] finding the *peintre-philosophe* in his *Diogenes* and other Stoic paintings a mind and spirit capable of freeing itself of its corporeal needs. After his discussion of Poussin's *Pymandre*, Félibien describes Poussin's appearance and concludes that: "if it is true, as they often say, that painters paint themselves into their own works, then one can know Poussin even better through his paintings." The man and his body are less truthful, less revealing than his paintings. What lies behind this avoidance of Poussin's body?

17 Nicolas Poussin, *Self-Portrait*, red chalk (London, British Museum)

In his earliest *Self-Portrait* (pl. 17), deranged and suffering from *morbus gallicus*, Poussin captures what he euphemistically called "my miserable urinary disease."[17] Instead of his later public perfomances – the self-portraits painted for Chantelou and Pointel – this red chalk drawing of 1639 is a private reflection exposing the disgust he felt in looking at his diseased body. Three years later, assuming the proposed date of 1639 is correct, Poussin mentions his trembling hand for the first time, a frightening intimation of disability. The symptoms did not worsen incrementally with age, and as noted by Blunt from his study of Poussin's drawings, the shaking seems to have "come on and gone off unpredictably." But by the mid-1650s the problem was entrenched. Many explanations can be proposed for Poussin's withdrawal from friends and acquaintances late in life as his illness worsened and death approached, but looking at his self-portrait of 1639 it is not difficult to imagine that self-revulsion was also involved. He did not want others to see him as he saw himself.

We will never know precisely how Poussin viewed his body before its decay in old age, when it became a source of frustration, isolation, and resignation, but we are presented with two different versions by colleagues and biographers – Giovanni Battista Passeri and André Félibien – who employed the painter's body to explain his art. Félibien's Poussin is marked by his singularity, exile, independence, and aloofness, in other words by psychological traits consistent with an alienation of self from body. Compared with Passeri, Félibien writes little about Poussin's health. He does not name Poussin's illness, whereas Passeri diagnoses it as syphilis, and generally Félibien sanitizes Poussin's body problems until the very end, when he lets Poussin speak briefly for himself, through his letters. Passeri, on the other hand, gives specific medical and bodily details.

* * *

Shuddering hands, especially those of famous artists, demanded explanations of acceptance or mitigation. Poussin's solution – turning away from practice to theory – and his biographer's extenuating explanations should be read in relation to Michelangelo and Bernini. Michelangelo and his mythologized transcendence of physical infirmity shadowed Poussin's decline and how he (and his biographers) dealt with intention and facture. Both Michelangelo and Poussin prided themselves as intellectuals whose art resided more in the realm of ideas than in material production. Both thought hands should be subjugated to mind. Both provided solutions to their biographers, helping them to excuse the physical imperfections of their work. "The hand must obey the highest intellect," wrote de' Dominici, quoting Michelangelo's Platonizing sonnet published by Benedetto Varchi in 1547.[18] What this passage shows is how by the eighteenth century Michelangelo had been assigned the role of intellectual artist of the mind-over-matter school. According to Michelangelo, artists "paint with the head not with the hands"; they express their ideas "only by the hand that obeys the intellect."[19] When Michelangelo first expressed such ideas, he was 67 years old and, despite a persistent hypochondria, he had few premonitions or early symptoms of losing control. Rather he was just struggling with one of his impatient patrons:

> Your Lordship sends to tell me that I should paint and not worry about anything else. I reply that one paints with the head and not with the hands, and if one cannot concentrate, one brings disgrace upon oneself. Therefore, until my affair [re ongoing negotiations about the tomb of Julius II] is settled, I can do no good work. . . . But to return to the painting, it is not in my power to refuse Pope Pagolo anything. I will paint unhappily and will make things that are unhappy.[20]

Five years later, in 1547, when his hand began losing some of its vigor, he theorized the relation of hand to mind in an attempt to raise his art into philosophy, thus distancing it from craft: "The excellent artist has no *concetto* / that one single marble does not enclose / with its excess; and that [*concetto*] is only attained by the hand that obeys the intellect." In his discussion of this sonnet, Varchi argued for the inclusion of painting and sculpture amongst the liberal arts despite their manual production: "even though painting and sculpture make use of the hands, they do not rely primarily on the strength of the body."[21] At age 80, Michelangelo warned the young painter Girolamo Muziano (1528–1592) about predatory time: "you must never, for any reason, imagine that you know enough and consequently stop trying to acquire more knowledge, but always proceed with studious work and do not wait until your eyesight wanes, your hand trembles, and your head cannot be directed toward attentive studies."[22] Like Lomazzo and Poussin, Michelangelo hoped that study would moderate the effects of aging. He might even have believed, as Vasari had him say, that "using the hammer kept his body healthy." It is certainly true that his "spirit and genius could not remain idle."

These idealist assertions mask an underlying anxiety felt by the hypochondriac Michelangelo that his hands might disobey his intellect and imagination, that his body was an inadequate vessel for his mind. By positing the dominion of mind over hand, he reveals a concern about

noncompliance. Could Mario Equicolo be right in asserting that "painting is the work and labor more of the body than the soul"?[23] Contemporary assumptions about the artist's hand as a secure sign of health or debility, maturity or old age probably fuelled his anxieties even more. How did he feel, we wonder, when at age 78 he received a request from the Portuguese painter Francisco de Hollanda (1517–1584) for a drawing so that his distant acquaintance could diagnose his health?[24] In a letter of August 1553 to Michelangelo, Hollanda fondly recalls the conversations they had "in those happy days of your old age," referring to his sojourn in Rome starting in 1538 when Michelangelo was 63. He asks Michelangelo to send him "any drawing in memory of your work, even if it is nothing more than some line or profile like those by the ancient Apelles, since it would be for me a true sign of your health and a permanent recollection of our friendship." Like Protogenes, Hollanda can appreciate a single nonmimetic line (here he compliments himself as much as Michelangelo), and in the line's subtlety and Michelangelo's dexterity he would be able to remember their discussions, recorded more prosaically in the *Diálogos em Roma*. Possibly more unnerving for Michelangelo was Hollanda's plan to use the drawing medically, as "true sign of your health," unnerving because by the 1550s the art world (evidently as far away as Portugal) knew about Michelangelo's deteriorating control of his hands. If he complied with Hollanda's request, and there is no evidence that he did, his drawing could expose the validity of his Platonizing view of art and craft as a wishful thought.

Having enrolled himself as old by age 42, Michelangelo eventually faced the most horrifying of disabilities for an artist: blindness. Eventually, as Vasari wrote in the Giunti edition of 1568, "his flesh betrayed his spirit" and he "could no longer draw clear lines."[25] Art historians interpret the results of this disability – the blurred, fudged, and smudged lines of his drawings – transcendentally as a metaphor of Michelangelo's deepening spirituality. They are, according to Charles de Tolnay, "inner prayers" (pl. 18).[26] Graphic technique also enabled David Rosand to diagnose an intimate spirituality and corporeal denial in Michelangelo's late drawings:

> The graphic complexity of the surface, its essential tactility, suggests a reluctance to let go, to lose touch with that body [of Christ]. The act of drawing has become an act of devotion. And the compulsive application of the one becomes the urgency of the other. The materiality of this experience is what we feel in the physicality of image in Michelangelo's late religious poetry, in which we hear the anguished yet always powerful voice of a penitent in longing search of his God. Both the poetry and the drawings are heard as private meditations, prayers of a deeply felt, desperate piety. Yet even as Michelangelo denies his art of the body, desiring to free his own soul from material bondage, the poetry itself returns us to the physical; even as he remains grounded in the flesh, the artist reaches toward heaven with the same aspiring energy that informs his own creatures.[27]

Other artists turned more deeply religious in old age, as Michelangelo did with his sonnets, and felt remorse about the lascivious nudes of their youth and deliberately devoted their remaining years to their spiritual life. Those who continued practicing their art limited it to edifying religious content; some even burned any offending earlier works they could find (Botticelli,

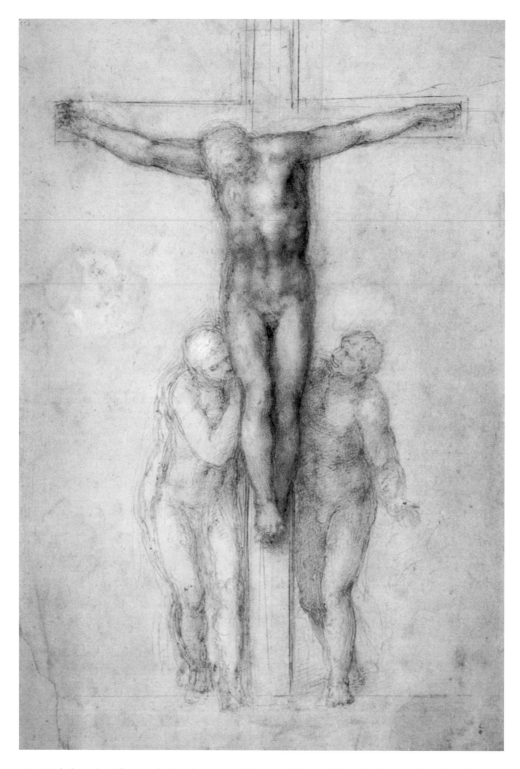

18 Michelangelo, *Christ on the Cross between the Virgin and St. John*, black chalk and white paint (London, British Museum)

Bartolomeo Ammannati, and Carlo Cignani),[28] casting them into the fires of hell. Possibly Michelangelo's motivation in burning his drawings was religious and not artistic (to conceal the effort of his work), as Vasari, the great aesthetic secularist, would have us believe.

* * *

Gianlorenzo Bernini (1598–1680), generally presented as an admirer of Poussin despite evidence to the contrary, studied the *Gathering of Phocion's Ashes* (Paris, Louvre) and gave him the double-edged moniker of "a great big brain" (*un cervellone grande*), thus prompting Chantelou to conclude that Poussin's paintings "had always been the product of his mind since his hands were clumsy."[29] Turning to Poussin's *Flight into Egypt* (current whereabouts unknown) painted in 1658 for Jacques Cérisier, Bernini concluded that "there comes a time when one should cease work, for there is a falling off in everyone in old age." Chantelou, ever the nuanced diplomat, realized the difficulty of such an exacting demand and suggested that "perhaps" painters could continue "only to keep themselves amused." Yes, Bernini agreed, but "their late works often did harm to their reputations." At the time, Bernini was three years older than Poussin when he painted the *Flight into Egypt* in 1658, and as Bernini advanced in years, he formulated a reason why he should be exempted from his own expectations:

> . . . an artist excellent in design need fear no want of vivacity or tenderness on reaching the age of decrepitude, because the practice of design alone is so efficacious that by itself it can supply what is lacking in the spirits, which languish in old age.[30]

> In it Bernini proved the truth of his familiar axiom, that the artist with a truly strong foundation in design need fear no diminution of vitality, sensitivity or other good qualities in his work when he reaches old age; for thanks to this sureness in design, he is able to make up fully for those defects which tend to petrify under the weight of years.[31]

Bernini tried to make "his familiar axiom" true by frequent repetition, and its optimism is consistent with his energetic character, but it never became axiomatic outside of his family.

The limits of Bernini's axiom must be carefully prescribed. He was not claiming greater powers or insight from age, and looking at his bland and flaccid *Bust of the Savior* (pl. 19) that Domenico cited as evidence of his father's continued vitality "at the decrepit age of eighty," one wonders how true his axiom really is. Domenico's conclusion that it "summarized and condensed all his art" shows filial devotion more than critical insight. Irving Lavin found in it a "spiritualized" self-portrait, complex and powerful.[32] In my view, Bernini's miraculous transformations of stone into molten wax and flesh seem to have petrified in old age, acquiring the hard and dry qualities that were conventionally ascribed to the elderly themselves. (Other art historians reject the Norfolk *Savior* as the original because it seems so distant from his other works: it's not an old Bernini, it's no Bernini.) Bernini's preparations for death, the spiritual exercises led by Father Marchesi, undoubtedly transformed his soul, and the process of carving the *Savior* could in itself be a spiritual exercise, but did they touch his art in any profound way beyond his choice of subject matter?

19 Gianlorenzo Bernini, *Bust of the Savior* (Norfolk, VA, Chrysler Museum)

Whether Bernini's axiom was his own or an appropriation from his reading of Lomazzo and Pietro da Cortona,[33] it was certainly an explanation that served his needs and conveniently avoided his thoughts about Poussin's decrepitude. For all his bluster with Chantelou and dogmatic assertion with his son, Bernini reveals an underlying anxiety that most aging artists must have felt: will I have to stop? should I stop? For many, this must have felt like, or actually been, a question of life and death: "If I work, then I live; when I stop, then I die," as Frans Floris pungently put it.[34] Alessandro Tiarini (1577–1668), on the other hand, nearly died of grief when he realized that Venetians would judge him by his late, mediocre *Madonna of the Rosary with SS Dominic and Joseph* (Venice, Chiesa dei Mendicanti) and not by his mature, vigorous work.[35] Concluding that his declining powers in senility ("l'ultima vecchiaia") were a punishment for his excessive desire to work forever, he consigned his brushes, palette, and easel to Sirani and devoted himself to "spiritual exercises." When Jean Jouvenet (1644–1717) suffered a stroke at age 69 that paralyzed his right hand, he avoided retirement by choosing a handicapped practice with his left hand. He was careful, however, in alerting viewers about the deterioration they found on display by signing his first post-stroke altarpiece, the *Annunciation* in Notre Dame in Paris: "J. Jouvenet, Dextra paralyticus Sinstra pinxit 1716".[36]

* * *

Poussin's "clumsy" hands became even clumsier with age. Evidently this great master of *disegno* was not exempt from the decline in old age that Bernini predicted for himself. Chantelou's attempt to salvage his countryman's reputation was characteristic of the first of two ameliorative approaches to the thematization of Poussin's hands. Félibien advised his readers to overlook the obvious physical effects of Poussin's aging hand because "what the artist conceives will always be more perfect than what the brush can execute."[37] Instead of seeing the imperfect material, the viewer (like Poussin himself) should extrapolate the palsied form and extract from it the originating idea. "Thus it is true that Poussin's very particular art is detached from material things and from his hand."[38] Or, as Jean Pierre Mariette imagined in 1741, "in the last days of his life with a trembling hand that refused to serve him. . . . the fire of his imagination still burned strongly, and this able painter continued to put forth magnificent conceptions even if it was painful to see them so badly executed."[39] By affirming for Poussin a healthy sustained imagination, his biographers differentiated this intellectual artist from many other old artists, like Pietro Perugino, whose age forced repetition on themselves. In this respect Claude Lorrain (1604/5?–1682), so often juxtaposed with Poussin as an Italianate French landscapist, fits the stereotype well, or, at least was made to fit by the Roman agent to Cardinal Leopoldo de' Medici:

Mr. Claude has some old drawings, but in small number, and he does not want to part with them, saying that he uses them. Now that he is old it seems too tiresome to him to make new things; he therefore offers to copy two of them and to give us the copies. Morandi does not want to accept, saying that nowadays his works contain weaknesses and are more than a hundred miles from the quality of the old ones.[40]

There are, however, unresolved tensions in this ameliorative approach. Félibien cited Galen's instrumental view that "reason is considered to be the Master who commands and orders; the hand obeys him like his servant." Vincenzio Borghini described the relationship as captain to soldier.[41] In old age, the "Master" loses his potency, and his servant commands in his place, a humiliating loss of status and upheaval of social hierarchy. What use is a lively imagination if your hand disobeys? More worrying still is that the trembling hand is not simply an impediment to expressing lofty conceptions, but the stuttering line is itself an unmediated sign of conceptual infirmities. Body and spirit decline in tandem, wrote Lucretius:

> We are conscious that mind and body are born together, grow up together and together grow old. With the weak and delicate frame of wavering childhood goes a like infirmity of judgement. The robust vigour of ripening years is accompanied by a steadier resolve and a maturer strength of mind. Later, when the body is palsied by the potent forces of age and the limbs have collapsed with blunted vigour, the understanding limps, the tongue rambles and the mind totters: everything weakens and gives way at the same time.[42]

If the body is the *signaturae* of the soul, as Giambattista della Porta proposed,[43] then symptoms of feebleness and palsy register an infirmity of mind and spirit. When Carlo Ratti found Giacomo Antonio Boni (1688–1766) lagging at age 67 in his work on the *Assumption of the Virgin* (Genoa, San Filippo Neri), he explained it not only in terms of the physical demands of large-scale fresco production but something deeper: "If this work did not meet general expectations, one must then blame the artist's old age and his imagination which had been already sterilized by so many vast productions."[44]

That these exceptionalist views of Poussin's old age originated with the artist himself is suggested by Poussin's innovative semantic move in defining style, maneuvering it away from the calligraphic, manual, and native talent, and finding a safe haven for it in theme and subject matter.[45] Writing in the 1650s when the sputtering lines of his drawings became more frequent and more pronounced, he chose to protect style from those areas that his deteriorating body threatened. Style is like an accent, wrote Agostino Mascardi – Poussin's source for his definition of style – but Poussin selected out that part. His dense French accent, like his shaky hand, reminded him how he could not fully control his body, that his tongue and hand had lives of their own and hence threatened his status as a cerebral artist.

* * *

Poussin's turn to theory in the 1650s is integral to our conception of him as a *peintre-philosophe*. From the perspective of old age, it can be seen as a refuge from aging and failing practice:

> He always planned to write a book on painting, annotating various materials that he read or noting what he thought himself, with the intention of organizing them when, because of his age, he could no longer work with a brush; and with that [we can see that] he was of the opinion that it is no longer appropriate for the old painter to tire himself because of his lack of spirit, as we have seen in many others.[46]

Theory and biography became a liberal arts refuge for other painters at the end of their careers. Giovan Battista Armenini (1533–1609) turned to theory, and Carlo Ridolfi to biography, as substitutes for painting and, in their cases, as compensation for failing careers. According to Raffaelle Soprani, Luigi Scaramuccia (1616–1680) was forced to do the same, but he might have been speaking of himself just as well.[47] Giampolo Lomazzo's sudden blindness forced him to replace his brush with a pen. The Florentine painter Giovan Maria Ciocchi (1658–1725) wrote *La pittura in Parnaso* (Florence, 1725) in his mid-sixties when his eyesight prevented him from painting.[48] The hypochondriacal Antonio Franchi (1634–1709) experienced heart palpitations and gout by age 60 and decided to write "a certain theoretical treatise on painting" instead of practicing the art itself.[49] For old artists like Poussin, Franchi, and Ciocchi, the turn to theory and criticism resonated with two old-age stereotypes: the narcissistic and nostalgic elder (see chapter 1), and the Platonic view of the wise elder distancing himself from the battles of practice. Like Narcissus who slips into a state of perpetual contemplation, they abandon the *vita activa* for a *vita contemplativa*.

Theory as a surrogate for practice confirms the physicality of painting. Poets, philosophers, historians, orators, physicians, scientists, and lawyers depended on their bodies in only the crudest of ways. Partial exceptions aside – the orator whose delivery relied on gesture, voice, and physical stamina,[50] or the surgeon who can no longer operate (a blessing for his patients) – liberal arts practitioners traded mainly in language instead of fine motor skills. An artist like Carlo Maratta (1625–1713), however, who remained mentally and physically vigorous, with good eyesight until at age 88 his hands started to tremble, was constrained to language. Sitting in his studio, he told his amanuenses how to paint in his place, much as Vincenzio Borghini imagined Bronzino or Vasari directing him in painting: "Next to those two strokes of white," Borghini has them say, "place two others, even brighter, and place them here, and a bit over there put a darker stroke."[51] Alessandro Magnasco (1667–1749) met a similar fate in old age when "he could no longer handle the brush because of a pronounced tremor of the hands" and consequently was reduced to "discussing his art" (*di ragionare dell'arte sua*), an activity he did with "incredible vigor and grace."[52] Carlo Ratti visited Magnasco in these years and poignantly reports how the painter would gaze at his useless hands that had abandoned him. Language was a poor substitute for paint and brushes.

Writers and other humanists were protected from this tragedy of old age because their art did not depend on their bodies. Borghini thought that the more an art depended on the body, the less noble it was.[53] Poets do not need their hands to communicate and hence are superior to painters. Architects who work with their hands are mere bricklayers. How this can make a difference in the way writers regard old artists and old writers can be shown with a letter from Pietro Aretino to Gian Maria, a young pupil of Gerolamo Savoldo.[54] Aretino was 57 at the time (1548), and although technically within the borders of old age, he created a role for himself beyond his actual years in describing himself as "that big old man" (*quel vecchione*). He took on a similar role several months earlier in advising Tintoretto to temper the impetuousness of his youth, as if Aretino himself could not be improvident in his words, diet, and lifestyle in general. Tintoretto acted too young, and Savoldo, then about 65 years old, acted too old. "It's a shame he's so old," judges one old man of another. To convey why Savoldo was precariously

situated, Aretino selected those effects of old age (rendered circumlocutiously as "unfortunately ripe in his years of life" or more bluntly as his "decrepitude") that did not threaten him as a writer: "one of the best practitioners (*gli essercitanti*) . . . in handling colors" (*il maneggiar dei colori*); his paintings are either "works of your brush" (*l'opere dal pennello di voi*) or "products of his hands" (*[le] cose de le mano*). Writing does not require, even if it usually involves, some manual or physical act like painting; its unique style is not inscribed in the material.

One can only imagine the mixture of regret and anxiety that even a theoretically inclined artist like Poussin must have felt. He knew Raffaello Borghini's seminal advice, at least in its reiterated version by Pietro da Cortona and Giandomenico Ottonelli, that artists in old age should recognize their abilities and time of life and lay down their brushes instead of entering an inevitable stage of decline.[55] Borghini, who was not a painter, meted out his dispassionate advice without personal complications or empathy, clueless about the emotional trauma behind his ideas; Pietro da Cortona (1596–1669), facing this decline at age 55, displaced the problem into the weakening work of Giuseppe Cesari d'Arpino (1568–1640). Had he hoped or, more likely, did he continue to hope that Lomazzo's ideas of prophylactic theory were correct? that theory prevents decline in old-age practice?[56] Pietro da Cortona read Lomazzo and applied the lesson to the Cavaliere Cesari d'Arpino, who, "painting more by instinct than learning," aged badly. When Giovanni Baglione failed to comment on the cause of the Cavaliere's decline, beyond simply old age, Bellori corrected him in the margins of his copy of the *Vite*: "This is to say [concerning d'Arpino's late degraded style] that he is a bold painter (*di spirito*) and not one of learning (*scienza*). Learning increases with age and boldness flags as one sees in the wonderful works of Pietro da Cortona when he became old and with the old Poussin and other old painters."[57] Sebastiano Resta seems to have combined Lomazzo's rejuvenating theory with Félibien's explanation of Poussin's transcendent ideas when he wrote that Poussin, like other painters grounded in theory (he also mentions Pietro da Cortona), produced "marvelous works" in old age because "knowledge increases with age while the spirits weaken when they become old."[58] To the extent that Poussin helped to shape his own biography, we can see Félibien as expressing Poussin's justification for continuing to paint.

* * *

Ophthalmologists today predict, often correctly, that at the age of 40 the farsighted will need glasses to read, embroider, or paint details. No big deal. But in early modern Italy it was, especially if you were a painter. Painters used eyeglasses and extended their careers with them,[59] but they were relatively blunt instruments. In the mid-eighteenth century Pietro Ligari complained that he could not find "most perfect glasses,"[60] but even if he had, they would not correct astigmatism or more serious problems of vision. Cataracts, glaucoma, macular degeneration, and other progressive dimming of sight had simply to be endured until blindness surrounded them. There were cases of mid-life blindness (Giampolo Lomazzo, Andrea Luigi d'Assisi, and Giovanni Bellinert, for example) and even one case of congenital blindness (the sculptor Giovanni Gonnelli), but most cases occurred much later and were considered almost synonymous with old age.[61] Some artists even in their eighties proudly and loudly declared that they did not need glasses (Francesco Albani, Giovanni Battista Castello, and Giammaria Morandi).[62] Others, like

Salvator Rosa, were forced to paint with imperfect glasses: "My eyesight has become so weakened that I can neither read nor paint without glasses . . . These have been the impediments of life, my friend. . . . I've given up all hope of painting on a small scale, and so I've done and am doing what I can, if not what I'd like to do."[63] Four years later, at age 53, Rosa feared that his declining eyesight would force him to abandon painting. Carlo Dolci (1616–1686), a painter known for his honesty and detailed natural style, played with his self-fashioned self as a myopic spectacled naturalist and his real self as a romantic Rosa type: *Self-Portrait* (pl. 20). Old-age blindness ended the careers of Benvenuto Garofalo, Benedetto Rovezzano, Bartolomeo Ammannati, Jacopo Bassano, Alessandro Tiarini, Giovanni Domenico Cerrini, Gioseffo Magnavacca, and many others.[64]

Imperfect work by old artists was often attributed to failing eyesight. Bandinelli blamed the coarse finish of the late pulpits in San Lorenzo in Florence on Donatello's eyesight: "When Donatello did the pulpits and doors of bronze in S. Lorenzo for Cosimo il Vecchio, he was so old that his eyesight no longer permitted him to judge them properly and to give them a beautiful finish; and although their conception is good, Donatello never did coarser work."[65] Michelangelo relied more heavily on touch as his eyesight failed him in old age. Sculpture is by definition a tactile art, but with loss of eyesight it became a dominant sense. "We know," wrote Cesare Ripa, "that Michelangelo, light and splendor of sculpture, becoming practically blind in old age from constant study, was used to handling (*palpeggiando*) statues, both ancient and modern, and determine by touch what they were, rendering judgment about their price and value."[66] And Rosand deftly captures the sculptor's touch in Michelangelo's late drawings:

> . . . the materiality of the surface itself, its insistent tactility, betrays the physical presence of the draftsman, the marks of a hand in search of form, a process of groping, caressing, of coaxing form from out of the depths of the paper. It is, we might say, the touch of the sculptor himself, here modeling and molding, patting and testing surface, always in direct contact with the forming image.[67]

In August 1562 Michelangelo asked Lorenzo Mariottini to send him a set of wood-carving tools.[68] Wood was an unusual choice for Michelangelo, but it was a pliant medium well suited for his physical weakness; so too was the small size (27 cm high) of the *Crucifix* (pl. 21) that he started for his nephew Leonardo. In his last year of life, working by touch as much as by sight and wanting to leave a legacy of better days for his nephew, Michelangelo started this reprise of his youthful Santo Spirito *Crucifix*.

Titian's experience fits the template established by Donatello and Michelangelo where loss of acuity in eyesight manifests itself in a loss of acuity in contour, shape, and detail. Domenicus Lampsonius, having heard about Titian's failing eyesight, wrote to him in March 1567 praying for God to give him "an old age with many happy years still and with good and sharp eyesight." His fear, evidently, was what harm it would bring Titian's "natural . . . divine, august and immortal" colors.[69] One year later Niccolò Stoppio, art dealer to Albrecht v of Bavaria, wrote to Johann Jacob Fugger that Titian "values his things [his current paintings] as much as or more than usual, and everyone says that he no longer sees what he makes and his hand trembles a lot which makes it difficult to bring his work to perfection which he has his assistants do."[70] His verdict is sour indeed. Not only have Titian's eyes and hands grown weaker and

20 Carlo Dolci, *Self-Portrait* (Florence, Uffizi)

21 Michelangelo, *Crucifix* (Florence, Casa Buonarroti)

incompetent, but his judgment has declined as well, not knowing or seeing what has happened to his painting.

Declining vision for both Donatello and Titian caused a coarsening imprecision of form. This was not the only consequence of old eyes, but it was the most common. Guercino (1591–1666), for example, admitted to Antonio Ruffo that now, at age 74, his damaged eyesight no longer permitted more detailed work and he proposed instead to paint something larger and in a broader style.[71] Marco Benefial's incipient blindness at age 88 is painfully evident in his drawing of the *Beheading of St. John the Baptist* (pl. 22). The sharp vision and steady hand of youth blurs and sputters in old age. This downward course is a biological reality, and hence a convenient model to plot changes in an artist's style. Most famously and influential for early modern biography, Vasari differentiated two stages of Titian's late painting. The beginning of the end consists of the painterly and seemingly careless mythologies for Philip II, between 1551 and 1562, which are compared with the more diligent and detailed work of his youth:

> But it is true that his method of painting in these late works is very different from the technique he had used as a young man. For the early works are executed with a certain finesse and an incredible diligence, so that they can be seen from close to as well as from a distance; while these last pictures are executed with broad and bold strokes and smudges, so that from nearby nothing can be seen whereas from a distance they seem perfect. This method of painting has caused many artists, who have wished to imitate him and thus display their skill, to produce clumsy pictures. For although many people have thought that they are painted without effort this is not the case, and they deceive themselves, because it is known that these works are much revised and that he went over them so many times with his colors that one can appreciate how much labor is involved. And this method of working, used in this way, is judicious, beautiful, and stupendous, because it makes the pictures appear alive and painted with great art, concealing the labor.

The second phase included deteriorated versions of his mature late work: "during these last few years he would have done well not to have worked save to amuse himself, for then he would have avoided damaging with inferior work the reputation won during his best years before his natural powers started to decline." During these "last few years," presumably between 1562 and 1566 when Vasari last visited Venice, Titian lost the patience and subtlety that Vasari described with such sensitivity for the Philip II mythologies. The paintings for Philip II were intentionally careless; the later ones were just plain sloppy. The first deceived viewers into mistaking controlled artifice for random splatter; the second were just what they appeared to be, messes.[72]

The effects of failing eyesight can be readily found in the broadening of brushstrokes that Titian made little attempt to disguise or blend. His brushes became the size of broomsticks, by one account, because he could see only big, bold strokes and, perhaps, he needed the distance of a broomstick to see the painting's surface at all. The visual result is blurry and a bit jumpy. The darker, somber palette might be another effect. If cataracts impaired his vision and deadened his colors, one can imagine Titian painting his autumnal worlds as he saw the real world around him. This conventional description of Titian's old age and late paintings appeals to viewers because an old-age language effectively joins visual and psychological attributes: somber, dulled, autumnal. This view relies on a narcissine epistemology where Titian's art is reflexively

22 Marco Benefial, *Beheading of St. John the Baptist* (Berlin, Staatliche Museen, Kupferstichkabinet, inv. 2051)

conditioned by his physical state. Now, in the next chapter, other more complicated possibilities will be explored where Titian is an active participant in formulating a style appropriate to his years.

4 Titian Performs Old Age

Titian was self-conscious of his age, never minimizing but deliberately maximizing it, seemingly unwilling to admit his true age. Even the age on his death certificate – 103 – is an invention.[1] Dates of birth and hence knowledge of one's age were less exact in the Renaissance than today, but the range of years assigned to Titian extends far beyond contemporary approximations. Five years before his death in 1576, Titian gave his age to Philip II as 95 years (making him 100 at death). In 1559 Philip II's secretary, García Hernandez, mentioned Titian's age as "more than 85" (at least 102 at death), but two years later he revised that number downward by three years, and by 1564 Hernandez's estimate had dropped another four years (making him 95 at death).[2] By this point Hernandez admitted to Philip II that he relied on hearsay – "according to those who know his age" – and that he really didn't know Titian's true age. The search for Titian's age was nearly as difficult as collectors' search for paintings by this elusive artist. Tomas de Zorzoza, Hernandez's replacement, revised the figure downward further, making Titian 85 years old in 1567 (or 94 at death). Ludovico Dolce claimed in 1557 that Titian painted the Fondaco de' Tedeschi frescoes in Venice at age 20 (or 98 at death); and Vasari approximated "about 66 years" in 1568 (or 74 at death). Both Dolce and Vasari knew Titian when they made these claims, and yet they varied by twenty-four years, a whole generation. Nor could his posthumous biographers agree. Giovanni Maria Verdizotti, Titian's "intimate friend" and occasional amanuensis according to Ridolfi, wrote that he died at age 90.[3] Raffaello Borghini, writing just eight years after Titian's death, lists his age as 98 or 99.[4] Carlo Ridolfi's 99 years became the definitive version for the following three centuries, reflecting the importance of his biography more than its accuracy.[5] What was Titian's actual age at death? The truth is we don't know, and we may never know. Usually scholars make estimates as to when he died: 1477, 1485, 1489, 1490, 1493, and 1495. The consensus today varies between 1489 and 1495, making Titian between 81 and 87 at his death.

Why was information about Titian's age so sought after, prone to rumor and disputed? The appeal of gossip and the curiosity of "extreme old age" (i.e. an octogenarian or older) certainly played a role, but underlying this is the more serious issue of practicing art in old age. What happens to a gifted master, a naturalist renowned for the accuracy of his representations, when hands and eyes experience the downward tug of old age? Why, under these conditions, would Titian fashion himself as older than his years when, it would seem, painters who wanted to conceal their age normally made themselves younger, not older, as did Giovanni Baglione (1571–1644) and Giuseppe Cesari d'Arpino?[6] Michelangelo's complaints about old age were probably a symptom of his hypochondria. Little evidence exists to suggest that Titian tended

toward hypochondria, although the little bit we have is worth mentioning. In a letter of 12 July 1530 to Federico Gonzaga, Duke of Mantua, Titian wrote about the passage and ravages of time:

> That Corva or Cornelia is not to be found here in Bologna, Signora Isabella has sent her to stay in Nuvelara for a change of air, she having been ill, and people say that she is pretty much the worse for the illness, though doing better now. And I, hearing this, doubted I could do anything good, what with her having been ill, and then myself being overcome by the great heat and also a little under the weather, and so as not to fall wholly ill myself, I did not go any farther, thinking to serve Your Excellency for the best in this matter and that you will be satisfied with this.
>
> At first this pleasant lady made such a good impression on me with her features and beauty that I was all afire to paint her in a way that no one knowing her would say I had not portrayed her several times already, and therefore I pray Your Excellency to leave this assignment to me, because at the end of about ten days I will show her to you, if you send to me in Venice the portrait which that other painter made of the said Cornelia, and I will return both to you post-haste, and Your Excellency will know, comparing them, how I desire to serve you.[7]

Titian gives Duke Federico a retrospective view of Corva – a beauty that set Titian aflame – contrasted with her present ruined condition. The passing of Corva's beauty tips Titian into anxious concern about his own health in the future. Should he attempt a journey in order to portray her, he'll be overcome by heat, possibly "falling" ill himself. And anyway he's "a little under the weather," even now. His anticipation of declining health with time is hypochondriacal: as past moves to present, so too will the present move to future along a single downward trajectory. His lack of empathy for Corva, not wanting to see a "worsened" beauty, and his greater concern for his own trivial health concerns is hypochondria's ugly twin, narcissism. From writing about her portrait, Titian quickly jumps to his own self-portrayal: "I . . . I . . . myself . . . myself. . . ." From her ravaged body and loss of beauty, Titian turns to his own inclement feeling. Anyway, for Corva's portrait Titian thought the real Corva to be unnecessary; he needed only the memory of his old flame. Titian will be nature's mirror with or without her.

Greedy Old Man

No single explanation is adequate for such a complex process of self-aging, and given the scant evidence about Titian's character, no definitive explanation may be possible. A good place to start, though, would be with a venerated stereotype, thriving on the stage, on the page, and in real life: the greedy old man. It seems that Titian used his age as an instrument of manipulation and, more specifically, as a means to enhance his income. "He does nothing other than demand money," wrote Giovanni Francesco Agatone to Guidobaldo della Rovere, Duke of Urbino, in 1564.[8] Two years later Agatone reminded Guidobaldo that "as I have written before, when it comes to money, [Titian] is the most obstinate man."[9] A year later he told Guidobaldo

that "there is no one in Venice more greedy for money than Titian."[10] Titian first referred to himself as old in 1548, and then again in 1553, but after 1559 it became a regular occurrence.[11] Most letters by Titian during the 1560s and until his death in 1576 reference his old age; invariably the context was an exhortation for more money. His letter of 6 December 1563 to Philip II is typical in structure and its rhetoric of the abject.[12] (This letter, like others signed by Titian, may not have been composed by the artist, but his various amanuenses presumably discussed the content with him and, it being sent out under his name, Titian must have approved its form as well.) In the first sentence he adopts a pose of servitude and self-denigration: why have you not responded to my pictures and letters, he asks plaintively? He can think of only two explanations for Philip's silence: "I greatly fear that either your servant Titian or my pictures must have displeased you." Whereas here Titian appears certain about Philip's dissatisfaction, in the next sentence he introduces doubt ("Però . . .") and dares to hope; after all, he reckons obsequiously, how could Philip's "infinite goodness" allow him to feel this way. All that he wants, Titian claims, is a sign (*sigillo*), no matter how small, or even a letter that he remains in Philip's favor. As an incentive for good behavior, Titian offers a *Last Supper* (actually the one he had been painting for the past seven years) as "a testimony to my devotion to you," a devotion so profound that Titian additionally offers to add ten years to his old age just for the honor of serving him. How Philip II understood this bizarre, ham-fisted offer can only be guessed, but from Titian's perspective it is consistent with his practice of artificial age inflation. Or, perhaps, this is a later version of an offer "to prolong the time of death just to be able to serve my great Signore."[13] Only in the seventh sentence does Titian open the real subject. What he wants is not symbolic (Philip's *sigillo*), but Philip's money. Titian closes his letter with the cloying promise to dedicate "the remainder of my final old age to you." This letter of exaggeration and manipulation was repeated, with minor variations, on 20 December 1563 and 5 August 1564.[14] The structure is duly repetitive (the humble pose of a respectful servant yielding to inducements for response), and his concern over money sounds obsessive.

Another long and curious letter to Philip II of 2 December 1567 explains how a payment for the *Martyrdom of St. Lawrence* (Escorial) gave him an unfavorable exchange rate.[15] After calculating the financial shortfall this caused, Titian blames García Hernandez for the mistake and concludes: "you'll have to excuse me if, because of the failure of your ministers, I have delayed until now sending the painting of St. Lawrence." What was this failure of Hernandez? He died prematurely before completing Titian's business. Titian knew this, but money blinded him to a greater loss beyond his own.

Desperation for money led Titian to other self-serving exaggerations than those involving his age. In July 1563 he claimed never to have received a penny (*un quatrino*) for his many years of work; and in August 1571 he blustered that he had received only a penny for eighteen years of work, a coercive distortion (actually a bald lie) that he used against the Venetian Republic as well.[16] But then Titian was given to distortions. To Cardinal Alessandro Farnese, Philip II, and the Venetian Signoria he professed such loyalty that he "gave all of myself and my whole life" exclusively to their service. (Here we see the advantage of Titian working for patrons geographically dispersed across Europe.) In a letter to the Signoria of 2 December 1573, Titian used the expression "condemned to pay" in reference to taxes.[17] Like Michelangelo, Titian thought

23 Titian, *Self-Portrait* (Berlin, Staatliche Museen, Gemäldegalerie)

his relatives were pinhead incompetents when it came to money (his money): "You write to me about having four ducats," he responded to his son Orazio in June 1559, "…as regards that, you are not counting the expense of sending you to Milan, or else, out of sheer light-headedness you have made a slip of the pen and, when you wanted to say two thousand ducats, you said just four."[18] The fact that this featherhead narrowly escaped murder while trying to collect this debt for his father seems to have made no impression. Titian subsequently allows his son four days instead of two to travel from Milan to Genoa – "be careful not to ride in the heat" – but this apparent display of parental concern is undermined by the fact that this trip could only be made in two days with extraordinary exertion. And, finally one last example, the story in Ridolfi that Titian jealously guarded his storeroom, locking it whenever he left so that no assistant could make copies of his work and cut into his profits. This sounds like a recasting of the "artist's secrecy" theme played out by so many biographers, but it may also be true, since the Spanish ambassador to Venice, Diego Guzmán de Silva, noted in 1575 that "I have been in Titian's house and grow more certain every day that not much can be expected of what has been done, which he guards so well that much subtlety is needed to see it."[19]

Titian's obsession with money did not originate from need. "He has earned a great deal of money," Vasari noted after his last visit in 1566, and Vasari was not easily impressed by an artist's wealth.[20] Titian's house in the Biri Grande was seigniorial, worthy of the noble guests he often entertained, and worthy too of burglary and litigation after his death.[21] Nor was he always greedy, or (if he was) he lived in a state of denial during his youth. It seems instead that he fell into this vice in his later years, befitting the stereotype he became, since in 1513 he proclaimed to the Signoria that "since I was a kid [*puto*], I, Titian of Cadore, have set myself to learn the art of painting, not so much for money-making greed as to acquire some little fame."[22] Titian's feelings toward money probably changed with age. Despite his wealth, he no doubt feared incapacity at least as much for financial as for artistic reasons. In the late 1560s he even declared (falsely) to the Venetian Signoria that he could no longer paint: "I remain a painter in name only" and hence "I can say that I am unable to earn a living or work in any way."[23]

In one sense, his avarice pegged him as typically old. Along with garrulity and melancholy, avarice was a conspicuous symptom of senescence. They are "stingy" according to Aristotle; or, as Horace put it: "the old wretch still seeks but fears and will not use his hoard."[24] According to Girolamo Cardano, speaking from personal and medical experience, "the old are garrulous, greedy, false, and scheming."[25] In a dialogue between the aged Giusto and his Soul, included in Giovan Battista Gelli's popular ramble *I capricci del bottaio* (Florence, 1549), Giusto's soul observes that "fearing constantly of not losing what you have, like the other avaricious elderly, you don't give me any time to rest."[26] Gelli thought "the vice of avarice is so peculiar and characteristic of old age that one can say almost proverbially that the old are all greedy."[27]

We know Titian to have been shameless about money and acquisitiveness, and so did his friends and acquaintances. Jacopo Bassano adapted the pose of Titian's *Self-Portrait* (pl. 23) for his own depiction of Titian as an elderly moneychanger possessively clutching his table of cash in *The Purification of the Temple* (pl. 24).[28] From this painting, if the identification is correct,

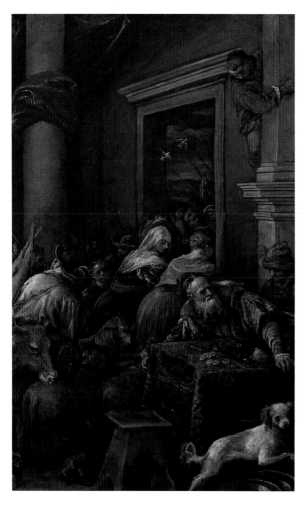

24 Jacopo Bassano, *The Purification of the Temple*, detail
(London, National Gallery)

and from Aretino's complaint (mistakenly taken as a joke) that Titian would have finished the *Pietro Aretino* in the Palazzo Pitti if only he had paid more money, it is clear Titian had a public reputation as a tightwad. Not only did he not bother to correct or modify it, he even contributed to it by portraying himself as Midas in the *Flaying of Marsyas* (pl. 25). Somewhere in the whining about poverty and neglected payments, there is an emotional truth for Titian: without the missing money, "I don't know how to find a way to live in my old age." Money sustained him. It was psychic as much as financial capital.

Titian's practice of reproducing earlier paintings is consistent with a nostalgic return by old artists to a style or subjects of their youth. Michelangelo did it as part of his late "private reformation of images."[29] It can also fall into the garrulous and greedy old man type.[30] Guido Reni is another famous case of an artist repeating himself for financial gain, although the motives were more clearly mercenary in his case, since he needed to feed a serious gambling problem.[31] Titian produced variants and replicas even for the most distinguished patrons, including Cardinal Alessandro Farnese, Emperor Maximilian II, Emperor Ferdinand, the Duke of Alba, and the Duke of Bavaria.[32] These are judged today to be low-quality studio versions, financially motivated when demand exceeded supply. Titian and other artists in high demand could be opportunistic and cunning in this way, and perhaps the explanation of the variants should be left at that. However, many variants are autograph, possibly initiated on spec, possibly engaged from personal interest.[33] The fact that the incidence of replicas increases in later years can be explained by rising demand and a slowing rate of production, but it is also worth considering it as a stereotypical form of senescent behavior: the imagination stagnates; originality lags; nostalgia thrives. More distant still from the realities of commerce, but still tangentially plausible, is the senescent habit of repetition – the same stories, the same figures – and of living in the past or, more precisely, re-enacting the past in the present.

The only accusation that the old Titian painted quickly and carelessly just for money comes from Pietro Aretino in 1545, just three years after he had declared his friend to be in "the ripeness

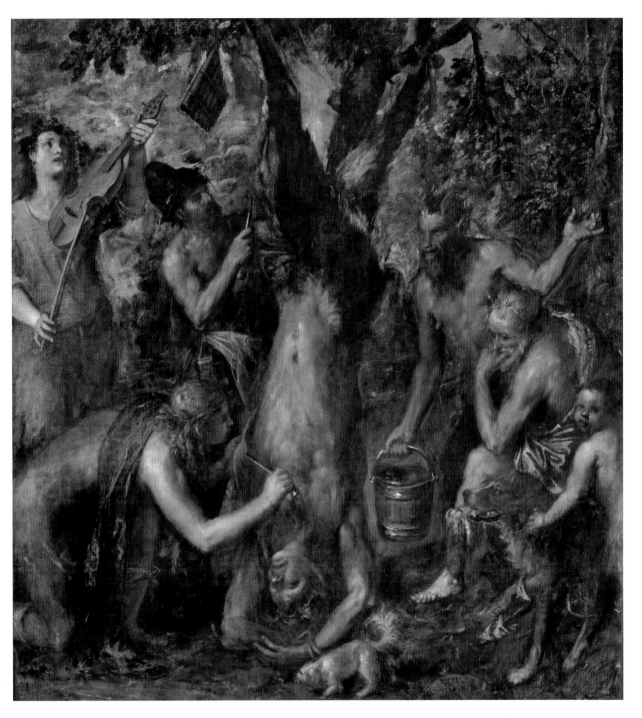

25 Titian, *The Flaying of Marsyas* (Kromeriz, Archbishop's Palace)

26 Titian, *Portrait of Pietro Aretino* (Florence, Palazzo Pitti, Galleria Palatina)

of old age."[34] In a letter submitted to Cosimo 1 de' Medici along with Titian's *Portrait of Pietro Aretino* (pl. 26), Aretino explains why it is "sketched rather than unfinished" by reference to financial motivations:

> the not small sum of money that Titian receives and the even greater greed for more is why he gives no heed to the obligations he should have for a friend nor to the duty proper to his family, but eagerly awaits with a strange intensity only that which promises great things. . . . Here is a similar portrayal of my own appearance, likewise the work of his paintbrush. Truly it breathes, its pulses beat, and it is animated with the same spirit that informs me in life. And if only I should have counted out more *scudi* for him, the clothes would have been actually shining and soft and firm as are actual satin, velvet, and brocade.[35]

It would have been finished better if only he had paid him more money. Less money means less time means less finish. Whether or not Titian left Aretino's portrait "unfinished" for financial reasons remains uncertain, although he did cut costs by using a discarded canvas.[36] The practice of adjusting one's style to fit the payment became a recognized practice in Venice. According to Giovanni Battista Marino, Palma Giovane (1544–1628), Titian's pupil in his later years, painted quickly and with messy brushwork (*strapazzati*) in his old age simply for financial gain.[37] Palma was then 71 years old, and Marino heard that "he makes few good works in his old age," so this comment fits neatly into two old-age stereotypes that had been applied to Titian: avarice as a motive for a style of painting and the decline into sloppiness with age. Marino wanted Palma to paint like a young man, with "industry" and "extraordinary affection," code words for a more finished, detailed, blended style. One year later when he received the painting, Marino reported that his fears had been justified, and he wanted Palma to know that its Parisian audience was equally disappointed: "there are many painters here who say that he did not make something great, being old."[38] The public perception that Marino accepts as true is that sketchiness in a painting can be expected from old, venal artists.

Titian's *Pietro Aretino* (pl. 26) prefigures his later painterly work in the sweep of pigmented light across his friend's chest and the approximate mauled hands, but in 1545 Aretino had good reason to comment on and justify its appearance, especially to Cosimo 1, who had become accustomed to the shellacked miniaturism of Bronzino's portraits. Aretino's satire slides between serious truths and playful inventions, often holding the two together in suspension, and this seems to be the case here. On the one hand, it must be a joke that plays on Titian's reputation as a shrewd business painter. After all, how could Aretino so completely misinterpret the pictorial intentions of his "alter ego"?[39] Actually, Aretino was serious, not so much about Titian's venality but about some overdue payments that Cosimo owed him.[40] He used Titian's portrait as a warning to Cosimo about what to expect from him in the future should he not pay up: a careless treatment just as Aretino received from Titian. The Titian that Aretino portrays is curiously equivocal. On the one hand, he is a painter in complete control of his art, adjusting his style to suit his purposes. On the other hand, he is a materialist who lets money dictate his art. The Titian that portrayed himself as Midas in the *Flaying of Marsyas* is similarly equivocal. On the one hand, as Midas, Titian refers to his golden touch, changing pigment

into gold, becoming rich with his hands. On the other hand, as Midas, Titian reveals himself as greedy and unwise, choosing a self-defeating gift and choosing the mortal Marsyas over Apollo.

The Invention of an Old-Age Style

If Titian managed his public image as old and greedy, as he obviously did, what implications does this have for his art? The paradox that motivates my study is this: Why would Titian adopt an aged persona when the public (and artists themselves) thought age brought artistic decadence? If he tried to refashion old age to his advantage, remaking old age into a Platonic wisdom, then his strategy would make sense, but Titian's was conventionally greedy, repetitious, and weak: "my impotent old age"; "these now-tired limbs weighted by the years"; "the weakness of my powers"; and "this afflicted body [is] dedicated to your service." Michelangelo whined about his old age in similar terms, but the important difference between them is that Titian did his whining in public to his patrons while Michelangelo kept it within a close circle of family and friends. The most likely answers to Titian's self-anointed status as an old man would involve the narcissism of hypochondria and irrational greed. Another, more distant possibility might involve the competition that Dolce, Vasari, and others fueled between Titian and Michelangelo. Vasari's lives of Michelangelo and Titian are routinely cited in order to polemicize opposing approaches to art – idealist and naturalist, *disegno* and *colorito*, masculine and feminine, Florentine and Venetian.[41] For all the commentary about these aesthetic oppositions, one has largely gone unnoticed: for Vasari, each artist represents a different model of aging. Befitting a naturalist, Titian's old age is corporeal, and his art suffers the consequences. For Vasari, Michelangelo was not a whining Platonizer but an artist worthy of hagiography.

The comparison of the two artists, however, is not just one of differences. Both were world-class complainers about old age, probably hypochondriacal, who wanted to use their bodies to gain sympathy. Both lost acuity of vision in old age and began to broaden and blur their drawing styles. Both produced images of the *Pietà* for their tombs. Both effectively controlled their public image with a judicious manipulation of information. Both obsessed about money and pestered their relatives about wasting it.[42] Titian described himself as "tormented" by money, and while Michelangelo clearly was so as well in dealing with his hapless nephew Leonardo, his publicized torments were mostly spiritual. What Michelangelo most wanted from his patrons was respect; Titian preferred money.

There are two schools of thought about the relationship of Titian's old age and his late works: the romantic and the pragmatic. The first and dominant view "Michelangelizes" Titian's old age. Represented here in a recent monograph by Filippo Pedrocco, it holds a direct correspondence between old age as a time of melancholy and the somber mood and tonality of his late work, rendering Titian as an Italian Rembrandt:

> Titian's final years were a time of tragic anxiety, haunted by feelings of despair and the presence of death. October 21, 1556 saw the sudden death of Pietro Aretino, his friend and close

companion for almost thirty years. Two years later, in the monastery of Yuste in Estremadura, Charles v, to whom Titian was attached by a genuine sense of gratitude and respect, died a lonely death. In 1559 Titian's brother Francesco, a trusted but anonymous assistant on many of his paintings, also died. And finally, in 1561, he lost his beloved daughter Lavinia, who had left her father's home in 1555 to marry Cornelio Sarcinelli of Serravalle. The pain of these losses transpires in some of his letters to Philip II, but it is primarily in his paintings that their effect can be detected. . . . As in the other paintings of the period, there is an atmosphere of dramatic intensity and repressed anguish.[43]

The second, minority view has long been a hobby horse for Charles Hope, who hopes to remove biographical assumptions from visual readings of style. He stakes a claim diametrically opposed to Pedrocco's:

Especially in the works from the last decade of Titian's life, when he was in his late seventies or early eighties, there is a certain loss in colouristic brilliance and in the definition of form. This is probably due to the failing eyesight and waning physical powers that were noted by several contemporaries. But there is no change in Titian's artistic ideals or approach. . . . Many art historians, however, have supposed that in his last years Titian developed a somewhat different style, characterised by a narrow colour range, a very sketchy type of brushwork and an emphasis on tragic themes. . . . Associated with the idea that Titian had an intensely personal, tragic late style is the widespread belief that in his last years he was lonely and isolated. This would certainly be consistent with romantic notions about artistic genius, but it is not compatible with what is known about Titian's circumstances.. . In his last years, therefore, Titian could not realistically be described as isolated and his circumstances were far from tragic. He was rich and famous, he had a flourishing studio, nine grandchildren, and an extended family, spread between Venice, Serravalle and Cadore.[44]

Hope wants to reconfigure Titian's late work by ridding his life of generic symptoms of old age as isolated, lonely, and tragic. Yes, he acknowledges, Titian did outlive many of his friends (Aretino, d. 1556; Sansovino, d. 1570; Francesco Zuccato, d. 1572), as well as his daughter Lavinia (d. 1574), but nonetheless he "was rich and famous" and had "a flourishing studio, nine grandchildren, and an extended family, spread between Venice, Serravalle and Cadore." If being "rich and famous" with a large family means a happy and gregarious life (a shaky proposition), then the dark tonality and inchoate forms of his late work cannot be a matter of self-expression. To diminish further the appeal of a tragic old age, Hope excludes from Titian's œuvre of finished paintings many of the most evocative ones like *Tarquin and Lucretia* (Cambridge, Fitzwilliam Museum) and the *Death of Actaeon* (London, National Gallery). If it is true, as he believes, that the standard of finish should be measured against works sent to Philip II before 1562, then we must believe that Titian's style did not advance after that time and that the so-called late style is simply a historical accident, however much it may "appeal to modern taste."

 In a related attempt to break the art-life mirror paradigm, Thomas Puttfarken suggests that we substitute for a lonely Titian a learned painter interested in theories of tragedy, following the renewed interest in Aristotle's *Poetics* from the 1540s onwards, and in novel expres-

sive effects. Style, for Puttfarken, is merely an instrument to express a subject and should be approached by scholars warily if at all: "To the extent to which questions of style and finish can obscure more important issues of meaning, I have throughout tried to avoid them."[45] Where he agrees with Hope and with most other Anglo-American scholars is in the belief that Titian's late work can be understood outside of his life and solely within the context of his pictorial goals:

> If I am right in arguing that for the last twenty-five years of his life (or even longer) Titian – whenever possible – was increasingly aiming at strong emotive effects by rendering in paint the pathos of human fear and pity, suffering and death . . . then one should expect to find the ultimate realization of this ambition in his final mythological scenes. This is not because of his own advancing age, or his own increasing misery in life, for which there is no evidence, but because in this field, unlike that of religious commissions, Titian remained more or less free to do as he liked.[46]

In a related move, Jennifer Fletcher notes a "conversation" between Nicolò Massa, a Venetian doctor, and Titian on or before 1566.[47] Massa questions Titian about his erratic technique (especially regarding the finishing touches) and suggests that it may be caused by the artist's famed capacity to enjoy the sensual pleasures of life. Titian tacitly accepts this explanation by saying that he is not always equally inspired to paint. Fletcher takes this conversation at face value, excluding Massa's underlying medical context of *Facile est inventis addere* (Venice, 1566) concerning the consequences of diet, sex, and other physical indulgences. Instead, she proposes to use it as an explanation for the different levels of finish in the Berlin *Self-Portrait*. If this line of reason is extended, then we lose any chance to interpret the broad and expressive range of Titian's late brushwork as intentional artistic statements. It is simply another version of other early modern explanations of old artists' paintings. They look the way they do, not because the artist wanted them that way, but because his age forced him to paint that way.

What Hope's account does not acknowledge is the range of techniques that can be found in the paintings for Philip II: that is, dry-brush on primed canvas (*Rape of Europa*; Boston, Isabella Stewart Gardner Museum); impasto relief and darkened tonality (*Perseus and Andromeda*; London, Wallace Collection). We also have the shredded surface of the *Flaying of Marsyas* (pl. 25), signed on the rock where Midas-Titian sits. In the San Salvatore *Annunciation* (pl. 27), whether or not it was misunderstood by the friars as unfinished and hence necessitating a second reiterated *fecit* in its signature, Titian transforms pigment into flame and light, where the immaculate conception of Christ is embodied by pigment as light. The *Martyrdom of St. Lawrence* in the Escorial, dispatched in the year of Titian's death, has "dripping slashes of paint [that] seem to melt down the canvas, as if light has become icing."[48] The standards set by these assuredly finished works can easily contain most undocumented late works such as the *Death of Actaeon* or the Hermitage *St. Sebastian*.

As with his age, Titian kept his audience guessing about the status of his late works. Noble collectors speculated about his physical condition and how it might affect his performance. By May 1573 Duke Guidobaldo della Rovere heard that "Titian no longer works with his own hands."[49] In a letter of February 1575, Antonio de Guzmán y Zúñiga, Marqués de Ayamonte,

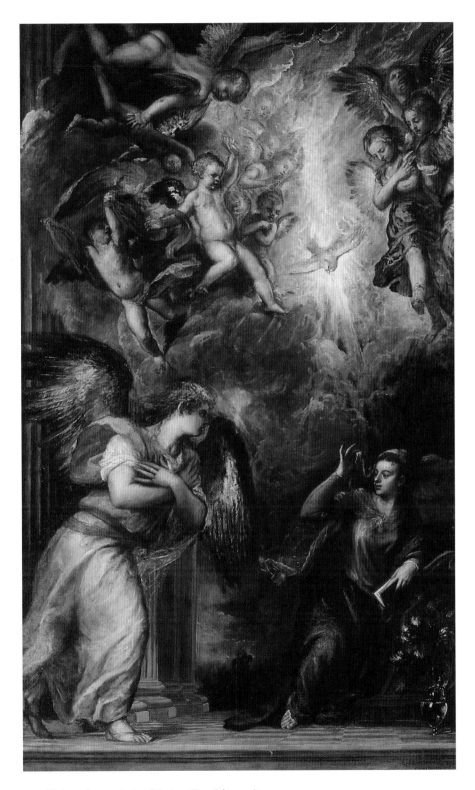

27 Titian, *Annunciation* (Venice, San Salvatore)

tells Diego Guzmán de Silva, the Spanish ambassador to Venice, about the effects of Titian's deteriorating condition:

> I fear, as you say, that Titian is too advanced in years to go on producing good painting. However, the style and spirit (*el aire y espíritu*) will not be driven out of his paintings by his trembling hand, even though it perhaps prevents him from rendering the colors and other details as he might with a firm hand.[50]

Ayamonte's uncertainty and his attempt to distinguish hand and spirit are issues that still remain unresolved today. Vasari faced the same problem. Despite his famous prejudices against Venetian painting, he still read Titian's mythologies with greater sensitivity than anyone before the passionate partisan Marco Boschini, and might even have convinced Hope to accept them as his gold standard. Yet, despite his commanding insight into Titian's late style, Vasari wavered at the end: "It would have been better for him in those last years to have painted only as a hobby so as not to diminish the reputation gained in his best years, when his natural powers were not declining toward imperfection." Even these praiseworthy mythologies provoke contradictory readings and a resulting ambiguity. Titian's late paintings, in contrast to his earlier style, were (for Vasari) sophisticated visual puzzles that appear to be one thing (sketched and careless), but in fact are something else altogether (premeditated, elaborate artifices). What is needed, Vasari tells us, is a viewer adept at uncovering *sprezatura*, a viewer like himself and unlike those "deceived" painters who saw only "clumsy pictures." Why, then, did he conclude Titian's life with a condemnation of the late "inferior" work painted when "his natural powers started to decline"? When Vasari was in Venice in 1566 he went to visit his "dear friend" Titian, and he found him, despite his great age, busy painting with his brushes in hand. Had so much changed between 1559 (the date of the *Rape of Europa*) and 1566, or was Vasari confused in this new pictorial terrain? He seems to fall back on the conventional, default position that holds old artists to be incompetent.

<p style="text-align:center">* * *</p>

Were Titian's paintings unfinished when they were dismissed by Vasari? By assuming them to be finished, did Vasari make the same mistake that haunts art historians today? Until the recent restoration of the *Pietà* in the Frari, Venice, Titian's tomb altarpiece, it was assumed that Palma Giovane's intervention after his master's death was substantial, based on the painting's inscription: "What Titian left inchoate, Palma reverently completed and dedicated to God."[51] But now the laboratory results show that it was much less *inchoatum* than assumed, at least according to Palma Giovane, who only added extra glazes along the seams and pigment to parts of the flying *putto*. But as post-restoration debates show, the question of Titian's late work remains unresolved.[52] Nor can we resolve it. We can, however, give an alternative reading that takes Titian's late style as a conscious pose and controlled self-presentation instead of as an unintended consequence of circumstance.[53] The question I want to pose is this: instead of a victim of old age, can Titian be seen as its master?

Until recently, debates about the *Flaying of Marsyas* (pl. 25) have been mostly iconographic, involving questions of figure identification (are there two Apollos? Orpheus and Apollo?), mean-

ings in Platonism (liberation of the spirit from the body) and art theory (triumph of divine art; painting as a Midas touch that transforms materials), and even as a reference to the Turks' flaying of Marcantonio Bragadin in 1571.[54] Daniela Bohde takes the impastoed style as a means for Titian to explore the dissection of flesh: "One has the impression [in looking at Marsyas' body] of gazing into a mysterious coat of unending skin, always unfolding, but never revealing a core."[55] Instead of discovering anatomical information, the viewer gains insight into Titian's painting technique: "glazed veils of paint, dry or strong impasto strokes without a finishing gloss are layered over each other." Hence peering into Marsyas' body and its "pulsating fibres," one discovers Titian's technique of layering pigments instead of anatomical facts. Bohde's conclusion can be taken a step further. Not only did Titian probe Marsyas' flayed body as a metaphor and demonstration of his late painterly technique, but he identified Marsyas' shredded skin with the ripped surface of pigment across the painting as a whole. Not only did Titian represent Marsyas' flayed skin, he enacted it

28 Titian, *The Flaying of Marsyas*, detail of pl. 25

across the painting's surface. Paint no longer represents things; it embodies them as well.

This most radical experiment in painterly brushwork queries the viewer about the limits and epistemology of painting, its literalism or materialism. I say "queries" because its jagged surface moves so far from contemporary practice that it would inevitably raise questions about its status (is it finished? a sketch? an interrupted work?) and about the status of painting in general. By representing himself as the foolish judge Midas, Titian seems to confess uncertainty about these questions. As Midas, Titian plays the traditional role of old men: greedy, melancholic, and equivocating (pl. 28). Midas-Titian adopts the traditional melancholic's pose, known to him from Dürer's *Melencolia I* and from Raphael's representation of Michelangelo as Heraclitus in the *School of Athens*. Melancholy is best known to art historians as the saturnine, artistic temperament, but in the Renaissance it was better known as the temperament of old age. Physio-

logically dry and cold and hence temperamentally melancholic, Saturn is the senescent plane-
tary god. He is barren, eating his children instead of propagating them, introverted and nos-
talgic. Michelangelo, the quintessential melancholic artist, thought himself old from an early
age. Giovanni Francesco Guerrieri (1589–*circa* 1655/59) experienced his melancholy somatically,
as an enervating old age. Writing to his brother-in-law, he complained that he felt "crushed and
weary," his joints ached, and with his health shattered (*sconquassato*) he lay in bed most of the
day "filled with melancholy."[56] For Titian, we have no secure biographical evidence of somatic
or psychological melancholy. What we do know is that he readily aged himself, rhetorically per-
formed old age as if it were a role he adopted for effect.

If his confessional role as Midas is prevaricating, his performance as an old artist was played
boldly. As in many late paintings, Titian provides the viewer with a range of visual clarity and
manual control. Midas, like other principal characters in his late work (the Virgin Mary in the
San Salvatore *Annunciation* and Diana in the *Death of Actaeon*), is rendered with a higher degree
of finish than Apollo's eloquent arm reaching up to the heavens and dissolving into the
sky. This range of finish establishes for the viewer the semantic and expressive field available to
Titian; it was also a kind of roving compositional device, focusing our attention on crucial
figures and places. However, it had an additional function of telling us about his physical
capacities. If he were to paint only with his fingers and huge brushes the size of "broomsticks,"
as first-hand accounts tell us, then his public might assume that old age restricted him to this
broad technique.[57] Because of old-age stereotypes and the gentle enquiries from Lampsonius
and others, Titian could have anticipated the pitying remarks that others heard in their old age:
poor Titian, he just can't see any better nor will his hand let him paint better than this. Hence,
to forestall this mistaken impression, he demonstrates his technical abilities. Those who inter-
pret the loose brushwork and blurred focus as signs of old age deny Titian a degree of auton-
omy and deliberation. As visual by-products of a physical condition, they may well be an
adaptive response to aging and a compensation for a deteriorating body, but they are also more
than that. Because the *Flaying of Marsyas* rips the painted surface more vigorously than other
late paintings, we are asked to see the peeling skin and clotting blood in relation to the impas-
toed pigment. Titian's pupil late in life, Palma Giovane, reported to Boschini how his master
"covered [his figures] with living flesh."[58] Titian does the same in the *Death of Actaeon* (pl. 29),
a painting so sketchy that Hope and others reject it as a finished work.[59] Here Titian set the
laceration of Actaeon in mid-ground obscurity without the graphic details of Marsyas' body,
but in compensation he gives us a close-up view of the dog's attack all over the painting's surface
(except for Diana's body, which remains appropriately unscathed), as if the dogs had chewed
the pigment itself. In both works, the painted surface stands metonymically for Marsyas' and
Actaeon's skin. It expressively amplifies the horror of flagellation and consumption. Titian as
Midas is responsible for Marsyas' condition just as Titian as artist causes the shredding of the
picture's skin.

* * *

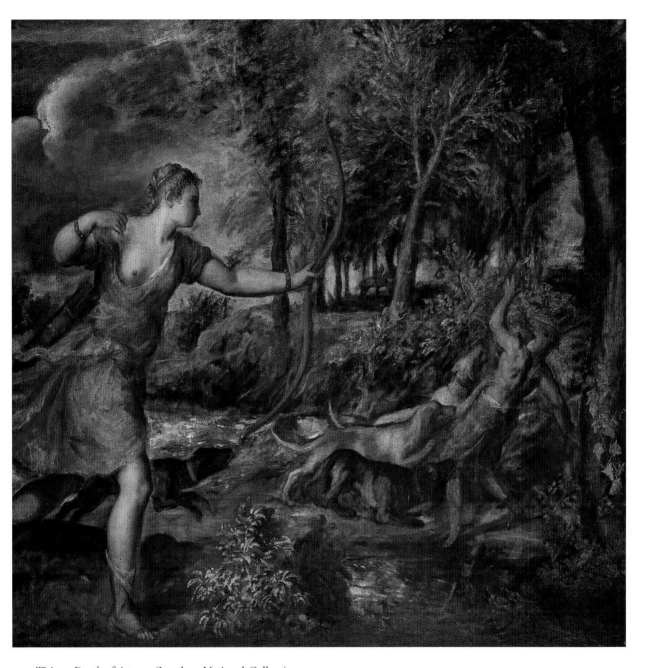

29 Titian, *Death of Actaeon* (London, National Gallery)

Painting as a cutaneous surface to be inspected for age and identity lies behind Giulio Mancini's connoisseurial techniques. Look at the *scorza* of a painting – the skin, peel, or bark – to determine its age.[60] The properties of skin gave early modern writers different ways to describe the painted surface. Karel van Mander's vocabulary of smoothly blended pigment (*vleesachtich*) borrows the tactile attributes of youthful skin – pliable, resilient, and soft.[61] Craquelure could be a symptom of a painting's age. Pietro Bellotti represented the desiccated, fissured skin of the aged *Fate Lachesis* (pl. 4) as a kind of craquelure. Synonyms for craquelure also referenced old skin. "This painting [of *Danae* attributed to Correggio]," wrote the art dealer Paolo del Sera to Leopoldo de' Medici, "has all of the signs of the antique, and it even has too many signs in it, because it is very wrinkled (*crepolato*)."[62]

Patina, another skin-related technique beloved by forgers, was defined by Baldinucci as "a term used by painters, otherwise they call it skin (*pelle*), and it is that universal darkening that time makes on pictures."[63] Time and painters can make patina, Marco Boschini noted, citing in evidence the aptly named mimic master Pietro della Vecchia, but only painters can make new paintings.[64] Boschini's phrase, "the patina of time," implies an old skin. Painters can also imitate old paintings by rendering surface blemishes, what Baldinucci called *macchie* on the painting's "skin." Another form of skin stains were liver spots or bruises (*lividetti o rossetti*), both symptoms of old age. Malvasia found them in Giacomo Cavedone's late work, presumably between the ages of 60 and 83, and in Guido Reni's controversial late style he saw "a certain wan bruising."[65]

If the flaying of Marsyas can be seen as performed on both the painting's surface as a whole, and not just on his body, in other words if the pigment surface can be thought of as a skin, then this could open new possibilities for understanding why Vasari and so many others resisted the crumbling, puckered, wrinkled, and sagging pigment of Titian's late work. The debate of Titian's late sketchy style during the sixteenth and seventeenth centuries focused on the questions of finish, intentionality, and visibility – did Titian intend them to look this way? are they works in progress without the final layer of skin? should we look at its mottled surface too closely? – and this debate still thrives in art history today. However, underlying this debate, at least in early modern literature, there may also be seen a resistance to Titian's old age. Not only does his technique originate in his dimming sight and uncertain hand, but also the painting's skin carries the signs of his age. Titian, in this respect, paints himself. Just as Titian's nude women age along with their creator, becoming older, heavier, and lumpier, so too does the painted skin of his creations age. The fattening of women and pigment in old age can also be observed in Titian's sometime Dutch emulator, Rembrandt van Rijn. Figures of other old artists aged differently. Old figures appeared inappropriately, out of the narrative context, such as the aged appearance of all the men in Pontormo's drawing of the *Benediction of the Seed of Noah* (London, British Museum).[66] Vasari found Pontormo's late figures to have large torsos but small legs and arms. Leo Steinberg analyzed the shrunken, flaying limbs in Michelangelo's late *Conversion of St. Paul* and *Crucifixion of St. Peter* in the Cappella Paolina in the Vatican to be embodied projections of his own frail physique.[67] Pontormo could be following Michelangelo in this respect, as was his wont at other times, or he could be responding to his own old age in similar ways.

Titian was supposedly the Juvenal of painting, at least according to Ludovico Dolce, who had reiterated the conventional parallels between Michelangelo and Dante, Raphael and Petrarch. In dedicating the *Paraphrasi nella sesta satira di Giuvenale* (Venice, 1538) to Titian, he found but did not specify a commonality, both were "a sharp snapper and scold of our times."[68] As a dinner companion, Titian must have had this satiric edge, even though Vasari notes only "courteous ways and manners," and the Florentine philologist Francesco Priscianese called him "a truly well-mannered person who seasons every honorable dinner party with his charms."[69] In prints and paintings it is a role seen only occasionally: in his hilarious woodcut of the *Monkey Laocoön*; in the dog shitting at the Egyptian Germans in the *Crossing of the Red Sea*; in the nervous glance the bull Jupiter gives to a fish in the *Rape of Europa*; and perhaps in the role as Midas assigned to himself.[70] Could his late style contain some self-irony, or at least some playful acknowledgment to the viewer that his paintings are becoming like himself: rheumy-eyed and wattle-skinned, just like his pigment and colors? Juvenal, after all, looked at himself as an old poet along with his aging peers with unflinching honesty:

> Give me long life, Jove, give me many years!
> This only, this, though sick or well, you pray for.
> Yet how continuous and how long old age,
> How full of ills! Deformed and ugly face
> Unlike its former self, a wrinkled hide
> Instead of skin, the hanging cheeks, the grooves
> Like those an old baboon carves on her jowls
> Deep in the shaded jungle of Africa.[71]

* * *

Another effect of time on paintings, according to Baldinucci, is a darkening of the surface. Guido Reni used this as an excuse for using so much white in old age: time will darken them, bring them into harmony, and eventually perfect his work. Titian's palette moved in the opposite direction as he aged, becoming ever more monotone and dim – pre-aged, as it were. His colors seem to fade slowly into twilight and lose their youthful intensity and purity. For Hope and other Titian scholars this "loss of colouristic brilliance" is an autonomic product of the artist's "failing eyesight and waning physical powers." If this were so, then other old artists with fading eyesight (and there were many) should manifest similar symptoms. But they did not. And Titian himself was selective in its use, as the example of *Spain Succoring Religion* (Madrid, Prado; dated 1575) shows. Other scholars see the gathering darkness, not as a biological artifact, but as an intentional means to express tragic or violent subjects. This, however, does not explain why Titian used the same palette for heroic, even slightly comic, renditions such as the *Perseus and Andromeda*. A third possibility has gone unremarked. Titian could be referencing his old age, which brings, as Maximianus reminds us, a dimming of the senses:

> Now hearing is less, taste less, my very eyes
> Grow dim; I barely know the things I touch,
> No smell is sweet, no pleasure now is grateful.[72]

How this affected individual painters must remain speculative. The coarsening and exaggeration of artists' late work, as noted by Baldinucci and Roger de Piles, may be a consequence of this gradual sensory deprivation. Stimuli, whether visual, tactile, or gustatory, need strengthening and amplification to have the same effect on the old as they once did in youth. Nowhere do writers find any benefit for artists whose senses become dulled with age, nothing like Cephalus telling Socrates: "I myself find that as age blunts one's enjoyment of physical pleasures, one's desire for rational conversation and one's enjoyment of it increase correspondingly."[73]

> I seem to see a bright light through the clouds;
> But the clouds themselves are brighter within my eyes.
> Daylight is gone though I still live; who will
> deny that hell is fenced with opaque darkness.[74]

Old age as the twilight years is more than a figure of speech. It describes an optical experience according to early modern physicians where "the eyesight becomes murky and shadowy . . . as if the eyes have smoke or a curtain drawn in front of them."[75] Bernardo de' Dominici found Francesco Solimena's failing eyesight in the excessive yellowing of his colors and in his tendency to use too much black in the shading of his figures. And according to the physician Scannelli, this is why Guido Reni turned to a lighter palette, in compensation for the darkening around him (see chapter 7). Many artists of all ages followed him, sweeping painting into an anticipatory Rococo that was, if we believe Scannelli, a physiologically induced phenomenon. Art itself had become old.

This, however, does not explain Titian's darkened palette. On the contrary, it would seem to mitigate against it. Sometimes, the elderly develop a sensitivity to light, but assuming that this relatively rare occurrence did not happen to Titian (rare, that is, compared with the effects of cataracts, which can produce a milky skein similar to Reni's late work), then we should look elsewhere, outside biology, for an explanation. The most common, and most likely, explanation is that Titian wanted to create a somber, mysterious mood, expressive of the painted subject or of a senescent melancholy. Whether Titian actually felt that melancholy himself, or was indeed happy being "rich and famous" as Hope suggests, is beyond determination.

If it was not an optical or emotional reflex, that is, if Titian was not "painting himself" in the usual Renaissance sense of the proverb, then perhaps it can be understood as a self-fashioned pose of old age. Playing to the viewer's belief that art and life intermingle, Donato Creti (1671–1749) addressed the viewer directly regarding his age, his art, and his personal life in his *Virgin and Child with Saints* (pl. 30). Next to his signature is a declaration of age (74), a painting showing himself with his family, and a curious note describing himself as "having always lived in a state of illness, and continuously sleepless for thirty-six years, being reduced to a state of delirium, unable to find rest by night or by day. Gentle viewer, reflect, and pity me."[76] The accuracy of his self-representation is confirmed by a legal document describing him as out of his mind and possibly schizophrenic.[77] Does the painting really look labored, flaccid, and "weary with the artist's old age," as one scholar recently observed, or did he look at it in this way because of Creti's pathetic appeal? If the altarpiece seems heavier and more carelessly composed

30 Donato Creti, *Virgin and Child with Saints*
(Bologna, Madonna di San Luca)

than his previous work, is this because Creti could paint in no other way or because he wanted to paint in this way? Most likely it was a combination of the two. He certainly wanted us to see his age and psychological state in the painting, since he meant the note to be read at the same time as looking at the painting. As a confessional statement, it prepares viewers for an interpretive stance chosen by the artist, just as he helped one biographer (Giovanni Pietro Zanotti) compose his biography: "oppressed by sadness, and weighed down with melancholy . . . assailed by sinister and troubling phantasms. . . . For his profession's sake he studies ceaselessly, sighs, suffers, and falls prey to obsessions, such is his longing for perfection and glory."[78]

Titian's late paintings present a style that assumed knowledge by his viewers of his age. He expected his public to see him painting in an elderly way, and by publicizing his age he helped to encourage them to see his painting as the product of age: old beyond his years, with shadows gathering around him, eyesight dimming, and the material world melting away. This is what old age is, he seems to tell us. This is who I am. In exaggerating his age, Titian wanted to discomfort his patrons and embarrass them into giving him more money. Age, he realized, was a powerful tool. By manifesting visually the symptoms of old age, Titian might also have wanted to manipulate his viewers, artistically as well as financially. Tommaso Campanella writes that we fear the elderly because of the "fetid exhalation that comes from their mouths and eyes."[79] So powerful is this exhaust that by simply "looking into a mirror, they will tarnish or blur it as if the mirror had that thick vapor applied to it." Could Titian's old-age vision play on people's gerontophobia, adding a layer of emotion and expression? Are his paintings a Campanellan mirror? Much as Leonardo wanted paintings to be mirrors of nature, transparent and neutral in their reflections, can Titian's paintings also be mirrors, ones tarnished by his senescent breath, ones that spoke to the viewer of another, dire reality awaiting all of us, should we be so lucky as to live to Titian's age, whatever that was?

5 Jacopo Pontormo in San Lorenzo

In 1545 Pierfrancesco Riccio, Cosimo 1's secretary and majordomo, awarded Pontormo (1494–1557) a prestigious Medici commission for Florence, a fresco cycle conspicuously located in the choir of San Lorenzo. Work dragged out for more than eleven years, in secret, until Pontormo died at age 62. When he was nearly halfway through this epic stint, Giovan Battista Gelli used him as a model of the prudent old man in the evocatively titled *I capricci del bottaio* (Florence, 1549).[1] Six years later, in a sonnet dedicated to Pontormo, Benedetto Varchi, the cycle's presumed iconographer, praised him for leading "our age" into a new antiquity and walking "along a secret path where no man has tread before, walking alone toward a glory never yet beheld."[2] When the frescoes were posthumously unveiled in 1558, public opinion was mixed: "they please some but not others," wrote Agostino Lapini in his diary.[3] But mostly not. Even Cosimo 1 predicted a negative response.[4] Florence "spoke with one voice" in condemning the frescoes, according to Baccio Bandinelli who knew just what it was like to be publicly humiliated. If Pontormo were still alive, Bandinelli speculated one year after the painter's death, he would be unable to go out in public.[5] All of this might have blown over had not Vasari secured the frescoes' disrepute for almost four centuries.[6]

What is curious about their posthumous reputation is not so much the rancour they generated (many other artworks suffered from bad press), but the fact that they came to emblematize the perils of old age. They inhabited a special place in the art world, not so much the last work of a great master, but a final long-winded statement that embodied a new categorical failure: art in old age. Pontormo was not particularly old when he died, but his artistic failure was invariably explained by early modern critics in terms of old age. Vasari increased Pontormo's age by three years for good effect, having him die at age 65. Raffaello Borghini used the San Lorenzo frescoes to preach about the perils of old age and to introduce the decay of art itself into Mannerism, an old-age style as the last chapter will show. In *Il riposo* (Florence, 1584), an art history and theory dialogue, Borghini took the San Lorenzo frescoes as an opportunity to theorize old age in art, the first such dedicated discussion of old age in art literature:

> Sculpture and painting are extremely difficult arts, that require firm judgment, keen eyesight, and a practiced and steady hand, all of which time weakens and consumes. Thus every sculptor and painter who has studied in youth and in the prime of life has worked with praise, in old age must retire from doing public works and turn his soul towards heavenly designs and leave the earthly. Since all human actions strive upwards towards a definite goal, when man has . . . reached the top of a mountain, even though one wishes to continue further, it is better to descend to the foot.[7]

Facing page: Jacopo Pontormo, *Expulsion from Paradise*, detail of pl. 31

31 Jacopo Pontormo, *Expulsion from Paradise*, black chalk (Dresden, Kupferstichkabinet)

Why Pontormo's final work became a public warning about painting too late in life, and how old age seeped through contemporary readings of the paintings themselves, is the subject of this chapter.

The San Lorenzo frescoes became famous as Pontormo's worst work, and possibly the least popular Renaissance painting. Of Florence's other famously bad artworks, such as Federico Zuccaro's frescoes in the cupola of Florence Cathedral, none except Bandinelli's *Hercules and Cacus* sustained notoriety for centuries as did Pontormo's.[8] They met with "universal applause" only once, in 1738, when they were destroyed forever with whitewash.[9] Twenty-six autograph drawings remain, including six compositional studies of the *Expulsion from Paradise* (pl. 31), *Offering of Cain and Abel with the Death of Abel* (Florence, Uffizi), *Moses Receiving the Tablets* (Uffizi), *Sacrifice of Isaac* (Bergamo, Accademia Carrara), *Four Evangelists* (Uffizi), and *Christ in Glory with the Creation of Eve* (pl. 32). The distribution of frescoes in the upper zone of the altar wall is recorded in an anonymous etching of the *Funeral Ceremonies in San Lorenzo on 12 November 1598 in honor of Philip II of Spain* (pl. 33). This etching also confirms that the *Expulsion* and *Christ in Glory with the Creation of Eve* are full and complete compositional studies accurately representing the fresco as executed. Various reconstructions of the other walls have been ventured; Philippe Costamagna made a definitive plan.[10]

Scholars today seek different motivations for the controversial reception in order to avoid (I believe) the discredited epistemologies of psychology and old age to explain artistic decline.[11] The choir of San Lorenzo was a significant political space, between the sacristies, and hence a likely site for political iconography regarding the Etruscan origins of Florence and Cosimo I as the founder of a new golden age.[12] Possibly for this

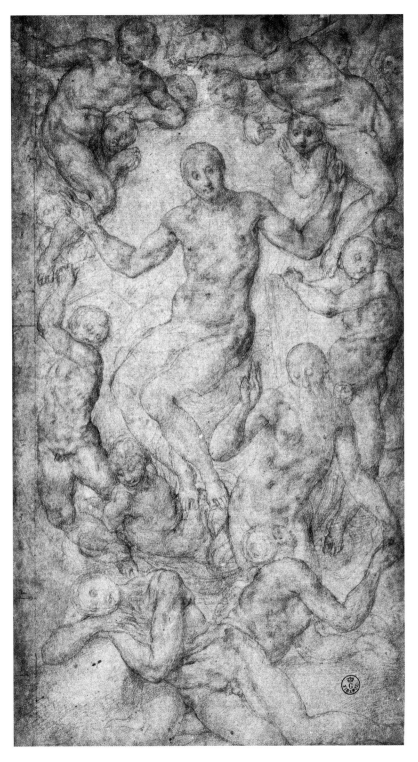

32 Jacopo Pontormo, *Christ in Glory with the Creation of Eve*, black chalk
(Florence, Uffizi)

33 *Funeral Ceremonies in San Lorenzo on 12 November 1598 in honor of Philip II of Spain*, detail, etching (Vienna, Albertina)

reason, it attracted those who wished to criticize Cosimo I covertly from the safer waters of art criticism. Like the criticisms leveled at Bandinelli's *Hercules and Cacus*, which were in part anti-Medicean attacks (so thinly veiled that Duke Alessandro "was compelled" to imprison the more vocal critics), Pontormo's work could hardly escape from associations that accrued to it because of place and patron.[13] However probable this might be, the only hint of a politically motivated response revolves around Pierfrancesco Riccio, Cosimo I de' Medici's majordomo:

[Duke Cosimo] resolved to have painted all the main chapel of the magnificent church of San Lorenzo, formerly built by Cosimo de' Medici the elder. So he gave charge of this to Jacopo Pontormo, either of his own will or, as we said, influenced by Messer Pier Francesco Ricci, his major-domo, and Jacopo was very glad of that favour. . . . Some people say that Jacopo, when he saw the work was being commissioned from him, notwithstanding that the very famous painter Francesco Salviati was in Florence and had brought to a happy conclusion the hall of the palace which was once the audience chamber of the Signoria, must needs pronounce that he would show the world how to draw and paint, and how to work in fresco, and moreover that the other painters were ten a penny, and other such arrogant and over-bearing words. But as I myself always knew Jacopo as a modest person, who spoke of every-one honourably and in the way to be expected of a good-mannered and virtuous craftsman,

such as he, I believe that these words were imputed to him wrongly and that he never uttered such boasts . . .[14]

Paolo Simoncelli, in unraveling the court politics behind this commission, suggests that the antipathy between Riccio and Vasari could have colored Vasari's unfavorable response.[15] Evidently Vasari would have chosen Salviati for the commission, and took Pontormo's protracted failure as evidence of his unsuitability for such a work, but it is difficult to separate Vasari's professional artistic judgment from his personal animosity toward (in his words) the "irascible and scornful" Riccio. Vasari's bitter past experiences, born from rejections by the "sect" (setta) of artists given to "making nonsense" who enjoyed Cosimo's patronage under Riccio's guidance, probably tainted the San Lorenzo frescoes by an original sin.[16]

Liturgically, the frescoes stood at the church's center. Because of the rampant nudity and possibly because of some iconographic oddities, the frescoes fell prey to some objections concerning decorum. The controversy over Michelangelo's *Last Judgment* shadows the San Lorenzo frescoes. Like Bandinelli's *Hercules and Cacus*, which as pendant to Michelangelo's *David* invited comparisons between the two artists, the San Lorenzo frescoes suffered from comparisons, in program and type, with the Sistine Chapel: too many nudes and theologically suspect.[17] Even Vasari, who remained silent with regard to Michelangelo's production, questioned the frescoes' correctness: "But I have never been able to understand the doctrine of this scene . . . specifically what he meant to signify in that part of the painting where Christ on high is bringing the dead back to life, while below His feet is God the Father, creating Adam and Eve . . ." Most scholars working on the San Lorenzo frescoes have enquired into Vasari's supposed confusion by identifying iconographic heterodoxies. A lively batch of articles have issued from Charles de Tolnay's hypothesis concerning a Valdesian program and from Kurt Forster's case for Benedetto Varchi and Vincenzio Borghini as sources for Pontormo, culminating in Massimo Firpo's magisterial book on Pontormo and Valdesian doctrines of justification by faith alone.[18] The famous Catholic reform text, *Beneficio di Cristo*, although circulated only in manuscript, is usually taken as the seminal source based on both intrinsic and extrinsic factors (Riccio owned a copy). The competing hypothesis, that Benedetto Varchi was the cycle's iconographer, is based on careful interpolations from Varchi's *Meditazione* and *Sermone alla Croce*.[19]

Finally, it should be recalled, the San Lorenzo choir was also an artistically charged space – between Brunelleschi and Michelangelo – that according to Anton Francesco Doni deserved a full day's study.[20] Could Pontormo rise to their heroic level and maintain a glorious Florentine tradition (a question that tormented Pontormo as well)? Florentines believed – "it was said," Vasari writes – that Pontormo wanted to "surpass all other painters . . . even Michelangelo." The devoted Bronzino was one such Florentine – "he tried beyond every human power to surpass himself and everyone else"[21] – without, however, identifying Pontormo's failure in this ambition as Vasari did. Pontormo failed the inevitable comparison with Michelangelo, as did Bandinelli, who (according to Vasari) also held "the firm opinion not only to rival Buonarroti but to surpass him. . . ."[22] Like Bandinelli's *Hercules and Cacus*, the infamy of the frescoes survived into the twentieth century, more than a century after their destruction, when (for example) Bernard

Berenson called them "a riot of meaningless nudes, all caricatures of Michelangelo."[23] The delays in their production and Pontormo's comparison of them to the Sistine Chapel must have raised expectations. Almost everyone commented on those eleven years, and even at its mid-point in 1549 Doni wondered "if by chance" they would be finished before "midnight" or the end of time.[24] Critics insinuated with their comments that something more should have come from those eleven years.

Politics, religion, and artistic emulation are more acceptable terms of interpretation today than the usual explanations given by early modern critics, who saw Pontormo's failure in terms of his character flaws (ones magnified by old age). Scholars today may distrust the discriminatory and deterministic attitudes that lie behind psychological and age-related explanations, but I think it worth considering how the methodology of Vasari and his followers can stimulate new readings of Pontormo's late work.

<p style="text-align:center">* * *</p>

Having then closed off the chapel [in San Lorenzo] with walls, hoardings and curtains, and given himself over to complete solitude, [Pontormo] kept it firmly locked up for eleven years so that no living soul except himself ever went in there, neither friends nor anyone else. Admittedly some youngsters who were drawing in the sacristy of Michelangelo, as young men will, climbed in by its spiral staircase on to the roof of the church, and having removed some tiles and the batten of one of the gilded rosettes that are there, saw everything; and when Jacopo was informed of this, he took it very badly, but then he reacted only by barricading it even more painstakingly . . . Imagining that he must surpass all the other painters, and, it was said, even Michelangelo, in this work, Jacopo painted in the upper part several scenes showing the Creation of Adam and Eve, their eating of the forbidden fruit, their expulsion from Paradise, the tilling of the earth, the sacrifice of Abel, the death of Cain, the blessing of the seed of Noah, and the occasion when he drew up the plan and measurements of the Ark. Then on one of the lower walls, each of which is thirty feet in both directions, he painted the inundation of the Flood, in which there are a mass of dead and drowned bodies, and Noah talking with God. On the other wall is depicted the universal Resurrection of the dead, which is to be on the last and glorious day, with such variety and confusion that the event itself will perhaps not be more real or, so to say, true to life than Pontormo has painted it. . . . At the top, in the center of the wall, over the windows, he painted in the middle Christ in majesty, on high, and surrounded by angels, all nude, who is bringing those dead people back to life to judge them. But I have never been able to understand the doctrine of this scene . . . specifically what he meant to signify in that part of the painting where Christ on high is bringing the dead back to life, while below His feet is God the Father, creating Adam and Eve. . . . [It] does not seem to me that in any place at all did he pay heed to any order of composition, or measurement, or time, or variety in the faces, or changes in the flesh colors, or, in brief, to any rule, proportion or law of perspective; and instead, the work is full of nude figures with an order, design, invention, composition, coloring, and painting done in his own personal way, with so much melancholy and so little pleasure for the beholder,

that I am resolved, since even I do not understand it though I am a painter myself, to let those who see it judge for themselves. For I truly believe I would drive myself crazy to become embroiled with this painting, just as, it seems to me, in the eleven years he spent on it, Jacopo sought to embroil himself and whoever looks at it with those extraordinary figures. And although there may be in this work some part of a torso, with its back turned, from the front, and some side views, executed with marvellous care and effort by Jacopo, who for almost everything made finished models of clay in the round, none the less as a whole it is alien to his own style and, as it appears to almost everyone, lacks correct measurements; because, for the most part, the torsos were large and the legs and arms small, not to mention the heads, in which one could see just nothing at all of exceptional excellence and grace he used to impart to them, to the perfect satisfaction of those who admire his other pictures. . . . Whereas he had thought in this work to surpass all the paintings there are, he did not even match to any extent his own pictures that he had done previously. Thus it can be seen that anyone who wishes to do more than he should, and (as it were) to do violence to nature, ruins the good qualities with which nature has generously endowed him. But what can or should one do except have compassion for him, seeing that men practising these arts of ours are as much subject to error as others? And the good Homer, as it is said, even he sometimes nods off asleep. . . . And because he died shortly before he finished this work, some affirm that he died from grief, remaining at the end of his days very greatly dissatisfied with himself. But the truth is that being old and exhausted from doing portraits, clay models, and working so much in fresco, he sank into a dropsy, which finally killed him at the age of sixty-five.[25]

Painted when Pontormo was "old and exhausted," his work (and especially the lower register) became unlike itself, "alien to his own style." Alienated from society, Pontormo "closed off the chapel with walls, hoardings and curtains" and worked in "complete solitude." Vasari, extrovert and socially ambitious with courtly manners, can easily be tainted as an unreliable and temperamentally alienated witness to Pontormo's life. This was not entirely the case. Vasari's defense of Pontormo against public charges of hubris and arrogance ("I myself always knew Jacopo as a modest person, who spoke of everyone honourably") indicates a more patient and sympathetic attitude than generally assumed. During his own old age, Vasari adopted Pontormo as a figure of pathos worthy of charity. Writing to Francesco de' Medici in February 1571, shortly before turning 60, Vasari mocked himself in order to manipulate Francesco: "Your poor Giorgio has become Pontormo in his old age, immobilized and alone." And even in the generally negative passage quoted above, the comparison of Pontormo to "the good Homer" as an explanatory model for the confusion and ineptitudes of a great painter shows just how forgiving he could be regarding the decline wrought by old age. The *Odyssey*, according to the pseudo-Longinus and many subsequent readers of *On the Sublime* (chapter 9), is a characteristic late work "when a great mind begins to decline."[26] The *Iliad*, written "in the prime of life," is full of "action and conflict," whereas the *Odyssey* "withdraws into itself and remains quietly within its own bounds." Old age as a time of introspection, true of Pontormo as much as Homer, although in markedly different ways, is manifested by a shift in sensibility – he also

likens Homer to "the setting sun: the size remains without the force" – and in subject. The *Odyssey*, characteristic of works by the elderly, shows "greatness on the ebb. It is as though the Ocean were withdrawing into itself and flowing quietly in its own bed. Homer is lost in the realm of the fabulous and incredible . . . [where] the mythical element predominates over the realistic."[27]

Nevertheless, because Vasari was so critical of the old Pontormo (and the critical tradition he spawned was even more edged) and because his Pontormo fitted so many artistic stereotypes of the loner melancholic, it is easy to dismiss this as a fictive revenge portrait. Elizabeth Pilliod presents the most carefully documented case against Vasari's Pontormo. She concludes:

> It is possible to argue that Vasari wished to demean Pontormo by making him look hopelessly silly in his old age, and by associating him with a lower class, that of artisans. Great caution must be applied to analyzing apparently psychological statements in Vasari: they are probably neither psychological nor pertinent . . . My work reveals that Vasari's account is unreliable, and sometime dishonest . . .[28]

Pilliod admits that Vasari's unreliability arose from his search for a poetic truth as much as historical fact, but in her account poetic truth involved Pontormo's social networks and status much more than the visual qualities of his painting. She resists Vasari's "mythography" and tries to normalize Pontormo. Similarly, Dario Trento, by contextualizing Pontormo's diary in Renaissance dietary regimes, hoped to render him as simply a health-conscious senior citizen.[29] (At about the same time Louis Waldman attempted to normalize that other great Renaissance eccentric, Piero di Cosimo.[30]) What we gain in documentary evidence by these revisionist accounts, however, is offset by a loss of psychological insight. What Pilliod omits from her impressive work is how Vasari's psychological profile might serve as a metaphoric analysis of Pontormo's art. What happens, I'd like to ask, if we take Vasari's life of Pontormo seriously as art criticism instead of simply as biography? How did Vasari and his followers analyze Pontormo's paintings through psychological analysis? What applications could their psychological methodology have for us today?

<p style="text-align:center">* * *</p>

Without pretending to give medical diagnoses, just descriptions of behavior patterns, we can reconstruct Pontormo as a persona whom Vasari and others thought to be an apt creator of his eccentric oeuvre. By modern standards, Vasari's Pontormo stretches and simplifies historical reality, while still retaining a vivid portrait of a complex and contradictory man, oddly mixing pride and self-loathing. Vasari's authoritative account set in motion a critical tradition that eventually rendered Pontormo as insane. He came to represent the Apollodorus type, as described by Pliny: "Apollodorus was in fact an artist of unequaled diligence and an impatient critic of himself, often breaking up completed statues when his artistic passion refused him satisfaction. For this he was surnamed *Insanus*, the Mad One . . ."[31] Like Apollodorus, Pontormo engaged in destructive behavior, at Santissima Annunziata, where "thinking he could do much better

work, he decided, without a word to anyone, to pull the work down and begin again from scratch," and again for the Medici, at Poggio a Caiano, "destroying and doing again every day what he had done the day before, he racked his brains so hard that it was piteous."[32] Many Florentines, according to Vasari, believed that Pontormo "died of grief, remaining at the end of his days very greatly dissatisfied with himself." Vasari disagreed with the cause of death but agreed that Pontormo was "always unhappy with himself."[33] The fact that "he would never rest content with things as they were" is most obviously a sign of perfectionism and idealism, but, "old and exhausted," he became victim to conflicted feelings about himself and his work: megalomania coexisting with a sense of inferiority. Divided within himself and warring with himself, like Apollodorus, Pontormo "imagined that he must surpass all the other painters" and failed precisely because of his unlimited ambition to top Michelangelo: "Whereas he had thought in this work to surpass all the paintings there are, he did not even match to any extent his own pictures that he had done previously."[34]

In the hands of his critics, Pontormo became as paradoxical as his art: "Wanting to surpass all other artists, he did not achieve much" (Francesco Bocchi).[35] "In his attempt to make something better, he failed to achieve something good" (Giovanni Cinelli).[36] "When men want to do too much, they do less" (Raffaello Borghini).[37] These delusions of grandeur followed by failure may be the reason why Vincenzio Borghini paired Pontormo with Baccio d'Agnolo as examples of biography that Vasari should (but didn't) avoid. (Baccio, it may be recalled from the Introduction, was the Icarus-figure who tried to equal Brunelleschi in completing the cupola of Florence Cathedral, but, following Michelangelo's harsh judgment, fell to earth and became a pavement specialist.)

Jacopo Pontormo manifested an impressive array of phobias in the minds of his early biographers: hypochondria, agoraphobia, gerontophobia, haptephobia (fear of being touched), and necrophobia (fear of dead bodies). Multi-phobic certainly, but united by a thread of narcissism and interiority, exemplary attributes assigned by Aristotle to old age. Borghini blamed Pontormo's hypochondria, worsened by old age, as the cause of the "very confused" compositions at San Lorenzo. Six years later Bocchi made the same observation. Cinelli thought that the San Lorenzo frescoes clearly showed the effects of "a most pernicious hypochondria" and that, considering Pontormo's advanced age, this was understandable: "There is beauty in the individual body parts, but as a whole this work is confused. Forcing himself to be better than good, he never became good."[38] According to Joachim von Sandrart, Pontormo made these frescoes under the spell of a "magna confusione, ut stulta quaedam dici queant, quamvis nec laude careant alia."[39] Melancholy, hypochondria's psychic sister, in its extreme form such as Pontormo's, also produced confusion. As the humor of Saturn, melancholy has long been identified with old age. We either grow more melancholic with age, or, according to Burton, this humor actually precipitates early "dotage."[40]

Vasari, Borghini, Bocchi, Cinelli, and von Sandrart were writing a kind of psycho-stylistics in which mental confusion is mapped out as pictorial confusion. They presupposed a correlation between paintings and the mental state of their creator, a correlation that transcends subject matter and permeates form and style. They also presupposed that paintings carry visual signs of the artist's psyche and that a viewer can re-experience the artist's emotional world by looking

at the painting. These are dangerous assumptions that invite abuse by mythically inclined interpreters who see all art as self-expressive. Vasari's psycho-stylistics can be explained by way of one example from his lengthy description of Pontormo in San Lorenzo:

> For I truly believe I would drive myself crazy to become embroiled [or entangled: *avviluppato*] with this painting, just as, it seems to me, in the eleven years he spent on it, Jacopo sought to embroil (*avviluppare*) himself and whoever looks at it with those extraordinary figures.[41]

For Vasari, this was a dangerous painting for artist and viewer alike. He even performed his own confusion by mislocating the *Noah* frescoes within the choir. Vasari's literary adviser, Vincenzio Borghini, used *avviluppare* to designate "confusing" compositions, presumably of the kind that Vasari described in San Lorenzo as having no "order of composition."[42] The use of *avviluppare* in art criticism can be traced back to Alberti's *Della pittura*, a text of renewed relevance after the publication of four editions and two Italian translations between 1540 and 1568. Alberti wrote: "I blame those painters who, wanting to appear copious, leave nothing empty, without composed order (*composizione*) but strewing dissolute confusion; consequently the composition (*storia*) does not appear made as something worthy but instead entangled (*aviluppata*) in turmoil."[43] Alberti's concern was composition, using *avviluppare* to designate the compositional confusion of excess. Vasari, however, elided entangled structures with the psychological conditions of their production and their emotional effects on viewers. Pontormo wanted to "embroil" the viewer amongst the figures, a psychological state that worried Vasari lest in looking too long he might become like Pontormo, driven mad (*impazzare*). By using the same term, *avviluppare*, to describe both Pontormo's experience and his own, Vasari hints at infection. Pontormo put something of his madness in the painting, and by looking at it Vasari will catch the malady. He drove himself crazy and now he would others. Vasari's intuition about Pontormo's contagious power bore fruit with later critics of Mannerist painting who routinely called it a "plague" and an "infection." (This end-of-life terminology is discussed in chapter 6.)

<p style="text-align:center">*　*　*</p>

Pontormo started a diary in January 1554 at age 60.[44] It is a personal meditation on diet, digestion, and weather, interspersed with progress reports about which limb of which figure he painted. He mentions no spiritual experience, thought, or feeling, only body functions and corporeal sensation. Death frequented Pontormo's thoughts as he wrote in his diary. At one point he expressed relief that he had survived the perennially unhealthy month following the vernal equinox: "during all of that moon, pestilent illnesses spawned which killed many good and moderate men, probably without any disorders. . . ."[45] At this time of year, when "a poisonous chill air" fought with the spring's warming, Pontormo confessed that he was "very afraid." This might well be why he started the diary in these dangerous months.[46] Good weather too can produce colds "that quickly kill, the kind that if you are immoderate in exercise, clothing or sex or if you eat too much, it can kill or harm you in a few days."[47] Waiting for signs of

a mortal condition, relieved when he escapes death's maw, Pontormo kept a diary of fear. "Pontormo . . . was so fearful of death," wrote Vasari, "that he would not even hear it mentioned, and he fled from having to encounter dead bodies." His young body was famously beautiful. His old body, like most old bodies in the popular imagination, was a disgusting thing.

The diary can also be read as a record of his body's decline, "a depository for carrion" in Salvatore Nigro's evocative phrase.[48] Barely a week passed without him recording some ailment: "I have some problem either with my stomach or my head or pains in my thighs or in my legs or arms or teeth, which happens continuously . . ."[49] Most involved swallowing, digesting, and eliminating food. In addition to these mundane travails, Pontormo suffered from dizzy spells (*uno capogirlo*), once lasting for a full day, and another time (after painting "the head with that rock under it") it lasted intermittently for three days.[50] Vertigo might have caused Pontormo's two falls, once while washing his feet, both times with painful results.[51] The first sentence of the first diary entry has him stumble onto the stage of his life: "On the 7th a Sunday evening in January 1554 I fell and hurt my shoulder and arm and felt badly and stayed in Bronzino's house for six days." His teeth hurt periodically, possibly from banging them when he fell, until at last "I pulled out a chip of a tooth and [now] I can eat a little better."[52] Pontormo was a difficult friend who could even exhaust the patience of the adoring Bronzino. One day he didn't bother to answer the door, first when Bronzino knocked, and again when his friend Daniello returned. "I don't know what they wanted," Pontormo remarked to himself. A week later, when Pontormo was reluctant to accept his dinner invitation, Bronzino became upset (*turbandosi*) and accused Pontormo of excessive suspicion (skirting on paranoia): "it seems as though one of your enemies had come to your house."[53] Pontormo argued with those entrusted to help him ("in the evening I quarreled with the steward, and he told me that I'd have to care for myself"), and his assistant Battista Naldini told him the same ("he said that I would have to care for myself because he had been scolded for no reason").[54] After one of these rebuffs, when Pontormo abandoned Bronzino in front of his house instead of coming in for dinner as planned – "I left him in front of the Cappello Apothecary and he saw me no more" – Bronzino's indulgence lapsed.[55] He wrote a satiric poem in *terza rima*, "The Prison," whose titular place represented Pontormo's protected bedroom and his guarded life in general. "I say to you," Bronzino asks Pontormo, "between staying in there and staying out here / what difference do you see?"[56] Bronzino's paradoxical answer suggests that belief and reality cannot be distinguished in Pontormo's confused world: "staying at home in some fantasy / let them say you're not there where / no one could believe you are not."[57]

By March 1554, Pontormo had finished the choir's upper zone, depicting *Christ in Glory* and the *Creation of Eve*, and had descended for over two years in hell, metaphorically and literally, by painting on the lower walls the *Deluge*, the *Resurrection of the Dead*, and *Descent into Hell*. His painted subject matter during these final years of his life mostly involved tormented bodies, drowning or drowned or falling into hell. His literary subject matter during these same years concerns his own suffering body. Life for Pontormo, at least his self-inscribed life, was strictly a somatic experience: what he ate and how much; how his body felt, especially his stomach and bowels; how the weather made him feel; which body part he painted; how long and how well he slept. The simple explanation for this would be Pontormo's gout, and his need to control

his diet for this notoriously food-sensitive disease. The more complicated explanation, which need not exclude the first, is that Pontormo's hypochondria became inflamed with old age and his daily immersion into the world of painted corpses.

<p style="text-align:center">* * *</p>

Most of Pontormo's diary is dietary. His consumption of meats attests to a rich and varied diet: lamb (twenty-six meals), pork (thirteen), fish (twelve), chicken (seven), pigeon (five), veal (four), goat (four), sausage (two), rabbit (two), thrush (two), duck (one), unspecified "meat" (fourteen), and eggs (sixty-six). He often weighed his food, especially bread. Interspersed amongst the food consumed are notations of the body parts that he painted:

> I did the thigh . . . I got a pastry . . . I did the other thigh and the whole leg . . . I had some eggs . . . I did one thigh and at night I cooked a piece of goat . . . I did the torso of the child that holds the chalice, and at night I had some good mutton for supper.

In today's diet-crazed world, none of this may seem exceptional. Early modern diet books sold well too, and medical practice often involved dietary prescriptions and prohibitions.[58] Pontormo's use of his stomach as a barometer of physical health falls within standard medical practice. He could almost be following Marsilio Ficino's advice from *Liber de vita*:

> Old people should realize that the night air and cold weather are deadly for them. They should be careful to get food which will produce a lot of blood and a lot of spirit, such as fresh lamb, and wine a little on the sweet side and very fragrant. Lamb is especially good for the heart's blood and wine especially good for the spirit.[59]

Food and weather, just as Pontormo logged it. Lamb was his favorite meat (30 percent of all meat consumption). In Michelangelo's circles in Rome during the 1530s, it was believed that "Protogenes used to eat very delicate and simple food so as not to thicken his intelligence."[60] Since Pontormo shared Protogenes' perfectionism ("Protogenes was very poor because of the great perfection he put into his work. . . . He was dissatisfied with his art, yet could not give it up"), Protogenes' dietary practice might have interested him. Vasari ironized the commonplace belief that we are what we eat when he made Fra Bartolomeo die from eating too many figs.[61] His pious body just couldn't stand so much passionate food, undermining it much as the beauty of his nude *St. Sebastian* distracted too many women in Santissima Annunziata (before it was transferred to the monastery, just for the men). Paolo Pino's Florentine painter Fabio in his *Dialogo di pittura* (Venice, 1548) gave a recipe for melancholic painters that used Ficino as its source. Pino assumed, as did Ficino, that how one treats one's body will affect one's soul, feelings, and experiences.

The *diaeta statica* or measured diet where food is weighed was rarely advised before the mid-sixteenth century.[62] Alvise Cornaro suggested it for the elderly, limiting their intake for longevity, but *Della vita sobria* was first published in 1558. Pontormo's record-keeping was thus an oddity, although less peculiar than that of Santorio Santorio (*sic*), physician and friend of Galileo, who compared the weight of food and drink ingested with the weight excreted.[63] When

Pontormo's diary is read in its entirety instead of in extracts, the tedious detail and obsessiveness become clear. For brevity, however, only a few passages will be cited or quoted (numbers refer to Nigro's edition):

(85) Tuesday evening I ate a lettuce salad and an omelette.

Wednesday evening, 2 *quattrini* of almonds and an omelette and walnuts and I made that figure which is above the head.

. . . (90) on 30 January 1555 I started those loins of that figure who is crying over that baby. On the 31st I did that little piece of cloth that wraps around her, the weather was bad and my stomach and bowels hurt for 2 days – the moon was at its first quarter.

On 2 February on Saturday evening and Friday I ate a cabbage and both nights I ate 16 ounces of bread, and not having been cold at work my body and stomach didn't hurt – the weather is damp and rainy.

. . . (91) on 15 March I started the arm that holds the belt, that was on Friday, and in the evening I dined on an omelette, cheese, figs and nuts and 11 ounces of bread.

Wednesday the 20th I finished the arm from Friday and Monday; I had already made the torso and on Tuesday I made the head for the arm I described. Thursday morning I rose early and saw such bad weather and wind and cold that I didn't work and stayed at home. Friday I did the other arm across from it; and Saturday a little of the blue background that was on the 23rd and at night I had 11 ounces of bread, two eggs and spinach.
Tuesday I did the head of the kneeling *putto* and ate 10 ounces of bread and received a sonnet from Varchi.

. . . (92) Tuesday I made the leg with the thigh under the backs, those I mentioned above; and in the evening I ate half a kid goat's head.

Wednesday two eggs and that night Cecho the baker had a stroke.

. . . (94) Monday fried lamb's liver.

Tuesday evening I dined on lamb's heart, boiled dry meat and 10 ounces of bread, and I started the arm of the figure that's like this.

Wednesday [Battista del] Tasso died; and Thursday I finished it and at night went to have supper with Daniello: roast kid goat and fish.

. . . (98) on the first of August Thursday I made the leg, and in the evening I dined with Piero, a pair of boiled pigeons.

Friday I did the arm that leans.

Saturday that head of the figure that is below that looks like this.

Sunday I dine at Daniello's with Bron[zino] where we had meatballs.

. . . (100) Friday the body that was St. Luke, I ate eggs and 14 ounces of bread and a cabbage. Saturday the arm and where it rests: I ate eggs and 9 ounces of bread and 2 dried figs. Sunday I had vermicelli with Bron[zino] and at night we had supper together.

Monday Tuesday Wednesday Thursday Friday I worked below that figure drawn up to the

cornice. Saturday I set up the cartoon that goes next to it. For supper I ate a good cabbage cooked by my own hand and at night I pulled out a chip from a tooth and [now] I can eat a little better.

Beyond the meticulous record of consumption, we have a curious fusion of eating and painting. Painted body parts (loins, arm, torso, head, leg) are mixed without syntactic distinction with animal body parts (a head, liver, heart). (How this fragmentation of bodies and corporeal experience manifests itself visually will be discussed below.) Pontormo patiently observed the unpleasant gastro-intestinal effects of his diet:

(82) It also sometimes happens that I feel full after eating, weighed down with sleep and food so that I feel bloated (*gonfiato*): that's the time to be careful, because it is health in excess.

(85) on 11 March 1554 . . . when Bronzino came to fetch me at home I was in bed – it was very late and, arising, I felt bloated (*gonfiato*) and full.

(90) on 31 [January 1555] my stomach and bowels hurt . . .

(92) [31] of March Sunday morning I ate at Daniello's fish and mutton, and in the evening I didn't eat, and Monday morning I had a painful bowel movement . . .

(97) on the 8th [July 1555] Monday. I started to have diarrhea. Tuesday I did a thigh, and the diarrhea was worse with a lot of bloody and white discharge. Wednesday I was worse so that about 10 times or more, at every hour I had to go, so I stayed at home and had a little soup . . . Thursday I did the other leg and my condition was a little better, I went 4 times; I had supper at San Lo and I drank a little Greek wine. Not that I feel I am well, because every three hours I have an attack. On the 12th Friday night I had supper with Piero and I think that the diarrhea is over, and with it the pains . . .

Thursday morning I passed two solid turds, and they came out looking like long wicks of cotton batting, like white fat.

Pontormo thought about intestinal matters so often that it even affected his memories of poetry. One evening he and Bronzino made a bet about Petrarch:

On 27 January I lunched and dined at Bronzino's home, and Alessandra arrived after lunch and stayed until the evening and then she left; and it was that evening that Bronzino and I returned to my house to see the Petrarch, that is *fianchi, stomachi,* etc. and I paid that which was bet.[64]

Each of them remembered a verse from Petrarch's *Trionfo della morte* differently. Pontormo lost the bet, however, noting that maybe the only part he could recall exactly were the words that captured his interest in digestive systems: "sides, stomachs, etc." That Bronzino won is hardly surprising, since he had a prodigious memory for poetry according to his friend Benedetto

Varchi ("he has memorized the whole of Dante and a great part of Petrarch"[65]), but it is easily imagined that the choice of the *Trionfo della morte* was Pontormo's. He owned a copy of it and must have been reading it recently, finding in it a resonance with the fearful anticipation of his own death. Especially telling is the verse that stuck in Pontormo's mind – "sides, stomachs, etc." – and to this extent his memory served him well:

> Sulla, Marius, Nero, Gaius and Mezentius,
> Sides, stomachs, and burning fevers,
> Make death seem more bitter than wormwood.[66]

<p style="text-align:center">* * *</p>

Being whitewashed, and with no engraved record or full compositional drawing for the *Flood* and *Resurrection of the Dead*, we can only imagine the dismal effect of the lower zone. Four partial compositional studies with a multitude of dead and suffering nudes suffice to give us a taste of this unsavory sight. Pontormo adopted a style of weaving his figures together, with one figure attached to or seemingly growing out of another. A chalk sketch for the *Flood* (pl. 34)

34 Jacopo Pontormo, *Flood*, black chalk (Florence, Uffizi)

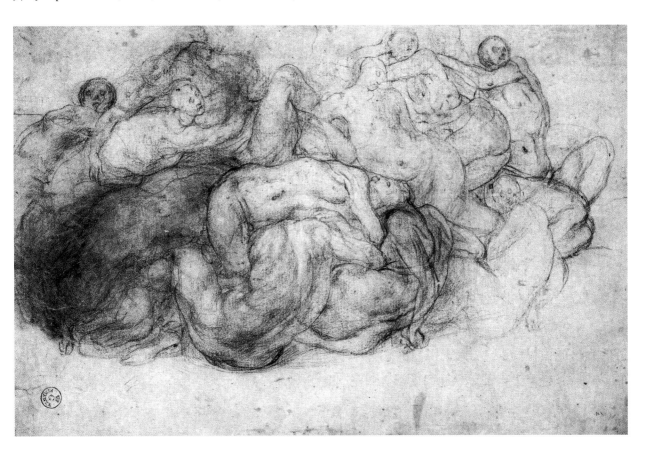

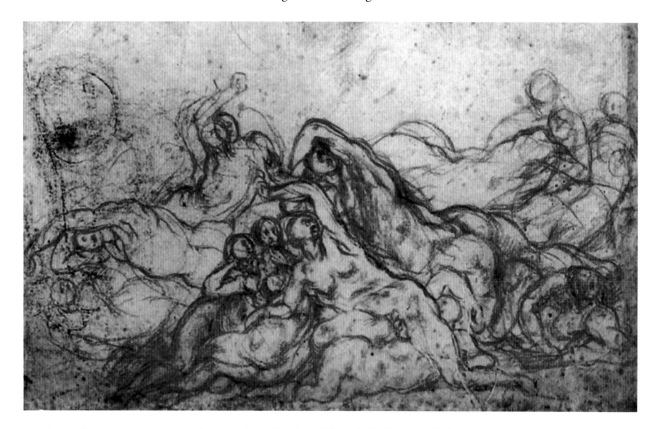

35 Jacopo Pontormo, *Resurrection of the Dead*, detail, red and black chalk (Florence, Uffizi)

and another of the *Resurrection of the Dead* (pl. 35) show how Pontormo achieved the sense of entanglements that bothered Vasari and others. Differentiation of individuals yields to a soggy, compacted mass of melting figures where a head disappears suddenly under a torso or a neck seems to become attached to an adjacent head, fusing them into a grotesque. Within the writhing mass of the *Flood* are two patterned groups of figures: one consists of three reclining figures, backs turned toward us, arrayed along the lower edge; the second group includes a sequence of three frontal figures at the upper right of the pile. These two figural sequences are variations on a theme, rear and front, all indulging in buttocks display with different degrees of suggestiveness. Buttocks also play a conspicuous role in the *Christ in Glory with the Creation of Eve* (pl. 32) in the way that Eve extrudes from Adam, almost herniated or, more troubling, expelled as excrement, only to nestle her head in God's groin. In the *Expulsion* (pl. 31), the legs of Adam and Eve are bowed into a single broken rib. Adam appears to be in gastric distress, bent over with stomach cramps even more severe than Eve's. They also appear to be stooped like the aged. Referring to Aristotle and Galen in his *Gerontocomia* of 1489, Gabriele Zerbi described the elderly as "distorted, curved, and humped."[67]

 I propose to call these late paintings "intestinal compositions," for various reasons: for the visual similarities of his limp sausage figures wrapped around each other to intestines; for Pon-

36 Michelangelo, *Battle of the Centaurs and Lapiths* (Florence, Casa Buonarroti)

tormo's fascination with his own intestinal workings and excretions; and for cramping and the prominent buttocks of his figures. "Intestinal" does not cover all facets of Pontormo's late style and cannot be taken as a way to explain his intentions. It is a poetic label, richly associative for the ailing Pontormo; it suggests how his corporeal experience might percolate into his art. Its stylistic origins can be traced back to Leonardo's and Michelangelo's figural compositions. Two examples, both famous amongst artists in Florence, show where Pontormo might have started thinking. In Leonardo's Burlington House Cartoon (London, National Gallery), the Christ Child's body flows into Mary's arm and the legs of Mary and Anne slot snugly together. Probably the closest to Pontormo's compositional mode is Michelangelo's *Battle of the Centaurs and Lapiths* (pl. 36), where the grotesque entwining of centaurs and Lapiths confuses the eye as it tries to separate one figure from another, one species from another. Other work could be cited, and this style has a history within Pontormo's own oeuvre as well, but with these brief comments I wish only to acknowledge that the San Lorenzo frescoes have a history in art. What Pontormo did, as he did with so much in his life as well, was to take a fashionable norm and push it to a pathological extreme.

Early modern intestines looked much as they do today, judging from illustrations in medical treatises (pls. 37 and 38). These intestines have undulating profiles similar to Pontormo's rip-

37 Andrea Vesalius, *De humani corporis fabrica*, Basel, 1543

38 Thomas Geminus, *Compendiosa totius anatomie*, London, 1559

pling figures. Several of the figures in Pontormo's diary look as if they have intestinal cramps (pls. 39 and 40), although they suffer worse torments than those in the *Flood*. "Intestinal" also describes many of Pontormo's bodies, de-boned and wormy. Their flaccid forms seem soft and pliant, a strange beauty of decay where traces of corporeal beauty are retained longer than their animating spirit. They are, by this account, like Narcissus shortly before his death, before he "melted" into the water.

Visually related to the intestinal style are the parasitic residents of the stomach and intestines. Worms afflicted people of any age, but old folk were thought to be particularly wormy, "long strings like cucumbers, all hanging together."[68] In his list of old-age horrors thought to be commonplace – "some stink from their armpits, some from their feet and many more from their foul mouths" – Girolamo Cardano includes "a belly full of worms." Stomach and intestinal worms were blamed for a wide range of physical and psychological sicknesses including cramps, heartburn, loss of appetite, bloating like dropsy, and "mental wanderings." Diagnosis is possible only through examination of one's stools, which might be one reason Pontormo inspected his feces.

Early modern writers on art discussed vermicular styles. The Florentine physician and art collector Antonio Cocchi, after observing the swarming *pedicelli* (or intestinal worms) through his microscope, "turgid and corrupt . . . anthropophagic animals,"[69] gave them a style – the

39 Jacopo Pontormo, *Diary*, folio 3r (Florence, Biblioteca Nazionale Centrale, Magliabechiano, VII, 1590)

40 Jacopo Pontormo, *Diary*, folio 4v (Florence, Biblioteca Nazionale Centrale, Magliabechiano, VII, 1590)

Asiatic style – because they were foreign bodies, corrupting their host and looking like that quintessential Asiatic ornament: the arabesque. The Venetian art critic Marco Boschini likened the compositional style of Florentine Mannerists to a slithery mass of sardines and maggots: "Their compositions considered as a whole are so confused that at first glance you cannot distinguish which leg or knee belongs to which person. In short, it is a market of maggoty nuts. Sardines in a barrel are rarely so crammed and crowded."[70]

Art historians today describe Pontormo's late figures as "swollen and extremely distorted . . . with attenuated torsos and tiny extremities" and as "a vague formlessness and macabre gigantism of swollen forms."[71] These are a connoisseur's account with no biographical content intended. When Pontormo's early critics described the San Lorenzo figures as swollen, their preferred term was *gonfiato*: "these figures are so bloated that one cannot distinguish what they are." They do not refer explicitly to the *Flood*, where drowned figures might be expected to be swollen. Appropriate to their subject in a literal sort of way, Gabriele Paleotti thought that "bodies bloated and deformed by water" were "disgusting" even in paintings of the Flood.[72] "Bloated" was also how Pontormo described himself twice in his diaries, probably in reference to his dropsy, a disease that causes swelling from an accumulation of serous fluid. The effect of his body's bloating is linguistically identified with his swollen, dropsical figures. His body drowned internally as he painted the *Flood*. Just before telling his readers that Pontormo died of dropsy, Vasari noted the anatomical defects in the San Lorenzo frescoes: "the torsos were large and the legs and arms small . . .". Swollen and encased by skin like a sausage, their contents seem to have loosened and shifted. Muscle, tendons, and bones seem liquefied. In a curious but unrelated aftermath, Johann Joachim Winckelmann described Baroque art – the third and final stage of art's life cycle (the Necessary, the Beautiful, and the Superfluous) – as distorted and exaggerated. The Baroque, he tells us, is what happens when Raphael's classicism is infected with "dropsy."

Another aspect of Pontormo's bloated forms, hopefully apocryphal, which ties together liquidity and morbidity, was first told by Giovanni Cinelli in his expanded edition of Bocchi's guide to Florentine art (1677). Like most guidebook writers of the time, Cinelli was a patriot and enthusiast. He chose only one work for condemnation – the San Lorenzo frescoes – whose defects he ascribed to Pontormo's character in general and specifically to his creepy studio models: "In the chapel, he kept corpses in a trough of water to make them very bloated."[73] These models infected the San Lorenzo neighborhood with a great stench. Giovanni Gaetano Bottari thought the story of Pontormo's waterlogged cadavers originated with Vasari, a strange mistake for this conscientious editor who claimed "to correct the many errors" in the *Vite*.[74] The kind of literalism that Cinelli invented for Pontormo stretches back to Seneca's story of Parrhasius torturing a slave.[75] Luca Signorelli supposedly used his son's corpse as a model for Christ in the *Lamentation* of 1502 (Cortona, Museo Diocesano), consoling himself with art.[76] Cinelli could also have read of early modern practices: Michelangelo nailing an indigent to a board and lancing his heart in order to paint a Crucifixion; Bernini burning himself to see what St. Lawrence should look like; and, closest to Pontormo's case, Caravaggio exhuming a corpse to serve as a model for the *Raising of Lazarus* (Messina, Museo Nazionale) and painting a prostitute drowned in the Tiber for his *Death of the Virgin* (Paris, Louvre).[77] In reality,

Pontormo would not have been allowed to set up this experiment, at least not for long, since (besides the smell) vapors from corpses were thought to transmit disease through the putrescent air. Furthermore, as Vasari observed, "Pontormo . . . fled from having to encounter dead bodies."

Drowning in his own fluids, Pontormo suffered from a fatal disease of surfeit liquidity. He observed and recorded in his diary his body's decline into a hellish death by internal drowning. Anton Francesco Doni, a rare admirer of Pontormo's San Lorenzo frescoes (at least those in the upper zone), portrayed hell as a place for drowning. His *Inferni* (Venice, 1553) includes illustrations of hell that resemble Pontormo's *Flood* more than they do a fiery Boschian inferno and are typical of sixteenth-century hells with their flooded plains and putrid swamps, restored to fire only in the seventeenth century.

Cinelli's story of Pontormo painting the San Lorenzo frescoes with troughs of waterlogged corpses may be a fictional embellishment to Vasari, but it contains a wonderful insight into Pontormo's relationship to his paintings. From Vasari we know that he "remained at the end of his days very greatly dissatisfied with himself." He tried to destroy his work – the Medici coat of arms with *Faith* and *Charity* and the Poggio a Caiano frescoes – "destroying and doing again every day what he had done the day before, he racked his brains for ideas so hard that it was piteous." This relentless perfectionism resulted in an antagonistic relationship between Pontormo and his work. Cinelli's story falls within this behavior pattern. To represent drowned bodies correctly, Cinelli put Pontormo into a physically and psychologically stressful situation: working in a closed space with a stench so strong it spread through the neighborhood; and working in close proximity to rotting cadavers when ordinarily "he fled from having to encounter dead bodies."

Other aspects of the San Lorenzo frescoes could have discomforted the agoraphobe Pontormo: "He never went to festivals or to any places where people get together, to avoid being caught in a crowd; and he was solitary beyond belief" (Vasari). By painting crowds of people – all those bodies rubbing against each other – might not Pontormo be producing an emotional *frisson* for himself and his agoraphobe viewers? "Thoroughly disagreeable," concluded one eighteenth-century English tourist.[78] The frescoes create a sense of claustrophia not just by the piling of figures but by their siting. Even without Pontormo's boardings, the choir feels shut in, with only two small windows in the upper zone, altogether a tight space of ungainly height. Inside the choir, the visitor's visual field would be occupied mainly by the *Flood* and the *Resurrection of the Dead* along the lower register. Imagine being surrounded by life-size corpses, swollen and rotting, as well as bodies being resurrected, and you can better understand why so many Florentines disliked these frescoes. Their response was visceral as much as intellectual. For Pontormo, with his fears of crowds, of being touched, of dead bodies, this was a horrific place, one charged with contamination, morbidity, and decomposition.

Art history has many crowded styles, from the Hellenistic bas-reliefs that influenced Mannerist painting to the entangled style of Gentile da Fabriano's *Adoration of the Magi* (Florence, Uffizi). However, for Pontormo, densely populated compositions were more than an artistic ideal, even if it were found in Michelangelo's *Battle of the Centaurs and Lapiths*, or, as was claimed soon after his death, a Mannerist failure. By painting figures hemmed into complicated

figural webs where, in Borghini's words, "figures seem stuck together," he imagined for himself and his viewers a situation of great personal anxiety. Other intentions could be involved, but which ones? an expiation of fear? an adaptive response to stress or some other kind of coping mechanism? It could be cathartic to paint what you fear, sublimating it into art. Possibly he found externalizing fears to be soothing, perhaps punishing, or maybe even erotic in a sado-masochistic way. The trouble is we don't know and probably can never know without the kind of evidence that we have for Giorgio De Chirico, who chronicled his stomach problems (flatulence as afflatus) and agoraphobia.

III Historiography

DELLA PITTURA

VENEZIANA,

E DELLE OPERE PUBBLICHE DE' VENEZIANI MAESTRI.

LIBRO QUARTO.

IO mi trovo esser giunto ad uno di que'
molesti passi, a cui ridur si suole ogni
scrittore d'istorie. Dopo una bella serie
d'illustri fatti, che dan vigore allo stile
di chi scrive, e rallegrano l'animo di chi leg-

6 Life Cycles of Art

The arts, like men themselves, are born, grow up, become old and die.
Giorgio Vasari, *Le vite de' più eccellenti pittori, scultori e architettori*
(Florence, 1550)[1]

And here we may observe, that the progress of an individual Student bears a great resemblance to the progress and advancement of the Art itself.
Sir Joshua Reynolds, *Discourses on Art* (Discourse VIII: London, 1778)[2]

DEGENERATION. As long as the arts are cultivated and protected, they should progress further and arrive at perfection. Experience proves this speculation to be false. The same thing that happens to men also happens to the arts: in old age, they often have greater insight, but they no longer have the same talent.
Francesco Milizia, *Dizionario delle belle arti* (Bassano, 1797)[3]

Art historiography grew up as biography and myth-making, and, by some accounts, it began to free itself only with Johann Joachim Winckelmann and Luigi Lanzi in the eighteenth century. But there were earlier attempts to give art a history that was independent of individual artists, driven not by geniuses but by a life force of art itself. The earliest, famously enigmatic claim appears in Vasari's *Vite* as part of his explanation for dividing the history of art into three periods (fourteenth, fifteenth, and sixteenth centuries), a crescendo leading to the perfection of Michelangelo: "The arts, like men themselves, are born, grow up, become old and die." Poised at the summit of perfection, at the height of maturity, what could Vasari and his contemporaries imagine for themselves but senility and death? The aging of art might be dismissed as just a figure of speech, but it reflected more than one writer's turn of phrase. It captures an ancient and enduring world view that anthropomorphized art and its history as a body, likening the life of art to the life of artists and endowing it with an inner life largely independent of external circumstances. Just as biographers devised late styles of "senescence" and "decrepitude" for old artists, so too did they (and others) submit art's history to a biological imperative.[4] Mannerism, with its excess of style, its inattention to content, and its search for pleasure, yielded itself to neo-Stoic and Catholic-reform critics who found in it signs of psychological and moral lassitude.

Vasari's biological structure of history and its seventeenth-century versions survive in modern art history. Heinrich Wölfflin took these life cycles and metaphors of old age as proof that "we always project a corporeal state conforming to our own." We do this with artworks, artists, and art periods because the foreign or historically distant can best be grasped narcissistically. Using

Facing page: Chapter heading from Anton Maria Zanetti, *Della pittura veneziana*, detail of pl. 41

Theodore Lipps's empathy theory (*Einfühlung*), Wölfflin argued that historians imaginatively project themselves into the past in order to render it vivid for the present. Because empathy lay behind early modern experiences of art – starting with Alberti's famous dictum "we laugh with the laughing, cry with the crying" and later in the emotional qualities assigned to pure form and color – it must have seemed an obvious way to describe a historian's relationship to history. The dangers of empathic solipsism – the shaping of history's miasma into the simpler forms of personal experience – concerned him less than leaving art and history inanimate. Later theories such as those by Henri Focillon and Wylie Sypher originated from similar needs to explain why period styles exist, and why art seems to change in recognizable and repeated patterns.[5] Although their arguments hinge on formal analyses and a Hegelian sense of history, the biological theory of recapitulation also provided a scientific allure. (Recapitulation theory states that ontology repeats phylogeny, that the development of an individual organism from embryo to maturity mirrors the evolutionary development of the species.) Despite a recent attempt by Jonathan Gilmore to revive Focillon,[6] their theories remain more as historical curiosities than viable models of historical explanation.

Empathy theory corporealizes history by means of metaphorical language. Metaphors of festering decay, fossilization, sclerosis, and other senescences gave meaning and a narrative structure to the histories of the late Roman Empire and late Middle Ages.[7] Old age and death invited hope for rebirth and reform, and hence more than just being diagnostic metaphors they were often attempts to cordon off a decadent present from a new era. So-called saviors of art – Raphael, Annibale Carracci, Poussin, Anton Raphael Mengs, etc. – needed a history in decline to justify their roles. Theories of historical decline as old age are generally dismissed as semantic illusions or narcissistic projections of the individual onto history. Those who believe them to be "just" metaphors tend to subscribe to the belief that historiography can be (and should be) protected from impressionistic uses of language that warp "historical truth." Recent historiography, however, especially in the wake of Hayden White's influential studies, accepts metaphoric language as a means to analyze historians' psychological or moral values that have infiltrated their readings of the past.[8] Metaphors reveal how we project our individual experience of maturation and decay onto the broader vista of societal change. It is this realization that serves as the theoretical foundation of this chapter.

Vasari's Ontogenesis

Discredited by its modern progeny, Vasari's dictum represented in 1550 a serious and original departure in explaining and mapping art's history. "I have divided the artists into three sections or, shall we say, ages (*età*), each with its own recognizably distinct style," wrote Vasari, and the divisions that he invented still structure undergraduate survey texts and are still being tested, modified, and rejected by art historians today.[9] Vasari's prefaces probe ways that an artist's style is subsumed within an immanent law of history's stylistic development, which defines and limits the formal language available to artists at any given time. Artists contribute to the development of period style and simultaneously are controlled by it. Artists are subject to their artistic age

as much as they were to their biological age. If nature's laws and regulative processes shaped both life and art, then by observing a life cycle in microcosm (one's own life) one can find the pattern for macrocosmic changes in society.

Discussions of Vasari's aphorism are mostly concerned with source hunting, usually with reference to ancient historians. Wolfgang Kallab identified Plutarch, Polybius, Paolo Diacono (in the Italian translation of *Cronica Longobardorum* of 1518), and Matteo Villani as sources for Vasari.[10] Julius von Schlosser cited Lucius Annaeus Florus and Velleius Paterculus; Erwin Panofsky discussed Florus; Ernst Gombrich cited Cicero, Quintilian, and Pliny; and Zygmunt Wazbinski introduced Lucretius and Livy for consideration.[11] In their search for context, art historians tend to project their own methods onto Vasari and assume that he too wrote about history as a historian whose sources can be reconstructed. Actually he wrote as an artist. Not only did Vasari himself make this claim, but an argument can be made that his ideas about historical change and periodization originated, at least in part, from art theory.[12] In any case, the diversity and complexity of the proposed sources overwhelm Vasari's simple axiom. They tell us more about how pervasive such ideas were in the mid-sixteenth century than about any particular text that Vasari might have consulted. What Vasari did was to distill popular ideas circulating in Florentine historiography and philology, ideas that were being introduced through new translations and editions of ancient texts. The lack of consensus amongst scholars concerning Vasari's source, the sheer number of possibilities proposed, and the plausibility of most proposals should tell us that Vasari adapted deeply rooted conventions about the shape of history and applied them axiomatically to the history of modern art.

According to Florus, "if anyone were to contemplate the Roman people as he would a single individual and review its whole life, how it began, how it grew up, how it arrived at what may be called the maturity of its manhood, and how it subsequently as it were reached old age, he will find that it went through four stages of progress."[13] Only the introduction of Florus' *Epitome bellorum omnium annorum DCC* survives, but its importance transcends its fragmentary state. Written about AD 122 it recapitulated and systematized body–state analogies that had been tested earlier by Seneca, Cicero, and Tacitus in more fragmentary forms.[14] Roman childhood, he tells us, started with Romulus; adolescence started with the consulship of Junius Brutus; manhood or maturity ended with the death of Augustus. Like many other imperial Romans who believed that they lived in a period of senescence (*senectus*), Florus saw a precipitous decline into old age after Augustus, one that was temporarily averted by the rule of Trajan.

The most complicated and comprehensive theory of historical recurrence, however, came much earlier with Polybius' *Histories*, mostly complete by 146 BC. *Anacyclōsis*, according to Polybius, is a naturally repeating sequence of polities: monarchy, tyranny, aristocracy, oligarchy, democracy, mob rule. Each form provides an opportunity and motive for the emergence of the following form, alternating between egalitarian and selfish governments and tending toward an increasingly pluralistic leadership. Of the ancient historians theorizing cyclical history, Polybius enjoyed a particular popularity in early and mid-sixteenth-century Italy, especially after the first Italian translation of his *Histories* in 1545 by Lodovico Domenichi, largely because his defense of liberty and his explanation of the fall of Greece to Rome resonated with Italians trying to understand their loss of dominion to Spain, France, and the Holy Roman Empire. Machiavelli's

Discorsi sopra la Prima Deca di Tito Livio and his Florentine Histories applied Polybian *anacyclōsis* to recent Florentine history. He found, like Polybius, that society moves "from order to disorder and then passes again from disorder to order, for worldly things are not allowed by nature to stand still. As soon as they reach their ultimate perfection, having no further to rise, they must descend."[15]

Vasari could have learned about the biological principles of historical change from any number of ancient or modern historians, as the list of proposed sources indicates, but more likely he learned about Polybian *anacyclōsis* and other theories of recurrence from Florentine linguists and literary critics, especially his literary advisers Vincenzio Borghini, Giovan Battista Gelli, and Benedetto Varchi. Lorenzo de' Medici identified three stages of the Tuscan language: *gioventù, adolescenza*, and *adulta*.[16] Gelli divided linguistic evolution into three stages (growth, perfection, and decay); Sperone Speroni divided it into four.[17] Varchi, applying a theory of *generatio* and looking to ancient Latin as a model for linguistic evolution, compared the life of languages to the four ages of man.[18] And Borghini thought the development of Latin could help to predict changes in Italian since all language, at least the "nature" rather than the "art" of language, must "be born, grow, and age" (*nasce, cresce e invecchia*).[19] Later historians of literature reconfigured the cycle to fit their current realities.[20]

Vasari's *Vite* include competing and sometimes incompatible epistemologies of historical change. With his aphorism, he subjected art to nature's laws, making it autonomous from the makers and consumers of art, much as he did by appealing to Fortuna's wheel and God's will.[21] On the other hand, he (or actually Adriani writing on his behalf) also identified the rise and fall of ancient art with extrinsic causes: patronage, political upheaval (the move to Constantinople), external devastation (the barbarian invasions), and internal suppression (the iconoclastic destruction).[22] Whereas his history of ancient and medieval art is highly rationalized and deterministic, modern art is characterized in the third preface as autonomous and is discussed without reference to politics, economics, or religion. The only causes for artistic progress are intrinsic to art itself (the discovery of the *Laocoön*, the Farnese *Hercules*, the *Apollo Belvedere*) or to nature. He wrote about the cultural consequences of politics in various individual "lives,"[23] but in the third preface he chose to underscore the autonomy of artistic progress. He had a powerful incentive for doing so. If ancient art decayed because of foreign invasions, then how should such portentous current events as the sack of Rome, the siege of Florence, and the collapse of the League of Cognac be read? These events were interpreted by historians in vastly different ways, and so too in the field of culture, and at least a few who knew Vasari – Lionardo Salviati and Claudio Tolomei, for example – acknowledged some adverse effects. Vasari, however, remained silent.

Cyclical theories that stage history into *saecula*, if not actual centuries then coherent "ages," presume a timetable. Old age might arrive sooner or later for different cultures, but it will always arrive. Vasari understood this, but no existing timetables by his contemporaries, neither historian nor philologist, helped him to decide where the chronological boundaries of modern art should be placed. Writers before Vasari had periodized art only in its broadest terms – ancient, Gothic, and modern – where modern art was always presented as an undifferentiated whole

and often with no specified starting point.[24] The divisions were also sometimes quirky.[25] Vasari could have turned to literary history for a model since the histories of art and literature were generally thought to follow parallel paths.[26] However, the canonical position of Cinquecento literary history, as it was promoted by Borghini and Salviati, and sanctioned by the Accademia della Crusca, held that Italian literature was born corrupt from late, decadent Latin, matured with Dante, Petrarch, and Boccaccio, maintained perfection from 1348 to 1420, and subsequently declined, only to be revived by Pietro Bembo in the early sixteenth century.[27] "Time cannot make changes other than natural ones whether with language or customs, just as one is born, matures and grows old, one after the other," wrote Borghini in one of his many appeals to life cycles as an explanation for linguistic change.[28]

The congruence of Giotto's and Dante's births could have proved irresistible, but Vasari found in art an entirely different trajectory from poetry, one of continuous improvement. What is so admirable about his conclusion is not just that he invented a new history when a ready-made one was at hand, but also that he had to overcome his belief that there existed "a certain kinship between all of the liberal arts."[29] In other words, he had to resist a popular and appealing belief in cultural unity, that the liberal arts experience historical change simultaneously, a belief that seems to have been especially Florentine.[30]

Unpleasant implications attended the analogy of history as ontogenesis for anyone writing during a golden age. Having meted out the previous ages in one-hundred-year periods, and having entered the second half of maturity, Vasari was caught by an inexorable and distasteful logic that anticipated that art would now "grow old and die." A life cycle that is an autonomous process, irreversible and beyond human control, conflicts with the more optimistic trajectory of unimpeded progress that informs most of the *Vite*. The more he emphasized the accomplishments of Michelangelo, the more firmly he established a case for decline. Underlying his exhortations for hard work, for an invigorating competition amongst artists, for the artist's acquisition of knowledge, and for the generous support of patrons is a belief in the efficacy and hope of self-improvement. His hope, however, was etched with doubt:

> Pondering over this matter many a time in my own mind, and recognizing, from the example not only of the ancients but of the moderns as well, that the names of very many architects, sculptors, and painters, both old and modern, together with innumerable most beautiful works wrought by them, are going on being forgotten and destroyed little by little, and in such wise, in truth, that nothing can be foretold for them but a certain and imminent death; and wishing to defend them as much as in me lies from this second death, and to preserve them as long as may be possible in the memory of the living.[31]

He knew that a "second death" must be approaching and might even be "imminent," but this did not deter him from hope or action. He knew for certain (*per il vero*) that death would come, since the first death in late antiquity predicated the second, but still he believed that it could be postponed by human effort. The two views of historical change contained in the Lives – one controlled by nature, the other by people; one a constant, the other a variable – correspond in their essential outlines to the inherent dualism of style itself: style as innate talent born from

the artist's character or "nature," which changes only as the artist ages; and style as a consciously manipulated artifice that the artist changes to suit the occasion (the subject, the site, the patron). It also corresponds to the "double bind," as Elizabeth Cropper puts it, that Vasari created by urging artists to imitate Tuscan ideals "while simultaneously recognizing that it was impossible to surpass them."[32]

Perfection predicated decline. Vasari did not state this directly, even though it was a common idea in philology at the time, but in 1685, when William Aglionby drew this conclusion for him after paraphrasing and interpreting Vasari's *Vite*, he was not stretching Vasari's intention. Given Vasari's biological model – Aglionby designates the Quattrocento as "Adolescence or Youth" and the early and mid-Cinquecento as "Virility or Manhood" – he thought that art after 1568 should decay. The fact that it had not yet, at least in his estimation, did not invalidate the principle: "I fear, [it] must Decay . . . because all things that have attained their utmost Period, do generally decline, after they have been at a stand for some time."[33] Vasari avoided any direct confrontation of this irony, that artistic success contained the seeds of its own destruction, and he certainly did not theorize it as writers would later, but glimpses of this dilemma can be found. Certainly his decision to include a lengthy account of the decline and death of ancient art establishes a historical epistemology that necessitates a "second death." In the "Preface to the Lives," he anticipated that modern art, having progressed so far, is more likely to decline than improve: "Once human affairs start to deteriorate, they become ever worse until the nadir has been reached."[34] Or, in reference to the cycle of fortune: "After fortune has carried men to the top of her wheel, she usually spins the wheel right round again."[35] In a letter on ancient art, addressed to Vasari and inserted into the *Vite* by Vasari just before publication, Giovanni Battista Adriani applied this sentiment to modern art: "long after the collapse of Europe, the arts and sciences began to be reborn, flourish, and finally reach the pinnacle of their perfection, where truly I believe they have now arrived, so that . . . there is more to fear that they will decline than hope for them to rise higher."[36] And yet at the same time Vasari looked forward to "a fourth age" (*la quarta età*) where he and others would lead art to greater heights:

> I rejoice to see, during your reign, these arts arrive at the highest level of perfection and to see Rome adorned with so many noble artists that, including those in Florence who spend their days working for Your Excellency, I hope that whoever will come after us will write about the fourth age and add it to my volume, an age endowed with other masters and other skills than those that I have described. I want to be in their company and prepare them studiously not to be the last age.[37]

Addressed to Cosimo I de' Medici, this should be seen as a self-serving promotional pitch at least as much as a dispassionate prediction. Yet, like so many others who gazed into the future, Vasari must have felt honestly torn between optimism and pessimism.

* * *

Mannerism as an "Age of Senility"

Vasari's uncertainty about the fate of art was quickly answered by a remarkable consensus in the following generation. The "fourth age" stumbled despite his preparations. Others came along who positioned themselves, as Vasari anticipated, by "add[ing] the fourth age to my volume," first Raffaello Borghini (1584), then Giulio Mancini (1617–21) and Giovanni Baglione (1642). But their verdict would have dismayed Vasari without, however, fully surprising him. The reception of Vasari's aphorism suggests that art historians have been asking the wrong question: not where did his aphorism originate, but what were its consequences. Concerning the question of the present state and future of art, writers from quite different walks of life arrived at the same unequivocal verdict: art was old, dying, or dead. Most blamed the painters themselves: Gabriele Paleotti in 1582, Giampolo Lomazzo in 1584, 1589, and 1590, Borghini in 1584, Armenini in 1587, Giovanni Paolo Gallucci in 1591, and Federico Zuccaro in 1605. Few would have disagreed with the Florentine poet Anton Francesco Grazzini (Lasca), who in 1580 sensed some elusive yet pervasive cause of art's decline: "a certain I don't know what kind of malign influence, either of the sun, or the stars or the moon, or of destiny or fortune."[38] Mancini, however, rendered most explicit what Vasari chose to avoid or mitigate. He called the period from the papacy of Julius III (1550–55) to that of Clement VIII (1592–1605) "the age of senescence and decrepitude" (*l'età della senettù e decrepidità*), thus rendering Mannerism as a final moribund phase of art's life cycle that Vasari had left open.[39] He prepared art for a new history coinciding closely with the start of a new century.

The sadness felt by late sixteenth-century painters looking back at better times (the golden age of Leonardo, Raphael, and Michelangelo) and their anger when those days are compared with their own is palpable in two "Laments" written by and for painters. Lomazzo's "Lament on Modern Painting," dedicated to the Bolognese painter Camillo Procaccini and published in 1589, is more of a rant against his peers than a careful analysis of causes:

> O poor me, unfortunate Painting, I have broken the eyes, mouth, and nose of those painters who are full to the brim with ignorance. . . . I am filthy, emaciated, dried up, and broken into pieces and disarrayed, with dislocated bones and almost half dead; and since there is no one to care for me, I accuse, so that I am more tattered (*strapazzada*) every day. Alas, where are those ancient ones? Alas, where are the good times when I was loved, revered, and taken to be a goddess? Now the rich are more scarce than a Midas, and the painter prostitutes their studio making everything for greed.[40]

The cause of decline – greed and prostitution – refers to Pliny's explanation for the fall of ancient art. What is especially interesting, and typical, is how Lomazzo creates a vivid portrait of Painting's physical decay, all with senescent attributes: poor and withered; desiccated and disjointed. She was once beautiful and loved as a goddess; now she is emaciated, brittle, and broken down. Her tattered (*strapazzada*) gown refers both to the fallen state of painters – the forlorn abandonment of the aged – and to their rapid and careless style of painting.

Federico Zuccaro clearly knew Lomazzo's "Rabisch" when he wrote his "Lament": *Il lamento della pittura su l'onde venete* (Parma, 1605). Like Lomazzo, Zuccaro conjured forth a shabbily

dressed and grieving "Painting" by means of her gown, which he called stained (*macchiata*), referring simultaneously to her poverty and filth and to the cause of her fallen state, Tintoretto's sketchy style of painting.[41] When Zuccaro sees "Painting" wandering along the Venetian shores, he asks her:

> Alas, what do I see? Who has stolen your beauty, and who induced you to such grievous sorrow? . . . This stained dress is the great pain that afflicts my heart and torments my soul. . . . Tell me, I pray you, the reason for such sadness that afflicts and torments your heart? And who has girded you in this dark cloak?" ["Painting" responds:] "Alas, I fell for a Dyer [Jacopo Tintoretto] who gave me hope for great things while he was in the flower of youth. He gave me two bracelets as a token of his love, but then strangely my world was set completely topsy-turvy. Oh what caprice, what crazed frenzy, what furor; but what seems to be worse still is that others followed him in this madness.[42]

Like Lomazzo's "Painting," Zuccaro portrays her as aged, in a fallen state from "the flower of youth." The fierce, contentious tone of these verses signals a passion that transcends the historical review Zuccaro pretends to give. It speaks to the bitterness he must have felt after losing important commissions to Tintoretto, notably the monumental *Paradise* for the Sala del Maggior Consiglio in the Doge's Palace.[43]

Most critics held the artists themselves responsible for the decline. They followed bad examples (Zuccaro's Tintoretto). They became old and greedy (Lomazzo). They acted narcissistically, more concerned with themselves than their audience, displaying their skill pretentiously and thus calling attention to themselves ("intent only to aggrandize themselves," as Paleotti put it).[44] Sometimes their education or society's expectations were blamed. Gallucci, Lomazzo, and Armenini wrote or edited theoretical treatises in order to correct tendencies to work by formulae, routine, and acquired habits (usually described as *di pratica* or *di maniera*) in an ostentatious display mode.

> From this we see that this noble art [of painting] is perversely honored today even though it proceeds with no precepts as a certain guide. Painters propose only their own drawings, or the drawings of others, to imitate . . . reducing painting to practice alone so that, like so many exploding volcanoes and like the blind groping their way, they try to satisfy the ignorant mob by stuffing their histories with a variety of pretty colors. . . . they give their figures forced and unnatural poses that cannot be seen in life . . .[45]

Lomazzo also accused artists of a lack of theory and patience and blamed the "times" for an absence of "such happy talents as in other times."[46] He called his contemporaries "mushroom painters," working without the light of theory, sprouting their bulbous forms from dead and decaying matter, pale and pasty.

Armenini explained the decline by reference to painters abandoning their profession for other pursuits or for a life of indolence; he blamed avarice, hasty work, and even "Nature" in decay for artistic decline.[47] The first sentence of *De' veri precetti della pittura* (Ravenna, 1586) opens despondently, first by paraphrasing Vasari on the possibility of decline and then by making that possibility a certainty:

I have always been and still am of the opinion that the splendid art of painting, though restored to that high and honored place from the squalor and ignominy into which it had fallen in past centuries, is nonetheless not on so strong or stable a footing that one should not rather fear that it will fall again than expect it will rise to still greater heights; indeed, the more I consider its present condition and the state in which it now finds itself, the greater this danger seems. For those craftsmen who raised it to such excellence with such success have dwindled to few, nor does one see their like being born again, and their works, which are so marvelous, are being consumed by time.[48]

He hopes that his precepts will "delay the collapse," but fear permeates the book, especially when he turns to the hordes of pedantic *Michelangelisti*: "What can we expect but that some day art will fall back into the simplicity and awkwardness in which it had been piteously buried for many centuries, along with many of the arts and sciences, by the barbarism of the Goths, Vandals, Longobards, and other foreign nations?"[49]

Both Lomazzo and Armenini wrote from bitter personal experience. Armenini was a learned painter whose ideas always outstripped his technique and vision, eventually forcing him to abandon his profession. His conclusion reveals an autobiographical nexus of his failure as a painter ("you will not see any of my works achieve fame"), his failure as a writer ("I am certain that my work would have had a more solid foundation and greater perfection than it now has if I had been less oppressed by hostile fortune and old age"), and the failure of modern painting.[50] Like Lomazzo, who started writing only after he became blind, Armenini may be said to have projected his own disappointments onto his contemporaries. The "imperfect condition of our present age" helps him to rationalize his own career failure.

The treatises by Lomazzo and Armenini in particular, as well as the theological art critics, set the stage for Giovanni Battista Agucchi, whose influence on seventeenth-century art criticism was profound (even though the "Treatise on Painting" remained largely unpublished until the twentieth century). Written between 1607 and 1615, Agucchi first articulated the decline-and-revival sequence whose effects still linger in art history today:

Then [after the deaths of Raphael, Michelangelo, Correggio, Leonardo, Sarto, and other early and mid-sixteenth-century artists] there came about the decline in painting from the peak it had gained. If it did not again fall into the dark shadows of the early barbarianism, it was rendered at least in an altered and corrupt manner and mistook the true path and, in fact, almost lost a knowledge of what was good. New and diverse styles came into being, styles far from the real and the lifelike based more on appearance than on substance. The artists were satisfied to feed the eyes of the people with the loveliness of colors and rich vestments.[51]

The Carracci then came along and "very soon they saw that it was necessary to restore art from the state it had fallen because of the corruption we had discussed." The Carracci, as reflected in mid-seventeenth-century art literature, were instrumental in defining mid- and late sixteenth-century painting as a dying or decadent art. As their role as the "restorers" of art solidified, so too did the art that needed restoration. Metaphors like "rebirth" and "sunlight" that were applied

to the Carracci concordantly asserted the historical position of Mannerism as a dark ages, barbarian and senescent.

Why did opinions about art's decline cohere so quickly and so uniformly? Certainly Vasari's life cycle of art promising descent into old age prepared art writers to find it, but why did they find it during the last two decades of the sixteenth century? The number of voices heard about contemporary art during these years, although unprecedented, is partly a by-product of a spike in art publications in the 1580s and 1590s:

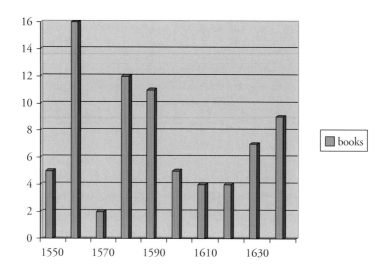

Graph 4 Numbers of books on art, published in Italy, by decade.

This, however, merely postpones an explanation. Why, we should then ask, did art literature flourish in just those years when art was perceived as in decline? The traditional but still current view is that ages of codification and reflection follow ages of innovation. An anonymous article in the short-run journal *Memorie per le belle arti* (February 1787) commented on the "strange proposition that the age where one finds the best writing on art is not that when artists make the best work."[52] There were practical reasons as well. Art academies included theory in their curricula on the premise that art had sunk into *pratica* and needed reform. Federico Zuccaro and Federico Borromeo founded the Accademia di San Luca in Rome and the Accademia del Disegno (Ambrosiana) in Milan respectively as institutional correctives to decline. Borromeo was familiar with Zuccaro's ideas by 1593, when he became the first Cardinal Protector of the Accademia di San Luca, and Zuccaro's *De origine e progresso dell'Accademia del Disegno* (Rome, 1605), co-written with Romano Alberti, was dedicated to Borromeo.[53] These were golden years for literary academies as well, along with their penchant for definition epitomized in the magnificent Crusca dictionary project. Above all, the Catholic reform, starting with the twenty-fifth session of the Council of Trent in 1563, can be credited with the sense of decline. The reformist movement as represented by Gilio da Fabriano, Paleotti, Gregorio Comanini, Bor-

romeo, and Johannes Molanus, amongst others, wanted to reinstate the primacy of the text and narrative clarity over artistic flourishes like anatomical and compositional complications. Decorum and decency trumped artistic originality.

<p style="text-align:center">* * *</p>

Agucchi left the chronology of decline and revival vague. Giulio Mancini, physician to Urban VIII and ruthless collector of art, corrected this a decade later in the "Considerations on Painting," written between 1617 and 1621 and left unpublished until 1956.[54] Like Agucchi's manuscript, it reached a wide audience nonetheless. Mancini's purpose was multifold: to update and correct Vasari; to be the first writer on connoisseurship; and to provide chronologies for a "universal" history of art. Mancini was the first to define Mannerism as an integral period with a defined chronology, and the first to show how Mannerism was figured through the concept of senility. He did not label Mannerism with any *maniera* cognate, nor did he assign to it many of the stylistic features that later became identified with Mannerism, nor was he even consistent in his evaluation, but he was the first to define its temporal boundaries and to render it as a closed period of art history. He was also the first to give it a name, "the age of senility," which, invented as it was by a physician, takes on an air of authority. Writing just as the last generation of Mannerists was dying off, Mancini essayed a new history of later sixteenth-century art with a chronological structure where none existed before. The difficulty of this endeavor and the originality of his solution should not be shadowed by the conventional wisdom that it helped to shape.

When Mancini diagnosed art as slipping into "an age of senility," he brought together two entirely original, albeit dubious, insights to the history of Mannerism: that it started in 1550 and ended in 1605; and that it was the moribund phase in a life cycle that had started in 1200. In defining its chronology, he wrote as a connoisseur (his *Considerazioni* is the first work on connoisseurship); in defining the biological or psychological attributes, he wrote as a physician, which is to say that his inventions of a periodized and pathologized Mannerism arose from a happy convergence of interests and training. As a collector and connoisseur, chronology and style stood at the center of his interests. His success in attribution and dating arose from his medical skills of autopsy and from his narrow focus of interests.[55] He examined paintings following a methodology that could not have differed too far from the diagnostic techniques he learned as a physician, seeking physical signs such as craquelure, varnish, underpaint, and brushwork that could unlock inner secrets.

Because dating is an important function of attribution, Mancini included a lengthy section, nearly half of the manuscript, outlining a universal "Calendar of painting" from Egypt to the present. He invented two divergent chronologies.[56] The less sophisticated one divides the history of art into ten sections: Egyptian and Etruscan; Greek; age of Augustus; age of Nero; age of Titus; catacomb painting; painting from the fourth to the twelfth centuries; Byzantine painting; painting from 1200 to 1550; and painting from 1550 to 1600. The divisions are abrupt, uneven, and lopsided. Most startling and with no accompanying explanation is the importance assigned to the brief fifty-year period of 1550 to 1600. In his more

sophisticated scheme, he divided history into two separate cycles – ancient and modern – each divided into four periods and modeled on the stages of life: *Fanciullezza*, *Gioventù*, *Virilità*, and *Decrepitezza* or *Senettù et decrepità*. Infancy (*fanciullezza*), from *circa* 1300 to the death of Julius II in 1513, enjoyed a brief spurt of youth (*gioventù*) and then settled into the most perfect period identified either as virility (*virilità*) or simply perfection (*perfezione*), which dates from 1521 to the investiture of Julius III in 1550.[57] The period from the papacy of Julius III (1550–55) to that of Clement VIII (1592–1605) was the age of senescence (*senettù*).[58]

Mancini also divided ancient art into four periods (*tempi o età*) without, however, consistently giving them anthropomorphic labels or even the same rate of rise and decline. Infancy and youth are folded into a single crude (*rozzezza*) stage preceding the rise of the Roman Empire.[59] Perfection (*perfezione*), which was also an alternate title for the modern period of virility, lasted from 27 BC (Augustus) to AD 284 with Diocletian. A shorter period of decline (*declinazione*) from Diocletian to Constantine (d. 337) was followed by a final lingering stage of decrepitude (*decrepitezza*) that lasted until art was reborn in the fourteenth century. The infancy of modern art follows the decrepitude of ancient art. Modern art, also having four periods with a decline into debilitating old age, is thus a sequel to and re-enactment of the previous cycle.

In dividing ancient and modern art into four periods each, Mancini created a mirrored structure that gives ancient art a prognostic value for emerging patterns of modern events.[60] The past also confirms his diagnosis of mid- and late sixteenth-century painting as old and decrepit. Like Vasari, who used Adriani's history of ancient art as a preface to his own modern history, Mancini believed in the reciprocity of past and present; yet unlike Vasari, who wanted to avoid or mitigate when he wrote that "the arts, like human beings, are born, grow up and become old and die," Mancini made it explicit. He uttered what Vasari dared not admit.

Mancini was not alone in identifying the Carracci with a revived art – the first explicit statement on this subject came from Benedetto Morello, who proclaimed in 1604 at Agostino Carracci's funeral that the Carracci were "the sole restorers of the true way of painting" – but he and Agucchi did initiate the contours of decay and rebirth that became the dominant view by mid-century. Agucchi and Mancini remained in manuscript and, although widely read, they never attained the influential reach of Bellori, Passeri, Malvasia, and others. That Agucchi and Mancini sketched out a chronology of a seventeenth-century renaissance that remains canonical even today is either an instance of astute prescience or, as revisionist historians might want to argue, a case of how tenacious early constructions of history are. Because their ideas survive today as roughly valid, they tend to sound obvious, but neither Agucchi nor Mancini had the luxury of hindsight. In 1603 the Bolognese painter Francesco Cavazzoni divided the history of art into five segments: ancient; 1500–25; 1525–50; 1550–75; 1575 to 1603.[61] This arbitrary and ham-fisted periodization reminds us of the difficulty faced by art writers when they try to impose order on a murky temporal landscape, growing ever more murky the closer one moves to the present.

Mancini was uncertain what style to give to the "age of senescence." He says little about its formal attributes, and the brief references to individual styles show no evidence of a predispo-

sition to use periodization metaphors. He does, however, give one interesting clue that was picked up by later writers. Old-age styles – both individual and collective – are called "washed out" (*dilavata*), suggesting an enervated world of shadowless pastels. Later *dilavata* became a common property assigned to late Mannerism by Malvasia, Baldinucci, and others, and, stranger still, became the main frame of reference for critiquing old-age seventeenth-century painting (the followers of Guido Reni's late style).[62] The most explicit writer in this respect was Vincenzo Vittoria, an inspired Spanish polemicist and insipid painter working in late seventeenth-century Rome. He is best known for a fierce pamphlet, *Osservazioni sopra il libro della Felsina Pittrice per difesa di Raffaello da Urbino, dei Carracci e della loro scuola* (Rome, 1703), attacking Malvasia's *Felsina pittrice* (Bologna, 1678).[63] Vittoria sought instances of bias against Raphael, no matter how slight or imaginary; the slanderous charge that Raphael was a "dry" painter especially concerned him. According to Vittoria, his teacher Carlo Maratta "angrily rejected the vulgar opinion current in our century that one should not follow Raphael in order to avoid having a dry and stony (or *statuino*) manner."[64]

Vittoria's comments on Mannerist painting appear in a still-unpublished dialogue in Spanish between "Carlo Maratta," "Giovanni Pietro Bellori," and a "Disciple" (Vittoria himself): *Academia de pintura del Senor Carlos Maratti* (*circa* 1687). In Maratta's *Academia* on the Pincio in Rome across seven "nights," they discuss a scattering of theoretical and historical issues.[65] The last three "nights" include a history of art, which, after recapitulating Vasari's history, moves on to the late sixteenth and seventeenth centuries. There "Bellori" labels the age of Vasari, Salviati, and Zuccaro as "the age of decrepitude" (*etad decrepida*) and gives it attributes that could be conventionally associated with old age: "that ideal and languid style" and "that languid and insubstantial style" (*quel estilo ideal y languido* and *quel estilo languido y insustanesa*).[66] Vasari and Salviati shared the Mannerist qualities of sluggish, indolent, and weak painting in their individual styles, "ideal and washed-out" according to Vittoria.[67]

Old-Age Mannerism

None of the early critics of Mannerism labeled this senescent period with any *maniera* derivative. When such terms were first coined – *Maniéristes* (1667), *ammanierato* (1681), *Manieristi* (1708), and *Manierismo* (1756) – they designated a period style only occasionally. More often they described a common tendency in all periods toward artificiality, introversion, speedy execution, and compositional complications. When they happened to refer to a specific period, and this tended to occur in the eighteenth century and not before, the chronology is unexpected. Anton Maria Zanetti completed Vasari's life cycle of art by dividing the history of Venetian art into five century-long periods: birth (Duecento and Trecento), growth (Quattrocento), maturity (Cinquecento), decay (Seicento), and rebirth (Settecento).[68] The Seicento Mannerists (*manieristi*) are a group of early and mid-seventeenth-century painters, starting with Palma Giovane (1544–1628) and ending with Pietro Bellotti (1627–1700).[69] The period is not defined exclusively by chronology – amongst painters of the revived "modern" style are some born in the 1630s: Antonio Zanchi, Andrea Celesti, and Sebastiano

DELLA PITTURA
VENEZIANA,
E DELLE OPERE PUBBLICHE DE'
VENEZIANI MAESTRI.

LIBRO QUARTO.

IO mi trovo esser giunto ad uno di que'
molesti passi, a cui ridur si suole ogni
scrittore d'istorie. Dopo una bella serie
d'illustri fatti, che dan vigore allo stile
di chi scrive, e rallegrano l'animo di chi leg-
ge, giungono circostanze che diverso effetto pro-
ducono; e che trasandar non si possono senza
offendere la veracità indivisa compagna degli ono-
rati racconti. Spiacevoli eventi della Pittura no-
stra ora narrar mi conviene; accrescendosi in me
la molestia per l'istessa natura della materia,
nimica al genio mio interamente. Perciò io
pre-

41 Chapter heading from Anton Maria Zanetti,
Della pittura veneziana, Venice, 1771

Bombelli – but by an artistic practice detached from nature and rule.[70] Zanetti's biological cycle situates the Seicento Mannerists in the position normally reserved for Cinquecento Mannerists. The Baroque is Mannerist. And both were senescent. Zanetti represented the Seicento Mannerists emblematically by the header image of paintbrushes and maul-stick bound at the center and flanked by a pair of splayed wings (pl. 41). The wings stand for the speed and flight of pictorial imagination, but perhaps also for the flying squadrons of Baroque figures.

No early history of Mannerism and its terminology has yet been written, but when it is, one crucial chapter will be Baldinucci's invention and application of *ammanierato*. He coined the term at the end of his definition of *maniera* in the *Vocabolario toscano dell'arte del disegno* (Florence, 1681) in order to warn against the inherent dangers of style itself:

> From the root *maniera* comes mannered (*ammanierato*) which one says of those works where the artist, distancing himself a lot from the true, draws entirely upon his own style as much in making human figures as animals, plants, draperies, and other things; these things could well appear to be made with ease and boldness, but they will never be good, nor will they have much variety. And this vice is so universal that it embraces, more or less, almost all artists.[71]

Baldinucci's neologism was quickly adopted by writers on art, suggesting a semantic need for such a term at this time when styles of contemporary art seemed to be ever more mannered.[72] Baldinucci did not intend *ammanierato* to be a period term – on the contrary it indicated "a vice . . . so universal that it embraces, more or less, most all artists" – although in practice he did use it as a period-specific failure starting with the followers of Raphael and ending with Cesari d'Arpino.[73] Artists identified as *ammanierato* would never fit under any modern label of Mannerism: Andrea Boscoli (1550–1606), Ventura Salimbeni (1567/68–1613), Giambattista Vanni (1599–1660), and Pietro Ricchi (1606–1675).[74]

Readers of Baldinucci embraced the term and applied it widely. Bernini's style was thought to be "mannered" because it was "far away from the boldness, good taste and noble simplicity of the ancients."[75] Borromini and Marino were twinned as mannered artists who over-embellish (*infrascare*).[76] Other artists fingered as "mannered" by various critics included Giovanni Bellini,

Michelangelo, Cesari d'Arpino, Orazio Borgianni (1578?–1616), Giovanni Lanfranco (1582–1647), Pietro da Cortona, Luca Giordano (1632–1705), Giuseppe Maria Crespi, Francesco Solimena, Antonio Balestra, Sebastiano Ricci, and Giambattista Tiepolo (1696–1770).[77] Those doing the fingering tended to hold Raphael as the gold standard for all art forever. One of Mengs's correspondents knew just what to say: "The worst thing to say of a painter is that he is mannered. Giordano, Solimena, Corrada [Giaquinto] and all others of his school are models of mannerism."[78] The new renaissance ushered through the ruins of Cinquecento Mannerism evidently met the same fate, only sooner than anyone had suspected.

Instead of applying *ammanierato* to Mannerism as an "age of senility," although he did do that once, Baldinucci preferred to characterize the style of aging artists as "mannered" (see "Old Narcissists" in chapter 2). Pietro Liberi (1614–1687), Ventura Salimbeni, and Mario Balassi (1604–1667) fell into mannered styles in old age, "as it happens with even with most of the best masters."[79] "Bending to old age," Luigi Lanzi wrote of Domenico Tintoretto, "he ran up against mannerism."[80] After reading Baldinucci's definition of style, Roger de Piles concluded that there are three stylistic stages in an artist's life:

> the first, which derives from the style of his master; the second, which is formed according to his own taste and in which resides the true measure of his talent and genius; and the third, which usually degenerates into what one calls the mannered (*maniéré*) because a painter, after having spent much time studying nature, wants to revel in habit instead of consulting nature any longer . . .[81]

De Piles thus made explicit what was implicit in Baldinucci's definition: that mannered styles were a general and seemingly unavoidable consequence of aging. Titian, whose fourth and last style "degenerated into habit," typified this unhappy deterioration.[82]

Because Mannerism was explained with various paradigms, not just senility, the visible symptoms varied depending on which epistemology was chosen. The belief that Mannerists are speedy painters, for example, is incompatible with Mannerism as senility.[83] On the other hand, the Mannerist propensity to be repetitive, confusing, sloppy, and loquacious in packed compositions conforms with a psychological profile of old age.[84] Old age as a cause of mannered painting seemed obvious to critics because the elderly tend to repeat themselves: "The old man talks much, though you hate it, and repeats it, / Then trembles and abandons what he said."[85] As the imagination cools in old age and as new memories dry up, the elderly turn to the past and start telling the same stories over and over. The Perugino-effect of repeated formulae (discussed in the Introduction) was founded on anecdotal geriatric psychology that has been confirmed by recent research. Using CAT scans of brain activity and how it changes with age, neuro psychologists have established how repeated, patterned responses carve out preferred neuro pathways. Apparently frequent use encourages further use. Everyone evidences a deepening of habit with age, but, as the Bolognese painter and art historian Luigi Crespi explained, Mannerists aged prematurely because their habits became fixed at an earlier age: "those painters called *manieristi* fall even sooner into decrepitude."[86]

* * *

Another neglected chapter in the history of Mannerism involves Roland Fréart de Chambray's neologism *maniériste* in his *Idée de la perfection de la peinture* (Paris, 1662):

> Poor Domenichino, the most learned of the Carracci pupils and possibly the only one deserving the name of painter today, has suffered this disgrace for a long time; almost all of his rivals are very inferior to him. . . . One will have to say of the blindness of painters of our day that they prefer to Domenichino the Giuseppini, the Lanfranchi and other similar mannerists (*manieristi*) whose paintings have only the false splendor of an "I don't know what" novelty which moderns call a fury of drawing and a boldness of the brush . . .[87]

This passage is framed, on the one hand, by a defense of Raphael against the "cabals" of critics like Boschini and Salvator Rosa, who were then denigrating Raphael's reputation,[88] and, on the other hand, by an acclamation of Poussin as "the most perfect of all the moderns" who alone has kept alive Raphael's art. He singled out Cesari d'Arpino and Lanfranco as the Mannerists and goes on to note that they were preceded by Samacchini, Parmigianino, Veronese, and Tintoretto. All were "superficial geniuses." What is most interesting about Fréart's "cabal" of "mannerists" is that it originated in the sixteenth century and continued to thrive unabated in 1662. It was an Italian problem that, in his view, only a Frenchman (Poussin) could resolve. By making Mannerists foreigners, Fréart was following mid-sixteenth-century criticism of *di maniera* painting that always referred to foreign or old-fashioned art. Gelli applied it to Byzantine mosaics; Vasari, writing from the vantage of a self-described age of artistic perfection, applied *maniera* to the second-age painter, Perugino, who "made all the figures with the same expression"; and the Venetian Dolce applied it to the Florentine Michelangelo, where "the forms and faces one sees are almost always alike."[89] Mannered painting at this stage in its history was an outsider's view of someone else's art (geographically or temporally), of Dolce looking at Michelangelo, of Vasari looking at Perugino, of Gelli looking at Byzantine mosaics. Fréart de Chambray in 1662 and Antoine Coypel, in a lecture to the French Academy in 1712, identified "mannerists" as modern Italians; from their perspective, French Mannerists did not exist. Passeri, the eighteenth-century Passeri, called Mannerism a foreign contagion that induced a perpetual state of unrest and agitation, making art appear more German than Italian.[90]

Fréart de Chambray's Mannerists as bad and foreign artists coincided with a broader critique of Italian culture as exhausted and senescent.[91] According to Dominique Bouhours, "the last century was for Italy an age of learning and civility; they furnished Europe with the greatest minds since the age of Augustus. The present century is for France that which the last century was for the Italians. . . . Compared to the French, all other peoples are barbarians."[92] These comments appear in *Les Entretiens d'Ariste et d'Eugène* (Paris, 1671). His next book, *La Manière de bien penser* (Paris, 1687), militated an angry pan-Italian response, including the multi-authored and multi-editioned *Considerazioni sopra un famoso libro franzese intitolato La manière de bien penser* (Bologna, 1703; Bologna, 1707; Modena, 1735), which dissected Bouhours' comments on Italian art and literature with passionate detail. A year later Fontenelle in his *Digression sur les Anciens et les Modernes* (Paris, 1688) claimed that as France entered a time of "mature virility" Italy sank deeper into an age of "senility."[93]

How did the Italians respond to French calumnies? What must it have been like to find oneself within two generations being demoted from the new Athens to a cultural backwater living in the past? One obvious strategy of self-defense would be retaliation. There were passionate nationalists – Giusto Fontanini, author of *Dell'eloquenza italiana*, advocated a linguistic purging of words with French or Spanish origins – but most Italians at the turn of the century agreed that the French had surpassed them in most intellectual and artistic areas. Bernini's critique of French architectural style as cramped and feeble, petty, miserable, and niggly, relied for its effect on its evocation of old-age attributes.[94] However, most Italians blamed themselves. Muratori acutely felt the loss of cultural empire – "you wouldn't believe how much Italian literature has decayed"; "we miserable Italians, famished for good writing" – but he rejected theories that assigned the cause to external or foreign influence, "civil wars, invasions of barbarians . . . or the tyranny of princes." Instead, he found the cause in contemporary morals and psychology: "nothing other than pure laziness (*ozio*). Laziness is that monster that little by little poisons minds and discourages them from the difficult road of virtue." He saw signs that "a few Italian minds have awakened from their slumber."[95] By *ozio* Muratori meant a combination of psychological pathologies: passivity, lethargy, habituated to the familiar, and self-complacency. "To wake the Italians from their sleep" was a related figure of speech he often used. Sleep, drowsiness, lethargy, self-satisfaction: these are also commonplace attributes of old age.

The prevailing opinion in Italy at the turn of the century was that Italian culture had declined into mediocrity, even into "decadence" (an oft-used term): political servitude, intellectual torpor, and economic decline were seen as the causes. In the art world, we have Bellori complaining in 1668 to Carlo Dati about the scarcity of good painters living in Italy and about the mediocrity of painting and poetry in general.[96] Bellori's friend and admirer, the painter Carlo Maratti, spoke in similar terms: "our century laments in vain that good painters do not exist or issue from our schools and that most of the most conspicuous works are badly done since our painters have abandoned their studies and good principles."[97] Giovanni Pietro Zanotti, in his first bit of art writing, a slight biography of Lorenzo Pasinelli in 1703, described contemporary painting as "decadent and enfeebled."[98] The cultural critique generally followed the lines established in antiquity to damn Asiatic oratory (another foreign style). According to Antonio Conti, the French were known "for the brevity, purity, and precision of their ideas and for the clarity and simplicity of style," whereas the Italians (like old men) "clouded and crowded their thoughts with doubts and ambiguities."

Italians who foresaw a new barbarian age gave it attributes normally associated with old age. Lorenzo Panciatichi, writing to Lorenzo Magalotti, understood it as part of a natural process, calling upon biological metaphors of transplantation and sterility for his explanation: "We Italians see from experience that the arts have crossed the Alps, transplanted and taken root in those countries that were called barbarian in other times but today are more civilized and learned whereas here the arts are withering away on sterile soil."[99] Others wondered how a new barbarianism could have descended on their country so quickly; how, as Benedetto Bacchini asked in a lecture given in 1690, Italy succumbed to "a new decay and languished again from exactly the same sickness."[100] Others saw in the similarity of symptoms – a Gothic Baroque – proof of

history's cyclicity. Benedetto Menzini, one of the founders of Arcadia writing in 1692, took the decline to be a natural and inevitable part of the historical process: "If Italy gradually declined from its most sublime degree, this occurred for the same reason that human bodies do likewise: when they arrive at the peak of truly perfect health, being able neither to improve upon this nor to remain long in this state, they must naturally decline."[101]

7 Turning Points: Micro-Macrohistories of Aging

Modern historiography employs the notion of "crisis" to invest history with a dramatic tension and narrative shape.[1] Crisis was originally a medical concept that described the turning point of a disease or, for the elderly, the initiation of death. The turning points of this chapter, although not labeled crises, functioned in similar ways. Three case studies – Raffaello Borghini on Pontormo; Pietro da Cortona on Cesari d'Arpino; and Francesco Scannelli on Guido Reni – will show how the old ages of influential artists were seen to precipitate a crisis in the "body of art" (to use Scannelli's medical metaphor) and lead to its decline. They envisioned history pivoting around the old age of Pontormo, d'Arpino, and Reni. The twinning of Pontormo's senescence with the origins of Mannerism rests on an organic metaphor that explained historical change in relation to body experiences. If art ages like artists, as Vasari and Mancini claimed, then a logical consequence would be to find a simultaneous senescence of art and artist at crucial moments in history. Not only is the template of historical decline found in the aging of artists, but the senility of an artist can infect the artistic community as a whole. Mannerism was a plague – "that shameful plague of AMMANIERATO" (Gabburri) and "a modern plague" (Zanotti) – just as the Baroque was deemed a "Gothic plague" (Albani and Bottari) and "a spreading plague."[2] Niccola Passeri had Mengs criticize Seicento Mannerism as "an infection that corrupts," one that needs "the expert hand of a surgeon to cure this cancerous plague."[3] Gothic art was the original plague.[4] By pathologizing Gothic, Mannerist, and Baroque art as plagues, they suggest that bad styles are contagions infecting a healthy society with deformity and pervasive decay, and that, like the plague, they inevitably return. Vasari, looking at Pontormo's frescoes in San Lorenzo, feared that he would be infected by the artist's madness.

The conjunction of an artist's death with the death of art probably originates in the grand funerals of Raphael and Michelangelo. Raphael, as Vasari famously told it, died painting the head of Christ in the *Transfiguration* (Vatican, Pinacoteca) and lay in state along with his final work hanging "at the head of the room . . . where his dead body and [Christ's] living body could be seen together." This was re-enacted by the new Raphael – Anton Raphael Mengs – who lay in state with his unfinished *Annunciation*.[5] The final paintings of Raphael and Mengs mark the end of their lives and their art. The two "bodies" coexisted, one mortal, the other eternal. Raphael reputedly was painting the head of Christ when he died on Good Friday, and, according to Vasari, "when this most noble painter died, Painting died too when she shut her eyes and remained almost blind." For Raphael lovers in the early seventeenth century, his death marked the end of Renaissance painting and the beginning of degraded "senile" Mannerism.

Old age, endings, and last works weave through much early criticism of Pontormo's San Lorenzo frescoes, as we discovered in chapter 5. Last works tended to be viewed through the ameliorative lens provided by Pliny: "for in them [the last and unfinished work] the line drawings are exposed and the plans of the artists can be seen, and in the midst of our blandishments of approbation is a sadness felt for a hand stilled even as it created."[6] Like dying words or deathbed confessions, last works for early modern writers are invested with a tragic nobility, truthful and transcendent.[7] It may be this intimacy between viewer and dying artist that led critics to believe that an artist's final work "exceeds every other."[8]

When Armenini turned to last works by mannered painters, however, he came to an opposing conclusion. Last works do sadden, he tells his readers, but not because an artist dies or because we see his death in the unfinished work, as Pliny would have it, but instead because they are the ignominious ends to illustrious careers. They may be truthful like other last things, but their truths reveal only the stains of old age:

> This [uneven quality of production] is best seen in the last and most important works made by men of great repute, such as those by Pietro Perugino painted in Florence, and those by Domenico Beccafumi in the chapel of the Duomo of his native Siena, and even more in the work of Jacopo da Pontormo in San Lorenzo, also in Florence. Being in such honored and great places, their paintings succeeded only in being much worse than all the others they made before. And certainly in considering this matter, I cannot help but wonder at those (and there are some) who, having work delivered into their hands, think they will be praised as skilled and gifted inventors and makers of *storie* by executing them quickly. In their works . . . they succeed only in becoming new masters of confusion, for immediately upon receiving the subject they begin to give it form by piling up many figures without regard for the limits of composition, using their own personal ways so that one can say that they found their inventions and planted them in their works . . .[9]

Armenini groups together Perugino, Beccafumi (*circa* 1486–1551), and Pontormo because each of them piled figures chaotically and artlessly in old age. Each of them deteriorated with age, inclining toward solipsism. These old men, these "new masters of confusion," paint their senility or dementia by "piling up many figures without regard for the limits of composition." When Armenini labeled their late works as "found" inventions, he is recalling Pliny's stories of images made by chance (Protogenes' tossed sponge accidentally depicting saliva on a dog's mouth) or images discovered in nature (figures in clouds or in stones). The found inventions of old artists, however, are not formative but deformed, piled, and "without limits." They acquire the chaotic degradation of old bodies no longer subject to the terms or limits of good composition. Beccafumi's frescoes in Siena Cathedral have an "ariaccia di volti spaventata" (pl. 42).[10] The image of compositional piles (*l'amucchiar di molte figure*), where the order and harmony of art degenerate into a mass, powerfully evokes associates of death and decay: a rubbish heap, perhaps, or a mound of plague corpses.

* * *

42 Domenico Beccafumi, *Ascension,* detail (Siena Cathedral)

Raffaello Borghini was the first writer, at least to my knowledge, who tied the old age of an artist to the decline of art in general. Borghini, nephew of Vasari's literary and iconographic adviser, Vincenzio Borghini, is not generally known as a deep or original thinker, probably with just cause, since *Il riposo* (Florence, 1584) is mostly a pastiche of Vasari, Doni, Gelli, Alberti, and others. His historical importance, such as it is, lies mostly in his comments on collecting, his opinionated responses to contemporary art, and his chosen literary form, a dialogue between a painter, a sculptor, and two noblemen.[11] Twenty-six years younger than Vasari and twenty-two years his uncle's junior, Borghini represents the generation of theological critics who cut their teeth on Michelangelo's *Last Judgment*. He condemned the fresco in the cupola of Florence Cathedral by Vasari and Federico Zuccaro, completed four years before the publication of *Il riposo*, for its excessive license, despite the fact that his uncle was one of its iconographic advisers.[12] Borghini, who was also a playwright, composed his dialogue with a large cast of real-life characters: a Florentine humanist and art collector, Bernardo Vecchietti; a sculptor and

nephew of Ridolfo Ghirlandaio, Ridolfo Sirigatti; and two Florentine noblemen, Baccio Valori and Girolamo Michelozzo.

Borghini envisioned the artist's life as a mountain that must be scaled. Some, like Pontormo, succeed in reaching the pinnacle of artistic perfection with their mature works; but what happens afterwards with the onset of old age? The artist can choose to remain at the top, stop painting, and counsel others from his superior perch; or, like Pontormo, be forced to descend. In Pontormo's case, on his way down the slope, he dragged the rest of art along with him. His *Flood*, or the end of civilization, became a turning point of Florentine artistic culture, the beginning of the end.

In Borghini's *Riposo*, it is Vecchietti who torments Sirigatti after he defended Pontormo's San Lorenzo frescoes. After condemning contemporary painters in general, Vecchietti launches into a three-page monologue detailing exactly how the frescoes are "badly observed." Artistically, the figures are painted "without any taste . . . in a shameless and unbecoming way," without artifice, good coloring, order, or grace.[13] Worse still are the iconographic mistakes: the *Flood* has no water, just dead bodies; the bodies in the *Last Judgment* are depicted at various stages of resurrection. Many, if not most, of the flaws are exactly those that Gilio da Fabriano complained about in Michelangelo's *Last Judgment*, thus locating Pontormo as an indiscriminate and stupid follower of Michelangelo. Like other *Michelangelisti*, he paid more attention to anatomical display than to the emotional and biblical content. In Borghini's parodic take,

> Pontormo made a great mountain of fat corpses, a disgusting thing to see, where some are shown being resurrected, others already resurrected, and others dead, shown in unseemly poses. And above, he showed some big babies with exaggerated gestures, sounding the trumpets, hoping that we will know them to be angels.[14]

Borghini could just as easily be describing the frontispiece of Vasari's *Vite*, or the frontispiece of his own *Il riposo* that he recycled from the Torrentino edition (pls. 43 and 44). In the lower level of the Torrentino and *Riposo* frontispieces, below *Fame* and the three arts of design, the ground cracks open, almost like an egg, to reveal within its shell a clutter of agonized, dying, and dead figures. This subterranean and probably infernal space resonates differently within the texts they introduce. For Vasari, it represents "the ravenous mouth" (*la voracissima bocca*) that devoured the ancients and threatened the moderns. His *Vite* would forestall "this second death" (*questa seconda morte*) for modern painters by preserving their memory. (Ironically, one means of preservation mentioned by Vasari involved a search for written evidence that awaits a fate, unless saved by Vasari, as "prey to dust and food for worms" (*in preda della polvere e cibo de' tarli*).[15] Vasari made his point of resurrection and survival more explicit in the Giunti frontispiece where the figures, possibly "the works of art mentioned by Pliny dug out of the earth,"[16] are clearly being resurrected, a fact that Vasari emphasized in his majuscule marginal inscription: "I PROCLAIM THAT WITH THIS BREATH THESE MEN HAVE NEVER PERISHED . . ."[17] Read within the context of the *Riposo*, however, the figures look terminally conquered. Decomposing underground, they represent the author's more pessimistic view of art's future. Because Borghini's history of modern art starts its decline into Mannerism with the San Lorenzo frescoes, it is possible to see the cutting

43 Frontispiece of Giorgio Vasari, *Le vite de' piu eccellenti pittori, scultori et architettori*, Florence: Giunti, 1568

and piling of figures in the frontispiece as a prefiguration of his arguments against Pontormo's carnal piles.

Besides being lifeless and decomposed, Pontormo's and Borghini's figures appear chopped up into limbs, torsos, heads, visually severed, with few whole figures. The figures are not actually cut up, but the piling produces this effect visually. This figural anatomization was integral to Pontormo's working method in old age. He was a slow worker, probably slowed further by age.

44 Frontispiece of Raffaello Borghini, *Il riposo, in cui della pittura e della scultura si favella*, Florence: Giorgio Marescotti, 1584

The marginal drawings in his diary are a unique record of activity and accomplishment, recording day by day or week to week which arm or leg he painted that day. A day's work never resulted in more than a single limb. Scanning the margins of his diary we see dismembered bodies or limbs waiting to be assembled (pls. 39 and 40). As his diary makes clear, he rarely worked continuously on one section of the fresco during these last years but shifted restlessly from one part to another. His concentration wandered like other old men's. Most early modern critics noticed how Pontormo thought more in terms of parts than the whole: "There may be in this work some part of a torso, with its back turned, from the front, and some side views" (Vasari); "Almost all the poses are unbecoming and illegitimate, and the only good parts are a

few muscles" (Borghini); "There are many beautiful things in the parts of these bodies, such as the distinction of muscles, the work as a whole is very confused" (Cinelli).

Other followers of Michelangelo besides Pontormo fell into this trap of pursuing emphatic anatomical detail at the expense of a unifying beauty. These "sophistic talents," wrote Armenini, "lost themselves in the details of the nude body . . . and engaged in long grand debates about every petty line of anatomy."[18] Giovanni Andrea Gilio da Fabriano, after writing the first extended critique of Michelangelo's *Last Judgment*, warned "the new anatomical painters" from making perversions of natural figures, what he linguistically mirrored as "figure, figurette, figuraccie e figuroni" and compared to "barbarian Latin."[19] Borghini complained that Florentine painters following Michelangelo "disposed and divided" their figures with rows of disembodied heads (*molti capi sopra capi*).[20] Pontormo sank into these lowly ranks of deluded followers, a tragic fall for an artist who was blessed in youth by Michelangelo – "This young man . . . will exalt painting to the very heavens" – and who later served as his amanuensis. Pontormo's harshest critic and fellow adulator of Michelangelo, Giorgio Vasari, specialized in the piled style that became identified with the failure of Mannerism, especially in his altarpieces for Santa Maria Novella and Santa Croce in Florence.

<p style="text-align:center">* * *</p>

Structurally, within *Il riposo*, the critique of Pontormo serves as a preface to an extended, thirty-three-page savaging of contemporary Florentine painting, exemplified by the altarpieces in Santa Maria Novella and Santa Croce by Vasari and his friends (pl. 45).[21] Borghini's verdict, as captioned in a long string of marginalia, was blunt and merciless: "Resurrection of Christ not well painted. . . . Baptism of Christ badly figured. . . . Confused painting. . . . Nativity of Christ badly painted. . . ."[22] Because his comments on Pontormo immediately precede this section, just as the making of the frescoes immediately precedes the making of the altarpieces in Santa Maria Novella and Santa Croce, he probably wanted us to read them chronologically and sequentially as cause and effect.

Borghini's pinning of Mannerism and Pontormo, of the decline of art and the decline of the artist, never attained the popularity of the competing paradigm that art died with the death of Raphael and revived with Annibale Carracci, the new Raphael: "After the death of the great Raphael, most painters departed from every good rule and painting fell headlong into ruin."[23] There were other local variants, such as "the grievous collapse of painting" in Venice after the death of Palma Giovane,[24] but these barely entered mainstream art history. A revived interest in Borghini's story came in the eighteenth century, the earliest being in 1725 when the Florentine painter Giovan Maria Ciocchi, pupil of his brother-in-law Pier Dandini, gave a four-part critique of Borghini's *Il riposo* in his little-known *Pittura in Parnasso* (Florence, 1725): first, that the nobility of the Florentine school should not be tainted by the failure of just a few artists (Vasari and his followers in Santa Maria Novella); second (and in partial contradiction with the first), that the defects of mid- and late sixteenth-century painting were systemic rather than individual failures; third, that artistic imperfections, being part of the human condition, should be tolerated; and finally, that Borghini nit-picked about technical matters that he had no qual-

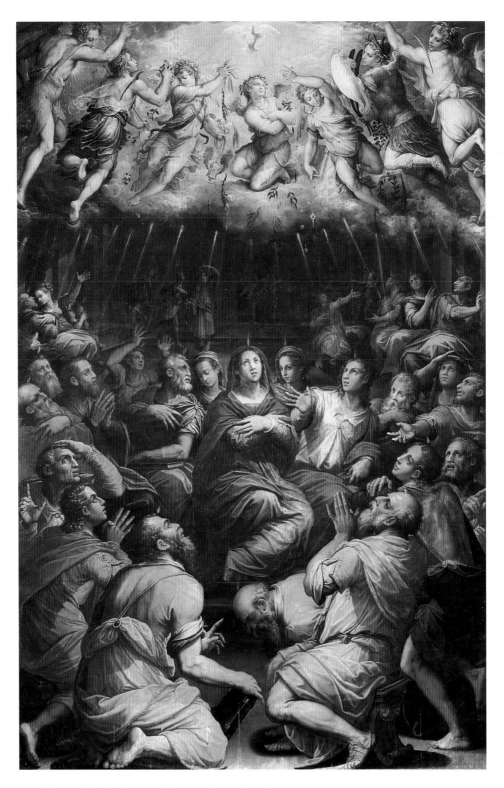

45 Giorgio Vasari, *Pentecost* (Florence, Santa Croce)

ifications (as a nonprofessional) to judge.[25] To find the so-called defects, concludes Ciocchi, Borghini had to examine the paintings with inappropriate visual technologies: microscopes and telescopes.

Five years later (possibly inspired by Ciocchi) Francesco Maria Niccolo Gabburri published a new edition of *Il riposo* (Florence, 1730), along with a preface by Giovanni Gaetano Bottari.[26] Unlike Ciocchi, however, he found *Il riposo* to be a worthy and neglected book. He managed to convince the librarian and art historian Anton Maria Zanetti and the Veronese painter (and follower of Carlo Maratta) Antonio Balestra. In October 1730, after receiving a copy of the new *Riposo* from Zanetti (who adopted aspects of it for his *Descrizione di tutte le pubbliche pitture de la città di Venezia*, Venice, 1733), Balestra wrote to Gabburri that he found it so "beautiful . . . and learned" that all painters should be given copies "to read and reread."[27] What he found particularly compelling in *Il riposo*, Balestra added in another letter to Gabburri a month later, was how closely the decline of contemporary art into "certain mannered styles" (*taluno delle maniere ammanierate*) paralleled the decline described by Borghini: "We see painting today going downhill in a big way; it is sadly true that successors to the celebrated masters of the past are not rising again, neither in the academies of Rome, nor Bologna, nor in other places."[28]

* * *

Two seventeenth-century readers of *Il riposo* applied Borghini's parallel structure of aging and historical watershed. Referring to Borghini as "a learned man," Pietro da Cortona and his theologian collaborator Giandomenico Ottonelli applied Borghini's reading of Pontormo's old age to Giuseppe Cesari d'Arpino (1568–1640):

> Because time weakens and consumes [judgment, eyesight, and coordination], the artist . . . should in old age restrain himself from making works for public display. The errors in Pontormo's work at S. Lorenzo in Florence can be attributed to old age in this respect. Pontormo, who had been so talented and made so many commendable figures, appears in this work to have lost it. The famous Cavalier Giuseppino [Cesari d'Arpino], judicious professor, must have had familiarity with this admonition to make his pronouncement with regard to the final things. Aged and with defective vision, he discerned in his work in the Sala [d'Orazi e Curiazi] on the Roman Campidoglio [Palazzo dei Conservatori] a notable difference in the excellence and perfection of art from those excellent and much admired works that he made in the same Sala as a vigorous youth.[29]

Pietro da Cortona (1597–1666) was aged 55 when he wrote this – on the cusp of old age if not already old (depending on who is counting) – and he was looking at the work of a painter in his early seventies, a painter of the heroic age and member of the "Triumvirate" along with Caravaggio (1571–1610) and Annibale Carracci (1560–1609).[30] A similar inter-generational view occurs with Borghini (1541–1588) and Pontormo (1494–1556). When Bellori (1613–1696) was reading the passage about Cesari d'Arpino in Giovanni Baglione's *Vite*, just the one that inspired Cortona, he turned to "Pietro da Cortona Vecchio" as a counter-example to d'Arpino. In the margins of Baglione's life of d'Arpino, Bellori wrote that "the style of this painter, that is the

Cavalier Giuseppe, like that of Pomarancio and other painters of spirit instead of science, is no longer followed."[31] The outdated Cavaliere was replaced by Bellori with Pietro da Cortona "Vecchio," whose weakening spirits were saved by his growing knowledge. Cortona's learning protected him from the psychically generated decline of d'Arpino. As for Cortona, he too sought a reassuring counter-example to modify the "universality" of Borghini's rule. He cited the case of the *Paradise* in the Doge's Palace painted by Tintoretto at age 82 with his usual "vehemence."[32] But even in this exception, he found an atrophied ability. The evidence he cites is that the monumental canvas fell short of the "perfection" and "excellence" of the preparatory sketch, "which one must attribute perhaps to corporeal weakness of that good old man."

The canny choice of Cesari d'Arpino to update and localize Borghini's old-age "errors of Pontormo" was based on Cortona's reading of Giovanni Baglione's *Vite de' pittori, scultori, et architetti* (Rome, 1642). Baglione was born two years before d'Arpino and was between 74 and 76 years old when he chose d'Arpino to exemplify above all others the ravages of old age. Two years before Baglione finished the *Vite*, d'Arpino died after finishing *Rape of the Sabines, Numa Pompilia Instituting the Vestal Cult*, and *Romulus Traces the Perimeter Foundations of Rome* (pl. 46). Commissioned in 1595 when d'Arpino was 27, the frescoes in the Palazzo dei Conservatori in Rome straggled on sporadically until his death in 1640 at the age of 72.[33] Like Pontormo's San Lorenzo frescoes, they became more famous for their delays than their art. With work spread over so many years, critics were invited to compare changes with age. Baglione marveled two years after d'Arpino's death that "they certainly took forty years to finish."

46 Giuseppe Cesari d'Arpino, *Rape of the Sabines* (Rome, Palazzo dei Conservatori)

47 Giuseppe Cesari d'Arpino, *Rape of the Sabines*, detail of pl. 46

But tired from having worked so hard, and with time running out before he would have to rest; since his constitution was weakened and his spirits cooled, his work no longer corresponded to his fame. . . . it showed that the force of his art no longer responded to his spirit, and as he grew older his work lost the gift of his brush.[34]

Neither Borghini nor Cortona specified the visual results of old age. Without entering into the murky realm of "spirit" – either the frescoes' or their creator's – it is still possible to identify a few examples of the general effects proposed by Borghini and Cortona. Like Pontormo, the frescoes' *giornate* grew smaller with age as d'Arpino worked more and more slowly.[35] Perhaps because he was working more slowly, he began thinking and composing in smaller and smaller parts, losing a sense of the whole, much like Pontormo too. Figures that are meant to be read together do not quite seem to exist in the same space. Take, for example, the Roman soldier whose head is on backwards and the huge-headed Sabine he is trying to haul away (pl. 47). This could be the kind of figural oddity that Cortona had in mind for d'Arpino's "defective vision." Old d'Arpino simply could not do any better. Or could he? Other figural groups are put together more solidly. Maybe he had good days and bad days. But the detail shown in plate 47 is such an extreme example of figural distortion that it could be taken as a visual joke, because d'Arpino has painted exactly what Leon Battista Alberti and others warned against: "Since in representing too vigorous movements, they make it so that in a single image one sees the chest and the buttocks in a single view; this being impossible to do and an even uglier thing to see."[36] By making this most basic mistake, d'Arpino could be playing a role expected of him – the disoriented dodderer – in order to critique the assumptions about old age that led to such a mistaken expectation. It is a kind of personal or insider's joke. D'Arpino seems to say, to finish

with this somewhat remote possibility: "this is how you expect me to paint, but I can paint badly to show you how well I can paint." After all, Michelangelo claimed crude and childish drawing to be the most difficult for an artist to imitate.

By the mid-seventeenth century d'Arpino was known as a "Mannerist" and even, according to Baldinucci, the last Mannerist who ended a decadent period starting with the followers of Raphael.[37] Cortona adopted Borghini's positioning of Pontormo's old age with the beginning of Mannerism by having the end of Mannerism coincide with d'Arpino's old age. D'Arpino's role as a closer underlies Sandrart's (fictional) story of his murder by Caravaggio. Published in 1675 but possibly recalling stories he heard in Rome from 1629 to 1635, the *Teutsche Academie* has Caravaggio act Oedipally in desiring the death of his former boss and *capo* of the old guard in order to dramatize a generational passage from late Mannerism to Baroque naturalism. One day Caravaggio challenged his former employer to a duel in order to settle "an old quarrel." The Cavaliere d'Arpino refused on the grounds that it would be undignified for a nobleman to fight someone beneath his station, a response that cut Caravaggio deeper than any sword could. Caravaggio sold his belongings, set out for Malta in order to become knight: "As soon as Caravaggio was knighted, he hurried back to Rome with the intention of settling his quarrel with d'Arpino. This haste, however, resulted in a high fever and he arrived in Arpino (the very birthplace of his adversary) as a sick man and died."[38]

Sandrart's apologue about competing generations and styles originated in stories circulating during his residence in Rome, after Caravaggio's premature death but before d'Arpino's. The Roman painter and writer Matteo Pagani dedicated his *Dialogo della vigillanza* (Rome, 1623) to d'Arpino and argued for his superiority over unnamed naturalists and tenebrists that sound much like Caravaggio and his followers. "Aurelio," d'Arpino's defender, tries to educate one of his detractors, "Licino":

> Those figures are so bold, there, amongst those trees, that they enrapture me in looking at them so well colored are they. But speaking now honestly and dispassionately, who would not confess that this is the true way of painting, who would not see those shadows as showing anything other than the living.[39]

"Licino" concedes this point, but then steers the conversation to d'Arpino's frescoes in the Palazzo dei Conservatori: "But many people diminish the glory of this man [d'Arpino] by saying that he took too long in making these works." "Aurelio" defends him – "Oh, this is not Giuseppe's fault because he is the fastest painter, and of this I need no testimonies"[40] – and contrasts d'Arpino's speed to the *caravaggisti*'s comparative slowness, a product of other technical limitations, especially their inability "to make a finger, draw an eye, put together a head, without having a model at their side. . . . As a result their paintings lack the spirit of Giuseppe's."[41] The details may look natural, but the contours will lack vivacity and consequently "their works seem like abandoned men overcome by some infirmity." Caravaggio and his young followers, in other words, paint lifeless and infirm paintings – figures with "defects of the skin . . . depicting knotted fingers and limbs disfigured by disease," according to Bellori[42] – whereas the octogenarian d'Arpino paints with spirit and the swiftness of youth.

* * *

Francesco Scannelli, a physician and author of *Microcosmo della pittura* (Cesena, 1657), predicated his art criticism on a principle related to Borghini's and Cortona's reading of old age and historical decline. Painters are the "microcosm" in his art theory. Painting is the macrocosm or the "body of art" where each organ was assigned to a different artist and style.[43] Raphael was the liver, Veronese the genitals, Michelangelo the skeletal structure, Titian the heart, etc. His inspiration for this microcosmic metaphor was probably Giampolo Lomazzo's *Idea del tempio della pittura* (Milan, 1590), where a sophisticated humoral-astrological-physiognomic division of painting was devised with seven epitomizing "governors" (Michelangelo, Gaudenzio, Poliodoro, Mantegna, Leonardo, Raphael, and Titian).[44] And a few years later it inspired Marco Boschini to organize *La carta del navegar pitoresco* (Venice, 1660) as a maritime metaphor where the Venetian "boat of painting" was built from artists: Bellini was the hull, Giorgione the rudder, Bassano the windows, Veronese the lantern, etc.[45] (Scannelli had read a draft of Boschini's *Carta* before completing his *Microcosmo*.) Despite his profession and the governing metaphor of his book, Scannelli never explicitly questioned how the history of art ages like artists. Like Giulio Mancini, the other great seventeenth-century physician-critic, he easily grasped the importance of Vasari's ontogenetic metaphor. He also understood the narrative structuring of Borghini's and Cortona's historiography that pinned micro- and macro-narratives of artists' old age and the aging of art.

Scannelli accepted the conventional story of art's cyclical history. In the first chapter, he presented a capsule history of painting from its rise in Egypt to its fall in Italy, a kind of microcosm of *Microcosmo*. Giotto revived painting; Raphael, Titian, and Correggio ushered in its "most excellent and perfect youth"; in a subsequent "continual decline," painting regressed to a new Quattrocento style of desiccation, which was halted only by the Carracci.[46] What happens next, Scannelli worried, will be another loss of "vigor" and a progressive "languishing."[47] He returned to the question of contemporary painting in chapter 17, where, according to the title, he gives "the reason why the best contemporaries come to change their styles to be lighter."[48] The problem as he saw it originated with Reni's late style that tended toward an "extreme lightness."[49] His perception of a generally lighter palette has some truth, as one can see in the finished late altarpiece by Reni of *St. Sebastian* (pl. 48). Scannelli gave two primary explanations for this phenomenon: the aging of paintings, and the aging of artists. On the former he writes:

> It was observed by Guido Reni himself, who noticed in the works of great masters, and particularly in those by the very thorough Carracci, that, even soon after they were painted, they became more than a little dark and ruined (*non poco oscurate, e guaste*).[50]

Reni knew, Scannelli concluded, that time would compensate for his lightened style and "in the long run would reduce the work to its proper balance (*convenevole mediocrità*)."

Contemporary painters adopted Reni's style, not so much with his farsighted motivations but simply because the public loved it. These painters, even distinguished ones, "find themselves to be a long way away from the necessary competencies of good painting." Not only are they incompetent, they (like Narcissus) do not even "recognize their inabilities" and are generally too fond of themselves. Some contemporary painters

> . . . either do not want to recognize, or do not know how to recognize, how the charming brightness of colors should be used. . . . Most painters today may be somewhat stylish

48 Guido Reni, *St. Sebastian* (Bologna, Pinacoteca Nazionale)

(*manierosi*) and even learned, but one still finds them to be missing an essential and true life-likeness and to be by far inferior to the first modern and most perfect masters [Raphael, etc.] and not even the equal of their first followers and sounder inheritors. One can say without dispute of these kinds of characters, however, that they do not breed such mistaken opinions except by the intensity of their feelings, which, in turn, obfuscate their learning. In time, this also corrupts the imagination of similarly inclined individuals . . . who are endowed much more with good luck than good understanding, come to be deceived by a too great affection for themselves . . .[51]

Appropriate to a narcissistic failure, Scannelli described contemporary painters as only interested in the skin. This is partly a consequence of their Carracci inheritance – the Carracci being the skin of the "body of painting" in the *Microcosmo* – but by mid-century the followers' skin had turned into "hard and calloused excrescences."[52] Scannelli probably understood those excrescences to be diseased outgrowths of the body and deformations of the skin, much like the "superfluous attire . . . and other excessive and superfluous excrescences" that contemporaries loved. He blamed Guido Reni's late style for introducing the vulgar to this seductive style:

Whence the judgment of those proficient in painting will reveal how every day the vulgar are dazzled when they see distorted paintings that satisfy superficially. These painters indiscriminately represented painted beauties that satisfy at first glance. . . . They only praise as the final goal of painting a mere representation of appearances with bright colors that reveal lascivious charms deprived of proportion and perspective. . . . They immediately cite in their defense the example of the famous Guido Reni who, they assert, was heaped with lofty praise and, through his extraordinary charm, attracted to himself as if by magic the eyes of the greatest rulers. . . . But I adhere much more to the foundation of good intellects than to the appearances and opinions of the vulgar when I say that the use of more white and less black should not be considered in painting except by chance and only for the proper external finish of natural objects . . .[53]

Reni's late style was a consequence of his old age: having entered "the winter of his life" he painted "so excessively white that it seems to have snowed out of season."[54] By whitening his palette, Reni led some of the best painters astray in their final years: Rubens, Guercino, Francesco Albani, and Pietro da Cortona. Cortona's mature style, identified with the frescoes in the Palazzo Barberini in Rome and the Palazzo Pitti in Florence, yielded to his late "declining" (*declinante*) style in the Chiesa Nuova, Rome.[55] Rubens and Albani were born within a few years of Reni, but for them and for the younger generation (Guercino and Cortona) it was less an individual choice than a sign of the times. Scannelli did not specify the connection between Reni's whitened late style and the old-age attributes of habits, memory, eyesight, and languid spirit, but his feelings about white and lighter styles are certain. Quoting the physician Girolamo Cardano (*Libro delle sottigliezze*), he concluded that painters should treat white as a poison (as indeed it was, with its high lead content).[56] It weakens a painting's "gravity" and produces a "decomposed [or dissolute] style (*tal maniera disgregante*)". Whereas "gravity" is a quality of maturity, something decomposed or given to dissolution is redolent with senescence. Hence

the formal characteristics of post-Reni painters express the spirit of their age, an old and decaying age.

Aptly for a physician, Scannelli's explanation of Reni's whitened style centers on old age. Albani adopted Reni's late light style not just because it was fashionable but, according to Scannelli, because his dimming eyesight needed more light.[57] With old age came an inability to work with precision, relying more on routines (*pratica*) established earlier in life. One's memory becomes blurred; eyesight fails; feelings are weakened or blunted, which are transferred to their figures, painting them languid and vitiated (*languidi e vitiati*).[58] Count Angelo degli Oddi owned a late work that Scannelli described as "in many parts distant from the imitation of nature . . . beautiful but fabulous precisely in the way of contemporary writers."[59] Scannelli does not tell us which writers of *romanzi* he had in mind, but the turn away from nature to the fabulous (*favoloso*) sounds like a borrowing from the Longinian tradition of Homer's old-age style. Old and discursive, Homer and Reni produced imaginative works liberated from nature more than their early work. Even when Scannelli acknowledged that the whitening could be part of a deliberate strategy by Reni to correct the darkening effects of time, he framed the question in terms of aging, albeit of paintings instead of painters aging. By labeling Reni's late style as languid and vitiated, he deployed two of several common terms of dissipated energy that were used to describe the elderly and their affairs (*debole, languido, fiacco, dilavato, pallido*). The septuagenarian Giovanni Lorenzo Bertolotto, for example, lost his youthful virility and vigor and started painting with "weak colors and shabby lines."[60] Cosimo Ulivelli's formerly "happy and bold colors" became with age "languid and not a little dull."[61]

Scannelli's medicalized late style posed some problems for Bologna's great art historian Carlo Cesare Malvasia, whose *Felsina pittrice* of 1678 honored Reni as the greatest of the Carracci followers. Malvasia wanted to rescue Reni's late style from the pathologies of old age that Scannelli had introduced into art literature. He reassured his readers that although "today it is unknown and strange," Reni's late style "will with time become well known and will finally meet with general esteem." He admitted, though, that the decline of style (*abbassamento di maniera*) and signs of old age (*fiacchezza*) can be observed. He assigned three reasons:

> Thus we will attribute what they call the decline in Reni's manner of painting first of all to his age, which was quite advanced, draining him of strength and spirit and which might also have weakened his work. Secondly, to necessity, since during this last period Guido dedicated himself fiercely to gambling, taking money in advance in order to satisfy his frequent losses. . . . Finally, it was thought that through continually brooding on his many obligations and commitments, Guido's aesthetic judgment was overwhelmed by the passions of his spirit, and he was unable to bring to his work his usual brio and daring.[62]

While admitting age as a factor, even giving it first place, the two other mitigating factors were not explicitly age-related. However, when Malvasia turned to the question of Reni's lighter palette, his explanation excluded age (except for the age of paintings) and instead asserted a thoughtful, farsighted approach:

> while the paintings of others lose a great deal with time, his [Reni's] improve, the white lead becoming yellow and taking on a certain patina that reduces the color to look true and

natural, whereas the others' works become too darkened, so that the half-tints and the prin-
cipal areas of light become equalized and cannot be distinguished and recognized in the
smoky darkness.[63]

Here Malvasia adopted Scannelli's argument regarding the darkening of paintings with time
and even added to it language reminiscent of old age. Painters without Reni's foresight pro-
duced works that dim with age, accreting qualities of a "smoky darkness" that could equally
describe an old man sinking into blindness.

Generally, however, Malvasia's lexical strategy tended to substitute the tainted psycho-stylis-
tic terminology of old age used by Scannelli (weak, enfeebled, vitiated, etc.) with one cleansed
by aesthetics and literary discourse (delicacy). Yes, he acknowledged, old age could produce a
"weakened" and "enfeebled" technique and a "decline of style," but what the public took to be
"weak and flaccid" (*debile e fiacca*) was actually "delicacy."[64] Like Scannelli, Malvasia recognized
the consequences of Reni's whitened style, finding them in use both locally (including the
elderly Guercino, Guido Cagnacci, and Carlo Cignani), and throughout Italy (Pietro Bellotti
in Venice, Carlo Dolci in Florence, and Pietro da Cortona, Andrea Sacchi, and Carlo Maratti
in Rome). However, unlike Scannelli, Malvasia used this proliferation of a problematic style to
unburden Reni of responsibility. Why, he seems to ask, blame the master for the damage
wrought by his followers? However, Malvasia reserved most blame for unlearned viewers who
saw Reni's late style as feeble, whereas erudite viewers such as himself recognized it as an inten-
tional delicacy:

> The second manner [i.e. the *ultima maniera*], however, will always please the most learned
> as much as the first will please the most curious. The latter [the first manner] will catch the
> eye, but the former [the second manner] will instruct; and if the second will be deemed too
> languid and delicate (*languida troppo, e delicata*) by the general public, the experts will exalt
> it as the most learned and supreme.[65]

Malvasia himself had problems with Reni's late style, but whatever the causes, he was less
intent on the style itself than on its reception by collectors and painters, who, by following its
example, "led art down the path of ruination." Like critics of the *Michelangelisti* who exempted
the master from the flaws of his followers, Malvasia identified two late styles. Reni was artisti-
cally and morally weakened with old age, but he tried to adapt with a "delicate" style, and
anyway these were inevitable failures that come with age. His followers had no such excuses.
In following Reni, they developed a style with the same attributes as Cinquecento Mannerists
(he uses the same chronology as Mancini: 1550 to 1605). Malvasia gave senescent attributes to
mid-century decline – "chimerical" with "washed-out, languid, and weak" – and, by introduc-
ing the Mannerists in the middle of his discussion of Reni, he alerted readers that the similar
styles signaled an ominous revival of Mannerism.[66]

The different readings of Reni's late style emerged as a newly contentious issue in the early
eighteenth century when Giuseppe Agostino Orsi published a translation of and commentary
on Dominique Bouhours' *Le Manière di bien penser dans les ouvrages d'esprit* (Paris, 1687), one
of many French anti-Italian books then in circulation, as noted earlier. Orsi's defense of Italian
culture (*Considerazioni sopra un famoso libro franzese intitolato La Manière di bien penser*,

Bologna, 1703) quickly became a compendium of epistolary responses published in 1707, and in 1735 it was expanded further into two volumes.[67] Bouhours accepted Scannelli's reading of Reni's late style as a sign of old age, weakened powers, and melancholy. Uncharacteristically, Orsi agreed, and it was Orsi more than Bouhours who motivated rebuttals from a group of art critics and biographers (Girolamo Baruffaldi, Francesco Montanari, and Giovanni Pietro Zanotti).[68] Their arguments addressed Malvasia's claim that the late style was not "washed-out, languid, and tired" but instead was subtle, deliberate, and sublime, "so delicate that it appears pure and unpainted, yet splendid so that it neither weakens nor swells lofty thoughts, but displays them best" (Baruffaldi) and "gentle, appearing to the eye with such sweetness that one enjoys the paintings without feeling in the least way offended" (Zanotti).[69] The problem with Reni's late style resided not with the artist and his age but with his audience and their stupidity. Niccola Passeri, paraphrasing Mengs at the end of the eighteenth century, has the classical purist criticize Seicento Mannerism as a style that "covers and taints painting with a dense haze and cloud."[70]

Notes

Introduction

1 Becca Levy, "Improving Memory in Old Age by Implicit Self-Stereotyping," *Journal of Personality and Social Psychology*, 71 (1996), 1092–1107. For a variation on this experiment, see Laurie O'Brien and Mary Lee Hummert, "Memory Performance of Late Middle-Aged Adults: Contrasting Self-Stereotyping and Stereotype Threat Accounts of Assimilation to Age Stereotypes," *Social Cognition*, 24 (2006), 338–58.

2 Becca Levy, "Handwriting as a Reflection of Aging Self-Stereotypes," *Journal of Geriatric Psychiatry*, 33 (2000), 81–94.

3 Giovan Battista Armenini, *De' veri precetti della pittura*, Ravenna, 1586; edition cited: ed. Marina Gorreri, Turin, 1988, 233.

4 Petrarch, *Letters of Old Age: Rerum Senilium Libri I–XVIII*, trans. A. Bernardo et al., Baltimore, MD, 1992, 265 (VIII.I).

5 For Albani's old age, see Catherine R. Puglisi, *Francesco Albani*, New Haven, CT, and London, 1999, 39–54.

6 *Il carteggio di Michelangelo: edizione postuma di Giovanni Poggi*, ed. P. Barocchi and R. Ristori, 5 vols., Florence, 1965–83, I, 278 (n. CCXXI).

7 Creighton Gilbert, "When Did a Man in the Renaissance Grow Old?," *Studies in the Renaissance*, 14 (1967), 7–32. Gilbert's argument that old age could begin at 40 is based on a few atypical examples. For a broader, more reliable survey of sources regarding the chronologies of aging, see Georges Minois, *History of Old Age from Antiquity to the Renaissance*, trans. S. H. Tenison, Chicago, 1989; and David Kertzer and Peter Laslett, eds., *Aging in the Past: Demography, Society, and Old Age*, Berkeley, CA, 1995.

8 Filippo Baldinucci, *Vocabolario toscano dell'arte del disegno*, Florence, 1681, 163 (first stage set between the ages of 50 and 70; second stage, *decrepitezza*, set after 70); Vincenzo Da Canal, *Vita di Gregorio Lazzarini* (*circa* 1732), ed. G. A. Moschini, Venice, 1804, LXXV–LXXVII (first stage set at 58 with *decrepitezza* starting at 70).

9 Andrea Zannini, "Un censimento inedito del primo seicento e la crisi demografica ed economica di Venezia," *Studi veneziani*, n. s., 26 (1993), 88 and 97.

10 Robert Finlay, "The Venetian Republic as a Gerontocracy: Age and Politics in the Renaissance," *Medieval and Renaissance Studies*, 8 (1978), 164.

11 *Il carteggio di Michelangelo*, ed. Barocchi and Ristori, II, 384 (n. DLXXXVI: "I am old and unwell"); III, 166 (n. DCCXIII: "as I am an old man, I have no hope of being able to execute anything else"); and III, 173 (n. DCCXIX: "I am an old man").

12 Giorgio Vasari, *Le Vite de' più eccellenti pittori scultori e architettori nelle redazioni del 1550 e 1568*, ed. P. Barocchi and R. Bettarini, Florence, 1967, III, 519.

13 Giulio Mancini, *Considerazioni sulla pittura*, ed. Luigi Salerno, Rome, 1957, I, 128–30.

14 Vasari, ed. Barocchi and Bettarini, III, 120.

15 Vincenzio Borghini, letter to Vasari, 14 August 1564; published in K. Frey, *Der literarische Nachlass Giorgio Vasari*, Munich, 1930, II, cdlix, 102: "Il FINE di questa vostra fatica [i.e. Vite] non e di scrivere la vita de pittori, ne di chi furono figl[i]uoli, ne quello che e feciono dationj ordinarie; ma solo per le OPERE loro di pittori, scultori, architetti: che altrimenti poco importa a noi saper la vita di Baccio d'Agnolo o del Puntormo. E lo scriver le vite, e solo di principi et huominj che habbino esercitato cose da principi et non di persone basse, ma solo qui havete per fine l'arte et l'opere di lor mano." An echo of Borghini's objection is reported by Torquato Malaspina in a lecture on writing biography given to the Accademia degli Alterati (Florence) in 1584 (T. Malaspina, *Dello scrivere le vite*, ed. V. Bramanti, Bergamo, 1991, 48-49): "[N]é giudico che per ciò debba esser biasimato Giorgio Vasari aretino perché scrisse un volume di vite de' pittori e scultori e d'altri che nell'architettura hanno sentito molto avanti . . .".

For a discussion of Vasari and Borghini, see Patricia Rubin, *Giorgio Vasari: Art and History*, New Haven, CT, and London, 1995, 190–95; and Elizabeth Pilliod, *Pontormo, Bronzino, Allori: A Genealogy of Florentine Art*, New Haven, CT, and London, 2001, 197–204. Borghini was also preparing Vasari for their collaboration in establishing the Accademia del Disegno less than two years later. Borghini wanted it to be an "ACADEMY OF PRODUCTION NOT DISCOURSE," a majusculed dictum he tried (unsuccessfully) to foist onto the new Accademia del Disegno. He tried putting it into practice, successfully, with the decorations for the marriage of Francesco de' Medici and Johanna of Austria in 1565. He must have enjoyed writing to Vasari with the news that Duke Cosimo decided to "leave the invention to me, and to you go the designs and styles."

16 In 1564 Cellini blamed Borghini for not being guaranteed inclusion in the *Labors of Hercules* for the Salone del Cinquecento in the Palazzo Vecchio, Florence (D. Francalanci and F. Pellegrini, "Introduzione," in *Il carteggio di Vincenzio Borghini*, ed. D. Francalanci et al., Florence, 2001, 38–39). Borghini handled Cellini's prickly narcissism with great care.

17 V. Borghini, "Selva di notizie," in *Pittura e scultura nel Cinquecento*, ed. P. Barocchi, Livorno, 1998, 99–100: "E che bel vedere sarebbe che quel Cischeranna [one of the "Berninchi" mocked by Borghini] chiedessi per ragione de l'arte la marritta a Raffaello d'Urbino o a Andrea del Sarto, o che Babbunto [another of the "Berninchi"] la volessi dal Bandinello! Questa sarebbe una ambizione scioc[c]a, voler dare alla persona quel ch'è de l'arte e fare quel che ha essere ἀνδραγαθία πατραγαθία."

18 Vasari, ed. Barocchi and Bettarini, IV, 613.

19 The literature is vast but a convenient entry and summary can be found in the following recent publications: Adele Seefe and Edward Ansello, eds., *Aging and the Life Cycle in the Renaissance: The Interaction between Representations and Experience*, Newark, DE, 2000; Monica Chojnacka, ed., *Ages of Woman, Ages of Man: Sources in European Social History, 1400–1750*, London, 2002; Pat Thane, ed., *A History of Old Age*, Los Angeles, 2005.

20 Giampolo Lomazzo, *Idea del tempio della pittura*, Milan, 1590; edition cited: *Scritti sulle arti*, ed. R. Ciardi, Florence, 1973, I, 248–52 (on old age) and 289, 292, and 361 (on Michelangelo).

21 Roger de Piles, *Abrégé de la vie des peintres*, Paris, 1699, 96 (edition cited: Paris, 1715, 95): "Il n'y en

a point aussi qui n'ait eu son commencement, son progrès & sa fin; c'est-à-dire, trois manières: la première, qui tient de celle de son Maître; la seconde, qu'il s'est formée selon son Goût, & dans laquelle réside la mesure de ses talens, & de son Génie; & la troisième, qui dégénère ordinairement en ce qu'on appelle manière: parce qu'un Peintre, après avoir étudié long-tems d'après la Nature, veut jouir, sans la consulter davantage, de l'habitude qu'il s'en est faite." For Baldinucci's definition of *maniera* and *ammanierato*, see P. Sohm, *Style in the Art Theory of Early Modern Italy*, Cambridge, 2001, 165–84. Pietro Guarienti ("Al lettore," in P. A. Orlandi, *Abecedario pittorico*, ed. P. Guarienti, Venice, 1753, 4r) accepted that all artists grow through three stages, but he defined the characteristics of those stages more simply as a gradual loss of youthful grace, vigor, and mastery: "Con ciò le prime, le seconde, e le ultime maniere di ciascun valente pittore arrivai a conoscere, e quando la forza, il brio, l'energia in essi accresciuta o scemata si fosse; essendo per lo più avvenuto che nelle ultime opere di quei pittori, che ad un'età avanzata pervennero, la primiera grazia, la maestà, la robustezza, l'espressione, la franca e la maestrevole condotta indarno si cerchi."

22 Gino Fogolari, "Lettere pittoriche del Gran Principe Ferdinando di Toscana a Niccolò Cassana (1698–1709)," *Rivista del Reale Istituto d'archeologia e storia dell'arte*, 7/i–ii (1937), 179.

23 J. W. von Goethe, *Maximen und Reflexionen*, Hamburger Goethe Ausgabe, XII, 470, n. 748; see J. Gantner, "Der alte Kunstler," in *Festschrift für Herbert von Einem*, ed. G. von der Osten and G. Kauffmann, Berlin, 1965, 71–76; Herbert von Einem, "Zur Deutung des Altersstiles in der Kunstgeschichte," in *Album Amicorum J. G. van Gelder*, ed. J. Bruyn et al., The Hague, 1973, 88–92; Herbert von Einem, *Beitrage zu Goethes Kunstauffassung*, Hamburg, 1956, 166–67.

24 J. Held, "Commentary," *Art Journal*, 1987, 127.

25 Von Einem, 1973, 91.

26 In addition to the discussions cited above, see Hans Tietze, "Earliest and Latest Works of Great Artists," *Gazette des beaux-arts*, 26 (1944), 273–84; Kenneth Clark, *The Artist Grows Old*, Cambridge, 1972; Irving Lavin, "The Sculptor's 'Last Will and Testament'," *Allen Memorial Art Museum Bulletin*, 35 (1977–78), 4–39; C. Soussloff, "Old Age and Old-Age Style in the 'Lives' of Artists: Gianlorenzo Bernini," *Art Journal*, 1987, 115–21; G. Labouvie-Vief, "Psychological Transformations and Late-Life Creativity," *Bulletin: Museums of Art and Archae-*

ology, The University of Michigan, 11 (1994–96), 71–83.

27 W. Friedlaender, "Poussin's Old Age," *Gazette des beaux-arts*, 60 (July–August 1962), 249.

28 Walter Friedlaender, *Nicolas Poussin: A New Approach*, New York, [1966], 86. For a definitive reading of the painting's iconography, without reference to Poussin's old age beyond a short quote from Bellori, see Elizabeth Cropper and Charles Dempsey, *Nicolas Poussin: Friendship and the Love of Painting*, Princeton, NJ, 1996, 303–07.

29 D. Rosand, "Editor's Statement: Style and the Aging Artist," *Art Journal*, 1987, 91.

30 W. R. Rearick, *The Art of Paolo Veronese, 1528–1588*, Cambridge, 1988, 158–59 (exhibition catalogue: Washington, DC, National Gallery of Art).

31 N. Spinosa, "Ribera and Neapolitan Painting," in *Jusepe de Ribera, 1591–1652*, ed. A. Pérez Sánchez and N. Spinosa, New York, 1992, 29 (exhibition catalogue: New York, Metropolitan Museum of Art).

32 Gail Feigenbaum, "Ludovico Carracci: un profile," in *Ludovico Carracci*, ed. Andrea Emiliani, Bologna, 1993, CVI (exhibition catalogue: Bologna, Museo Civico Archeologico and Pinacoteca Nazionale).

1 Gerontophobia and the Anxiety of Obsolescence

1 Bernardo de' Dominici, *Vite de' pittori, scultori, ed architetti napoletani*, Naples, 1742, III, 109: "Tardi si avvidde il Marullo del suo peccato, e cercò, ma invano, di tornare alla sua bella prima maniera appresa dal suo Maestro, che và appresso a quella ottima dell'eccellentissimo Guido Reni, poichè la mano [of Marullo] avvezza alle seccaggini in una età avanzata non era più idonea a ripigliar la prima morbidezza, la qual cosa se avesse fatto, quando era in età più fresca, gli sarebbe forse riuscito, perchè avrebbe avuto gli spiriti pronti a far che la mano ubbidisse all'intelletto. Per la qual cosa veggendosi ogni giorno divenir peggiore, andava come fuori di se ad osservare le opere sue più belle, e spesso nella Chiesa di S. Severino, vedendo il quadro della S. Anna, e la venuta dello Spirito Santo, rampognava se stesso, e la sua superbia dicendo forse: dove m'hai tu condotto. Ecco io giovane hò dipinto queste opere così buone, ed ora Uomo attempato non so quel che mi faccia."

2 John Cairney, Professor of Psychiatry, University of Toronto, and Julie Ann McMullin, University of Western Ontario.

3 Juvenal, *Satires* 10. 187–99, trans. G. G. Ramsey, Cambridge, MA and London, 1956.

4 Phillip Lopate, "The Story of My Father," in *Getting Personal*, New York, 2003, 358. For studies that prove the contrary, i.e., that the elderly are more varied physically, socially, and psychologically than generally assumed, see E. A. Nelson and D. Dannefer, "Aged Heterogeneity: Fact or Fiction? The Fate of Diversity in Gerontological Research," *Gerontologist*, 32 (1992), 17–23.

5 M. S. Haynes, "The Supposedly Golden Age for the Aged in Ancient Greece: A Study of Literary Concept of Old Age," *Gerontologist*, 3 (1963), 28.

6 Gabriele Zerbi, *Gerontocomia, On the Care of the Aged; and Maximianus, Elegies on Old Age and Love*, Rome, 1489; trans. L. R. Lind, Philadelphia, 1988, 53; Aristotle, *Posterior Analytics*, ed. and trans. E. S. Forster, Cambridge, MA, and London, 1960, II. 658b. 14–26.

7 Bernardina Sani, *Rosalba Carriera: lettere, diari, frammenti*, Florence, 1985, II, 697 (n. 603: letter from Antonio dall'Agata in Gorizia to Rosalba Carriera, 26 August 1744): "Parlerà bene al suo perspicacissimo intendere, ma le sue opere, sin che haverà il moto a sua disposizione, saranno più sempre belle e stupende, quando ancora havesse cento anni; è vero che molti, anzi la maggior parte de bravi pittori, quando han conosciuto che s'avanzavano gl'anni, e che già havevan fatto glorioso nome, hanno anche principiato a decader dal primo bel modo di adoprar il penello e sempre più a tal segno che non si conoscevan più per opere del tale, ma così non si può dire della gran si.ra Rosalba le cui opere vuol che sodisfino al suo inarrivabile intendere, senza cercar alcun vantaggio del suo gloriosissimo nome, onde così è necessario, se humanamente si può più avanzare, che sempre avvanzi più tosto che cada, d'un minimo punto."

8 E. Cropper, "The Beauty of Woman: Problems in the Rhetoric of Renaissance Portraiture," in *Rewriting the Renaissance: The Discourses of Sexual Difference in Early Modern Europe*, ed. M. Ferguson et al., Chicago, 1986, 175–90; and E. Cropper, "The Place of Beauty in the High Renaissance and its Displacement in the History of Art," in *Place and Displacement in the Renaissance* (Medieval and Renaissance Texts and Studies, 132), ed. A. Vos, Binghamton, NY, 1995, 159–205.

9 Giulio Mancini, *Considerazioni sulla pittura*, ed. A. Marucchi, Rome, 1956, I, 234: "[N]on si maravigliava che dipingesse così bene e si belle le cose di questo mondo, poichè dipinggeva se stessa essendo lei bellissima. . . ." This was possibly

inspired by Ottaviano Rabasco, *La pallade ignuda: della famosa pittrice Lavinia Fontana. Canzonetta*, Rome, 1605, n. p.: "Mà se i modi Celesti / Formar non osi d'immortal sembiante, / Tù, che dal Ciel l'havesti, / Fingi le tue maniere e vaghe, e sante; / Ch'havrai Pallade espressa, / Se delle tele fai specchio à te stessa."

10 As quoted in note 7 above.

11 For Passignano, see Filippo Baldinucci, *Notizie de' professori del disegno dal Cimabue in qua*, 3 vols., Florence, 1681–1728; edition cited: ed. P. Barocchi, Florence, 1975, III, 442–43: "Una delle ultime cose ch'e' facesse, fu una tavola per la chiesa di S. Basilio al canto alla Macine, nella quale veramente apparve alquanto inferiore a se stesso, non già perchè egli non avesse conservato quel gran sapere, che fu suo proprio in ogni età, ma perchè nessuno è di coloro che molto fanno, che ogni cosa conduca colla medesima felicità, massimamente in vecchiaia. . . . ma nel portarle a fine durava gran fatica, e nelle cose del disegno, prima che la mano avesse obbedito all'altissimo intelletto suo gran tempo abbisognava, ond'è che i suoi disegni e schizzi veggonsi affaticati e gretti." For Francesco Bassi, see Gino Fogolari, "Lettere pittoriche del Gran Principe Ferdinando di Toscana a Niccolò Cassana (1698–1709)," *Rivista del Reale Istituto d'archeologia e storia dell'arte*, 6/i–ii (1937), 179 (letter from Ferdinando de' Medici to Cassana, 17 March 1703).

12 Carlo Ratti, *Delle vite de' pittori, scultori, ed architetti genovesi*, Genoa, 1768, II, 227–28: "Dopo le riferite Opere [in Genoa, the Palazzo Saluzzo and the Palazzo Brignole] proseguì il Parodi a dipingere: ma con un'esecuzione tanto fiacca, e stentata; che le posteriori pitture più non sembrano di mano di questo chiaro Soggetto. Inferiori a queste son le pitture, che egli fece in due volte di stanze del palazzo Durazzo; ove negli anni addietro avea dipinto quelle cose sì stupende, che già dicemmo. In queste [228] due volte ei dipinse, nell'una la Giustizia, e la Pace; e nell'altra il Tempo, che mette in chiaro la Verità. Ma siccome elleno erano di pennello assai fiacco, così poi furono in molte parti dal Boni, Pittor Bolognese, ritocche. . . . Fiacchissima poi fu la pittura della cappella di S. Bernardo in Castelletto; nel che diede sì poco saggio di se, che riesce difficile a credersi quella esser sua fattura. Colpa tutta della vechiaia, che intiepidisce la fantasia, appanna gli occhi, rende vacillante la mano, ed estingue l'antico brio. Quindi l'attempato Artefice manca d'attività per li robusti, e fini lavori. Finalmente caduto infermo il Parodi nel mese d'aprile dell'anno 1740 dopo alcuni giorni cessò di vivere in età d'anni settanta-

due. . . . Non conobbero i Medici la sua malattia. Fu però sentimento comune, che lo smoderato uso del cioccolatte, di cui negli ultimi anni della sua vita unicamente nutrivasi, gli avesse infiammato le viscere."

13 De' Dominici, *Vite*, III, 377.

14 Susan Sontag, "The Double Standard of Aging," in *Psychology of Women*, ed. J. Williams, San Diego, CA, 1979, 462–78. For a review by psychologists, see S. Wilcox, "Age and Gender in Relation to Body Attitudes: Is There a Double Standard of Aging?," *Psychology of Women Quarterly*, 21 (1997), 549–65.

15 *The Literary Works of Leonardo da Vinci*, ed. J. P. Richter (third edition), London and New York, 1970, n. 1163.

16 *Treatise on Painting by Leonardo da Vinci*, ed. and trans. Philip McMahon, Princeton, NJ, 1956, II, 252.

17 For Ruzante on the aged as well as the following examples from Maynard and Ronsard, see Georges Minois, *History of Old Age from Antiquity to the Renaissance*, trans. S. H. Tenison, Chicago, 1989, 253–60.

18 For Boulanger's lost frescoes, see Giuseppe Fabrizi, *Sposizione delle pitture in muro del Ducale Palazzo della nobil terra di Sassuolo*, Modena, 1784, 127–28; and M. Pirondini, *Ducale Palazzo di Sassuolo*, Genoa, 1982, 87–88. A description of the lost frescoes is given in Marcus Verrius Flaccus' *De verborum significatu*. Although the original text of this is lost, extracts are recorded by Sextus Pompeius Festus, *De verborum significatu* (252. 10–11). The story of Zeuxis dying from laughter after painting a portrait of an old woman is repeated by Carlo Dati, *Vite de pittori antichi*, Florence, 1667, 40–42 (along with other ancient artists who supposedly died of laughter).

19 Giovanni Giorgio Nicolini, *Le ombre del pennello glorioso del molt'illustre Signore Pietro Bellotti, Eccellentissimo Pittore*, Venice, 1659 (second edition, with new preface), 69. He likens the "veins and fissures" of Bellotti's *Fate Larchesi* to the bark of old, dried fir trees. For further descriptions of her wrinkles, see 81–82.

20 Tomaso Garzoni, *L'hospidale de' pazzi incurabili*, Venice, 1594, 7v–8r (Discorso II: Dei pazzi frenetici e deliri). Earlier editions were published in 1586, 1587, 1589, and 1593.

21 T. Gwilliam, "Cosmetic Poetics: Coloring Faces in the Eighteenth Century," in *Body and Text in the Eighteenth Century*, ed. Veronica Kelly and Dorothea von Mücke, Stanford, CA, 1994, 144–59 (on 146–47).

22 The references to Ruzante and Maynard, as well as the Ronsard quote that follows, appear in a useful survey of old age by Georges Minois, *History of Old Age from Antiquity to the Renaissance*, trans. Sarah Hanbury Tenison, Chicago, 1990, 249–55.

23 Francesco Scannelli, *Il microcosmo della pittura*, Cesena, 1657, 61.

24 A. Zuccari, "Le immagine per il 'De bono senectutis' di Gabriele Paleotti e un ipotesi su Philips e Theodoor Galle," in *Studi in storia dell'arte in onore di Denis Mahon*, ed. M. G. Bernardini, S. Danesi Squarzina, and C. Strinati, Milan, 2000, 57–68. In a letter to Silvio Antoniano of 28 August 1595, Paleotti discusses how best to represent good old age for the frontispiece of *De bono senectutis*. He notes that old age, "from the outside," seems to be horrible and deformed (*horrida et deforme*) but from the inside it is beautiful. He thought the palm to be a good frontispiece emblem: "La Palma è fruttuosa in vecchiezza, è anchora horrida e spinosa, ma produce frutto delicato."

25 Dennis Gutmann, "The Cross-Cultural Perspective: Notes Toward a Comparative Psychology of Aging," in *Handbook of the Psychology of Aging*, eds. J. Birren and K. Schaie, New York, 1977, 302–26.

26 Carlo Ridolfi, *Le maraviglie dell'arte ovvero le vite degli illustri pittori veneti e dello stato*, Venice, 1648; edition cited: ed. D. von Hadeln, Rome, 1956, II, 218.

27 Lione Pascoli, *Vite de' pittori, scultori, ed architetti moderni*, Rome, 1730, I, ed. A. Marabottini et al., Perugia, 1992, 274–75 ("Vita di Gio. Battista Gaulli").

28 Richard Spear, *The "Divine" Guido: Religion, Sex, Money, and Art in the World of Guido Reni*, New Haven, CT, and London, 1997, 295 (letter to Trotti, 11 July 1639): "I have begun not to undertake as many things as are asked of me, and I even have begun not to like myself, whether it be because of age, which has begun to be burdensome (*grave*), or the great fatigue from so many projects, or traveling – I don't feel vigorous any more (*non mi sento più in vigore*), and I will accomplish a lot, even too much, if I finish what I have started, almost against my will, as I have said."

29 From the translation by Anne Summerscale, *Malvasia's Life of the Carracci: Commentary and Translation*, University Park, PA, 2000, 233.

30 Ratti, *Delle vite de' pittori, scultori, ed architetti genovesi*, II, 130 ("vita di Giovanni Stefano Robatto"): "Erasi in oltre prefisso di dipingere secondo il prezzo, che gli avesse stabilito chi gli commetteva il lavoro. E però solea facetamente dire, che altri serviva da Sig. Robatto, ed altri da Maestro Arro-

batto; alludendo al verbo genovese *arrobattare*, che significa *precipitar giù una cosa*. Così egli praticò nell'età avanzata, non lasciandosi fuggire verun progetto di lavorare, benchè a vilissima mercede; onde intanto assuefacendosi a un dipingere trascurato, e scorretto, perdette in vecchiaia quanto di perfezione, e di credito avea negli anni precedenti acquistato."

31 Giorgio Vasari, letter to Michelangelo, 17 March 1563. Karl Frey, *Der Literarische Nachlass Giorgio Vasari*, Munich, 1923, 736.

32 Carlo Cesare Malvasia, *Felsina pittrice: vite de' pittori bolognesi divise in duoi tomi*, Bologna, 1678; edition cited: ed. G. P. Zanotti et al., 2 vols., Bologna, 1841, II, 183; translated and discussed in Puglisi, *Francesco Albani*, 39. Puglisi gives a complete account of Albani's late years, his financial and family troubles, and the consequences for his art.

33 Raffaelle Soprani, *Vite de' pittori, scoltori, et architetti genovesi*, Genoa, 1674, I, 149 ("Vita di Lazzaro Tavarone"): "Stanco alla fine per tante fatiche il nostro Pittore, e aggravato dagli anni, e dalle indisposizioni, non era più in istato d'esporsi agl'incomodi, che reca il lavorare a fresco su' palchi. Per la qual cosa egli abbandonò i pennelli, e si diede ad una vita ritirata in sua casa; dove molto divertivasi con la bella raccolta, che fatto s'avea di preziosi disegni, i quali insieme co' suoi, e con quelli del suo Maestro oltrepassavano il numero di duemila."

34 Giovanni Baglione, *Le vite de' pittori scultori et architetti*, Rome, 1642; edition cited: ed. H. Röttgen, Vatican City, 1995, 78.

35 Vasari on Raffaellino del Garbo, Giorgio Vasari, *Le vite de' più eccellenti pittori scultori e architettori nelle redazioni del 1550 e 1568*, ed. P. Barocchi and R. Bettarini, Florence, 1976, IV, 119. Ridolfi (*Le maraviglie dell'arte*, ed. von Hadeln, II, 203–04) on Palma Giovane.

36 Salvator Rosa, *Satire*, ed. Danilo Romei, Milan, 1995, 108 (III, 436–38): "ma, scorsi i più degli anni e giunti al senior, / fra la prigione e lo spedal si mirano, / non ostante il or fumo e 'l loro ingenio."

37 John Michael Montias, *Artists and Artisans in Delft: A Socio-Economic Study of the Seventeenth Century*, Princeton, NJ, 1982, 113.

38 Giovanni Pietro Bellori, *Le vite de' pittori, scultori e architetti moderni*, ed. Evelina Borea, Turin, 1976, 624–25.

39 Cignaroli, "Serie degli artisti veronesi," in *Supplementi alla cronaca di Pier Zagata*, Verona, 1749, 222; and Antoine Joseph Dézaillier d'Argenville,

Abrégé de la vie des plus fameux peintres, Paris, 1762, 312.

40 In his notes to Malvasia (*Felsina pittrice*, ed. Zanotti et al., II, 205–06), Zanotti inserted his life of Carlo Cignani from *Storia dell'Accademia Clementina*, Bologna, 1739: "Intanto il Cignani crescea molto in decrepità, e tuttavia non scemando [weakening] lo spirito, e le forze del corpo permettendolo, andava qualche volta pignendo e l'anno MDCCXV, ottantesimo settimo dell'età sua, fece all'Elettor Palatino un Giove allattato con molte figure, che prima molti, e molt'anni gli avea promesso, e riuscì certamente commendabil pittura, e intelligenza grandissima richiederebbesi a non giudicarla operazione di più fresca età. . . . Dopo il nominato quadro cominciò il Cignani a perdere alquanto di robustezza e di sanità, a cagione d'alcuni accidenti, che gli sopravvenivano. Era egli di complessione forte e robusta, e però il male abbisognò di molto tempo per abbatterlo, quantunque decrepito fosse. . . . Non si può certamente pensare dell'anima sua altro che bene, per le sue morali e cristiane virtù, e se nella sua giovanezza si mostrò alquanto inclinato alla passione d'amore, e, se questo affetto secondando, talora dipinse cose troppo tenere, ed a' lascivi uomini pericolose, n'ebbe in età avanzata, e particolarmente negli ultim'anni, rimordimento, e dispiacere grandissimo, nè si saziava mai di chiederne perdono al Signore. Nell'ultima sua malattia era smanioso, che si abbrucciasse un bellissimo quadro di una Danae ignuda, che avea presso di se, nè si acchetò finchè il Conte Felice suo figliuolo non gli promise di coprirla decentemente, secondo una esatta onestà, come poi fece elegantemente, e in modo che la bellezza del quadro non ne patì, e questo quadro il conservano gli eredi dello stesso Cignani."

41 M. Gualandi, ed., *Nuova raccolta di lettere sulla pittura, scultura ed architettura*, Bologna, 1845, II, 218–19.

42 F. S. Baldinucci, in *Zibaldone baldinucciano*, ed. B. Santi, Florence, 1981, II, 302 ("Vita Bartolomeo del Bimbo"): "Nell'età decrepita di sopra ottanta anni, benché ridotto ad una emaciazione e debolezza straordinaria, seguitò a dipignere e bene quanto mai, avendo peraltro sempre consegnere e bene quanto mai, avendo peraltro sempre conservata la solita stabilità di mano e di mente con una comportabile vista, effetto della sua sempre conservata moderazione in tutte le sue azioni e della sua sempremai goduta sanità." For Fenzoni, see Scannelli, *Il microcosmo della pittura*, 203: "dipinse altre non poche operationi publiche, e private, come quello,

che visse quasi per un secolo intiero, e nella sua ultima vecchiezza dissegnava di continuo con la penna, e dava in tal modo a conoscere il talento, e gusto della Professione, essendo stato mai sempre, come ben nato, con gran decoro, e riuscì per ogni parte a suoi giorni uno splendore della Professione."

43 Stefano Guazzo, *La civil conversatione*, Brescia, 1574; edition cited: ed. Amedeo Quondam, Modena, 1993, I, 119 (at the beginning of a useful compilation of commonplaces: I, 119–23).

44 De' Dominici, *Vite*, III, 464: "even if some works appear to be weak and languid in parts of their design, at least according to various professors, one must still be reasonable and worthy of praise considering that they were painted when [Giacomo Manecchia] was already old and infirm."

45 De' Dominici, *Vite*, III, 143–44 ("Vita di Andrea Vaccaro"). In section titled in margin (143): "Opere fatte in Vecchiezza da' valenti Professori devonsi compatire per gli Spiriti già mancati. Ma pur deve esser compatita la debolezza di queste, e di altre opere che Andrea dipinse in Vecchiezza; dapoichè con la gravezza degl'anni suol rallentarsi il primiero vigore degli spiriti, e per conseguenza viene a mancare il fervore dell'immaginazione, e quella perfezione de' sensi esterni, ch'è tanto necessaria all'operante; onde sovvente vediamo il valentuomini di prima riga non dipinger più, come per lo passato, de' quali moltissimi esempli addurre in questo luogo potrei; ma per brevità basti solo mentovarne tre famosi a' nostri giorni, l'uno il Cavalier Calabrese, che nell'ultimo di sua vita dipingeva per pratica con poche pennellate, lasciando la tela per mezza tinta, e con assai debolezza come si vede da' due quadri da lui mandati alla Chiesa della SS. Nunziata, dipinti nell'eta di 82 anni. Il secondo l'eccellentissimo Carlo Maratta, Ape ingegnosa che ha raccolto il miele da' fiori di tutti i Valentuomini, onde ha dato fuori più opere singolari per bellezza e per erudizione, che niuno altro valente Professore, e pure negl'ultimi anni divenne debole, come si vede dal Battesimo di Nostro Signore mandato alla nostra Certosa, del quale altro non comperaron que' Monaci, che il glorioso nome dell'Autore; l'altro il nostro celebre Francesco Solimena, che avendo per l'innanzi fatto opere degnissime dell'immortalità, ora che hà passato gli ottanta, non dipinge come gl'anni addietro, e pure egli è un Artefice vigoroso negli Studj, e consumato nelle fatiche. La debolezza però che mostrò Andrea nella sua vecchiezza meritò positivo biasimo, e fu indegna di scusa, dapoichè non avendo egli giammai dipinto a fresco, volle poi

carico di anni provarvisi, e quel ch'è peggio in un opera grandiosa, ed in una Chiesa delle più insigni della nostra Patria, come di S. Paolo Maggiore, che fu già famoso Tempio di Castore, e Polluce."

46 P. Santucci, *Ludovico Mazzanti, 1686–1775,* L'Aquila, 1981, 125–26 (letter of November 1735 from Antonio Widmann to the painter Ludovico Mazzanti, then in Naples): "mentre le ultime opere da lui spedite a Venezia hanno riportato pochissimo applauso e più tosto disapprovazione e compatimento per essere avanzato assai in età."

47 De' Dominici, *Vite,* III, 594. For Solimena's paintings in Venice, see Ferdinando Bologna, *Francesco Solimena,* Naples, 1958, 162–64. For Solimena's influence on Venetian painters, see U. Ruggeri, "Solimena e Venezia: qualche appunto," in *Angelo e Francesco Solimena due culture a confronto,* ed. V. De Martini and A. Braca, Naples, 1994, 235–43.

48 For Solimena's return to the Baroque during the 1730s, see Bologna, *Francesco Solimena,* 162–65; and Nicola Spinosa, *Pittura napoletana del Settecento dal barocco al rococo,* Naples, 1988, 26–27. For the Venetian turn away from the Baroque, best articulated by Vincenzo da Canal (*circa* 1731–32) and Anton Maria Zanetti (1733), see P. Sohm, "The Critical Reception of Paolo Veronese in Eighteenth-Century Italy: The Example of Giambattista Tiepolo as Veronese *Redivivus,*" in *Paolo Veronese – fortuna critica und künstlerisches Nachleben,* Sigmaringen, 1990, 87–108; and P. Sohm, "Seicento Mannerism: Eighteenth-Century Definitions of a Venetian Style," in *Treasures of Venice: Paintings from the Museum of Fine Arts, Budapest,* ed. G. Keyes et al., Minneapolis Institute of Art, 1995, 51–66 (especially 58–61).

49 For Antonio Widmann as collector and patron, see Francis Haskell, *Patrons and Painters: Art and Society in Baroque Italy,* New York, 1971, 214 and 250; and Fabrizio Magani, *Il collezionismo e la committenza artistica della famiglia Widmann, patrizi veneziani, dal Seicento all'Ottocento,* Venice, 1989, 58–65. The Widmann family commissioned a series of paintings from Gregorio Lazzarini (Tiepolo's teacher) and a fresco cycle by Louis Dorigny; see Vincenzo da Canal, *Vita di Gregorio Lazzarini,* Venice, 1809 (written in 1732), 28, 42, and 52.

50 Giorgio Gronau, *Documenti artistici urbinati,* Florence, 1936, 229 (doc. CCCLIV).

51 For a history of this fraught commission, see Cristina Acidini Luchinat, *Taddeo e Federico Zuccari fratelli pittori del Cinquecento,* Rome, 1999, II, 247–48.

52 G. B. Volpato, *La verità pittoresca, circa* 1682, c. 370; quoted in Elia Bordignon Favero, *Giovanni Battista Volpato, critico e pittore,* Treviso, 1994, 120: "[I grandi maestri] quanto più si sono avanzati nell'età hanno più perfettamente operato, e . . . ne dà un vivo e sicuro esempio il Bassano, che essendovi del medesimo in Bassano appunto opere di quattro maniere totalmente lontane e diverse per il disegno e per il colorito, dalla mutazione delle quali che sempre erano in meglio si vede che con l'età andava sempre nell'intendimento avanzando . . ."

53 The problem of epigonism became a more critical issue in the seventeenth century, partly because of Vasari's canon formation; see Maria Loh, "New and Improved: Repetition as Originality in Italian Baroque Practice and Theory," *Art Bulletin,* 86 (2004), 477–504. Also on epigonism, see Ridolfi, *Le maraviglie dell'arte,* ed. von Hadeln, II, 62 (Domenico Tintoretto tried so hard to equal his father that he could design only "frills and splendors"); Malvasia, in a "Nota di pittori presenti dal '42 in qua, data dal signor Conte Malvasia," contained in a letter of 18 May 1675 by Annibale Ranucci to Leopoldo de' Medici (published in Baldinucci, *Notizie,* ed. P. Barocchi et al., VI, 354–55); Giovanni Battista Volpato, "La verità pittoresca svelata à dilettanti: ove con peregrine ragioni scolasticamente spiegata si fa chiaramente vedere che cosa sia pittura come possa un huomo da per se steso acquistarla praticarla et intenderla" (Bassano, Biblioteca Comunale MSS 31 A 25, fols. 48–49); and Volpato, *Il vagante corriero,* Vicenza, 1685, II.

54 As argued convincingly by Elizabeth Pilliod, *Pontormo, Bronzino, Allori: A Genealogy of Florentine Art,* New Haven, CT, and London, 2001.

55 Paolo Giovio, *Scritti d'arte: lessico ed ecfrasi,* ed. Sonia Maffei, Pisa, 1999, 202–04: "At postquam illa perfectae artis praeclara lumina Vincius, Michael Angelus atque Raphael, ab illis saeculi tenebris repente orta, illius famam et nomen admirandis operibus obruerunt, frustra Perusinus, meliora aemulando atque observando, partam dignitatem retinere conatus est, quum semper ad suos bellulos vultus, quibus iuvenis haeserat, sterilitate ingenii recidere cogeretur, sic ut prae pudore vix ignominiam animo sustineret, quando illi augustarum imaginum nudatos artus et connitentis naturae potestates in multiplici rerum ominum genere stupenda varietate figurarent."

56 P. Sohm, *Style in the Art Theory of Early Modern Italy,* Cambridge, 2001, 90–97. For Vasari on Perugino in general, see J. Conaway Bondanella, "Giorgio Vasari, Pietro Perugino and the History

of Renaissance Art," in *Pietro Perugino, Master of the Italian Renaissance*, Grand Rapids, MI, 1998, 82–99 (exhibition catalogue: Grand Rapids Art Museum).

57 Giorgio Vasari, *Le vite de' più eccellenti pittori scultori e architettori nelle redazioni del 1550 e 1568*, ed. P. Barocchi and R. Bettarini, Florence, 1967, III, 608–10.

58 Aristotle, *On Rhetoric*, II, xiii, 3–12 (1389b–1390a); trans. G. A. Kennedy, New York and Oxford, 1991, 167–68.

59 Ovid, *Epistulae ex Ponto*, 3. 9. 39–40.

60 Sohm, *Style in the Art Theory of Early Modern Italy*, 90–97.

61 The inscription under Perugino's self-portrait in Perugia, Palazzo dei Priori: "Perdita si fuerat pingendi, Hic rettulit artem / Si nusquam inventa est, Hactenus ipse dedit."

62 Giovan Battista Armenini, *De' veri precetti della pittura*, Ravenna, 1586, 26 (I, I); edition cited: ed. Marina Gorreri, Turin, 1988. For further discussion of this passage, see Robert Williams, "The Vocation of the Artist as Seen by Giovanni Battista Armenini," *Art History*, 19 (1995), 518–36.

63 De' Domenici, *Vite de' pittori, scultori, ed architetti napoletani*, Naples, 1742, II, 314: "Aveva Belisario fra suoi Discepoli Luigi Rodrigo, virtuosissimo di costumi, il quale essendo riuscito il migliore della sua scuola, fra l'altre opere, dipinse tutte le storie della vita di nostro Signore, che sono a fresco nella Chiesa del Carmine Maggiore, per la quale opera ebbe Luigi dal Popolo, e da' Professori una piena laude. Or fra la gente che la mirava, e lodava si mescolò [mingled] Belisario, già fatto vecchio, e volle il caso, che dimandasse ad alcun Pittore, chi fosse colui che quell'opera avesse dipinta fingendo non conoscerlo, per udir con le proprie orecchie il giudizio che se ne dava. Colui non conoscendo Belisario, ed essendo per avventura amico di Luigi, e nemico dell'iniquità del Maestro, gli rispose: Che l'opera era di Luigi Rodrigo, discepolo di Belisario, ma che, come lo sorpassava ne' buoni costumi, così anche lo aveva sopravanzato col pennello; e in somma lodò tanto Luigi, che l'invidioso Belisario nulla pensando alla sua vecchiezza, ne all'esser Cristiano, ma solamente, che lo scolare col nome acquistato gli avrebbe tolte di mano le buone occasioni, si propose farlo morire; Per ricoprire nondimeno la sua iniquità, finse congratularsi con lui, e seguitò per molti giorni ad usargli amorevolezza, e per questa via mangiando alcuna volta, o bevendo insieme, fu dato all'infelice Rodrigo un lento veleno che in breve tempo lo consumò, sicchè non potè terminar l'opera della Chiesa della

Concezione degli Spagnuoli, che poi fu compiuta da Pacecco di Rosa, e da Giuseppe Marullo discepli del Cavalier Massimo Stanzioni. Ma che? L'iniquo, invidioso maligno vecchio non andò lungo tempo impunito del suo misfatto, benchè desse segni di pentimento d'un tanto errore, dapoichè essendo negli ultimi anni della sua vita notato di errori in varie sue pitture, e quasi deriso da' Pittori, che non lo temevano più come prima, ed avendo udito, che dal Cavalier Massimo erano stati notati errori in alcune figure dipinte in S. Severino, fattosi accomodare il ponte, cercò di emendar così vecchio gli errori notati; ma avendo forse sempre innanzi l'atroce suo misfatto, e non bene avertendo ove potesse il piede, cadde dal Palco, e sol tanto visse quanto potè dar segno di confessione ad un di que' Religiosi, che con gli altri Monaci erano accorsi all'infelice spettacolo."

64 Luigi Lanzi, *Storia pittorica dell'Italia dal risorgimento delle belle arti fin presso al fine del XVIII secolo*, Bassano, 1809 (edition cited: ed. M. Capucci, Florence, 1968–74, II, 124–25): "Quivi aveva voluto emular Michelangiolo, e restare anch'esso in esempio dello stile anatomico che già cominciava in Firenze a lodarsi sopra di ogni altro. Ma egli lasciò ivi ben altro esempio, e solamente insegnò a' posteri che il vecchio non dee correre dietro alle mode."

65 Agnolo Bronzino, *Rime in burla*, ed. Franca Petrucci Nardelli, Rome, 1988, 386.

66 Karel van Mander, *The Lives of the Illustrious Netherlandish and German Painters, from the First Edition of the Schilder-boeck (1603–1604)*, ed. and trans. Hessel Miedema, Doornspijk, 1994, I, 165.

67 Originally published by G. B. Lorenzi, *Monumenti per servire alla storia del Palazzo Ducale di Venezia*, Venice, 1868, 157–58 (n. 337).

68 Rona Goffen (*Renaissance Rivals: Michelangelo, Leonardo, Raphael, Titian*, New Haven, CT, and London, 2002, 269–70) finds a rivalry between Titian and Michelangelo being played out with the *Battle of Agnadello* and the *Battle of Cascina*. She does not mention the similarity of marketing strategies.

69 Karen-edis Barzman, *The Florentine Academy and the Early Modern State*, Cambridge, 2000, 29 and 36–38.

70 Barzman, *The Florentine Academy and the Early Modern State*, 38.

71 Natale dalle Laste, "De Musaeo Philippi Farsetti: epistola ad Cortonensium Academiam," in *Nuova raccolta d'opuscoli scientifici e filologici*, 13 (1765); reprinted in Natalis Lastesii, *Morosticensis Gratulationes*, Venice, 1767, III–35 (on 131–32).

72 Baglione, *Le vite*, ed. Röttgen, 137: "Pur venendovi a vederla Federico Zucchero, mentre io era presente, disse, Che rumore è questo? E guardando il tutto diligentemente, soggiunse. Io non ci vedo altro, che il pensiero di Giorgione nella tavola del Santo, quando Christo il chiamò all'Apostolato; e sogghignando, e maravigliandosi di tanto rumore, voltò le spalle, & andossene con Dio."

73 Giovanni Gaetano Bottari and Stefano Ticozzi, eds., *Raccolta di lettere sulla pittura, scultura e architettura*, Milan, 1822, VII, 514–15.

74 For Nebbia on his teacher Girolamo Muziano, from his poem "Dell'eccellenza della pittura" (1598), see A. Satolli, "La pittura dell'eccellenza, prolegomena ad uno studio su Cesare Nebbia nel suo tempo," *Bolletino dell'Istituto storico artistico orvietano*, 36 (1980), 255–75.

75 For a discussion of these two examples, see Loh, "New and Improved," 477–504.

2 Narcissus Grows Old

The chapter title was coined by Erin Campbell, to whom I am indebted for its use here.

1 Aristotle, *On Rhetoric*, II, xiii (1389b–1390a), trans. John Freese, London, 1982.

2 G. Ciampoli, *Prose*, Rome, 1649, 169 ("Capo ventesimoterzo. Che la novità nelle lettere è odiosa à i Vecchi, & à i Potenti"): "Il peggio è, che questa importunità si trova familiare in due sorti di persone, alle quali è debita la riverenza. Tali sono i Vecchi, & i Potenti; quelli venerandi per l'autorità, questi formidabili per la forza odiano chi può loro insegnare, come se gli volesse degradare. Mà l'età moriente merita qualche compassione, & i suoi consigli non possono tanto, che levino alle dottrine incognite il concorso de i giovani spassionati: il negotio è molto più pericoloso coi Grandi. Quasi ogni potente è Narciso di se stesso, nè si ritrova Rettorica più facile, che il persuadere superiori d'ingegno, dove si trova preminenza di Principato."

3 For the sake of brevity, no summary of Narcissus scholarship will be attempted here. Louise Vinge (*The Narcissus Theme in Western European Literature up to the Early 19th Century*, trans. R. Dewsnap and L. Grönlund, Lund, 1967) wrote the indispensable guide. Only the remarkable review of Narcissus sources (literary and visual) by Hans-Karl and Susanne Lücke rivals Vinge in scope and depth: *Antike Mythologie: Ein Handbuch. Der Mythos und seine überlieferung in Literatur und bildender Kunst*, Hamburg, 1999. Useful analyses

of Narcissus in antiquity include P. Hadot, "Le Mythe de Narcisse et son interprétation par Plotin," *Nouvelle revue de psychanalyse*, 13 (1976), 81–108; G. Rosati, *Narciso e Pigmalione: illusione e spettacolo nelle Metamorfosi di Ovidio*, Florence, 1983, 1–50; J. Elsner, "Naturalism and the Erotics of the Gaze: Intimations of Narcissus," in *Sexuality in Ancient Art*, ed. N. Kampen, Cambridge, 1996, 247–61; S. Bartsch, "The Philosopher as Narcissus: Vision, Sexuality and Self-Knowledge in Classical Antiquity," in *Visuality Before and Beyond the Renaissance*, ed. R. Nelson, Cambridge, 2000, 70–97.

4 L. B. Alberti, *Opere volgari*, ed. Cecil Grayson, Bari, 1973, III, 62.

5 Indispensable thematic analyses of Narcissus in relation to art theory include the following: for Alberti's origin story, see C. Baskins, "Echoing Narcissus in Alberti's *Della Pittura*," *Oxford Art Journal*, 16 (1993), 25–31; D. Arasse, "Presentation," *Albertiana*, 4 (2001), 160–64; H. Damisch, "L'Inventeur de la peinture," *Albertiana*, 4 (2001), 165–87; Stephen Bann, *The True Vine: On Visual Representation and the Western Tradition*, Cambridge, 1989, 105–201; N. Land, "Narcissus Pictor," *Source*, 16 (1997), 10–15; H. Damisch, "Narcisse Baroque?," in *Puissance du baroque: Les forces, les formes, les rationalités*, Paris, 1996, 29–42; G. Wolf, "'Arte superficiem illam fontis amplecti': Alberti, Narziss und die Erfindung der Malerei," in *Diletto e maraviglia: Ausdruck und Wirkung in der Kunst von der Renaissance bis zum Barock*, ed. C. Göttler et al., Emsdetten, 1998, 11–39; P. Carabell, "Painting, Paradox, and the Dialectics of Narcissism in Alberti's *De pictura* and in the Renaissance Theory of Art," *Medievalia et Humanistica*, n. s., 25 (19980, 53–73; J. Heffernan, "Speaking for Pictures: The Rhetoric of Art Criticism," *Word and Image*, 15 (1999), 19–33 (but especially 21–22 on "Philostratus: The Art Critic as Narcissus"); C. Kruse, "Selbsterkenntnis als Medienerkenntnis: Narziss an der Quelle bei Alberti und Caravaggio," *Marburger Jahrbuch für Kunstwissenschaft*, 26 (1999), 99–116; Claudia Nordhoff, *Narziss an der Quelle: Spiegelbilder eines Mythos in der Malerei: des 16 und 17 Jahrhunderts*, Munster and Hamburg, 1999; U. Pfisterer, "Künstlerliebe. Der Narcissus-Mythos bei Leon Battista Alberti und die Aristoteles-Lektüre der Frührenaissance," *Zeitschrift für Kunstegeschichte*, 64 (2001), 305–30. These studies have shaped my reading of the Narcissus myth in relation to the proverb "Every painter paints himself."

6 Lattanzius Placidus, *Narrationes fabularum ovidianarum*, ed. H. Magnus, in *Ovidii Metamorphoseon*,

Berlin, 1914, 692 (II, fab. 5–6). For discussion, see Maurizio Bettini and Ezio Pellizer, *Il mito di Narciso: immagini e racconti dalla Grecia a oggi*, Turin, 2003, 74–75.

7 *Lucretius on the Nature of the Universe*, ed. and trans. R. E. Latham and revised by J. Goodwin, Harmondsworth and New York, 1951, 39 (II. 61–79).

8 See the discussions of Ronsard, "Narcissus," in *Bocage* (Paris, 1554), Ovid, *Métamorphose figuré* (Lyon, 1557), and other sixteenth- and early seventeenth-century poems and illustrations in Vinge, *The Narcissus Theme*; G. Mathieu-Castellani, "Discours baroque, discours maniériste: Pygmalion et Narcisse," in *Questionnement du baroque*, ed. A. Vermeylen, Louvain and Brussels, 1986, 51–74; R. Crescenzo, "La Figure de Narcisse à l'époque baroque: reflexions sur l'iconographie et la thématique de Narcisse dans la littérature et l'illustration des livres de 1580 à 1640," in *Antiquités imaginaires*, ed. P. Hoffmann, P.-L. Rinuy, and A. Farnoux, Paris, 1996, 185–201; G. Mathieu-Castellani, "Narcisse Maniériste?" in *Manierismo e letteratura*, ed. D. Dalla Valle, Turin, 1986, 351–61.

9 Andrea Alciati, *Emblematum liber*, Lyon, 1531, emblem 69.

10 Ileana Chirassi, *Elementi di culture precereali nei miti e riti greci*, Rome, 1968, 143–55.

11 C. G. Julian and P. W. Bowers, "Harmful Effects Due to *Narcissus* and its Constituents," in *Narcissus and Daffodil: The Genus Narcissus*, ed. Gordon Hanks, London and New York, 2002, 399–407 (on 406).

12 D. Brown, "Compounds from the Genus *Narcissus*: Pharmacology, Pharmacokinetics and Toxicology," in *Narcissus and Daffodil*, ed. Hanks, 332–68.

13 Philostratus, *Imagines*, trans. A. Fairbanks, Cambridge, MA, and London, 1931, 80–82 (I. 23). See also M. Conan, "The *Imagines* of Philostratus," *Word and Image*, 3 (1987), 168; G. Wolf, "The Origins of Painting," *RES*, 36 (1999), 67; Elsner, "Naturalism and the Erotics of the Gaze," 253.

14 The few discussions of "Every painter paints himself" tend to focus on the material around Leonardo: M. Kemp, "'Ogni dipintore dipinge se': A Neoplatonic Echo in Leonardo's Art Theory?," in *Cultural Aspects of the Italian Renaissance: Essays in Honour of Paul Oskar Kristeller*, ed. C. Clough, Manchester and New York, 1976, 311–23; F. Zöllner, "'Ogni pittore dipinge sé': Leonardo da Vinci and 'Automimesis'," in *Künstler übersich in seinem Werk: Internationales Symposium der Biblio-*

thek Hertziana, ed. M. Winner, Weinheim, 1992, 137–60.

15 The origins of the proverb may reside in Aristotelian principles of causation most popular in scholastic philosophy, where God is likened to a signet ring and matter as wax. It was often summarized by the statement "every agent acts like itself" (*omene agens agit sibi simile*). For a discussion of this in relation to Dante (whose theory of love, we will see, inspired Leonardo's explanation for automimesis), see Patrick Boyde, *Dante Philomythes and Philosopher: Man in the Cosmos*, Cambridge, 1981, 225.

16 In a letter to Paolo Cortese, in *Prosatori latini del Quattrocento*, ed. E. Garin, Milan, 1953, 902.

17 Savonarola, *Predice sopra Ezechiele*, ed. R. Ridolfi, Rome, 1955, I, 343 (predica xxvi). After his reference to the saying ("one says that every painter paints himself"), he limits its meaning to the artist's *concetto* (probably meaning invention or iconography), specifically rejecting the possibility that painters imitate themselves "as man" or in "their different fantasies." Matteo Franco, *Il "Libro dei Sonetti"*, ed. Giulio Dolci, Milan, 1933, 24 (poem XI): "Sa' tu di quel ch'io ghigno? / Ch'ogni pittor sempre dipigne sè: / peto petuzzo, or su, dividiam te." Anton Francesco Doni, *La seconda Libraria*, Venice, 1551, 30v: "E si suol dire che ogni pittor dipinge sè, & che ogni simile apetisce il suo simile: ma se non ci solle che ogni regola patisce eccettione; si potrebbe dire che questo huomo galante havesse trovato il suo Genio havedo tradotta." Giovan Maria Cecchi ("L'Ammalata," in *Commedie inedite*, ed. G. Tortolli, Florence, 1855, 167) cites as proof that physicians, like everyone else, draw conclusions based on their present condition: "Il dipintor suol dipinger sé stesso". Orlando Pescetti, *Proverbi italiani: raccolti e ridotti*, Venice, 1603, 283r. For a summary of the literature, see Zöllner, "'Ogni Pittore Dipinge Sé'." For modern renditions, see Georgia O'Keeffe's observation that Alfred Stieglitz "was always photographing himself" (in *Georgia O'Keeffe: A Portrait of Alfred Stieglitz*, exhibition catalogue, New York: Metropolitan Museum of Art, 1978, 11). Roy Lichtenstein said: "I like to pretend that my art has nothing to do with me" (quoted in an interview with Deborah Solomon, "The Art behind the Dots," *New York Times Magazine*, 8 March 1987, 112).

18 Giorgio Vasari, *Le vite de' più eccellenti pittori scultori e architettori nelle redazioni del 1550 e 1568*, ed. P. Barocchi and R. Bettarini, Florence, 1987, VI, 118: "Ogni pittore ritrae se medesimo bene."

19 Salvator Rosa, *Satire*, ed. D. Romei, Milan, 1995, 103 ("La Pittura," lines 223–34): "Altri studiano a far sol animali / e, senza rimirarsi entro a gli specchi, / si ritraggono giusti e naturali. / Par che dietro al Bassan ciascuno invecchi, / rozzo pittor di pecore e cavalle, / et Eufranore e Alberto han negli orecchi, / e son le scole lor le mandre e stalle, / e consumano in far l'etadi intere / bisce, rospi, lucertole e farfalle, / e quelle bestie fan sì vive e fiere, / che fra i quadri e i pittor si resta in forse / quai sian le bestie finte e quai le vere."

20 Giovanni Battista Passeri, *Vite de' pittori, scultori ed architetti che hanno lavorato in Roma, morti dal 1641 fino al 1673*, ed. G. Bianconi and G. G. Bottari, Rome, 1772 (the manuscript was completed between 1673 and 1679). Edition cited: *Die Künstlerbiographien von Giovanni Battista Passeri*, ed. J. Hess, Leipzig and Vienna, 1934, 344–45: "Essendo osservato da Annibale [Carracci], e degl'altri fratelli ci fecero riflessione, et un giorno, che stava così intento alla loro operazione gli disse Agostino, *impararesti tu a dipingere?* Al quale rispose francamente: *Sì che io imparerei. Vien quà*, gli replicò, *fa così*, e fecegli un mezz'occhio con la penna, e gle lo diede, acciò seco il portasse per imitarlo."

21 David Levine, "Pieter van Laer's 'Artists' Tavern': An Ironic Commentary on Art," in *Jahrbuch der Preussischer Kulturbesitz*, Sonderband 4 (1987), 169–91.

22 Carlo Cesare Malvasia, *Felsina pittrice: vite de' pittori bolognesi divise in duoi tomi*, Bologna, 1678; edition cited: ed. G. P. Zanotti et al., Bologna, 1841, II, III.

23 For proverbs, see the essays by David Cram and James Obelkevich in *Wise Words: Essays on the Proverb*, ed. Wolfang Mieder, New York, 1994.

24 Claudio Achillini, letter to Giacomo Gaufrido, dated 4 January 1633; published in Giovanni Battista Manzini, ed., *Il trionfo del pennello: raccolta d'alcune compositioni nate à gloria d'un ratto d'Helena di Guido*, Bologna, 1633, 46.

25 Leonardo, *The Notebooks of Leonardo da Vinci*, ed. Jean Paul Richter, London, 1888, I, 293.

26 G. Visconti, *I canzonieri per Beatrice d'Este e per Bianca Maria Sforza*, ed. P. Bongrani, Milan, 1979, CLXVIII, 117–18.

27 Leonardo, *On Painting*, ed. and trans. Martin Kemp and Margaret Walker, New Haven CT, and London, 1989, 204.

28 Leonardo, *Treatise on Painting*, 86; Kemp, "'Ogni dipintore dipinge sé'," 311–23. Savonarola wrote that painters always capture their unique and stable *concetto*: Savonarola, *Prediche sopra Ezechiele*, ed. Ridolfi, I, 343 (predica xxvi); quoted in R. Steinberg, *Fra Girolamo Savonarola: Florentine Art, and Renaissance Historiography*, Athens, OH, 1977, 48.

29 Dante, *Purgatorio*, XXIV, 52–60; discussed by Zöllner, "'Ogni pittore dipinge sé'," 144.

30 Cicero, *De amicitia* (*Cicero on the Good Life*, trans. M. Grant, Harmondsworth, 1971, 189); Aristotle, *Nicomachean Ethics*, trans. David Ross, Oxford, 1954, 232–38 (IX, 7–8); Marsilio Ficino, *Sopra lo amore ovvero Convito di Platone*, ed. G. Rensi, Milan, 1998, 148–49 (Orazione VII, cap. viii: "Come può lo amante diventare simile allo amato"): "E però nessuno di voi si maravigli se udisse alcuno innamorato avere conceputo nel corpo suo alcuna similitudine della persona amata. Le donne gravide molte volte desiderando il vino, veementemente pensano al vino desiderato. Quella forte immaginazione gli spiriti interiori commuove: e commovendogli, in essi dipinge lo immagine del vino desiderato. Questi spiriti muovono similmente il sangue, e nella tenera materia del concetto la immagine del vino scolpiscono. Or' chi è sì poco pratico, che non sappia che un Amante appetisce più ardentemente la persona amata, che le donne gravide il vino? E però più forte e fermo cogita. Sì che non è maraviglia che il volto della persona amata, scolpito nel cuore dello Amante, per tale cogitazione si dipinga nello spirito: e dallo spirito nel sangue si imprima. Spezialmente perché nelle vene di Lisia già è generato il mollissimo sangue di Fedro: in modo, che facilmente può il volto di Fedro nel suo medesimo sangue rilucere. E perché tutti i membri di tutto il corpo, come tutto il giorno si appassiscono, così ribagnandosi a poco a poco per la rugiada del nutrimento rinverdiscono, seguita che di dì in dì, il corpo di ciascuno, il quale a poco a poco si disseccò, similmente si rifaccia. Rifansi i membri per il sangue, il quale da' rivoli delle vene corre. Adunque maraviglieraiti tu, se il sangue di certa similtudine dipinto, la medesima ne' membri disegni in modo che Lisia finalmente riesca simile a Fedro in qualche colore, o lineamento, o affetto, o gesto?"

31 Sears Reynolds Jayne, *Marsilio Ficino's Commentary on Plato's Symposium*, Columbia, MO, 1944, 211–12.

32 S. Speroni, *Dialogo d'amore* (completed 1537); edition cited: Mario Pozzi, ed., *Trattatisti del Cinquecento*, Milan–Naples, 1996, II, 545–50; partly translated and discussed by M. Pardo, "Artifice as seduction in Titian," in *Sexuality and Gender in Early Modern Europe: Institutions,*

Texts, Images, ed. J. G. Turner, Cambridge, 1993, 55–89.

33 In a letter of 4 January 1633, Claudio Achillini wrote to Giacomo Gaufrido (with Guido Reni in mind) that: "i pittori, per un'instinto di natura, dissegnando, e colorendo figure, dissegnano, e coloriscono senza propria industria, ò consiglio, se medesimi, ò almeno figure in gran parte somiglianti à se medesimi." The letter is published in G. B. Manzini, ed., *Il trionfo del pennello: raccolta d'alcune compositioni nate à gloria d'un ratto d'Helena di Guido*, Bologna, 1633, 46.

34 Charles Alphonse du Fresnoy, *L'Art de peinture: traduit en françois. Enrichy de remarques, reveu, corrigé, & augmenté*, Paris, 1684, LXIV.

35 Lomazzo, *Tratatto dell'arte de la pittura*, Milan, 1584, bk. 6, p. 437: "Ma tutta la forza di questo ritrarre quello che nella mente alcuno s'imprime, consiste nell'havere una grandissima avvertenza di conoscere se stesso, e quello che sua mente desidera, e con facilità e grazia esprimerla fuori in opera, eleggendo quello di bello e di buono, che ne gl'altri vede."

36 Philo Judaeus, "On Monarchy," in *Works*, trans. C. D. Yonge, London, 1855, III, 177–204 (*De monarchia*, I, 216).

37 Ficino, *Theologia platonica*; in *Opera omnia*, Basel, 1576 (translated and discussed by E. H. Gombrich, "Botticelli's Mythologies," *Journal of the Warburg and Courtauld Institutes*, 8 (1945), 59).

38 Malvasia, *Felsina pittrice*, II, 136

39 Giulio Mancini, *Considerazioni sulla pittura*, ed. A. Marucchi and L. Salerno, Rome, 1957, I, 8–9.

40 Hippocrates, *Regime IV or Dreams*, LXXXVI (trans. W. H. S. Jones, IV, Cambridge, MA, 1931). For a discussion of Hippocrates and Aristotle on dreams, see M. Andrew Holowchak, *Ancient Science and Dreams: Oneirology in Greco-Roman Antiquity*, Lanham, MD, and New York, 2002. For sixteenth-century interpretations of Hippocrates on dreams, see Nancy Siraisi, *The Clock and the Mirror: Girolamo Cardano and Renaissance Medicine*, Princeton, NJ, 1997, 178–82. For seventeenth-century dreams, see N. Armstrong and L. Tennenhouse, "The Interior Difference: A Brief Genealogy of Dreams, 1650–1717," *Eighteenth-Century Studies*, 23 (1990), 458–78.

41 Mancini, *Considerazioni sulla pittura*, I, 306–07.

42 For a discussion of these texts in relation to Mancini, see Philip Sohm, *Pittoresco: Marco Boschini, his Critics and their Critiques of Painterly Brushwork in Seventeenth- and Eighteenth-Century Italy*, Cambridge, 1991, 76–77.

43 G. Masi ("'Quelle Discordanze Si Perfette': Anton Francesco Doni, 1551–1553," *Atti e Memorie dell'Accademia Toscana di Scienze e Lettere La Colombaria*, n. s. XXXIX, 53 (1988), 11–112, on 46–70) discusses the following passage from Doni's *Mondi* (3v): "Dante finse d'andare vivendo all'Inferno Purgatorio et Paradiso. Matteo Palmieri mostrò d'esser guidato dalla Sibilla nell'altro mondo, et scrisse nuove inventioni d'anime et d'altre cose molto sottili da imaginarsi. Virgilio fu divino, il Sanazzaro nell'*Archadia* mirabile, et altri infiniti hanno scritto cose supreme. Ci sono stati poi nella religion Christiana alcuni Santi che hanno rivelato per via di visioni molto belle verità. I pittori, per venir più basso, anchora eglino si sono ingegnati di darci alcune cose astratte per le mani, dipingendoci il monte di Parnaso, le Historie d'Ovidio sotto coperta di favole; et Luciano per vere narrationi ha scritto di dotte cose. Et insino a Esopo con i topi, ranocchi, mosche et scimie ci ha ottimamente amaestrati."

44 Philippe Morel (*Les Grotesques: les figures de l'imaginaire dans la peinture italienne de la fin de la Renaissance*, Paris, 1997, 37–40) discusses Doni's discussion of grotesques, *macchie*, and figures in clouds as forms of dreams (*Disegno*, Venice, 1549, 15v, 22r, 41v–42r).

45 For this and the following, see especially Aristotle, *De somniis*, I, 458b, I; I, 459a, 18–19; III, 461b, 14–23 and III, 23, "On Dreams," trans. J. I. Beare, in *The Complete Works of Aristotle*, ed. J. Barnes, Princeton, 1984, I, 729–35; and Aristotle, *De anima*, trans. W. S. Mett, Cambridge, MA, and London, 1936, III, 2, 425b, 22–25; 3, 428a, 5–8. For a useful discussion of Aristotle on dreams, see G. Cambiano and L. Repici, "Aristotele e i sogni," in *Il sogno in Grecia*, ed. G. Guidorizzi, Bari, 1988, 121–35.

46 Maximianus, *Elegies on Old Age and Love*, trans. L. R. Lind, Philadelphia, 1988.

47 Plato, *The Republic* (329a–329d); trans. Paul Shorey in Plato, *The Collected Dialogues*, ed. E. Hamilton and H. Cairns, Princeton, NJ, 1961, 578.

48 Aristotle, *On Rhetoric*, II, xiii, 9 (1390a). See also Horace, *Epistles* (II, 76–103) in *Satires, Epistles, and Arts poetica*, trans. H. R. Fairclough, Cambridge, MA, and London, 1978, 403–05.

49 Aristotle, *On Rhetoric*, II, xiii, 1 (1389b); trans. G. A. Kennedy, Oxford, 1991, 167.

50 Aristotle, *On Rhetoric*, II, xiii, 3–12 (1389b–1390a); trans. Kennedy, 167–68.

51 Petrarch, *Familiarum rerum*, XXIV, 3 (letter to Marcus Tullius Cicero); edition cited: Petrarch, *Epistole*, ed. Ugo Dotti, Turin, 1978, 539–41.

52 Ovid, *Epistulae ex Ponto*, 3. 9. 39–40; edition cited: Ovid, *Tristia; Ex Ponto*, trans. A. L. Wheeler, Cambridge, MA, and London, 1988 (2nd ed., rev. G. P. Goold). For a review of the literature, see J. de Luce, "Ovid as an Idiographic Study of Creativity and Old Age," in *Old Age in Greek and Latin Literature*, ed. Thomas Falkner and Judith de Luce, Albany, NY, 1989, 195–216.

53 R. N. Butler, "The Life Review: An Interpretation of Reminiscence in the Aged," *Psychiatry*, 26 (1963), 65–76.

54 F. Cerreta, *Alessandro Piccolomini: letterato e filosofo senese del Cinquecento*, Siena, 1960.

55 Alessandro Piccolomini, *Della institution morale*, Venice, 1560; in *Prose di Giovanni della Casa e altri trattatisti cinquecenteschi del comportamento*, ed. A. di Benedetto, Turin, 1970, 513–16 (cap. xii: "De' costumi de' vecchi"). On 513: the old malign others, "essendo stati infinite volte ingannati dalla fallacia del mondo." On 514, the old become utilitarian instead of moral: "per l'amore che portano incredibilmente a se stessi, per conoscer che l'uomo non si può fidar di niuno salvo di se stesso, vengono sempre ad amar più le cose utili che l'oneste e le onorevoli." On 515: "Vivono i vecchi più secondo la memoria del passato che secondo la speranza dell'avvenire, per esser molta quella parte della vita che hanno passata, e brevissimo il restante che hanno a vivere. Onde segue che i vecchi, per aver sempre riguardo al pasato, prendono gran diletto di ragionare . . . giudicando che i tempi ne' quali eran giovani molto più felici fossero che quelli dove sono in vecchiezza: la qual cosa communemente è falsissima . . ."

56 A. Piccolomini, *L'Alessandro*, ed. F. Cerreta, Siena, 1966 (first prologue); trans. R. Belladonna, *Alessandro*, Ottawa, 1984.

57 Baldassare Castiglione, *Il libro del cortegiano*, II, i; as *The Book of the Courtier*, trans. C. S. Singleton, ed. D. Javitch, Garden City, NY, 2002, 66.

58 Giovan Battista Gelli, *I capricci del bottaio*, Florence, 1549; in *Trattatisti del Cinquecento*, ed. Mario Pozzi, Milan and Naples, 1996, II, 1023.

59 Lione Pascoli, *Vite de' pittori, scultori, ed architetti moderni*, ed. A. Marabottini et al., Perugia, 1992, 815.

60 Benvenuto Cellini, *Rime*, ed. V. Gatto, Rome, 2001, 87: "Questa [la mia boschereccia poesia] è vizio onesto in chi e' si pone, / ch'invecchia è forza al far qualche pazzia." For Cellini's old-age melancholy expressed in his letters and poetry, see B. Maier, "Cellini scrittore e il conflitto eroico tra 'virtù' e 'fortuna'," in *Da Dante a Croce*, Milan, 1992, 159.

61 Cellini, *Rime*, 128 ("Sogno"): "Quella gentil bugiarda a queste notte / io si sentia lamentar, poi che credea / che spenta la lucerna affatto avea, / smarrita giva in queste nuove grotte. / Quell'altre vidi poi sì mal condotte, / a quel Angel Michel, ch'ancor vedea / quei lumi spenti, e le gran strade rotte. / Chiamavan Ercol che venisse ancora / a liberarle; a cui rispose: "Come / venir poss'io in così scuri campi? / Mi trasse il Bandinel del sentir fuora; / benvenuto sarei a quel sol nome. / Or siam perdute, e non è chi ne scampi!" / Qual più vergogna avvampi, chi spegne il lume e la gran tosca Scuola / lasciando quella cieca, nuda e sola." For an important analysis of antagonism between Cellini and Bandinelli, see F. Vossilla, "Baccio Bandinelli e Benvenuto Cellini tra il 1540 ed il 1560: disputa su Firenze e su Roma," *Mitteilungen des Kunsthistorischen Institutes in Florenz*, 41 (1997), 254–313.

62 Letter from G. P. Zanotti to G. G. Bottari, 9 July 1762; published in Giovanni Gaetano Bottari and Stefano Ticozzi, eds., *Raccolta di lettere sulla pittura, scultura ed architettura*, 8 vols., Milan, 1822–25, IV, 220–21: "Oh che secolo, torno a dirlo, becco cornuto! E il dico per la pittura e per la poesia, che sono sorelle, e amorose, e vanno insieme d'accordo precipitando . . ."

63 Carlo Dati, *Delle lodi del Commendatore Cassiano dal Pozzo: Orazione*, Florence, 1664, n. p.; reprinted in *Raccolta di prose fiorentine*, Florence, 1731, pt. I, vol. IV, 182–229 (193–94); quoting Cassiano dal Pozzo on modern Gothic architecture: "Gran vergogna dell'età nostra, che quantunque sempre rimiri sì belle idee e norme tanto perfette negli edifici vetusti, tuttavia permette che per capriccio d'alcuni professori i quali si voglion dipartire dall'antico, l'architettura alla barbarie faccia ritorno! Non così fecero il Brunellesco, il Buonarroti, Bramante, il Serlio, il Palladio, il Vignola e gl'altri restauratori [*sic*] di sì grand'arte, i quali dalle misure delle fabbriche romane trassero le vere proporzioni di quegl'ordini regolatissimi, da cui niuno giammai s'allontanò senz'errore." Quoting an oft-repeated remark by Cassiano dal Pozzo: "Gran vergogna dell'età nostra, che quantunque sempre rimiri si belle idee, e norme tanto capriccio d'alcuni professori, i quali si voglino di partir dall'antico, l'architettura alle barbarie faccia ritorno! Non così fecero il Brunellesco, il Buonarruoti, Bramante, il Serlio, il Palladio, il Vignola, e gli altri restauratori [*sic*] di si grand'arte . . ." For the influence on Bellori's "Idea," see G. Perini, "Disegno romano dall'antico, amplificazioni fiorentine, e modello artistico bolognese," *Cassiano*

dal Pozzo. Atti del Seminario Internazionale di Studi, ed. F. Solinas, Rome, 1989, 203–19.

64 Vleugels was Director of the French Academy in Rome and editor of Ludovico Dolce's *Dialogo della pittura intitolato l'Aretino* (Florence, 1735). On p. 304, just after Dolce's "Aretino" says that "at the present I fear that painting will lose its way yet another time," Vleugels inserts that this prophecy is more true for his time than it was for Dolce's: "Pure è stato qui profetizato più per il tempo nostro presente, che per qualunque altro passato."

65 For Passeri's critical opinion of art, see P. Sohm, *Style in the Art Theory of Early Modern Italy*, Cambridge, 2001, 19–25. His choice to arrange his lives of artists by their death dates instead of by birth dates (the biographical standard) could be related to his views on the decline of art.

66 Martin S. Lindauer, "The Span of Creativity Among Long-Lived Historical Artists," *Creativity Research Journal*, 6/3 (1993), 221–39. Martin S. Lindauer, "Creativity in Aging Artists: Contributions from the Humanities to the Psychology of Old Age," *Creativity Research Journal*, 5/3 (1992), 211–31; and especially the articles by Dean Keith Simonton: "Creative Productivity: A Predictive and Explanatory Model of Career Trajectories and Landmarks," *Psychological Review*, 104/1 (1997), 66–89; "Age and Literary Creativity: A Cross-Cultural and Transhistorical Survey," *Journal of Cross-Cultural Psychology*, 6/2 (1975), 259–77; "Emergence and Realization of Genius: The Lives and Works of 120 Classical Composers," *Journal of Personality and Social Psychology*, 61/5 (1991), 829–40; and for his overview of his own work, see "Creativity from a Historiometric Perspective," *Handbook of Creativity*, ed. R. J. Sternberg, Cambridge, 1999, 116–36.

67 Malvasia, *Felsina pittrice*, II, 145.

68 Pascoli, *Vite*, 274–75.

69 Richard Wallace, *The Etchings of Salvator Rosa*, Princeton, NJ, 1979, 106.

70 Emilio Negro and Nicosetta Roio, *Giacomo Cavedone, pittore, 1577–1660*, Modena, [1991]; revised edition: Modena, 1996, 85–86. Malvasia (*Scritti originali*, Bologna, 1982, c. 198v) remarked on Cavedone copying his earlier work.

71 Filippo Baldinucci, *Vocabolario toscano dell'arte del disegno*, Florence, 1681, 88 (quoted and discussed in chapter 6, p. 144).

72 Filippo Baldinucci, *Notizie de' professori del disegno dal Cimabue in qua*, Florence, 1681–1728; edition cited: ed. P. Barocchi, Florence, 1975, V, 105: "Ben'è vero, che nell'ultimo tempo intervenne a lui ciò, che accader suole anche alla più parte de'buoni maestri, i quali, innamorandosi a lungo andare alquanto più del lor proprio modo di dipingere, cadono nell'ammanierato, abbandonando bene spesso l'obbedienza al naturale, ed il perfetto disegnare." Giovambattista Vanni also turned away from nature and became mannered late in life: ibid., IV, 547.

73 Baldinucci, *Notizie*, ed. Barocchi, III, 429: "Fu grazioso nelle teste, e diede alle sue figure bella disinvoltura, seguitando la maniera del cavalier Francesco Vanni suo fratello uterino, ma non diede già loro tanto rilievo e verità quanto egli fece, perchè essendo stato uomo molto inclinato a' passatempi, ed essendosi troppo presto contentato di sè e del proprio modo di dipingere, e così avendo poste le ricreazioni nel luogo de' grandi studi ch'egli aveva a principio intrapresi, non fu poi maraviglia, ch'è lasciasse di sua mano, massimamente negli ultimi tempi, assai cose alquanto secche, troppo dintornate, particolarmente ne' panneggiamenti, e molto ammanierate, ed in somma assia differenti in bontà da quelle che fecero vedere i suoi pennelli negli anni suoi più verdi."

74 Baldinucci, *Notizie*, ed. Barocchi, IV, 592–93: "E certo che se egli [Balassi] non si fosse tanto innamorato del proprio modo di fare (vizio che ha tolto il pregio alla maggior parte de' buoni pittori), le sue pitture sarebbero sempre state nel gran credito che egli in vita le tenne, facendole pagare forse più di orni altro; laddove per aver poi dato molto nell'ammanierato, alcune di esse dopo sua morte scermarono alquanto di prezzo." See also Francesco Moücke, *Serie di ritratti degli eccellenti pittori dipinti di propria mano che esistono nell' Imperial Galleria di Firenze. Colle vite in Compendio de Medesimi*, Florence, 1756, III, 63. On Balassi: "[M]a indi presso al terminar de' suoi giorni, ingannato dalla fallace novità di stano capriccio, malaccorto azzardossi a mutare l'antica maniera, deformando in pruova di ciò alcune delle più belle pitture, che fatte giammai avesse, col ritoccarle in uno stile non suo, e affatto sconvenevole e ammanierato." For a fourth example, see Baldinucci, *Notizie*, ed. Barocchi, IV, 547 (Giovambatista Vanni).

75 M. Lacombe de Prezel, *Dizionario portile delle belli arti; ovvero Ristretto di ciò che spetta all'Architettura, alla Scultura, alla Pitture, all'Intaglio, alla Poesia, ed alla Musica*, Venice, 1758, 222: *Caricar nella maniera*. "Significa che un Pittore copi continuamente se stesso nelle sue Figure, nelle sue attitudini, nelle sue arie di testa, e simili, lo che diventa vizio."

76 Francesco Sansovino, *Venetia città nobilissima et singolare descritta*, Venice, 1581, 3.

77 A thorough article on Rangone and his patronage was published by Erasmus Weddigen, "Thomas Philologus Ravennas: Gelehrter, Wohltäter und Mäzen," *Saggi e memorie di storia dell'arte*, 9 (1974), 29–75; and is now updated in his impressive book *Jacomo Tentor F.: Myzelien zur Tintoretto-Forschung: Peripherie, Interpretation und Rekonstruktion*, Munich, 2000. His discussion focuses on Rangone's hermeneutics without reference to longevity and narcissism.

78 Published in Weddigen, "Thomas Philologus Ravennas," 59: "Landera partij che metto jo tomaso Ravena D. & K.r guardian grando dela prefatta schola chel mi sia conseso potter metter una mia in magine hover sttattua figura jn piera dal vivo jn piedi in piera hover di bronzo amio ben e plazetto fatta amie spexe e con li proprj mij danarj sotto il capo del lion in un nichio nela fazada dela nostra preditta schola dj S. Marcho forj sul campo di san Zuane polo abia a sttar p[er]pettuamente con questa Inscripzione THOMAS PHILOLOGUS RAVENAS PHYSICUS EQUES G MAG ANO MDLXII."

79 Weddigen, "Thomas Philologus Ravennas," 61: "detto ms. Jac.o [Tintoretto] si offerse al ditto Guardian et al suo Vicario a finirle [the paintings] perfettamente levando la figura dell'Ex Ravena et in loco di essa mettendo altra accomodata et insieme di finir perfettamente la quarta tella . . ."

80 Weddigen, "Thomas Philologus Ravennas," 64: "concesso et perpetuamente osservato da V. Serenità e s. Ill.me et Ecc.me chel possi mettere et eternamente stare una sua figura dal vivo, et imagine di bronzo in piedi over sedendo, come par a V. Serenità, fatta a spese sue, oltra li sopradetti ducati mille nella fazzada davanti essa chiesia, con sue arme, litere et ogni altra cosa pertinente ad uno benefattore."

81 Bruce Boucher, *The Sculpture of Jacopo Sansovino*, New Haven, CT, and London, 1991, I, 113–18.

82 Weddigen, "Thomas Philologus Ravennas," 68: "Concedevano facoltà di poter fabricar la porta maestra sopra il fondamento de Canal Grande che risponde con il suo sottoportico alla porta della capella del S.to Sepolcro, che è in detta loro chiesa et ciò di pietre vive con sue collonne et ornamenti nel modo, forma et secondo il modello del predetto Ecc.te Giacomo Sansovino, et nella parte di sopra di essa porta nel quadro possi far poner la inscrittione in lettere antique intagliate in pietra, sopra il frontispizio di essa ponervi la immagine, overo statua di pietra di s. Thomaso." The convent

was attached to the church of San Giovanni in Bragora.

83 Montaigne, *Complete Essays*, trans. D. Frame, Stanford, CA, 1958, 458 (II. 13).

84 Gabriele Paleotti, *Discorso intorno le immagini sacre e profane*, Bologna, 1582; edition cited: P. Barocchi, ed., *Trattati d'arte del Cinquecento*, 3 vols., Bari, 1960–62, II, 335: "di essere accecato dall'amor proprio, sì come anticamente favoleggiorno i poeti di Narciso, che invaghito vanamente della sua faccia, estinse la propria vita col troppo amore di sé stesso."

3 Poussin's Hands and Titian's Eyes

1 Pierre Rosenberg and Louis-Antoine Prat eds., *Nicolas Poussin: La Collection du Musèe Condé à Chantilly*, Paris, 1994, 130.

2 Pierre Rosenberg and Louis-Antoine Prat, *Poussin Catalogue raisonné des dessins*, Milan, 1994, n. 367 (dating the drawing as *circa* 1660); for a discussion of the Washington *Landscape with Two Figures*, dated *c.* 1655, see n. 365

3 Giovan Pietro Bellori, *Le vite de' pittori, scultori e architetti moderni*, Rome, 1672; edition cited: ed. Evelina Borea, Turin, 1976, 459. For a discussion of the *Apollo and Daphne*, see Pierre Rosenberg and Louis-Antoine Prat, eds., *Nicolas Poussin, 1594–1665*, Paris, 1994, 520–21; Elizabeth Cropper and Charles Dempsey, *Nicolas Poussin: Friendship and the Love of Painting*, Princeton, NJ, 1996, 303–07.

4 Pliny, *Natural History*, trans. H. Rackham, Cambridge, MA and London, 1958, XXXV. 40. 145. Bartolomeo Facio applied this to Gentile da Fabriano: see M. Baxandall, "Bartholomaeus Facius on Painting: A Fifteenth-Century Manuscript of the *De Viris Illustribus*," *Journal of the Warburg and Courtauld Institutes*, 27 (1964), 90–107 (especially 100–01).

5 In Paolo Pino's *Dialogo di pittura* (Venice, 1548; edition cited: P. Barocchi, ed., *Trattati d'arte del Cinquecento*, 3 vols., Bari, 1960–62, I, 124–25) the Florentine painter "Fabio" renders his verdict on old age: "gli intelletti nostri sono impediti dall'imperfezzione corporea, a tal ch'aggiugniamo prima alla morete ch'al termine dell'intendere. [Lauro:] questo è ch'il nostro Pino scrive nell'opere sue 'faciebat'. [Fabio:] È ben fatto. Il medesimo scriveva il dio della pittura Apelle, volendo farsi intendere che sempre scorgea maggior profondità nel sapere, e quanto più s'impara, tanto più vi riman da imparare." This confession that "our

intellects are hindered by corporeal imperfection so that we add our intentions [to the painting] before death," that physical decline may prevent the realization of painters' intentions, is moderated by the belief that painters (at least good painters like Pino himself, then around 40 years old) grow wiser with age. For Pino's age, see V. Mancini, "In margine a un volume monografico su Paolo Pino, artista e teorico dell'arte," *Arte veneta*, 46 (1994), 83–91.

6 Anthony Blunt, *The Drawings of Poussin*, New Haven, CT, 1979, 78.

7 "Many of these late drawings [by Guercino] are hesitant and lack the characteristic BRIO of earlier studies. Broken contours and lines of fluctuating intensity are a particular feature of Guercino's draughtsmanship in this period [the late period, 1650–66], perhaps indicative of the unsteady hand and failing sight of old age (see Nos. 156–8)." Nicholas Turner and Carol Plazzotta, *Drawings by Guercino from British Collections*, London, 1991.

8 Poussin, letter of 16 November 1664 to Chantelou (in N. Poussin, *Lettres et propos sur l'art*, ed. A. Blunt, Paris, 1989, 171), describing his condition one month after the death of his wife: "chargé d'années, paralytique, plein d'infirmités de toutes sortes, étranger et sans amis. . . . Voilà l'état où je me trouve. . . . J'ai si grande difficulté à écrire pour le grand tremblement de ma main . . ." Poussin (p. 172), January 1665 to Félibien (published by André Félibien in *Entretiens sur les vies et sur les ouvrages des plus excellens peintres anciens et modernes*, Trevoux, 1725, VIII, 308): "Je suis devenu trop infirme et la paralysie m'empêche d'opérer. Aussi, il y a quelque temps que j'ai abandonné les pinceaux, ne pensant plus qu'à me préparer à la mort. J'y touche du corps: c'est fait de moi." Félibien adds in his life of Poussin: "Nous avons N . . . qui écrit sur les oeuvres des peintres modernes et de leurs vies. Son style est ampoulé, sans sel et sans doctrine." Poussin (p. 176), 26 July 1665 to l'Abbé Nicaise: "Je suis en peine de vous répondre à cause de la débilité de ma main tremblante qui ne veut plus obéir ainsi comme je le voudrais. . . . J'ai quitté les pinceaux pour toujours. Je n'ai plus à présent qu'à mourir, ce qui sera l'unique remède à mes maux qui m'afflingent. Dieu veuille que ce sera bientôt, car la vie me pèse troppe."

9 Bernardo de' Dominici, *Vite de' pittori, scultori, ed architetti napoletani*, Naples, 1742, III, 109.

10 Raffaelle Soprani, *Vite de' pittori, scoltori, et architetti genovesi*, Genoa, 1674, I, 269–70.

11 Lucia Longo, "Testimonianze documentarie su Antonio Triva 'pittore di corte' in Baviera (1669–1699)," *Arte Veneta* 41 (1987), 199.

12 Carmen Bambach, "Leonardo, Left-handed Draftsman and Writer," in *Leonardo da Vinci, Master Draftsman*, ed. C. Bambach, New Haven, CT, and London, 2003, 34 (exhibition catalogue: New York, Metropolitan Museum of Art).

13 Antonio Palomino, *Lives of the Eminent Spanish Painters and Sculptors*, trans. Nina Mallory, Cambridge, 1987, 39.

14 From Albrecht Dürer, *De symmetria partium hunanorum corporum*, trans. Joachim Camerarius (Nuremberg, 1532), fols. Aija ff. For a general account of this text, see Peter W. Parshall, "Camerarius on Dürer: Humanist Biography as Art Criticism," in *Joachim Camerarius (1500–1574): Beiträge zur Geschichte des Humanismus im Zeitalter der Reformation* (Humanistische Bibliothek, ser. I, Abhandlungen, 14), ed. F. Baron, Munich, 1978, 11–29.

15 Giorgio Vasari, *Le vite de' più eccellenti pittori scultori e architettori nelle redazioni del 1550 e 1568*, ed. P. Barocchi and R. Beltarini, Florence, 1971, III, 366 (with Michelangelo who, "parlando di Gentile, usava dire, che nel dipingere aveva avuto la mano simile al nome.") And Vasari (III, 369) concluding that "essendo fatto parletico, che non operava più cosa buona. In ultimo, consumato dalla vecchiezza, trovandosi d'ottanta anni, si mori."

16 O. Bonfait, "Poussin au carrefour des années 1960," in *Nicolas Poussin, 1594–1665*, ed. P. Rosenberg and L.-A. Prat, Paris, 1994, 106–17 (exhibition catalogue: Paris, Grand Palais).

17 N. Turner, "L'*Autoportrait* dessiné de Poussin au British Museum," in *Nicolas Poussin, 1594–1665*, ed. Alain Mérot, Paris, 1994, I, 81–97 (Actes du colloque organisé au musée du Louvre).

18 De' Dominici, *Vite*, III, 442–43.

19 The first quote appears in a letter of 1542 to an unnamed prelate: *Il carteggio di Michelangelo: edizione postuma di Giovanni Poggi*, ed. P. Barocchi and R. Ristori, 5 vols., Florence, 1965–83, IV, 151–52 (n. MI). The second quote comes from the opening stanza of the sonnet: "Non ha l'ottimo artista alcuna concetto" (Michelangelo, *Rime*, ed. E. N. Girardi, Bari, 1960, 151). This sonnet has a long history of interpretation, starting most famously with Benedetto Varchi's lecture read to the Accademia Fiorentina in 1547: *Due lezzioni . . . nella prima delle quale si dichiara un sonetto di M. Michelangelo Buonarroti. Nella seconda si disputa quale sia piu nobile*

arte la scultura, o la pittura, Florence, 1549. Vincenzio Borghini cited to prove the following assertion: "Nelle quali non solo come platonico, ma come vero e natural filosofo conobbe che da l'intelletto nostro non può usire operazione alcuna perfetta, mediante le mani artefici, se non ha prima concepuUto l'idea di quella tal costa; talché l'intelletto si può dire esser quella cosa" (V. Borghini, "Selva di notizie," in *Pittura e scultura nel Cinquecento*, ed. P. Barocchi, Livorno, 1998,111–12). The most complete discussion of its meanings can be found in David Summers, *Michelangelo and the Language of Art*, Princeton, NJ, 1981, 203–33.

20 *Il carteggio di Michelangelo*, IV, 151–52.

21 Varchi, *Due lezioni*; edition cited: Benedetto Varchi and Vincenzio Borghini, *Pittura e scultura nel Cinquecento*, ed. Paola Barocchi, Livorno, 1998, 21. See also Varchi, in *Opere*, Florence, 1590, II, 618–19: "In due modi e per due cagioni non obbedisce la mano all'intelletto, o perché non è esercitata e non ha pratica, e questo è difetto del maestro; o perché è impedita da qualche accidente . . . E questo è difetto della fortuna o d'altri che del maestro; ma in qual si voglia di questi duoi modi, non si possono esercitare in modo che ben vada l'arti manuali, perché la mano è lo strumento delle arti." For a discussion of Varchi's metonymic use of the hand to signify artistic practice or execution, see Leatrice Mendelsohn, *Paragoni: Benedetto Varchi's Due Lezzioni and Cinquecento Art Theory*, Ann Arbor, MI, 1982, 100–02.

22 U. Procacci, "Una 'Vita' inedita del Muziano," *Arte veneta*, 8 (1954), 245 (Niccolo Gabburri, quoting Muziano remembering Michelangelo).

23 Mario Equicolo, *Institutioni al comporre in ogni sorte di rima della lingua volgare, con un eruditissimo Discorso della pittura e con molte segrete allegorie circa le Muse e la poesia*, Milan, 1541; published in *Scritti d'arte del Cinquecento*, ed. P. Barocchi, Milan and Naples, 1971, I, 259–60.

24 Francisco de Hollanda, *I trattati d'arte*, ed. Grazia Modroni, Livorno, 2003, 197; letter signed Francesco d'Olanda to Michelangelo, from Lisbon, 15 August 1553.

25 Giorgio Vasari, *Le vite de' più eccellenti pittori scultori e architettori nelle redazioni del 1550 e 1568*, ed. P. Barocchi and R. Bettarini, Florence, 1987, VI, 94 and 104.

26 Charles de Tolnay, *The Art and Thought of Michelangelo*, New York, 1964, 81.

27 David Rosand, *Drawing Acts: Studies in Graphic Expression and Representation*, Cambridge, 2002, 214.

28 Giovanni Pietro Zanotti, *Storia dell'Accademia Clementina di Bologna*, Bologna, 1739, I, 154. Cignani tried to burn a nude *Danae* but was prevented from doing so with promises to keep it "decently covered."

29 Paul Fréart de Chantelou, *Diary of the Cavaliere Bernini's Visit to France*, ed. A. Blunt and G. Bauer, trans. M. Corbett, Princeton, NJ, 1985, 111 (August 10).

30 Domenico Bernini, *Vita del Cavaliere Gio. Lorenzo Bernino*, Rome, 1713, 167.

31 Filippo Baldinucci, *Vita del Cavaliere Gio. Lorenzo Bernino: scultore, architetto, e pittore*, Rome, 1682; as *The Life of Bernini*, trans. C. Enggass, University Park, PA, 1966, 66–67.

32 I. Lavin, "Bernini's Death," *Art Bulletin*, 54 (1972), 158–86; I. Lavin, "La Mort de Bernini: visions de rédemption," in *Baroque Vision Jésuite du Tintoret à Rubens*, ed. Alain Tapié, Caen, 2003, 105–19. For an excellent critique of the reasons behind Lavin's attribution, see Catherine Soussloff, "Old Age and Old-Age Style in the 'Lives' of Artists: Gianlorenzo Bernini," *Art Journal*, 1987, 118–19.

33 I am assuming that the passage in *Trattato della pittura e scultura, uso ed abuso loro, composto da un Theologo e da un Pittore, per offerirlo al Sigg. Accademici del Disegno di Firenze* (Florence, 1652) concerning old age was inspired by, or even written by, Pietro da Cortona instead of its co-author, Giandomenico Ottonelli. For further discussion, see chapter 7.

34 Karel van Mander, *The Lives of the Illustrious Netherlandish and German Painters, from the First Edition of the Schilder-boeck (1603–1604)*, ed. and trans. Hessel Miedema, Doornspijk, 1994, I, 226 (fol. 242r).

35 Carlo Cesare Malvasia, *Felsina pittrice: vite de' pittori bolognesi divise in duoi tomi*, Bologna, 1678; edition cited: ed. G. P. Zanotti et al., 2 vols., Bologna, 1841, II, 134.

36 A. J. Dézallier d'Argenville, *Abrégé de la vie des plus fameux peintres*, Paris, 1752, III, 352.

37 Félibien, *Entretiens*, 1725, I, 54–55.

38 Félibien; quoted by Puttfarken, "Roger de Piles, une littérature artistique destinée à un nouveau public," in *Les "Vies" d'artists*, ed. M. Waschek, Paris, 1996, 88: "il est donc vrai qu'il y a un art tout particulier qui est détaché de la matière & de la main de l'artisan."

39 Pierre-Jean Mariette, ed., *Description sommaire de dessins des grand maistres d'Italie, des Pays-Bas et de France, du Cabinet de Feu M. Crozat*, Paris, 1741, 115.

40 Helen Langdon, *Claude Lorrain*, Oxford, 1989, 124; letter of July 1662 to Cardinal Leopoldo de' Medici. I am grateful to Richard Spear for this reference.

41 Borghini, "Selva di notizie," 134.

42 *Lucretius on the Nature of the Universe*, ed. and trans. R. E. Latham, Harmondsworth and New York, 1951, 78: III, 445–460. For Galen's medical reading of this phenomenon, see Galen, "The Soul's Dependence on the Body (That the Faculties of the Soul Follow the Mixtures of the Body)," in *Selected Works*, ed. and trans. P. N. Singer, Oxford, 1997, 159.

43 Francesco Stelluti, *Della Fisonomia di tutto il corpo humano . . . Hora brevemente in tavole sinottiche ridotta e ordinata*, Rome, 1637, n. p. In the dedicatory letter, Stelluti notes the importance of Della Porta's work on signatures as signs of character, commenting that it has proven useful for princes to determine the motives and honesty of courtiers.

44 Carlo Ratti, *Delle vite de' pittori, scultori, ed architetti genovesi*, Genoa, 1768, II, 381.

45 P. Sohm, *Style in the Art Theory of Early Modern Italy*, Cambridge, 2001, 115–43.

46 Giovan Pietro Bellori, *Le vite de' pittori, scultori e architetti moderni*, Rome, 1672; edition cited: ed. E. Borea, Turin, 1976, 456.

47 Soprani, *Vite*, I, 150. Lione Pascoli, *Vite de' pittori, scultori, ed architetti moderni*, 2 vols., Rome, 1730–36 (edition cited: ed. V. Martinelli, Perugia, 1992, 150) accepted Soprani's opinion: "Ma s'era alquanto raffreddato per un trattato di pittura, che avea fra mano, in cui molto tempo impiegò prima di darlo alle stampe, e per mancanza del natural vigore già indebolito dalle continue fatiche, che fino allora avea fatte, e per l'imminente vecchiaja, che non più come innanzi gli permetteva di fare."

48 Giovan Maria Ciocchi, *La pittura in Parnaso*, Florence, 1725 (in preface to the reader).

49 F. S. Baldinucci, *Vite di artisti dei secoli XVII–XVIII*, ed. Anna Matteoli, Rome, 1975, 45–46 and 49–51 (letter from Franchi to Ludovico David, 13 July 1709); Sebastiano Bartolozzi, *Vita di Antonio Franchi lucchese pittor Fiorentino*, Florence, 1754, 79–82.

50 Cicero, *De senectute*, trans. W. Falconer, Cambridge, MA, and London, 1923, IX. 28: "The orator, I fear, does lose in efficiency (*languescat*) on account of old age, because his success depends not only upon his intellect, but also upon his lungs and bodily strength. In old age, no doubt, the voice actually gains (I know not how) that magnificent resonance which even I have not lost, and you see my years; and yet the style of speech that graces the old man is subdued and gentle, and very often the sedate and mild speaking of an eloquent old man wins itself a hearing."

51 Pascoli, *Vite*, ed. Martinelli, 207; Borghini, "Selva di notizie," 136.

52 Ratti, *Delle vite de' pittori, scultori, ed architetti genovesi*, II, 161: "Guardandosi intanto le mani, con esse lagnavasi, che lo abbandonassero . . ."

53 Borghini, "Selva di notizie," 134: "Delle quali m'occorre dire che di sua natura quanto più la fatica s'immerge nel corpo, tanto pare men nobile e meno necessaria a dar riputazione: come, verbigratia, se Virgilio avessi dettato i sua versi stando a diacere, non sarebbe manco eccellente poeta che avendo scritto di sua mano, perché lo scrivere di manu propria o d'altri non varia lo artificio, e se possibil fussi senza parlare esprimere ae sua concetti, poteva risparmiare anche questa fatica."

54 Pietro Aretino, *Lettere sull'arte*, ed. E. Camesasca and F. Pertile, Milan, 1957, CDLXXXIV (letter of December 1548 to Gian Maria, Pittore).

55 Giandomenico Ottonelli and Pietro Berrettini, *Trattato della pittura e scultura, uso ed abuso loro, composto da un Theologo e da un Pittore, per offerirlo al Sigg. Accademici del Disegno di Firenze*, Florence, 1652, 175.

56 For Poussin's knowledge of Lomazzo's *Idea del tempio della pittura* (Milan, 1590), see Erwin Panofsky, *Idea: Ein Beitrag zur Begriffsgeschichte der alteren Kunsttheorie*, Berlin, 1960; as *Idea: A Concept in Art Theory*, trans. J. Peake, New York, 1968, 242–43.

57 Bellori's copy of Giovanni Baglione's *Le Vite de' pittori scultori et architetti* (the edition of 1642; now in the Accademia dei Lincei) has been reproduced in an edition by Valerio Mariani (Rome, 1935), who also transcribed the marginalia in the Appendix now in Biblioteca Vaticana; published by C. D'Onofrio, *Roma nel Seicento*, Florence, 1969; notes from *circa* 1665–67; and see Herwarth Röttgen, *Il Cavalier Giuseppe Cesari d'Arpino: un grande pittore nello splendore della fama e nell'inconstanza della fortuna*, Rome, 2002, 210–11: "questo vuol dire essere [d'Arpino] pittore di spirito, e non di scienza. La scienza s'acrese e gli spiriti mancano quando si diventa vecchio, esempio ne siano le mirabil opera di Pietro da Cortona Vecchio e di Monsù Poussin vecchio, e altri vecchi." For further discussion of d'Arpino's late frescoes in the Sala dei Conservatori and their place in seventeenth-century art historiography, see chapter 5 For an opposing view that claims this theory to be beloved by the elderly whose creativity has grown weak and stale, see Agostino Scilla,

"Discorso. Per l'Accademia del Disegno in Roma" (1688), mss. in Rome, Biblioteca Casanatense, cod. 1482, fol. 141: "All'erta allerta. Giovani bene intenzionati alla guardia. La sfrontata audacia così raggiona voi pur adesso l'udirete ma non vi nuocerà in questo giorno. Udiamola per detestarla e per conoscerla più d'appresso nelle sue pernicisissime regole. *Compendiariam picturam faciam*, promette per ingannare la sfacciata giovanotti io vi voglio professori bravi in poco spazio di tempo, e cio farasti non per la strada d'intisichirvi sotto i precetti dell' arte, che i vecchi ranciti amatori dell' antichià predicano necessarii per l'acquisto di essa, ma sotto la guida della facilità."

58 A. Vannugli, "Le postille di Sebastiano Resta al Baglione e al Vasari, al Sandrart e all'Orlandi: un'introduzione storico-bibliografica," *Bollettino d'arte*, 76 (1991), 145–54 (on 153, n. 32). In his note appended to Baglione's life of Cesari d'Arpino, Resta notes that d'Arpino "mostrò che all'animo suo più non rispondevano le forze; e per l'accrescimento de gli anni mancavagli, il valor del pennello. . . . Questo vuol dire essere pittore di spirito, e non di scienza. La scienza s'accresce, e li spiriti mancan quando si diventa vecchio. Essempio ne siano le mirabili opere di Pietro da Cortona Vecchio e di Monsù Possin vecchio, et altri vecchi."

59 Pascoli, *Vite*, ed. Martinelli, 630 (on Cesare Pronti); and for Rosa using glasses by age 49, see A. de Rinaldis, ed., *Lettere inedite di Salvator Rosa a G. B. Ricciardi*, Rome, 1939, 166–67 (letter 132, 1664), 174 (letter 138, 1665), and 176 (letter 139, 1665); and Raimonda Riccini, ed., *Taking Eyeglasses Seriously: Art, History, Science, and Technologies of Vision*, exhibition catalogue, Milan, Palazzo dell'Arte, 2002.

60 Pietro Ligari, letter of 7 April 1749; written from Sondrio (unpublished; original in Sondrio, Biblioteca Comunale): "Hora l'età mia dificulta il dipingere senza l'uso di perfettissimi Occhiali, ma di tal sorte qui non ne posso avere; onde la prego provedermene due ò tre pari de' più perfetti e chiari per l'età di 65 e 70 Anni incase che il Sig.re volesse che vi arivassi . . ."

61 For Lomazzo, see M. Giuliani and Rossana Sacchi, "Per una lettura dei documenti su Giovan Paolo Lomazzo, 'istorito pittor fatto poeta'," in *Rabisch: il grottesco nell'arte del Cinquecento. L'Accademia della Val di Blenio, Lomazzo e l'ambiente milanese*, Lugano and Milan, 1998, 323–35. For Bellinert, see Baglione, *Le vite*, 154–55: "Finalmente la disgratia, che bene spesso accompagna la virtù, il fece in breve divenir cieco, & il povero giovane con danno della professione non ha potuto dar complimento

alle opere . . . benche morto non sia, vive però privo della luce, e de gli usi del pennello." For Gonnelli, see Filippo Baldinucci, *Notizie de' professori del disegno dal Cimabue in qua*, Florence, 1681–1728; edition cited: ed. P. Barocchi, Florence, 1975, IV, 620–29; and Elizabeth Cropper and Charles Dempsey, *Nicolas Poussin: Friendship and the Love of Painting*, Princeton, NJ, 1996, 213.

62 For Albani, see Michelangelo Gualandi, *Nuova raccolta di lettere sulla pittura, scultura ed architettura*, Rome, 1856, II, 218–19 (letter of 9 December 1659 from Ferdinando Cospi to Cav. Cerchi). For Castello, see Ratti, *Delle vite de' pittori, scultori, ed architetti genovesi*, I, 110: "Fu anche favorito da Dio d'una continua, e perfetta salute, e d'una vista sì perspiace, che già in età di quasi novant'anni senza adoperare occhiali maneggiava in piccolissimi fondi i pennelli, e coloriva minutissime cose con istupore di chiunque lo vedea lavorare." For Morandi, see Pascoli, *Vite*, ed. Martinelli, 582: "La vista sufficiente gli serviva, e lo servì fino alla decrepità, perchè non ebbe mai uopo d'occiali neppur nel quadro, che faceva per Firenze, e la flagellazione di N. S. vi figurava, e ne' due che faceva per S. Pietro a montorio, e S. Francesco, e S. Antonio vi rappresentava che furono gli ultimi."

63 Salvator Rosa, *Lettere*, ed. Gian Giotto Borrelli, Naples, 2003, 324–25 (4 October 1664). Rosa often complained about his declining eyesight from this date forward: ibid., 332 (3 June 1665), 337 (31 October 1665), 345 (16 June 1666), 376 (14 July 1668), 380 (1 December 1668), 387 (3 June 1669), and 389 (17 August 1669).

64 For Garofalo, see Giorgio Vasari, *Le vite de' più eccellenti pittori scultori e architettori nelle redazioni del 1550 e 1568*, ed. P. Barocchi and R. Bettarini, Florence, 1984, V, 414. For Ammannati, see Baglione, *Le vite*, 29. For Bassano, see Giovanni Gaetano Bottari and Stefano Ticozzi, eds., *Raccolta di lettere sulla pittura, scultura ed architettura*, 8 vols., Milan, 1825, III, 265–66 (letter CX, from Francesco Ponte, writing in Venice on 25 May 1581, to Niccolò Gaddi): "Li molti travagli e l'indisposizione che ha avuto mio padre [Jacopo Bassano], non mi ha lassato più presto che ora mandar li disegni; e prometto a V. S. ill. che con fatica ne ho potuto avere da mio padre, perchè ormai non disegna più, nè può operar molto con gli pennelli sì per la vista, come anco per esser di molti anni; ma ho fatto travar questi, i quali erano a caso in casa, li quali mando insieme con questi di mia mano." For Tiarini, see Malvasia, *Felsina pittrice*, ed. Zanotti et al., II, 134. For Cerrini, see Pascoli, *Vite*, ed. Martinelli, 121: "già cominciava ad invecchiare, e nota-

bilmente gli scemavano le forze, e lo spirito. Visse nulla di meno molti altri anni senza quasi mai lavorare, perchè calata gli era anche la vista, e caduto finalmente ne' 1681. . . ." For Corte, who was forced to stop painting in 1718 because of bad eyesight, although, according to Dal Pozzo, he continued to work in *chiaroscuro*, see Enrico Maria Guzzo, "Documenti per la storia dell'arte a Verona in epoca barocca," *Atti e memorie della Accademia di agricoltura scienze e lettere di Verona* (ser. VI, vol. XLII), 167 (1990–91), 258. The painter Nicolò Castello was dismissed as an expert witness in court because "per la sua grave età e mancamento di vista non essercita più la professione"; quoted in Maurizia Migliorini and Alfonso Assini, *Pittori in tribunale: un processo per copie e falsi alla fine del Seicento*, Nuoro, 2000, 127. For Magnavacca, see Zanotti, *Storia dell'Accademia Clementina di Bologna*, I, 193. I wish to thank Eike Schmidt for the references to sculptors who went blind: Rovezzano and Santi Buglioni.

65 Bottari and Ticozzi, *Raccolta di lettere*, I, 71–72; trans. in H. W. Janson, *The Sculpture of Donatello*, London and Princeton, NJ, 1957, 209; letter of 7 December 1547 from Bandinelli to Cosimo I.

66 Cesare Ripa, *Iconologia*, Padua, 1611, 473: "sappiamo, che Michel Angelo Buonaruota, lume & splendore di essa [la scultura], essendogli in vecchiezza per lo continuo studio mancata quasi affatto la luce, soleva col tatto palpeggiando le statue, antiche, o moderne che si fossero, dar giuditio, & del pezzo, & del valore." I am grateful to Eike Schmidt for this reference. For other references to Michelangelo's weakening eyesight, see Michael Hirst, *Michelangelo and his Drawings*, New Haven, CT, and London, 1988, 8. For an interesting article on touch and the Renaissance artist, see J. Cranston, "The Touch of the Blind Man: The Phenomenology of Vividness in Italian Renaissance Art," in *Sensible Flesh: On Touch in Early Modern Culture*, ed. E. Harvey, Philadelphia, 2003, 224–42 (especially 237–40).

67 Rosand, *Drawing Acts*, 217.

68 C. De Tolnay, "Un bozzetto di legno di Michelangelo," in *Stil und überlieferung in Kunst des Abendlandes. Akten des 21 Internationalen Kongress für Kunstgeschichte*, Bonn, 1964, II, 71–73. For a review of the literature, see Giorgio Bonsanti's catalogue entry in *The Medici, Michelangelo, and the Art of Late Renaissance Florence*, New Haven, CT, and London, 2002, 218–19 (exhibition catalogue: Florence, Palazzo Strozzi, and Detroit Institute of Art).

69 For the letter of 13 March 1567 from Dominicus Lampsonius, in Liège, to Titian, see Clemente Gandini, ed., *Tiziano: le lettere*, Cadore, 1977, n. 180: "prego Nostro Signor Dio darle una vecchiezza ancora a molti anni facile et gioconda con bona et acuta vista, et ogni bene, prosperità, et contento." [G. M. Verdizotti], *Breve compendio della vita del famoso Titiano Vecellio di Cadore*, Venice, 1622, n. p.; Carlo Ridolfi, *Le maraviglie dell'arte ovvero le vite degli illustri pittori veneti e dello stato*, Venice, 1648; edition cited: ed. D. von Hadeln, Rome, 1956, I, 209: "e benche ridotto all'estrema vecchiezza e quasi in tutto privo di lume, imitando il famoso Apelle, non passava giorno senza formar alcuna cosa. . . ."

70 Letter of 29 February 1568; first noted by H. Zimmermann, "Zur richtigen Datirung eines Portraits von Tizian in der Wiener kaiserlichen Gemäldegallerie," *Mitteilungen des Instituts für Oesterreichische Geschichtsforschung*, 6 (1901), 850: "ma il ma è que lui stima le cose sue al paro o più di solito et ogniuno dice che non vede più quello qu'el fa et li trema tanto la mano che stenta a ridurre cosa alcuna a perfettione et lo fare alli suoi giovani."

71 Guercino, letters to Antonio Ruffo, 6 May, 11 July, and 22 September 1665; in V. Ruffo, "La Galleria Ruffo nel secolo XVII in Messina," *Bolletino d'arte*, 10 (1916), 112–15.

72 Sohm, *Pittoresco*, 36–62.

4 Titian Performs Old Age

1 Harold Wethey, *Titian: The Religious Paintings*, London, 1969, I, 40. From the *Liber mortuorum* at San Canciano: "Adì dito [27 August 1576] ms Titian pitor e morto de ani cento e tre, amalato de febre. Licenziati."

2 Matteo Mancini, *Tiziano e le corti d'Asburgo nei documenti degli archivi spagnoli*, Venice, 1998, 258, n. 136, 281, n. 161, and 324, n. 203.

3 [Verdizotti], 1622, n. p. (c. 3r–v): "Morì finalmente il gran Titiano di età d'anni 90, et fu sepolto nella chiesa de' Frari di Venezia . . ." For Verdizotti and Titian, see Carlo Ridolfi, *Le maraviglie dell'arte, overo le vite de gl'illustri pittori veneti*, Venice, 1648; edition cited: ed. D. von Hadeln, Rome, 1956, I, 208; Giorgio Vasari, *Le vite de' più eccellenti pittori scultori e architettori nelle redazioni del 1550 e 1568*, ed. P. Barocchi and R. Bettarini, Florence, VII ("vita Tiziano"); and C. Hope, "The Early Biographies of Titian," in *Titian 500*, ed. J. Manca, Hanover, NH, 1993, 167–97 (on 173).

4 Raffaello Borghini, *Il riposo in cui della pittura e della scultura si favella*, Florence, 1584,. 529: "Morì ultimamente di vecchiezza, essendo d'età d'anni 98 o 99, l'anno 1576, essendo la peste in Vinegia, e fu sepellito nella chiesa de' Frari . . ."

5 Ridolfi, *Le maraviglie dell'arte*, ed. von Hadeln, 1, 209: "onde d'anni 99 terminò il viaggio della vita, ferito di peste il 1576."

6 Baglione subtracted seven years from his age when writing his autobiography; and Arpino gave his age in the census of 1605 as 29 instead of 38: Giovanni Baglione, *Le vite de' pittori scultori et architetti*, Rome, 1642; edition cited: ed. H. Röttgen, Vatican City, 1995, II, 28; and Herwarth Röttgen, *Il Cavalier Giuseppe Cesari d'Arpino. Un grande pittore nello splendore della fama e nell'incostanza della Fortuna*, Rome, 2002, 125. I am grateful to Richard Spear for these references.

7 Clemente Gandini, ed., *Tiziano: le lettere*, Cadore, 1977, 22, n. 13, letter to Federico Gonzaga, 12 July 1530.

8 Giorgio Gronau, *Documenti artistici urbinati*, Florence, 1936, 102 (doc. LXIII), letter of 15 November 1564.

9 Gronau, *Documenti artistici urbinati*, 103 (doc. LXXI), letter of 2 March 1566.

10 Gronau, *Documenti artistici urbinati*, 105–06 (doc. LXXX), letter of 17 May 1567: "Altre volte ho scritto a V. Ecc.a, che non è in Vinegia il più ingordo homo al danaro di quell che è il Titiano, e da ingordigia è proceduto, che tanto sfacciatamente s'è fatto lecito di scrivere di non haver saputo, ch'ella habbi havuuto il quadro, temendo di morire prima ch'egli habbi qualce [scudo] da lei."

11 Mancini, *Tiziano e le corti d'Asburgo*, 170–71, n. 50, (letter of 1 September 1548 to Antoine Perrenot de Granvelle, Bishop of Arras); 218, n. 97, (letter of 23 March 1553 to Philip II).

12 Mancini, *Tiziano e le corti d'Asburgo*, 295–96, n. 177 (letter of 6 December 1563 to Philip II): "Non havendo già molte e molte man di lettere mandate insieme con le pitture a Vostra Maestà havuto mai da lei risposta alcuna, io temo grandemente che o le pitture mie non le siano state di sodisfattione, o che'l suo servo Titiano non le sia più in quella gratia nella quale gli pareva di esser prima. Però mi sarebbe altro modo caro di esser certo o dell'una cosa o dell'altra: perchè sapendo l'intentione del mio gran Re mi sforzerei di far si, che per avventura cesserebbe ogni cagione delle mie doglianze. Dunque l'infinita benignità di Vostra Maestà si degni d'esser servita ch'io resti consolato almeno di veder il suo sigillo, se non sue lettere: che le giuro per la devotione mia verso di

lei, che se questo sia sarà possente agiunger diece anni di più a questa mia ultima età per servir la Maestà del mio Catholico Signore. Oltra che questa o sarà un eccitamento a mandarle con più lieto e securo animo la cena di pittura è un quadro lungo braccia otto et alto cinque; et di corto sarà fornita. Però la Maestà Vostra si degnerà similmente di essere servita ch'io sappia a' cui doverlo consignare, acchè la materia di questa devotione possa essere a Vostra Maestà un testimonio della mia verso di lei. Et perchè delle tante altre mie pitture mandate fin hora a Vostra Maestà, non ho havuto mai pur un minimo danaro in pagamento io non riceverò altro dalla sua singolar benignità e clementia se non che almeno mi sieno pagatele mie provitioni ordinarie dalla camera di Milano per comandamento di Vostra Maestà di quella maniera, che la sua benignità sa imponere quan-do vuol sovenir efficacemente i suoi devotissimi servitori. Della qual cosa supplicando humilissimamente Vostra Maestà Catholica et dedicandole il resto di questa mia ultima vecchiezza in suo servitio, mi raccomando in sua buona gratia."

13 Mancini, *Tiziano e le corti d'Asburgo*, 291–92, n. 173 (letter of 28 July 1563 to Philip II).

14 Mancini, *Tiziano e le corti d'Asburgo*, 297, n. 178 (letter of 20 December 1563 to Philip II).

15 Mancini, *Tiziano e le corti d'Asburgo*, 343–44, n. 224 (letter of 2 December 1567 to Philip II).

16 Mancini, *Tiziano e le corti d'Asburgo*, 291–92, n. 173 (letter of 28 July 1563 to Philip II), and 366–67, n. 246 (letter of 1 August 1571).

17 Gandini, ed., *Tiziano*, 266–67, n. 197 (petition of 2 December 1573 to the Signoria).

18 Gandini, ed., *Tiziano*, 177, n. 140 (letter of 17 June 1559 to Orazio Vecellio). For a discussion of Orazio, see Lionello Puppi, *Su Tiziano*, Milan, 2004, 44–48.

19 Mancini, *Tiziano e le corti d'Asburgo*, 412, n. 292 (letter of 26 February 1575 from Guzmán de Silva to the Marqués de Ayamonte); cited and translated by M. Falomir, "Titian's Replicas and Variants," in *Titian*, ed. David Jaffé, exhibition catalogue, London, National Gallery, 2003, 67: "He estado en la casa de el Ticiano y cada día me confirmo más en que no se puede esperar mucho de lo que agora haze si no en el hecho, lo qual tiene tan a recaudo que es menester harta destreza para verlo quanto más para sacarselo, por no se faltara cuidado para ello . . ."

20 Vasari, ed. Barocchi and Bettarini, VI, 169.

21 The most complete discussion of Titian's wealth and estate can be found in Lionello Puppi,

Per Tiziano, Milan, 2004, 25–36, 61–84, and 89–96.

22 Originally published by G. B. Lorenzi, *Monumenti per servire alla storia del Palazzo Ducale di Venezia*, Venice, 1868, 157–58, n. 337; and quoted frequently thereafter.

23 Gandini, ed., *Tiziano*, 266–67, n. 197 (petition of 2 December 1573 to the Signoria).

24 Aristotle, *On Rhetoric*, trans. J. H. Freese, Cambridge, MA, and London, 1926, II, xiii, 6; Horace, *Ars poetica*, trans. H. Rushton Fairclough, Cambridge, MA, and London, 1926, 169–70.

25 Girolamo Cardano, *The Book of my Life (De Vita Propria Liber)*, trans. Jean Stoner, New York, 2002, 252. For old age and avarice, see *The Notebooks of Leonardo*, ed. Jean Paul Richter, London, 1883, II, 356.

26 Giovan Battista Gelli, *I capricci del bottaio*, Florence, 1549; in *Trattatisti del Cinquecento*, ed. Mario Pozzi, Milan and Naples, 1996, II, 899; and Giovan Battista Gelli, "Letture dantesche," ibid., I, 999–1000.

27 Gelli, "Letture dantesche," in *Trattatisti del Cinquecento*, 999–1000.

28 For a discussion of this self-portrait, see Joanna Woods-Marsden, *Renaissance Self-Portraiture: The Visual Construction of Identity and the Social Status of the Artist*, New Haven, CT, and London, 1998, 159–67. For Bassano's portrait of Titian, see Richard Cocke, "Titian the Second Apelles: The Death of Actaeon," *Renaissance Studies*, 13 (1999), 303.

29 P. Joannides, "'Primitivism' in the Late Drawings of Michelangelo: The Master's Construction of an Old-age Style," in *Michelangelo Drawings*, ed. Craig Hugh Smyth, Washington, DC, and Hanover, NH, 1992, 245–61.

30 For garrulity as a form of old-age disinhibition, see A. P. Shimamura, "Aging and Memory Disorders: A Neuropsychological Analysis," in *Cognitive And Behavioral Performance Factors In Atypical Aging*, ed. M. L. Howe, M. J. Stones, and C. J. Brainerd, New York, 1990, 37–65.

31 Richard Spear, *The "Divine" Guido: Religion, Sex, Money, and Art in the World of Guido Reni*, New Haven, CT, and London, 1997, 38–43.

32 M. Falomir, "Titian's replicas and variants," 61–68.

33 A list of autograph variants painted after 1560 following designs before 1545 would include (but not necessarily be limited to) *Nymph and Shepherd* (Vienna, Kunsthistorisches Museum), *Christ Carrying the Cross* (Madrid, Prado), *Tribute Money*

(London, National Gallery), *Crowning of Thorns* (Munich, Alte Pinakothek), and *Judith* (Detroit Institute of Arts).

34 Pietro Aretino, *Lettere sull'arte*, ed. E. Camesasca and F. Pertile, Milan, 1957, I, 217 (letter CXLV); and Gandini, ed., *Tiziano*, 67, n. 51, (6 July 1542): "certo che il pennel vostro ha riserbati i suoi miracoli ne la maturità de la vecchiezza."

35 Aretino, *Lettere sull'arte*, II, 106–08 (letter of October 1545): "La non poco quantità di denari che messer Tiziano si ritrova, e la pure assai avidità che tien d'accrescerla, causa che egli, non dando cura a obbligo che si abbia con amico, né a dovere che si convenga a parente, solo a quello con istrana ansia attende che gli promette gran cose. . . . Certo ella respira, batte i polsi e move lo spirito nel modo ch'io mi faccio in la vita. E se più fussero stati gli scudi che gliene ho conti, invero i drappi sarieno lucidi, morbidi e rigidi, come il da senno raso, il velluto e il broccato . . ." For a review of the literature on the Aretino portrait, see Francesco Mozzetti, *Tiziano: Ritratto di Pietro Aretino*, Modena, 1996; and Valeska von Rosen, *Mimesis und Selbstbezüglichkeit in Werken Tizians: Studien zum venezianischen Malereidiskurs*, Emsdetten and Berlin, 2001, 302–09.

36 L. Mucchi, "Radiografie di opere di Tiziano," *Arte veneta*, 31 (1977), 297–304.

37 G. B. Marino, *Lettere*, ed. M. Guglielminetti, Turin, 1966, 230 and 263.

38 Marino, *Lettere*, 306.

39 Aretino, *Lettere: libro secondo*, ed. F. Erspaner, Parma, 1998, II, 329, n. 149 (February 1540): "uno altro me medesimo." Francesco Priscianese (*Della lingua latina*, Venice, 1540, n. p.; published by G. Padoan, "A casa di Tiziano, una sera d'agosto," in *Momenti del Rinascimento veneto*, Padua, 1978, 371–93; slightly revised in *Tiziano e Venezia*, Vicenza, 1980, 361), after a Bacchanalian themed dinner, noted that Titian enjoyed Aretino's company "because every likes attract": "Erano convenuti col detto m. Tiziano (perché ogni simile suo simile appetisce) alcuni de' più pellegrini ingegni che oggi si truovino in questa città, e de' nostri principalmente m. Pietro Aretino, nuovo miracolo di Natura, e appresso il grande imitatore di quella con l'arte dello scarpello, come col pennello il Signore del convito . . ."

40 For an excellent discussion of Aretino wrangling with Cosimo and his unhelpful majordomo Pierfrancesco Riccio, see Mozzetti, *Tiziano*.

41 These familiar polarities have enriched studies of Renaissance art theory and criticism for many years. For a recent review of and significant refine-

ment to past scholarship, see Fredrika Jacobs, "(Dis)assembling: Marsyas, Michelangelo, and the Accademia del Disegno," *Art Bulletin*, 84 (2002), 426–48.

42 For a brilliant history of Michelangelo's finances, both real and imaginary, see Rab Hatfield, *The Wealth of Michelangelo*, Rome, 2002.

43 Filippo Pedrocco, *Titian*, New York, 2001, 63.

44 C. Hope, "Titian's Life and Times," in *Titian*, ed. Jaffé, 26–28.

45 T. Puttfarken, *Titian and Tragic Painting: Aristotle's Poetics and the Rise of the Modern Artist*, New Haven, CT, and London, 2005, 185. Fortunately he does not succeed in avoiding questions of style since they are too deeply embedded in Titian's "meaning or emotive or poetical ambitions."

46 Puttfarken, *Titian and Tragic Painting*, 189.

47 J. Fletcher, "Titian as a Painter of Portraits," in *Titian*, ed. Jaffé, 29–42 (on 39).

48 David Jaffé, "Late Titian," in *Titian*, 152.

49 Gronau, *Documenti artistici urbinati*, 107 (doc. LXXXVI), letter to Agatone, 5 May 1573.

50 Mancini, *Tiziano e le corti d'Asburgo*, 411, n. 291: "Remo, como V. S. dize, que la vejez de Ticiano es mas de la que es necesseria para pintar muy bien, mas el aire y espritu de sus pinturas no le quitará el tremblar la mano, si bien quitará el asentar muy bien los colores y otros particulares que con tener la mano segura se pueden hazer, y tambien temo que será malo de acabar con el que la comience y peor que la acabe."

51 C. Hope, "A New Document about Titian's *Pietà*," in *Sight and Insight: Essays on Art and Culture in Honour of E. H. Gombrich at 85*, ed. J. Onians, London, 1994, 153–67. And for the restoration, see Giovanna Nepi Scirè, "Tiziano, 'La Pietà'," *Quaderni della Soprintendenza ai beni artistici e storici di Venezia*, 13 (Restauri alle Gallerie dell'Accademia), 1987, 31–41.

52 For a subtle model (one that goes much further than anything in the Titian literature) for distinguishing unfinished work and *abbozzi*, and for interpreting the complexities of work left in an artist's studio at death, see Spear, *The "Divine" Guido*, 305–15. Linda Freeman Bauer's work also provides rich clues for further work in this area: "'Quanto si disegna, si dipinge ancora': Some Observations on the Development of the Oil Sketch" *Storia dell'arte*, 32 (1978), 45–57; and "Oil Sketches, Unfinished Paintings, and the Inventories of Artists' Estates," in *Light on the Eternal City* (Papers in Art History from The Pennsylvania State University, II), ed. H. Hager and S. Munshower, University Park, PA, 1987, 93–107.

53 Late styles are usually deemed to be part of a natural development, either following the trajectory of an artist's earlier development or responding to the natural consequences of aging, but the idea of it as a purposeful construction is rare. An important exception is Paul Joannides' reading of Michelangelo's late work as a return to the origins of art, with knowing references to fourteenth-century art and the Byzantine *orans*: "'Primitivism' in the Late Drawings of Michelangelo," 245–61.

54 The main iconographic considerations are found in Philipp Fehl, "Realism and Classicism in the Representation of a Painful Scene: Titian's 'Flaying of Marsyas' in the Archiepiscopal Palace at Kremsier, reprinted in his *Decorum and Wit*, Vienna, 1992, 88–103; Augusto Gentili, *Da Tiziano a Tiziano: mito e allegoria nella cultura veneziana del cinquecento*, Milan, 1980, 147–58; S. J. Freedberg, "Il musicista punito: il supplizio di Marsia," in *FMR*, 45 (1986), 140–52; and J. Rapp, "Tizians Marsyas in Kremsier: Ein neuplatonisch-orphisches Mysterium vom Leiden des Menschen und seiner Erlösung," *Pantheon*, 45 (1988), 70–89. For commentaries on questions of completion and studio participation, see A. Gentili, "Tiziano e il non finito," *Venezia Cinquecento*, 2/4 (1992), 93–127; *Le Siècle de Titien: l'âge d'or de la peinture à Venise*, exhibition catalogue, Paris, Grand Palais, 1993, 623–25 (catalogue entry by F. Valcanover); Daniela Bohde, "Haut, Fleisch und Farbe: Körperlichkeit und Materialität in den Gemälden Tizians," Emsdetten and Berlin, 2002, 271–342 (Dissertation, Universität Hamburg, 1998).

55 D. Bohde, "Skin and the Search for the Interior: The Representation of Flaying in the Art and Anatomy of the Cinquecento," in *Bodily Extremities: Preoccupations with the Human Body in Early Modern European Culture*, ed. Florike Egmond and Robert Zwijnenberg, Aldershot, 2003, 10–47. This article is a revised and expanded version of parts of her dissertation, listed in the preceding note.

56 Letter of Giovanni Francesco Guerrieri to Carlo Muzzi, dated 24 July 1655; published by Marina Cellini and Giuseppina Tombari Boiani, "Appendice documentaria," in *Giovanni Francesco Guerrieri da Fossombrone*, ed. Andrea Emiliani and Marina Cellini, Bologna, 1997, 216–17.

57 For Marco Boschini's report of Palma Giovane's observations in Titian's studio, see *Le ricche minere della pittura veneziana*, Venice, 1673; edition cited: *La carta del navegar pitoresco*, ed. Anna Pallucchini, Venice and Rome, 1966, 711–12. For a record of a conversation between Francisco de Vargas (Charles V's ambassador) and Titian in his studio, see

Antonio Pérez, *Segundas cartas de A. P. Mas los Aphorismos dellas facadas por el curioso que facò los de las Primeras*, Paris, 1603, 120v. Vargas asked Titian about his technique and especially his large paintbrushes: "porque auia dado en aquella manera de pintar tan sabida suya de golpes de pinçel grosseros, casi como borrones el descuydo . . . Y no cõ la dulzura del pinzel del los rros de si tiempo." For Titian's broomstick brushes, see D. Rosand, "Titian and the Critical Tradition," in *Titian: His World and his Legacy*, ed. D. Rosand, New York, 1982, 23–24; and David Rosand, *Painting in Sixteenth-Century Venice*, Cambridge, 1997 (revised edition), 20–22 and 189. For Titian painting with his fingers, see Philip Sohm, *Pittoresco: Marco Boschini, his Critics and their Critiques of Painterly Brushwork in Seventeenth- and Eighteenth-Century Italy*, Cambridge, 1991, 25–26 and 151–52.

58 Marco Boschini, *La carta del navegar pitoresco*, Venice, 1660; edition cited: ed. A. Pallucchini, Venice and Rome, 1966, 711–12.

59 For an alternative reading that brings into play the sketchy monochrome as an intentional form, see Cocke, "Titian the Second Apelles."

60 Giulio Mancini, *Considerazioni sulla pittura*, ed. A. Marucchi and L. Salerno, Rome, 1957, I, 134.

61 Paul Taylor, "The Concept of Houding in Dutch Art Theory," *Journal of the Warburg and Courtauld Institutes*, 55 (1992), 210–32; P. Taylor, "The Glow in Late Sixteenth and Seventeenth Century Dutch Paintings," *Leids Kunsthistorisch jaarboek*, II (1998), 159–78. The following example can be added to Taylor's excellent studies. Honthorst played with the implications of the painted surface as skin in his *Mocking of Christ* (Amsterdam, Rijksmuseum) where the flagellation wounds on Christ's body are represented by an absence of the final layers of paint, as if the skin had been ripped off to reveal the green underpaint.

62 Paolo del Sera, letter of 25 August 1657 to Leopoldo de' Medici, in *Archivio del Collezionismo Mediceo. Il Cardinal Leopoldo. Volume primo: rapporti con il mercato veneto*, ed. Miriam Fileti Mazza, Milan and Naples, 1987, I, 172. Sera also confirms the age and authenticity of a *Susanna and the Elders* by Veronese with reference to its *crepature* (ibid., I, 383; letter of 4 March 1656).

63 Filippo Baldinucci, *Vocabolario toscano dell'arte del disegno*, Florence, 1681, s. v. *patena*: "Voce usata da' Pittori, e diconla altrimenti pelle, ed è quella universale scurità che il tempo fa apparire sopra le pitture, che anche talvolta le favorisce." and *Notizie de' professori del disegno dal Cimabue in qua*,

ed. Domenico Maria Manni, Florence, 1772, XII, 49: "Ebbe un particolar talento a far apparire a stupore tutte quelle macchie e quelle stessa pelle e patina (come dicono i pittori) che suol fare il tempo sopra l'antiche pitture."

64 Boschini, *La carta del navegar pitoresco*, ed. Pallucchini, 536–39.

65 Malvasia on Cavedone (*Scritti originali*, Bologna, 1982, c. 205v): "Ma si come nel disegno cercò un'abbreviatura la cercò parimente nel colore di poche mestiche servendosi e delle principali, ridendosi di quelli che per via delle mezze tinte di certi lividetti o rossetti fanno passaggio da lumi scuri e biasimando la tanta finitezza, leccatura e diligenza il che a lui riusciva in quel suo far facile non so pi come ad un altro e prima che ad un altro poi non sarebbe riuscito ed avrebbe forse degenerato in strapazzo." For Reni and other seventeenth-century painters of *lividetti*, see Carlo Cesare Malvasia, *Felsina pittrice: vite de' pittori bolognesi divise in duoi tomi*, Bologna, 1678; edition cited: ed. G. P. Zanotti et al., 2 vols., Bologna, 1841, II, 58.

66 J. Cox-Rearick, "Pontormo, Bronzino, Allori and the lost 'Deluge' at S. Lorenzo," *Burlington Magazine*, 134 (April 1992), 239–48.

67 Leo Steinberg, *Michelangelo's Last Paintings*, Oxford, 1975, 39–40.

68 L. Dolce, *Paraphrasi nella sesta satira di Giuvenale*, Venice, 1538 (dedicatory letter dated 10 October 1538): "Giuuenale, eccellente M. Titian, Giuuenale acutissimo morditore et riprensor delle malvagita d'i suoi tempi tra le altre sue belle satire una ve ne lasciò iscritta . . ." Agostino Gentili (*Da Tiziano a Tiziano*, 174) discusses Dolce's dedication in relation to Titian's inability to read Latin.

69 Vasari, ed. Barocchi and Bettarini, VI, 169: "Nella sua casa di Vinegia sono stati quanti principi, letterati e galantuomini sono al suo tempo andati o stti a Vinezia, perchè egli, oltre all'eccellenza dell'arte, è stato gentilissimo, di bella creanza e dolcissimi costumi e maniere." Priscianese, *Della lingua latina*, n. p.: "Io fui invitato il giorno delle calende d'Agosto a celebrare quella maniera di Baccanali . . . in uno dilettevole giardino di messer Tiziano Vecellio veneziano, dipintore (come ogniuno sa) eccellentissimo e persona veramente atta a condire con le sue piacevolezze ogni onorevole convito."

70 For the *Rape of Europa*, see Philipp Fehl, *Decorum and Wit: The Poetry of Venetian Painting: Essays in the History of the Classical Tradition*, Vienna, 1992, 88–103. For the *Crossing of the Red Sea*, see David Rosand and Michelangelo Muraro, *Titian and the*

Venetian Woodcut, exhibition catalogue, Washington, DC, National Gallery of Art, 1976, 70–73; and Una Roman D'Elia, "The Decorum of a Defecating Dog," *Print Quarterly*, XXII (2005), 119–32; For the *Monkey Laocoön*, see E. Schmidt, "'Furor' und 'Imitatio': Visuelle Topoi in den Laokoön-Parodien Rosso Fiorentinos und Tizians," in *Visuelle Topoi: Erfindung und tradiertes Wissen in den Künsten der italienischen Renaissance*, ed. U. Pfisterer and M. Seidel, Munich and Berlin, 2003, 351–83.

71 Juvenal, *Satires*, 10. 187–99, trans. G. G. Ramsey, Cambridge, MA, and London, 1956.

72 Maximianus, *Elegiae* (first published in 1473 and in *Cornelii Galli fragmenta*, ed. Pomponio Gaurico, Venice, 1501); as quoted by Gabriele Zerbi, *Gerontocomia, On the Care of the Aged; and Maximianus, Elegies on Old Age and Love*, Rome, 1489; trans. L. R. Lind, Philadelphia, 1988, 56.

73 Plato, *The Republic* (329a–d), trans. Paul Shorey, in Plato, *The Collected Dialogues*, ed. E. Hamilton and H. Cairns, Princeton, NJ, 1961, 578.

74 Maximianus, *Elegiae*, I. 145–50.

75 Bernardino Christini, *Pratica medicinale & osservationi*, Venice, 1683, I, 82.

76 E. Riccòmini and C. Bernardini, eds., *Donato Creti: Melancholy and Perfection*, Milan, 1998, 14 and 20 (exhibition catalogue: New York, Metropolitan Museum of Art). Creti's signature and inscription are extreme variations of a more common practice of old artists to sign their works along with their age as testimony to their continuing abilities. See, for example, G. P. Zanotti, *Storia dell'Accademia Clementina di Bologna*, Bologna, 1739, I, 240 on Marc'Antonio Franceschini's late *Annunciation* signed: "M.A.F. fecit anno Domini MDCCXXVI aetatis suae annorum 78 complectorum."

77 G. Perini, "Donato Creti inconsueto," *Arte a Bologna (Bollettino dei Musei civici d'arte antica)*, I (1990), 62: Creti as "mentis veluti impos et a se ipso distractus."

78 Zanotti, *Storia dell'Accademia Clementina di Bologna*, III, 99 (opening of Creti's *vita*): "La pittura, come la poesia, richiede un'animo sereno, e tranquillo, essendo necessario, che lo spirito possa liberamente sollevarsi a meditar, ed indagar quelle idee, che al già stabilito suggetto più si confanno, e questo mal può fare qualora venga dalla tristezza oppresso, e ingombrato dalla malinconia. Se mai vi fu pittore, che venisse assalito, e conturbato da tetri, e molesti fantasmi, cosiche n'avesse talora a perdere il senno, e la sanità, non che la quiete, e il riposo, è certamente quello di cui ora

debbo favellare; tuttavia in mezzo ancora a tante perturbazioni ha potuto arrivare dove pochi altri, col favore della quiete, e della tranquillità, sono giunti."

79 Tommaso Campanella, *Del senso delle cose e della magia*, ed. A. Bruers, Bari, 1925, 285.

5 Jacopo Pontormo in San Lorenzo

1 G. B. Gelli, *I capricci del bottaio*, Florence, 1549; in *Trattatisti del Cinquecento*, ed. M. Pozzi, Milan and Naples, 1996, II, 1027.

2 On 26 March 1555 Pontormo's diary reads: "I did the head of the bending cherub and I had 10 ounce of bread for supper and Varchi gave me a sonnet" (*Diario*, Florence, Biblioteca Centrale Nazionale, ms. Magliabechiano, VIII, 1490, 65v; published edition cited: Pontormo, *Il libro mio*, ed. Salvatore Nigro, Genoa, 1984). Benedetto Varchi, *Sonetti*, Florence: Lorenzo Torrentino, 1555:

> Mentre io con penna oscura e basso inchiostro
> Tanti anni e tanti un vivo LAURO formo,
> Voi con chiaro pennello alto PUNTORMO
> Fate pari all'antico il secol nostro:
> Anzi mentre io col volgo inerte dormo,
> Voi novo pregio alla cerussa e all'ostro
> Giugnete tal, che fuor del vile stormo,
> A dito sete, e per esempio mostro.
> Felice voi, che per secreto calle,
> Ove orma ancor non è segnata, solo
> Ven gite a gloria non più vista mai.
> Onde la donna più veloce assai
> Che strale, o vento, e ch'è sempre alle spalle,
> Invan daravvi homai l'ultimo volo.

3 Giorgio Vasari, *Le vite de' più eccellenti architetti, pittori e scultori italiani*, ed. Graetano Milanesi, Florence, 1906, VI, 287–88 quotes Lapini in his edition of Vasari: "si scopersono le pitture della Cappella et del Coro dell'Altar maggiore di San Lorenzo, cioè il Diluvio e la Risurrezione de' morti, dipinta da M. Iacopo da Pontormo, la quale a chi piacque, a chi non." The seventeenth-century Florentine painter Giovan Maria Ciocchi (*La pittura in Parnaso*, Florence, 1725, 85–86) believed, plausibly, that the negative response gathered strength only gradually.

4 Louis Waldman, *Baccio Bandinelli and Art at the Medici Court: A Corpus of Early Modern Sources*, Philadelphia, 2004, 740, n. 1312, letter of *circa* 1559 to Cosimo I: "E io ne l'ò una grandissima fede nel vostro giudicio, richordandomi che già mi diciesti che 'l Pu[n]tormo farebe una pitura che no'

piacierebe, che a sé chosì è riu[s]cito chome V.a E.a la profetò."

5 Waldman, *Baccio Bandinelli*, 744, n. 1314, letter of 1559 regarding the suspension of work in the choir of the Florence Cathedral: "E che ciò sia vero V.a S.a [*sic*] tenga cierto se 'l Punt[o]rmo fusi vivo no' potrebe u[s]cire fuora perché, per esere la città molto i[n]chrinato al chulto divino, per una de le chalunie dichano che à cha[n]crato la divozione di quela chiesa." Ibid., 740 (n. 1312), letter of *circa* 1559 to Cosimo I: "E tuta la città ne parla per una bocha che l'è ispaventevole e molto disonesta e spetacholo molto cho[n]tradio . . ."

6 In addition to the following discussion of post-Vasari responses, see the anonymous *Note di pitture, sculture et fabriche notabili della città di Firenze*, n. d. (end of the sixteenth century); published in P. Galletti, "Ricordi antichi d'arte fiorentina," *Rivista fiorentina*, I/1 (1908), 29–38 (on 33).

7 Raffaello Borghini, *Il riposo in cui della pittura e della scultura si favella*, Florence, 1584, 196; in Erin Campbell, "Old-Age Style and the Resistance of Practice in Cinquecento Art Theory and Criticism," Ph.D. dissertation, University of Toronto, 1998, 15: "La scultura, e la pittura, rispose il Sirigatto, son arti difficilissime, che ricercano giudicio fermo, vedere acuto, e mano pratica, e salda, le quali tutte cose il tempo indebolisce, e consuma. Perciò doverebbe ogni scultore, e pittore, che in gioventù ha studiato, e nell'età virile ha con laude operato, nella vecchiezza ritirarsi dal fare opere publiche, e volger l'animo a disegni celesti, e lasciare i terreni, conciosiacosa che tutte l'attioni humane salgano infinò a un certo segno, al quale essendo l'huomo arrivato, quasi come alla cima d'un monte, gli conviene, volendo piu avanti passare, scendere in basso. Perciò si veggono molte opere di valenthuomini fatte quando l'età cominciava à mancare, molto di gratia, e di bellezza differenti dall'altre prime fatte da loro." For a thorough discussion of this seminal passage, see Campbell, "Old-Age Style," chapter 1. For the "mountain of life" metaphor, see Luigi Cornaro, *The Art of Living Long*, Milwaukee, WI, 1917; reprinted New York, 1979, 96.

8 For these and other criticisms, see D. Heikamp, "Antologia di critici: Poesie in vitupero del Bandinelli," *Paragone*, n. s. XV, 175 (1964), 59–68; L. Waldman, "'Miracol' novo et raro': Two Unpublished Contemporary Satires on Bandinelli's 'Hercules,'" *Mitteilungen des Kunsthistorischen Institutes in Florenz*, 38 (1994), 419–26.

9 For the history of their destruction, see E. Ciletti, "On the Destruction of Pontormo's Frescoes at S. Lorenzo and the Possibility That Parts Remain," *Burlington Magazine* CXXI, 921 (1979), 764–70. For the public applause ("con applauso universale"), see G. G. Bottari in Giorgio Vasari, *Le vite de' più eccellenti pittori scultori e architetti . . . corrette da molti errori e illustre con note*, ed. Bottari, Rome, 1759–60, II, 668. Luigi Lanzi (*Storia pittorica dell'Italia dal risorgimento delle belle arti fin presso al fine del XVIII secolo*, Bassano, 1809, 163–64; edition cited: ed. M. Capucci, Florence, 1968–74, I, 124–25) made the same point with more moderate language: "imbiancata già senza querela degli artefici."

10 Philippe Costamagna, *Pontormo*, Milan, 1994, 252–54.

11 The most comprehensive reviews of scholarship on the San Lorenzo frescoes are Antonio Pinelli, *La bella maniera: artisti del Cinquecento tra regola e licenza*, Turin, 1993, 5–32; and Costamagna, *Pontormo*, 92–93 and 252–65. The most recent and complete catalogue of Pontormo's drawings for San Lorenzo is by Carlo Falciani, *Pontormo: disegni degli Uffizi*, Florence, 1996, 163–77. For a useful review of Pontormo's artistic practices and stylistic evolution later in life, see David Franklin, *Painting in Renaissance Florence, 1500–1550*, New Haven, CT, and London, 2001, 199–211.

12 Janet Cox-Rearick, *The Drawings of Pontormo: A Catalogue Raisonné with Notes on the Paintings*, Cambridge, 1964; V. Stoichita, "Pontormo und die 'Aramäer': Neue Betrachtungen zur Ikonographie der zerstörten Fresken im Chor von San Lorenzo in Florenz," *Mitteilungen des Kunsthistorischen Institutes in Florenz*, 32 (1988), 127–43; J. Cox-Rearick, "Pontormo, Bronzino, Allori, and the Lost 'Deluge' at San Lorenzo," *Burlington Magazine*, 134 (April 1992), 239–48; P. Simoncelli, "Pontormo e la cultura fiorentina," *Archivio storico italiano*, 153 (1995), 487–527. For a covert political use of Pontormo after his death, see Karen-edis Barzman, *The Florentine Academy and the Early Modern State: The Discipline of Disegno*, Cambridge, 2000, 33–34; she suggests that the choice of Pontormo for the first burial in the Compagnia ed Accademia del Disegno chapel (at Santissima Annunziata) was motivated by Cosimo I de' Medici's need to find a surrogate for Michelangelo after he had withdrawn from Florence to distance himself from (what he took to be) an illegitimate regime. Hence, at the time of his death Pontormo and his San Lorenzo frescoes were understood in a political as well as an artistic

context. The fact that the San Lorenzo frescoes were destroyed one year after the end of Medici rule and the accession of the Habsburg-Lorraines as Grand Dukes in 1738 indicates just how long that political affiliation survived.

13 Louis Waldman, "'Miracol' novo et raro': Two Unpublished Contemporary Satires on Bandinelli's 'Hercules'," *Mitteilungen des Kunsthistorischen Institutes in Florenz*, 38 (1994), 419–26.

14 Giorgio Vasari, *Le vite de' più eccellenti pittori scultori e architettori nelle redazioni del 1550 e 1568*, ed. Rosanna Bettarini and Paola Barocchi, Florence, 1984, v, 331; in *the Lives of the Artists Volume II*, trans. G. Bull, Harmondsworth, 1987, 268.

15 P. Simoncelli, "Jacopo da Pontormo e Pierfrancesco Riccio: due appunti," *Critica Storica*, 17 (1980), 331–48. For more information on Riccio, see G. Fragnito, "Un pratese alla corte di Cosimo I: riflessioni e materiali per un profilo di Pierfrancesco Riccio," *Archivio storico pratese*, 62 (1986), 31–83. For further comments on the court intrigues behind the San Lorenzo commission, see Pinelli, *La bella maniera*, 14–19; and D. Trento, "Pontormo e la corte di Cosimo I," in *Kunst des Cinquecento in der Toskana. Atti del Convegno in onore di Sylvie Béguin*, Munich, 1992, 139–45.

16 For Vasari on the *setta* gathered around Riccio, see Giorgio Vasari, *Le vite de' più eccellenti pittori scultori e architettori nelle redazioni del 1550 e 1568*, ed. P. Barocchi and R. Bettarini, Florence, 1984, v, 221 (life of Tribolo) and v, 497. For these artists as makers of jokes or nonsense (*baie*), see Vasari, v, 405 (life of Bastiano detto Aristotile da San Gallo).

17 Massimo Firpo (*Gli affreschi di Pontormo a San Lorenzo: eresia, politica e cultura nella Firenze di Cosimo I*, Turin, 1997) argues, unconvincingly from my point of view, that the stylistic criticisms mask the recognition of the frescoes' heretical nature as illustrations of the Valdesian doctrine of justification by faith alone.

18 C. de Tolnay, "Les Fresques de Pontormo dans le choeur de San Lorenzo à Florence. Essai de reconstition," *Critica d'Arte*, 9 (1950), 38–52; K. Forster, "Pontormo, Michelangelo, and the Valdesian Movement," in *Stil und Überlieferung in der Kunst des Abendlandes. Akten des 21 Internationalen Kongress für Kunstgeschichte in Bonn*, Berlin, 1967, II, 181–85; and in his monograph *Pontormo*, Munich, 1966, 91–98. For important refinements and emendations, see R. Corti, "Pontormo a San Lorenzo: un episodio figurativo dello 'spiritual-

ismo italiano'," *Richerche di storia dell'arte*, 6 (1977), 5–47; S. Lo Re, "Jacopo Pontormo e Benedetto Varchi: una postilla," *Archivio storico italiano*, 150 (1992), 139–62; Simoncelli, "Pontormo e la cultura fiorentina," 1995, 487–527; Firpo, *Gli affreschi di Pontormo*.

19 For the most careful presentation of this hypothesis, along with a review of past literature on Varchi and Pontormo, see Lo Re, "Jacopo Pontormo e Benedetto Varchi," 139–62.

20 A. F. Doni, *Disegno*, Venice, 1549, 48r (in a letter of 17 August 1549 to a friend in Ferrara).

21 Domenico Moreni, ed., *Sonetti di Angiolo Allori detto il Bronzino ed altre rime inedite*, Florence, 1823, 55; published in Deborah Parker, *Bronzino: Renaissance Painter as Poet*, Cambridge, 2000, 75–76.

22 Vasari, ed. Barocchi and Bettarini, v, 249.

23 B. Berenson, *The Florentine Painters of the Renaissance*, New York and London, 1909, 81.

24 Doni, *Disegno*, 48r: "Ma se per sorte saranno finite le pitture del choro del Pontorno vi raccomando a Dio, ché sarà mezza notte, tanto havrete che fare insieme con la tavola del Rosso."

25 Vasari, ed. Barocchi and Bettarini, v, 331–33; trans. Bull, 269–71.

26 "Longinus," *On the Sublime*, in *Ancient Literary Criticism. The Principal Texts in New Translations*, D. A. Russel and M. Winterbottom ed. and trans., Oxford, 1972, 500.

27 "Longinus," *On the Sublime*, 500. Homer is also evoked by Luigi Lanzi in defense of the aged Titian (*Storia pittorica dell'Italia dal Risorgimento delle belle arti fin presso la fine del XVIII secolo*, Bassano, 1789; edition cited: ed. M. Capucci, Florence, 1970, II, 70): "Convengono tuttavia i periti che anco le ultime sue opera insegnan malto; quasi come dicono i poeta dell'Odissea, poema scritto in vecchiaia, ma da Omero."

28 Elizabeth Pilliod, *Pontormo, Bronzino, Allori: A Genealogy of Florentine Art*, New Haven, CT, and London, 2001, 5 and 9.

29 D. Trento, "Due edizioni del diario di Pontormo e la Pontormania," *Ricerche di storia dell'arte*, 34 (1988), 35–54.

30 L. A. Waldman, "Fact, Fiction, Hearsay: Notes on Vasari's Life of Piero di Cosimo," *Art Bulletin*, 82 (2000), 171–79.

31 Pliny, *Natural History*, trans. H. Rackham, Cambridge, MA, and London, 1958, XXXIV. 19. 81–82; and Vincenzo Borghini, *Selva* (in E. Carrara, "Vasari e Borghini sul ritratto: gli appunti pliniani della *Selva di Notizie*," *Mitteilungen des Kunsthistorischen Institutes in Florenz*, 44 (2000),

243–91, on 274): "Costui fece un Apollodoro che fu fittore, ma tanto fastidioso et tanto [in]sazievole nelle cose sua che non si satisfaceva mai et spesso spezzava ciò ch'egli havva fatto, et però fu chiamato insano. Questa sua natura e' l'espresse in modo che non pareva in quel bronzo la figura d'un huomo, ma la stizza propia."

32 Vasari, ed. Barocchi and Bettarini, v, 309 and 318–19.

33 Vasari, ed. Barocchi and Bettarini, v, 333

34 Vasari, ed. Barocchi and Bettarini, v, 333.

35 F. Bocchi, *Eccellenza della statua di San Giorgio di Donatello*, Florence, 1584; edition cited: P. Barocchi, ed., *Trattati d'arte del Cinquecento*, 3 vols., Bari, 1960–62, III, 185.

36 Giovanni Cinelli, in F. Bocchi, *Le bellezze della Città di Firenze . . . Scritte già da Francesco Bocchi, ed ora da Giovanni Cinelli ampliate, ed accresciute*, Florence, 1677, 516–17.

37 Borghini, *Il riposo*, 484–85: "Dal che si può giudicare che, quando gli huomini vogliono strafare, fanno peggio." Borghini's use of *strafare* probably identifies this passage by Vasari (see Giorgio Vasari, *Le vite de' più eccellenti pittori scultori e architettori nelle redazioni del 1550 e 1568*, ed. P. Barocchi and R. Bettarini, Florence, 1976, IV, 206–08) as Borghini's source: "Quando basta il fare, non si dee cercare di volere strafare per passare innanzi a coloro che, per grande aiuto di natura e per grazia particolare data loro da Dio, hanno fatto o fanno miracoli nell'arte . . . [as it happened to Uccello] e ai giorni nostri, e poco fa, [a] Iacopo da Puntormo."

38 Cinelli, in Bocchi, *Le bellezze della Città di Firenze*, 516–17: "Da questa pittura perocchè fu l'ultima di suo pennello anzi biasimo che lode parmi ne ritraesse, e ciò cred'io esser adivenuto, per aver egli dato in una pertinacissimo Ipocondria, ond'è scusabile assai; Durò tal lavorie undici anni, ne mai volse ch'alcuno il vedesse: Nelle parti di que' corpi molte cose belle vi sono, come la distinzione de' muscoli, ma tutta l'opera in se è molto confusa, e sforzandosi di far più che meglio, non gli fù possibile arrivare al bene: così talvolta gli uomini di stima, troppo di lor medesimi presumendo ingannati rimangono, poiche secondo alcuni non vi è artifizio, non colorito non grazia: l'attitudini quasi tutte ad un modo, molte delle quali sono anche un pò disconvenevoli."

39 Joachim von Sandrart, *Academia nobilissimae altis pictoriae*, Nuremberg and Frankfurt, 1683, 146.

40 Robert Burton, *The Anatomy of Melancholy*, London, 1621, 71.

41 Vasari, ed. Barocchi and Bettarini, v, 332; trans. Bull.

42 Vincenzio Borghini, "Selva di notizie," in B. Varchi and V. Borghini, *Pittura e scultura nel Cinquecento*, ed. P. Barocchi, Livorno, 1998, 119: "talché non si dien noia fra loro e faccin el tutto ben disposto e composto, non confuso et aviluppato . . ."

43 Leon Battista Alberti, *Opere volgari*, ed. C. Grayson, 3 vols., Bari, 1973, III, 68: "Biasimo io quelli pittori quali, dove vogliono parere copiosi nulla lassando vacuo, ivi non composizione, ma dissoluta confusione disseminano; pertanto non pare la storia facci qualche cosa degna, ma sia in tumulto aviluppata." Lodovico Domenichi (*Della pittura*, Venice, 1547, 28v) translated this passage from the Latin differently from Alberti: "Et certo io biasimo quei pittori, iquali per volere parere copiosi; & perche non vogliono, che vi rimanga alcuna cosa vota, per questo non seguono compositione alcuna; ma seminano ogni cosa confusamente, & dissolutamente: la onde l'historia non pare, che tratti una cosa, ma che faccia tumulto." For the Alberti editions, see *De pictura* (Basel, 1540); *Della pittura*, trans. Ludovico Domenichi, Venice, 1547, and Florence, 1568; *Della pittura*, trans. Cosimo Bartoli, Venice, 1568. Vasari's use of *aviluppare* was adopted by Ferdinando Leopoldo del Migliore in *Firenze città nobilissima illustrata*, Florence, 1684, 166: "Impazzò, par che accenni il Vasari, prima che ne staccasse il pennello, avviluppatosi in considerar troppo al vivo e ridurre all'atto di espression naturale le qualità di quei malinconici e funesti accidenti [referring to the *Flood*], ché in vero gli scorci sono stravaganti e l'attitudini sconvolte."

44 Pontormo's diary was first published in its entirety by Frederick Clapp, *Jacopo Carucci da Pontormo: His Life and Work*, New Haven, CT, 1916, appendix III (310–16). The new transcription by Emilio Cecchi (Jacopo da Pontormo, *Diario "fatto nel tempo che dipingeva il coro di San Lorenzo," 1554–1556*, ed. E. Cecchi, Florence, 1956) appeared in time to catch and influence the Mannerism fad of the 1960s. Subsequent editions include the definitive philological reordering by J. C. Lebensztejn ("Jacopo da Pontormo, Diario," *Macula*, 5/6 (1979), 2–111). See also Pontormo, *Il libro mio*, ed. Salvatore Nigro, Genoa, 1984; reprinted in S. Nigro, *L'orologio di Pontormo*, Milan, 1998, 81–121; Dario Trento, *Pontormo: il diario alla prova della filologia*, Bologna, 1984; and Pontormo, *Diario*, ed. R. Fedi, S. Zamponi and E. Testaferrata, Rome, 1996.

45 Pontormo, *Il libro mio*, in Nigro, *L'orologio*, 82: "in tucto quella luna naque infermità pestifere che amazorno dimolti huomini regolati e buoni e forse senza disordini."

46 J.-C. Lebensztejn ("Specchio nero," *Bullettino Storico Empolese*, 8/xxix, n. 5–6, (1985), 200) relates Pontormo's belief about early spring to Hippocrates (*Aphorisms*, III, 12).

47 Pontormo, *Il libro mio*, in Nigro, *L'orologio*, 82: "Di sorte che se si trova disordinato d'exercitio, di panni o di coito o di superfluità di mangiare, può in pochi giorni spaciarti o farti male."

48 Pontormo, *Il libro mio*, in Nigro, *L'orologio*, 47.

49 Pontormo, *Il libro mio*, in Nigro, *L'orologio*, 82.

50 Pontormo, *Il libro mio*, in Nigro, *L'orologio*, 85 and 93.

51 Pontormo, *Il libro mio*, in Nigro, *L'orologio*, 85 and 110.

52 Pontormo, *Il libro mio*, in Nigro, *L'orologio*, 98–100.

53 Pontormo, *Il libro mio*, in Nigro, *L'orologio*, 106.

54 Pontormo, *Il libro mio*, in Nigro, *L'orologio*, 97.

55 Pontormo, *Il libro mio*, in Nigro, *L'orologio*, 103.

56 Agnolo Bronzino, *Rime in burla*, ed. Franca Petrucci Nardelli, Rome, 1988, 324 (lines 28–29): "Ditemi un po' da star quivi a star fuora / che differenza ci vedete voi?" Nardelli (433) suggests that the "maestro" (line 17) to whom Bronzino addresses the poem is Pontormo.

57 Bronzino, *Rime in burla*, ed. Nardelli, 328 (lines 166–71): "Ben di cert'arti, come dir la vostra, / e di cert'altre, come dir la mia, / la prigione stranetta esser dimostra, / che, stando in casa in qualche fantasia, / facciàn dir di non v'esser, dove quivi / non si può creder che tu non vi sia."

58 Nancy Siraisi, *The Clock and the Mirror: Girolamo Cardano and Renaissance Medicine*, Princeton, NJ, 1997, 71–85.

59 Marsilio Ficino, *Liber de vita*, Florence, 1489; as *The Book of Life*, trans. C. Boer, Woodstock, CT, 1980, 51 (bk. II, cap. 8).

60 Francisco de Hollanda, *Diálogos em Roma*, 1538–48, bk. IV, cap. 8; in Francisco de Hollanda, *I trattati d'arte*, ed. Grazia Modroni, Livorno, 2003, 156–57: "Costumava de comer cousas mui delicadas e temperadas para lhe não engrossarem o engenho. . . . Escuma, não lhe podia dar aquela imperfeição e desmancho que ele desejava de fazer . . ."

61 I would like to thank Paul Barolsky for this reference.

62 In addition to Siraisi's work on Cardano (*The Clock and the Mirror*), see Ken Albala, *Eating Right in the Renaissance*, Berkeley and Los Angeles, 2002, 14–47.

63 Roy Porter, *Flesh in the Age of Reason*, London, 2003, 122–24.

64 Pontormo, *Il libro mio*, in Nigro, *L'orologio*, 90: "Adi 27 di genaio desinai e cenai in casa Bronzino, e venevi dopo desinare l'Alesandra e stette insino a sera e poi se s'andò: e fu quella sera che Bronzino e io venimo a csas a vedere el Petrarcha, cioè *fianchi, stomachi* ecc; e pagai quello che s'era giocato."

65 Letter by Varchi to Bronzino and Niccolò Tribolo, 1 May 1539, published by Parker, *Bronzino*, 16–17 and 171–72.

66 Petrarch, *Triumphus mortis*, II, vv. 43–46, in Petrarch, *Trivmphi*, ed. Marco Ariani, Milan, 1988, 263: "Sulla, Mario, Neron, Gaio e Mezenzio / Fianchi, stomachi, febbri ardenti fanno / Parer la morte amara più ch'assenzio."

67 Gabriele Zerbi, *Gerontocomia, On the Care of the Aged; and Maximianus, Elegies on Old Age and Love*, Rome, 1489; trans. L. R. Lind, Philadelphia, 1988, 32.

68 Battista Codronchi, *De morbis qui Imolae, et alibi communiter hoc anno mdcII vagati sunt*, Bologna, 1603, 21; quoted by Piero Camporesi, *The Incorruptible Flesh: Bodily Mutation and Mortification in Religion and Folklore*, trans. T. Croft-Murray, Cambridge, 1988, 111–16.

69 Antonio Cocchi, *Dei bagni di Pisa trattato*, Florence, 1750; in *Opere*, 3 vols., Milan, 1824, II, 168.

70 Marco Boschini, *La carta del navegar pitoresco*, Venice, 1660; edition cited: ed. A. Pallucchini, Venice and Rome, 1966, 376–77. For a discussion, see Philip Sohm, *Pittoresco: Marco Boschini, his Critics and their Critiques of Painterly Brushwork in Seventeenth- and Eighteenth-Century Italy*, Cambridge, 1991, 103.

71 Cox-Rearick, "Pontormo, Bronzino, Allori and the lost 'Deluge' at S. Lorenzo," 241.

72 Gabriele Paleotti, *Discorso intorno le immagini sacre e profane*, Bologna, 1582; edition cited: P. Barocchi, ed., *Trattati d'arte del Cinquecento*, II, 422 (II, xxxvi): "Come, nel dipingere il diluvio al tempo di Noé, è disgustoso il voler raffigurare i corpi gonfi e deformati dall'acqua."

73 Cinelli, in Bocchi, *Le bellezze della Città di Firenze*, 517: "il Pontormo diede in un eccesso di melanconia, e per fare al naturale quelle figure del Coro di S. Lorenzo state sotto l'acqua del Diluvio, teneva i cadaveri ne' trogoli d'acqua per farli così gonfiare, ed appestare dal puzzo tutto il vincinato."

74 G. G. Bottari in Vasari, *Le Vite*, 1759, II, 668: "Finalmente ne dice [Vasari] il peggio, che può per questa pittura di s. Lorenzo, la quale veramente era

stravagante, e fino i corpi dipinti nella storia del diluvio, si dice, che furono disegnati da' cadaveri tenuti sotto l'acqua per fargli gonfiare."

75 Seneca the Elder, *Declamations*, trans. M. Winterbottom, Cambridge, MA, and London, 1974, II, 448–75 (controveriae x, 5).

76 Giorgio Vasari, *Le vite de' più eccellenti pittori scultori e architettori nelle redazioni del 1550 e 1568*, ed. P. Barocchi and R. Bettarini, Florence, 1971, III, 637.

77 For Bernini, see Domenico Bernini, *Vita del cav. Gio. Lorenzo Bernini*, Rome, 1713, 15. For Caravaggio's *Death of the Virgin*, see Giovan Pietro Bellori, *Le vite de' pittori, scultori e architetti moderni*, ed. Evelina Borea, Turin, 1976, 213. For Caravaggio's *Resurrection of Lazarus*, see Francesco Sussino, *Le vite de' pittori messinesi*, ed. V. Martinelli, Florence, 1960, 112. Sussino (p. 113) then mentions the story of Michelangelo's *Crucifixion*, which he believes to be a "favola." See also Elizabeth Cropper, "Michelangelo Cerquozzi's Self-Portrait: The Real Studio and the Suffering Model," in *Ars naturam adiuvans: Festschrift für Matthias Winner*, ed. V. van Flemming and S. Schütze, Mainz am Rhein, 1996, 401–12.

78 Quoted by Costamagna, *Pontormo*, 13, n. 15.

6 Life Cycles of Art

1 Giorgio Vasari, *Le vite de' più eccellenti pittori scultori e architettori nelle redazioni del 1550 e 1568*, ed. P. Barocchi and R. Bettarini, Florence, 1967, II, 31.

2 J. Reynolds, *Discourses on Art*, ed. Robert Wark, New Haven, CT, and London, 1975, 152 (Discourse VIII: 10 December 1778).

3 F. Milizia, *Dizionario delle belle arti*, Bassano, 1797, I, 215: "DEGENERAZIONE. Finchè le arti sono coltivate e protette, dovrebbero far ulteriori progressi, e giungere alla perfezione. L'esperienza prova la falsità di questa speculazione. Accade alle Arti quel che accade all'uomo: nella sua vecchiaja egli ha spesso più lumi che nella sua maturità, ma non ha più li stessi talenti."

4 G. P. Bellori, *Le pitture antiche del sepolcro de Nasonii nella via Flaminia*, Rome, 1680, 5: "Poiche la Pittura, e la Scoltura essendo animate dal disegno, che è la vera forma loro, vanno così congiunte di studio, d'intelligenza, e di forza di Natura, che tolta la materia del marmo, e del colore, in tutte l'altre parti si uniscono, e si abbracciano insieme come un'arte sola di un solo intelletto, e di un Genio, che le regge, e le perfetziona alla più bella imitazione delle cose naturali. Hanno

però sperimentato sempre l'istessa sorte nel nascere, e morire, e risorgere in vita frà le rivolutione del Tempio, e de' costumi; tanto che dall'una, e dall'altra vicendevolmente si possono trarre similtudine, ed insegnamento."

5 Henri Focillon, *La Vie des formes*, Paris, 1934; as *The Life of Forms in Art*, trans. C. Hogan and G. Kubler, New York, 1992, 52–63; Wylie Sypher, *Four Stages of Renaissance Style*, New York, 1955, 5–10 and 30–34. See also Heinrich Wölfflin, *Principles of Art History*, London, 1932, 323: Baroque as a "late style."

6 Jonathan Gilmore, *The Life of a Style: Beginnings and Endings in the Narrative History of Art*, Ithaca, NY, 2000.

7 J. Tollebeek, "'Renaissance' and 'Fossilization': Michelet, Burckhardt, and Huizinga," *Renaissance Studies*, 15 (2001), 354–66. For an excellent review of decline as a historical concept, see R. Starn, "Meaning-Levels in the Theme of Historical Decline," *History and Theory*, 14 (1975), 1–31.

8 For metaphors and history, see Hayden White, *Tropics of Discourse: Essays in Cultural Criticism*, Baltimore, MD, 1985; F. R. Ankersmit, *Historical Representation*, Stanford, CA, 2001; and Reinhart Koselleck, *The Practice of Conceptual History: Timing History, Spacing Concepts*, trans. T. S. Presner, Stanford, CA, 2002.

9 Giorgio Vasari, *Le vite de' più eccellenti pittori scultori e architettori nelle redazioni del 1550 e 1568*, ed. P. Barocchi and R. Bettarini, Florence, 1971, III, 5–6. For a discussion of this passage and Vasari's structure of history, see P. Sohm, "Ordering History with Style: Giorgio Vasari on the Art of History," in *Antiquity and its Interpreters*, ed. A. Payne, A. Kuttner, and R. Smick, Cambridge, 2000, 40–55.

10 Wolfgang Kallab, *Vasaristudien*, ed. J. von Schlosser et al., Vienna and Leipzig, 1908, 182–84.

11 J. von Schlosser, *La Letteratura artistica*, ed. Otto Kurz, Florence, 1977, 315–16; E. Panofsky, "The First Page of Giorgio Vasari's *Libro*," in *Meaning in the Visual Arts*, Harmondsworth, 1970 (second edition), 255–57. For discussions of Vasari's ideas on progress and decline, see the important contributions by Kallab, *Vasaristudien*, 405–08; E. H. Gombrich, *Norm and Form: Studies in the Art of the Renaissance*, London, 1966, 1–8; W. Prinz, "I ragionamenti del Vasari sullo sviluppo e declino delle arti," in *Giorgio Vasari: storiografo e artista*, Florence, 1976, 857–66; Z. Wazbinski, "L'Idée de l'histoire dans la première et la seconde édition des *Vies* de Vasari," ibid., 1–25 (who makes very useful distinctions between the two editions of the *Vite*).

Patricia Rubin (*Giorgio Vasari: Art and History*, New Haven, CT, and London, 1995, 164) accepts Panofsky's suggestion of Florus. For a discussion of cycles in historiography, see G. W. Trompf, *The Idea of Historical Recurrence in Western Thought from Antiquity to the Reformation*, Berkeley and Los Angeles, 1979. Of these many historians, the most topical for Vasari might have been Polybius, whose theories of anacyclosis received much attention after the first Italian translation of his work in 1545 by Lodovico Domenichi. For the reception of Polybius in Italy, see Arnaldo Momigliano, *Polybius between the English and the Turks*, Oxford, 1974, 347–72.

12 Sohm, "Ordering History with Style," 40–55.

13 L. Annaeus Florus, *Epitome of Roman History*, trans. E. S. Forster, Cambridge, MA, and London, 1929, I, introduction, 4–5, p. 7: "Si quis ergo populum Romanum quasi unum hominem consideret totamque eius aetatem percenseat, ut coeperit utque adoleverit, ut quasi ad quandam iuventae frugem pervenerit, ut postea velut consenuerit, quaatuor gradus processusque eius inveniet." Panofsky, "The First Page of Giorgio Vasari's *Libro*," 255–57. For surveys of cyclical theories of history, see Trompf, *The Idea of Historical Recurrence in Western Thought*; Gordon Williams, *Change and Decline: Roman Literature in the Early Empire*, Berkeley and Los Angeles, 1978. For its application by Guarino, Polizano and Lorenzo de' Medici, see M. L. McLaughlin, "Humanist Concepts of Renaissance and Middle Ages in the Tre- and Quattrocento," *Renaissance Studies*, 2 (1988), 131–42. For other examples, see below.

14 Cicero, *De re publica*, trans. C. Walker Keyes, London, 1970 (Loeb edition), i. xxix. 45; II. i. 3; II. xxv. 45; III. xxiii. 34. Seneca, *Ad Lucilium epistulae morales*, Cambridge, MA, 1961 (Loeb edition), XC. 6. Tacitus, *Historiae*, trans. C. Moore and J. Jackson, Cambridge, MA, and London, 1962, II (*Annals*, trans. J. Jackson, III, 26 and 55). For a discussion, see F. G. Maier, "Niedergang als Erfahrung und Begriff: Die Zeitgenossen und die Dirse Westroms," in *Niedergang: Studien zu einem geschichtlichen Thema*, ed. Reinhart Koselleck and Paul Widmer, Stuttgart, 1980, II, 370–470.

15 Niccolò Machiavelli, *Florentine Histories*, trans. L. Banfield and H. Mansfield Jr., Princeton, 1988, 185–86 (V, 1). For an elaboration, see Machiavelli, *Discorso o dialogo intorno alla nostra lingua*, ed. Bortolo Tommaso Sozzi, Turin, 1976, I, 12, and 39; II, pr. and 5; III, 43.

16 Lorenzo de' Medici, *Opere*, ed. A. Simioni, Bari, 1914, I, 21; cited by McLaughlin, "Humanist Concepts," 140. He also mentions, p. 137, another example from Leonardo Bruni.

17 Giovan Battista Gelli, *Ragionamento sopra le difficoltà di mettere in regole la nostra lingua*, Florence, 1551; edition cited: *Opere*, ed. I. Sanesi, Turin, 1952, I, 469–72 (discussion of linguistic change as a natural, inevitable process of progress and decline that he likens to the rise and fall of an arc and the swing of a pendulum). In his notes on the history of art, written before 1550 (Kallab, *Vasaristudien*, 182–84), Gelli explains changes in history in relation to both nature and society (G. Mancini, "Vite d'artisti di Giovanni Battista Gelli," *Archivio storico italiano*, 17 (1896), 37): "Ma perchè la natura osserva sempre questo ordine, che così come quando ella à lasciato condurre l'arti e le scienzie ne la loro perfezione mediante gl'ingegni degl'uomini, ella o per ghuerre o per morte d'huomini o per mescolanza di gente barbare e rozze le fa rovinare e quasi dimenticar del tutto, così ancora quando elle sono al tutto rovinate ella produce huomini che nuovamente le ritrovino e aiutin ritornare a la perfezzion loro..." Speroni has "Pietro Bembo" liken languages to trees, with each species (each language) following the same cycle, albeit with different timing: "che qual arbor tosto nasce, fiorisce, & fa frutto; tale tosto invecchie, & si muoia." Quoted and discussed by Richard Waswo, *Language and Meaning in the Renaissance*, Princeton, NJ, 1987, 158–64. See also Giulio Camillo Delminio, *Della imitazione* (*circa* 1530; published in *Trattati di poetica e retorica del Cinquecento*, ed. B. Weinberg, Bari, 1970, I, 162–63), where language is likened to a garden whose plants, even with patient tending, will eventually wither and die.

18 Varchi, *Ercolano* (written before 1565).

19 For a fascinating discussion of Borghini's linguistic history in relation to Vasari, see Robert Williams, *Art, Theory, and Culture in Sixteenth-Century Italy: From Techne to Metatechne*, Cambridge, 1997, 53–57. For the most complete discusions of Borghini's theories on linguistic change, see Vincenzio Borghini, "Lingue perché si variino o mutino," in *Scritti inediti o rari sulla lingua*, ed. J. R. Woodhouse, Bologna, 1971, 79–125; and Giovanni Pozzi ("Il pensiero linguistico di Vincenzio Borghini," in *Lingua e cultura del cinquecento*, Bologna, 1975, 271–72) who quotes Borghini: "Il tempo non ha che fare né con la lingua né con gli abiti e quanto a sé non fa altra mutazione che le naturali, cioè che chi nasce cresce

e invecchia di mano in mano." The rate of progress and decline can be altered by attentive writers – Borghini uses the metaphor of the writer as gardener cultivating, weeding, pruning – and by the general state of health of culture and politics.

20 Emanuele Tesauro, *Il cannocchiale aristotelico*, Turin, 1654; revised and much expanded: Venice, 1665; edition cited: Turin: Zavatta, 1670, 147; and Ezio Raimondi, ed., *Trattatisti e narratori del Seicento*, Milan–Naples, 1960, 51: "Vassi mutando sempre co'l tempo la maniera del favellare; et per certe veci le voci Gramaticali, nascono, crescono: maturano, invecchiano, et muoiono." When it came to periodizing ancient art, Tesauro (p. 205) adopted a similar chronology and terminology as Mancini but cites their common source, Lucius Florus: *fanciulezza* (the first 250 years under the kings); *adolescenza* (the following 250 years from Brutus to Appius Claudius); *virilità* (the next 250 years to Trajan); *vecchiezza* (the following 250 years). Tesauro saw his own age as one of *virilità*, which started in the sixteenth century.

21 Giorgio Vasari, *Le vite de' più eccellenti pittori scultori e architettori nelle redazioni del 1550 e 1568*, ed. P. Barocchi and R. Bettarini, Florence, II, 17: "Ma perché quando le cose umane cominciano a declinare, non restano mai d'andare sempre perdendo, se non quando non possono più oltre peggiorare." For God's will, see II, 31; for Fortuna, see II, 17.

22 For Vasari on medieval art, see A. Thiery, "Il medioevo nell'introduzione e nel proemio delle *Vite*," *Il Vasari: storiografo e artista*, Florence, 1976, 351–81. For the background of Vasari's ideas on the decline of medieval art, see Panofsky, "The First Page of Giorgio Vasari's *Libro*," 21–42 and 114–18; and T. Buddensieg, "Gregory the Great, the Destroyer of Pagan Idols: The History of a Medieval Legend Concerning the Decline of Ancient Art and Literature," *Journal of the Warburg and Courtauld Institutes*, 28 (1965), 44–65.

23 M. Warnke, "Die erste Seite aus den 'Viten' Giorgio Vasaris: Der politische Gehalt seiner Renaissancevorstellung," *Kritische Berichte*, V, n. 6, (1977), 5–28.

24 L. Ghiberti, *Commentarii*, ed. L. Bartoli, Florence, 1998, 3.1.8, 87 (Pietro Cavallini kept in his work "un poco della maniera antica cioè greca") and 3.2.5, 90 (Duccio painted in "la maniera greca"). For Raphael's letter to Leo of 1519 (re "tre maniere di edificii"), see Francesco Di Teodoro, *Raffaello, Baldassar Castiglione e la Lettera a Leone X*, Bologna, 1994; A. Manetti, vita Brunelleschi. F.

Villani (*De origine civitatis Florentiae et eiusdem famosis civibus*, circa 1400) divides Florentine painting of the fourteenth century into three phases. By "modern" Vasari usually meant anything from Cimabue on, but in the third preface he explicitly limited it to everything from Leonardo on: "la terza maniera, che noi vogliamo chiamare la moderna." Antonio Manetti, *Vita di Filippo Brunelleschi*, ed. Carlachiara Perrone, Rome, 1992, 74–76.

25 Ludovico Dolce, writing in 1536 before he gave much thought to the visual arts, believed that modern art started with Michelangelo who led art out of the "shadows" that had "obscured and almost extinguished [art] for many centuries:" Dolce, Dedication to his translation of Horace's *Poetica*, Venice, 1536; quoted by G. Padoan, "A casa di Tiziano, una sera d'agosto," in *Monumenti del Rinascimento*, Padua, 1978, 354 ("quasi ritratto non di mano di Michele Agnolo, che per gran miracolo di natura la dignità della pittura e della scoltura, già per tanti secoli oscura e quasi spenta, ha tolto dalle tenebre, e ridotta col darle vita nell'antica sua bellezza, o di quelli che a lui più s'avicinano: il gentilissimo Titiano, Antonio da Pordenone, o'l mio Bernardin Licino, ma come d'uno di coloro che tolgono gli esempi da questi per avezzarsi a dipingere").

26 See, for example, Aeneas Sylvius Piccolomini, *Der Briefseschsel des Eneas Sylvius Piccolomini*, ed. R. Wolkan, Vienna, 1918, II, 100 (letter of 1492): "Dum viguit eloquentia, viguit pictura sicut Demosthenis et Ciceronis tempora docent Postquam cecidit facundia lacuit et pictura. Cum illa revixit, haec quoque caput extulit. Videmus picturas ducentorum annorum nulla prorsus arte politas. Scripta illius aetatis rudia sunt, inepta, incompta. Post Petrarcham emerserunt litterae; post Jotum surrexere pictorum manus; utramque ad summam iam videmus artem pervenisse."

27 Lionardo Salviati, *Degli avvertimenti della lingua sopra I Decamerone*, Venice, 1586, II (bk. 2, cap. 2). Borghini's chronology (J. R. Woodhouse, ed., *Scritti inediti o rari sulla lingua*, Bologna, 1971, 5–6) varies somewhat: "Io ho veduto libri scritti dal MCCC al MCCCXLVIII che fu l'anno della gran mortalità e scritti pur da persone idiote e semplici, e non vi si truova uno errore della lingua. . . . Similmente ne ho dal MCCL al MCCC e vi si veggono regolatissimamente osservate le congiugazioni, i numeri, i modi, i tempi brevemente tutto quello ove oggi si pecca assai bruttamente. E si conosce che la natura stessa o l'uso comune, che sia me' dire, era in quella età regola vera e sicura. Dal

MCCCC al MCCCL si comincia a trovar qualch'errore, ma non tanti a un pezzo quanti oggi. Dal MCCCL ad MD ella dette un gran tracollo e da questo tempo in qua è venuta di mano in mano talmente peggiorando che quasi si può dire guasta in alcune parti, che quel tutto buono e come naturale corpo del vero e puro toscano si è pur sempre mantenuto." See also Borghini's "Lingue perché si variino o mutino" (ibid., 184–91). Robert Williams (*Art, Theory, and Culture in Sixteenth-Century Italy*, 53–57) discusses the relationship of Borghini's and Vasari's histories. For a survey of these and other views, see G. A. Padley, *Grammatical Theory in Western Europe, 1500–1700*, Cambridge, 1985, II, 32–33; P. B. Diffley, "Literature as Language: Paolo Beni's Critique of Dante," 243–56. Paolo Beni held a view of continual amelioration closer to Vasari's. He rejected Borghini's and Salviati's views on the "peggioramento della favella" and argued instead that when the Italian language was closest to its corrupt origins in "Barbarian Latin" it was least perfect, but as time passed it became ever more perfect. Bembo arranged the history of literature differently with the fifteenth century as a period of decay and the sixteenth century, at least up to 1525, as a time of renewal: Pietro Bembo, *Prose*, Venice, 1525; edition cited: ed. Carlo Dionisotti, Turin, 1960, 121–31.

28 Quoted in Pozzi, "Il pensiero linguistico di Vincenzio Borghini," 271 (see also 238–40 and 272–73).

29 Giorgio Vasari, *Le vite de' più eccelenti pittori scultori e architettori nelle redazioni del 1550 e 1568*, ed. P. Barocchi and R. Bettarini, Florence, 1971,III,7.

30 Lorenzo Valla, *Elegantie lingue latine*, preface to first book; in *Opera omnia*, ed. E. Garin, Turin, 1962, 594–99; Vespasiano da Bisticci, *Le Vite*, ed. Aulo Greco, Florence, 1970, I, 32.

31 Giorgio Vasari, *Le vite de' più eccelenti pittori scultori e architettori nelle redazioni del 1550 e 1568*, ed. P. Barocchi and R. Bettarini, Florence, I, 9–10.

32 Elizabeth Cropper, "La più bella antichità che sappiate desiderare: History and Style in Giovanni Pietro Bellori's 'Lives'," in *Der Künstler über sich in seinem Werk* (Wolfenbütteler Forschungen. Kunst und Kunsttheorie, 1400–1900), ed. M. Winner, Wolfenbüttel, 1991, 157.

33 William Aglionby, *Painting Illustrated in Three Dialogues... Together with the Lives of the Most Eminent Painters*, London, 1685, 82–83.

34 Vasari, ed. Barocchi and Bettarini, II, 16 ("Proemio delle Vite"): "perché quando le cose umane cominciano a declinare, non restano mai d'andare sempre perdendo, se non quando non possono più oltre peggiorare."

35 Vasari, ed. Barocchi and Bettarini, II, 16: "Ma perché la fortuna quando ella ha condotto altri al sommo della ruota, o per ischerzo o per pentimento il più delle volte lo torna in fondo..."

36 G. B. Adriani, "Lettera... a M. Giorgio Vasari; nella quale brevemente si racconta i nomi, e l'opere de' più eccelenti Artefici antichi in Pittura, in Bronzo, & in Marmo," in Vasari, ed. Barocchi and Bettarini, I, 180: "[T]ornando alla memoria degli uomini con molta fatica e lungo studio e spesa di tempo, da quanto tempo in qua dopo il disfacimento di Europa, e delle nobili arti e scienze, elle cominciassero a rinascere, a fiorire, e finalmente siano venute al colmo della loro perfezione, dove veracemente io credo ch'elle siano arrivate; tale che (come delle altre eccellenze suole avvenire, e come altra fiata di queste medesime avvenne) è più da temerne la scesa, che da sperarne più alta la salita."

37 Vasari, ed. Barocchi and Bettarini, I, 4–5, dedication to Cosimo I de' Medici: "E non pur io, che mi son dedicato per servo perpetuo a la Santità Sua, ma tutti gl'ingegnosi artefici di questa età ne debbono aspettare onore e premio tale et occasione d'esercitarsi talmente, che io già mi rallegro di vedere queste arti arrivate nel Suo tempo al supremo grado della lor perfezzione e Roma ornata di tanti e sì nobili artefici, che, annoverandoli con quelli di Fiorenza che tutto giorno fa mettere in opera l'Eccellenza Vostra, spero che chi verrà dopo noi arà da scrivere la quarta età del mio volume, dotato d'altri maestri, d'altri magisterii che non sono i descritti da me – nella compagnia de' quali io mi vo preparando con ogni studio di non esser degli ultimi."

38 Anton Francesco Grazzini detto il Lasca, *Le rime burlesche*, Florence, 1882, 325–28 (written upon the dedication of the cupola frescoes in Florence Cathedral).

39 Giulio Mancini, *Considerazioni sulla pittura*, ed. A. Marucchi and L. Salerno, Rome, 1957, I, 105. In another section (I, 299–305) Mancini calls it *Secolo succedente* following the period of *Perfezione*, which implies a decline without stating it as directly.

40 Giampolo Lomazzo, *Rabisch*, Milan, 1589; edition cited: ed. D. Isella, Turin, 1993, II, 24.

41 For Zuccaro in Venice, see Michel Hochmann, *Venise et Rome, 1500–1600: deux écoles de peinture et leurs échanges*, Geneva, 2004, 403–16. For Zuccaro's "Lamento," see P. Sohm, *Style in the Art Theory of Early Modern Italy*, Cambridge, 2001, 146–53.

42 Federico Zuccaro, "Il lamento della pittura su l'onde venete," in *Lettera a prencipi e signori amatori del dissegno, pittura, scultura et architettura*, Mantua, 1605; in *Scritti d'arte di Federico Zuccaro*, ed. D. Heikamp, Florence, 1961, 119: "Che veggio, ohimè? Chi tua beltà ti fura, / E chi t'induce à così grave pianto, / O del Mondo bellezza alma Pittura?/ Dimmi, ti prego, la cagion di tan-to / Duol, che t'affligge, e ti torment il core . . ."

43 For a review of the contested relations between Zuccaro and Tintoretto, see C. Damian, "L'étape vénitienne du jeune Federico Zuccaro," *Bulletin de l'Association des historiens de l'art italien*, 8 (2001–02), 18–19; and for an argument in favor of dating Zuccaro's drawing of *Paradise* to the competition of 1577, see W. R. Rearick, "Titian and Artistic Competition in Cinquecento Venice: Titian and His Rivals," *Studi Tizianeschi*, 2 (2004), 31–43 (on 34–35).

44 Gabriele Paleotti, *Discorso intorno le immagini sacre e profane*, Bologna, 1582, bk. II, cap. lii; edition cited: P. Barocchi, ed., *Trattati d'arte del Cinquecento*, 3 vols., Bari, 1960–62, II, 499–502.

45 Lomazzo, *Rabisch*, ed. Isella, II, 24 (the poem titled "Lament on Modern Painting" is dedicated to the painter Camillo Procaccini).

46 Giampolo Lomazzo, *Trattato dell'arte della pittura*, Milan, 1584; edition cited: *Scritti sulle arti*, ed. R. Ciardi, Florence, 1973, II, 418; and Lomazzo, *Idea del tempio della pittura*, Milan, 1590; edition cited: *Scritti sulle arti*, ed. Ciardi, I, 255.

47 Giovanni Battista Armenini, *De' veri precetti della pittura*, Ravenna, 1586; edition cited: ed. M. Gorreri, Turin, 1988, 9.

48 Armenini, *De' veri precetti della pittura*, ed. Gorrer, 9. The wording (*salire, a temere, a basso; alto/altezza*) indicates the source as Vasari (III, 7): "e mi par potere dir sicuramente che l'arte . . . sia salita tanto alto, che piú presto si abbia a temere del calare a basso, che sperare oggimai piú augumento." "Io non sempre stato e son tuttavia d'opinione che questa bellissim'arte della pittura, se ben da quella bassezza e viltade ove era ne' secoli passati caduta, si veda oggidi ad alto et onorato grado risorta, nondimeno non abbia ciò fatto con cosí fermo e stabil piede, che non s'abbi piú tosto a temere che sia per ricadere a basso, che aspettare ch'ella abbia a salire a maggior altezza; perciò che, quanto io piú considero i suoi presenti effetti e lo stato nel quale essa ora si trova, tanto piú parmi vedere il pericolo suo maggiore: conciosiacosaché siano venuti meno quegli artefici che con tanta eccellenza e felicità l'avevano sollevata, né se ne vedon rinascere de gli altri in gran parte come quelli perfetti, e tuttavia l'opere loro, che son maravigliose, vadano col tempo consumandosi."

49 Armenini, *De' veri precetti della pittura*, ed. Gorrer, 13–14 and 80.

50 Armenini, *De' veri precetti della pittura*, ed. Gorrer, 254 and 258.

51 Denis Mahon, *Studies in Seicento Art and Theory*, London, 1947, 247; trans. R. Enggass and J. Brown, eds., *Italy and Spain 1600–1750: Sources and Documents*, Eaglewood Cliffs, NJ, 1970, 29.

52 *Memorie per le belle arti*, Rome, February 1787, III, 26.

53 P. M. Jones, "Federico Borromeo's Ambrosian Collection as a Teaching Facility for the Academy of Design," in *Academies of Art Between Renaissance and Romanticism*, ed. A. Boschloo et al., The Hague, 1989, 44–60; Pamela Jones, *Federico Borromeo and the Ambrosiana: Art Patronage and Reform in Seventeenth-Century Milan*, Cambridge, 1989.

54 Giulio Mancini, *Considerazioni sulla pittura*, ed. A. Marucchi and L. Salerno, 2 vols., Rome, 1956. The impressive notes and commentary have not been surpassed, but see now Frances Gage, "Giulio Mancini's Considerazioni sulla pittora: Recreation, Manners and Decorum in Seventeenth Century Roman Picture Galleries," Ph.D. dissertation, Johns Hopkins University, 2000.

55 For two splendid discussions of Mancini's diagnostic practices, see Carlo Ginzburg, "Clues: Roots of an Evidential Paradigm," *Clues, Myths, and the Historical Method*, trans. J. and A. Tedeschi, Baltimore, MD, 1989, 96–125 and Richard Spear, *The "Divine" Guido: Religion, Sex, Money, and Art in the World of Guido Reni*, New Haven, CT, and London, 1997, 270–74.

56 For careful philological analysis of the manuscripts in terms of their structure and chronology of writing, see Mahon, 1947, 279–331; and Salerno and Marucchi in Mancini, *Considerazioni sulla pittura*.

57 Mancini, *Considerazioni sulla pittura*, I, 299–305.

58 Mancini, *Considerazioni sulla pittura*, I, 105. In another section (I, 299–305) Mancini calls it *Secolo succedente* following the period of *Perfezione*, which implies a decline without stating it as directly.

59 Mancini, *Considerazioni sulla pittura*, I, 295–97.

60 The notion of modern art mirroring ancient art would have been well known to Mancini from the

two writers he critiqued at greatest length: Vasari and Lomazzo. One of the various organizing structures given to the "temple of painting" by Lomazzo, besides astrology, physiognomy, and humors, was an attendant ancient artist assigned to each of his seven governors. Johann Joachim Winckelmann also divided ancient and modern art into the same number of periods (five instead of Mancini's four) and invested its organic development with identical qualities: an archaic style (pre-Phidian and pre-Raphaelite), a High or Sublime Style (Phidias, Leonardo, and Raphael), a Beautiful Style (Praxiteles to Lysippus; Correggio), the Imitative or Eclectic Style (the Romans and the Carracci and followers) and a period of decay that identified early medieval art with Carlo Maratta and late seventeenth- to and early eighteenth-century painting. For Winckelmann's history, see Alex Potts, *Flesh and the Ideal: Winckelmann and the Origins of Art History*, New Haven, CT, and London, 1994, 33–46 and 67–71. For my synopsis, I rely on Charles Dempsey, "The Greek Style and the Prehistory of Neoclassicism," in Elizabeth Cropper, *Pietro Testa, 1612–1650: Prints and Drawings*, Philadelphia, 1988, xxxix. Dempsey's article is the fundamental history about the invention of "Greek style" in the seventeenth century; but it does not note the parallel histories of ancient and modern art as discussed by Vasari and Mancini.

61 M. Pigozzi, ed., *Bologna al tempo di Cavazzoni: approfondimenti*, Bologna, 1999, 51.

62 Mancini, *Considerazioni sulla pittura*, I, 240. For *dilavato*, see ibid., I, 299–305.

63 For a thorough biography of Vittoria, see S. Rudolf, "Vincenzo Vittoria fra pitture, poesie e polemiche," *Labyrinthos*, 13/16 (1988–89), 223–66.

64 For this and other critiques of Raphael's allegedly dry and stony style, see Sohm, "Style in the Art Theory of Early Modern Italy," 28–33.

65 Vittoria, *Academia de pintura del Senor Carlos Maratti* (Rome, Biblioteca Corsiniana, Cod. 660, 44 A 5). Vittoria, n. d., fols. I, 227–8, 389–90, and 445–48. For a thorough biography of Vittoria, see Rudolph, "Vincenzo Vittoria." Vittoria's *Academia* is a dialogue divided into seven "nights" (*noches*) between Maratta, Bellori, and a *dicipulo*, presumably Vittoria. Prandi ("Contributi alla storia della critica: un'*Academia de Pintura* delle fine del Seicento," *Storia dell'arte*, 1941, 201–16) has dated it between 1686 (because it is not mentioned in Baldinucci's *Notizie*) and 1690, when a collection of poems by Giovanni Prati (*Il genio divertito*) mentions it. Rudolph ("Vincenzo Vittoria," 262)

notes that, according to Giovanni Mario Crescimbeni (*L'istoria della volgar poesia*, Venice, 1731, 91), the life of Carlo Maratta published in 1731 was "pienamente incominciata da Giovanni Pietro Bellori, e continuata dal Canonico Don Vincenzo Vittoria, la quale è in podere di Faustina Maratti sua figlia, nostra Arcade."

66 Prandi, "Contributi alla storia della critica," 212–13. Prandi gives no page reference. I could not find it, but considering Vittoria's scrawl and Prandi's superior paleographic skills I defer to him. In a particularly squirrelly script on fol. 448 he refers to Luca Cambiaso painting for Sixtus V when he (Cambiaso) was of an "etad mui decrepita," but this is not the passage that Prandi refers to. For the attributes of Mannerism, see *Academia de pintura*, folio 445: "quel estilo languido y insustanesa del Salviati, del Vasari y de otros y des pues que murieron los dicipulos de Rafael . . ."

67 Vittoria, n. d., fol. 386: "Fue Jorge [Vasari] mui pronto en la execucion de usu obras, abundante in el inventor aunque fu estilo sue ideal y dislavado . . ."; 351: "Fu estilo sue [Salviati] ideal y deslavado simil al de su amigo Jorge Vasari."

68 The brief descriptions of Books 1, 2, and 3 are based on Zanetti's prefaces (Anton Maria Zanetti, *Della pittura veneziana*, Venice, 1771, 1–3, 6–7, 87–89, 201–02). Fourteenth- and fifteenth-century painting, presented respectively as naive (*semplicissima semplicità*) and as calculated renditions of nature, stand in relation to each other much as Giorgio Vasari first described them in 1550. Book 1 opens with a truncated account of thirteenth- and fourteenth-century painting before turning to the first mature phase of Venetian painting in the fifteenth century. Book 2, devoted to Giorgione, Titian, Tintoretto, Veronese, and Bassano, introduces those qualities that Zanetti had found missing in the fifteenth century: an imagination that transcends the literal and sensible; a technique that translates the artist's ardent genius (*genio fervido*) into visible form. Book 3 takes as its subject the "Disciples and Imitators of Giorgione and Titian" and presents Sebastiano del Piombo, Palma Vecchio, Lotto, Pordenone, Bonifacio Veneziano, Schiavone, and others as artists who initiated the shift away from normative beauty. At their best, they followed "the style of the Masters as a good guide," but therein also lay the seeds of artistic decline. Nevertheless, Zanetti insisted that the followers of Giorgione and Titian "should *not* be called nephews but sons of nature" and hence do *not* deserve the Horatian epithet of servile imi-

tators (*Imitatores servum pecus*). In so doing he was anticipating the perils of imitation that in his account would lead to the decline of painting in the seventeenth century.

69　Zanetti, *Della pittura veneziana*, 300–73. The *manieristi* include Palma Giovane, Lionardo Corona, Andrea Vicentino, Santo Peranda, Francesco Maffei, Matteo Ponzone, Antonio Aliense, Pietro Malombra, Giovanni Contarini, Paolo Piazza, Pietro Damini, Dario Varotari, Giulio Carpioni, and Carlo Ridolfi.

70　P. Sohm, "Seicento Mannerism: Eighteenth-Century Definitions of a Venetian Style," in *Treasures of Venice: Paintings from the Museum of Fine Arts, Budapest,* ed. G. Keyes et al., Minneapolis Institute of Art, 1995, 51–66. Nature, considered by the Mannerists to be a circumambiguous route to truth, was replaced by more expeditious means of image-making: 1) art becomes the model for art, not in the form of selective Ciceronian imitation but as servile, uncritical imitation; 2) the artists' "sterile imagination" (*la fantasia sterile*) or "abundant imagination" no longer consult nature and makes "studious copies" (*le studiate repliche*) from it; 3) "practice" (*pratica*) instead of theory or principles (*principii*) guide the artist who accordingly works by routine and physical habit and "derives everything from the palette and brush": Zanetti, *Della pittura veneziana*, 300–02. For Vicentino, Peranda, and Aliense giving free rein to their imaginations, see ibid., 330, 336, and 344. Zanetti excludes Carpioni, Varotari, and Damini from "the servile ideas and excessively free awkwardness of the Mannerists": ibid., 373. For the "mannered brushwork" ("incolpa . . . di maniera") of Bellucci as exemplary of the Mannerists, ibid., 413. This epistemology of Mannerism explains the forms that it produces: the variety of nature having been abandoned, forms become monotonous: Zanetti (ibid., 323–24) discusses here "la loro uniformità di stile . . . ch'è gran segno della decadenza d'un'arte." This refers to the collective uniformity of style of the Mannerists, which frustrates even learned attempts to distinguish the style of one master from another. Freed from the controls of reason, theory, and the careful imitation of nature and good art, imagination and practice run rampant, allowing painters to work with excessive haste (*speditezza*). Zanetti (ibid., 300–01, 330) describes Andrea Vicentino as "Abbondante era la fantasia. . . . facile era il suo pennello"). See 344 and 351 for the *speditezza* of Mannerism.

71　Filippo Baldinucci, *Vocabolario toscano dell'arte del disegno*, Florence, 1681, 88: "Maniera f. Modo,

guisa, forma d'operare de' Pittori, Scultori, o Architetti. Intendesi per quel modo, che regolarmente tiene in particolare qualsivoglia Artefice nell'operar suo; onde rendesi assai difficile il trovare un'opra d'un maestro, tutto che diversa da altra dello stesso, che non dia alcun segno, nella maniera, di esser di sua mano, e non d'altri: Il che porta per necessità ancora ne' maestri singularissimi una non so qual lontananza dall'intesa imitazione del vero, e naturale, che e tanta, quanto è quello, che essi con la maniera vi pongono del proprio. Da questa radical parola, maniera, ne viene ammanierato, che dicesi di quell'opre, nelle quali l'Artefice discostandosi molto dal vero, tutto tira al proprio modo di fare, tanto nelle figure umane, quanto negli animali, nelle painte, ne' panni, e altre cose, le quali in tal caso potranno bene apparir facilmente; e francamente fatte; ma non saranno mai buone pitture, sculture, o architetture, nè avranno fra di loro intera varietà; ed è vizio questo tanto universale, che abbraccia, ove più ove meno, la maggior parte di tutti gli Artefici."

72　In addition to the sources cited below, see Anton Maria Salvini, *Prose toscane*, Florence, 1715, I, 347: "Lo studio e l'artifizio si potria tacciare come troppo e sfacciato, e che il componimento esca assia lungi da' confini del naturale e dello schietto, per essere soverchiamente ammanierato." Salvini, *Discorsi accademici*, Florence, 1725, I, 449: "Gli antichi maestri, che non concedevano tanto al caricato ammanieramento dell'arte, ma copiavano la natura." G. G. Bottari, in Giorgio Vasari, *Le vite de' più eccellenti pittori scultori e architetti . . . corrette da molti errori e illustrate con note,* ed. Bottari, Rome, 1759–60, II, 121: in making a portrait "bisogna stare strettamente attaccati alla natura, per non dare nell'ammanierato." Antonio Palomino rendered it in Spanish as *amanerado* to describe how Francisco de Solís painted "without availing himself of the study of the model except on rare instances:" *Museo pictórico*, Madrid, 1715–24; as *Lives of the Eminent Spanish Painters and Sculptors*, trans. Nina Mallory, Cambridge, 1987, 261. In coining *ammanierato*, Baldinucci echoes Scannelli's atypical use of *manieroso* as "non poco lontane dall'apparenza del vero . . . e vera naturalezza," although Scannelli was not consistent in this usage (*Il microcosmo della pittura*, Cesena, 1657, 109 and 202).

73　Filippo Baldinucci, *Notizie de' professori del disegno dal Cimabue in qua,* 3 vols., Florence, 1681–1728; edition cited: ed. P. Barocchi, Florence, 1975, IV, 15–16. So close were style and Mannerism that at

one point in the *Notizie*, ignoring his own fine lexical division in the *Vocabolario*, he lapsed into a more rudimentary speech pattern that took them to be the same thing. Ibid., v, 14: "Ed in ogni altro scuopresi talora alquanto di quel difetto, che dicesi maniera, o ammanierato, che è quanto dire debolezza d'intelligenza, e più della mano nell'obbedire al vero." He even applied it to a group of unnamed ancient artists (ibid., IV, 505): "Sono stati poi altri artefice, che noi diciamo *di maniera* o *ammanierati*, i quali avendo formate alcune idee di volti a lor capriccio, non solo non hanno scelto il più bello che può far la natura, ma non hanno imitato eziandio quello che ella è solita di fare: e questi son degni d'ogni biasimo."

74 See below for most references. For Baldinucci's applications, see *Notizie*, ed. Barocchi, III, 76–77, on Boscoli: "discostandosi alquanto dal naturale e dal modo di colorire degli altri pittori"; ibid., v, 31: "E benchè tali disegni siano, come noi sogliamo dire, aggrottescati e ammanierati molto, non lasciano contuttociò di far bella mostra, per la vivacità e spirito delle figure, e per la varietà e novità dei concetti, di abiti, di berrette, di calzari, di acconciature, armature e simili, che è in sustanza tutto quello, che si ricerca nei disegni fatti solamente per quel fine"; ibid., III, 76–77 and 429; v, 105. For Vanni, see ibid., IV, 547.

75 Charles de Brosses, *Lettres Familières sur l'Italie*, ed. Y. Bezard, Paris, 1931, II, 45 (letter 39). Tiberio Soderini, "Orazione," in *Orazione e componimenti poetici in lode delle belle arti: Relazione del solenne concorso e della distribuzione de' premi. Celebrata sul Campidoglio dall'Insigne Accademia del Disegno*, Rome, 1776, 33–34, thought the poses of Bernini's statues to be "mannered," coyly prevaricating in the text ("I do not dare to name that great man"), only to name him directly in the notes, and includes Marino and Borromini along with him.

76 Francesco Algarotti, *Saggio sopra quella quistione perché i grandi ingegni a certi tempi sorgano tutti a un tratto e fioriscono insieme*, Venice, 1757; edition cited: *Saggi*, ed. G. Da Pozzo, Bari, 1961, 354: "E quando venne poi il Marini a infrascare la poesia di concetti e di acutezze, quando fece quasi lo istesso il Borromini nell'Architettura. . . . "On the other hand, he thought that seventeenth-century music was far removed from the simpering or mincing manners (*smancerie*) of the other arts: *Opere*, 1791, VII, 147. See also Soderini, "Orazione", 33–34. Francesco Milizia (*Dell'arte di vedere nelle belle arti*, Venice, 1781, II; edition cited: *Dizionario delle belle arti*, Bassano, 1797, I, 113–14; and 1827, II, 164, s.v. Borromini) also brought Borromini

and Marino together as examples of the "deforming" and "mutilation" of art: "Borromini in Architettura, Bernini in Scultura, Pietro da Cortona in Pittura, il Cavalier Marino in Poesia son peste del gusto." The alliterative troika of Berrettini, Bernini, and Borromini was not Milizia's invention. They were either condemned for their "liberties" and "caprice" (letter by La Teulière to Surintendant Villacerf, April 1693, in A. de Montaiglon, *Correspondance des Directeurs de l'Académie de France a Rome avec les Surintendants des Batiments*, Paris, 1887, I, 380–81) or identified as the last adherents of ancient models before their followers reduced their art to "trifles and deformities and extravagances" (Lione Pascoli, *Vite de' pittori, scultori, ed architetti moderni*, 2 vols., Rome, 1736, II; edition cited: ed. V. Martinelli, Perugia, 1992, 501).

77 Fréart on Lanfranco; quoted below in note 87. Nicolas Vleugels (1668–1737), Director of the French Academy in Rome, comments on Pietro di Cortona's mannered style in the 1735 edition of Ludovico Dolce's *Dialogo della pittura intitolato l'Aretino* (32–34): "Il paese di Pietro da Cortona è greve, di maniera, e non fa grand'effetto, ma tuttavia egli è buono per un uomo, di cui non era di questo il mestiere. . . . Tuttavolta quantunque egli li facesse spesso dopo gli studj sopra il naturale, lo stile de' suoi alberi è sempre lo stesso, grave, attonato, ed ha, come io ho detto, un poco di maniera." For Cortona's drapery as "troppo manierosi" and "maniéré par tout," see Luigi Scaramuccia, *Le finezze de' pennelli italiani*, Pavia, 1674, 42; and Roger de Piles, *Abrégé de la vie des peintres*, Paris, 1699; edition cited: Paris, 1715, 246. For Giordano as *manierato*, meaning both a technical facility and ability to mimic the styles of other painters, see N. Pio, *Vite di pittori, scultori et architetti (Cod. mss Capponi 257)*, ed. C. and R. Enggass, Vatican City, 1977, 68. For Crespi, see Lodovico Bianconi, "Lettera scritta da Perugia al sig. abate Carlo Bianconi in Roma nella quale si danno notizie intorno alla vita di Raffaello da Urbino (28 ag. 1776)," in *Opere*, Milan, 1802, 30: "Pel colorito dovrebbe tacere anche il suo Padre, se vivesse, perchè disegnò, è vero, ragionevolmente bene, ma colorì manieratissimo. Si direbbe, che ha nevicato sulla punta del naso, o sulla cima del capo alle sue figure." For Ricci, see Lione Pascoli, *Vite de' pittori, scultori ed architetti moderni*, Rome, 1736, II, 385–86; edition cited: V. Martinelli ed., Perugia, 1992, 815: "Era Sebastiano . . . pronto a intraprendere qualunque opera faragginosa, e più d'una insieme, se l'occasione gli si presentava. Non

è perciò da maravigliarsi, se fosse, conforme ho detto in principio, alquanto ammanierato, perché mi pare eziandio d'aver datto altrove in simil proposito, che tali professori non possono star toppo alla correzione, ed al vero attaccati." Francesco Algarotti, *Opere*, VIII, 377 (writing in 1741 regarding the Dresden project: Balestra, "pittor grazioso, benché un poco manierato").

78 Giuseppe Niccolo d'Azara, in introduction to Anton Raphael Mengs, *Opere*, ed. D'Azara, Rome, 1787, XXXIV: "La peggior taccia d'un pittore è dirgli si amanierato. Giordano, Solimena, Corrada, con tutta la sua scuola, sono modelli di amanierati."

79 Baldinucci, *Notizie*, ed. Barocchi, V, 105; see also III, 429; IV, 457; and IV, 592–93. For the relevant quotations and a discussion, see chapter 1.

80 Luigi Lanzi, *Storia pittorica dell'Italia dal Risorgimento delle bene arti fin presso la fine del XVIII secolo*, Bassano, 1789; edition cited: ed. M. Capucci, Florence, 1970, II, 91.

81 De Piles, *Abrégé de la vie des peintres*, 1699, 95 (in part 2, "De quel Auteur est un Tableau" of the chapter on connoisseurship, "De la Connoissance des Tableaux"): "Il n'y en a point aussi qui n'ait eu son commencement, son progrès sa fin; c'est-à-dire, trois maniéres: la premiére, qui tient de celle de son Maître; la seconde, qu'il s'est formée selon son Goût, & dans laquelle réside la mesure de ses talens, & de son Génie; & la troisiéme, qui dégénére ordinairement en ce qu'on appelle maniére: parce qu'un Peintre, après avoir étudié long-tems d'après la Nature, veut jouir, sans la consulter davantage, de l'habitude qu'il s'en est faite."

82 De Piles, *Abrégé de la vie des peintres*, 1699, 267–68.

83 For the association of speed with youth, see Pietro Aretino who admits to Tintoretto that "the years will gradually provide for this [to reduce the rapidity of what you have done], because they and nothing else can rein in the racing negligence which willing, quick youth so heartily exploits" (Aretino, *Lettere sull'arte*, ed. E. Camesasca and F. Pertile, Milan, 1957, II, 205). Campbell (forthcoming) shows how Aretino relied on ancient rhetoric for this typecasting: Seneca, *Epistles*, trans. R. M. Gummere, Cambridge, MA and London, 1917, XL, 2–3 ("the rapid style . . . is assigned to the young speaker; from the old man eloquence flows gently, sweeter than honey"); Quintilian, *Institutio oratoria*, trans. M. E. Butler, Cambridge, MA, and London, 1921 II, iv. 5; and Cicero, *De oratore*, trans. E. W. Sutton and H. Rackham, Cambridge, MA, and London, 1942 II, XXI. 88 (Sulpicius as a

youth had a delivery that was "rapid and impetuous the result of his genius, and his diction agitated and a little too exuberant, as was natural at his age").

84 For criticisms of these stylistic defects, see chapter 7. For a standard account of aged orators rambling, repeating, and generally gassing off, see Francesco Panigarola, *Il predicatore overo Demetrio Falereo dell'elocutione*, Venice, 1609; edition cited: in *Degli autori del ben parlare*, Venice, 1642, I, 43ff. For a discussion of old age as a hardening of habit, see Avicenna, *A Treatise on the Canon of Medicine*, trans. O. Cameron Gruner, London, 1930, I, 53; and Gabriele Zerbi, *Gerontocomia, On the Care of the Aged; and Maximianus, Elegies on Old Age and Love*, Rome, 1489, chap. I, 30 and chap. VI, 57.

85 Maximianus, *Elegie della vecchiaia*, trans. D. Guardalaben, Florence, 1993, 52 (I, 201–02).

86 Luigi Crespi, *Felsina pittrice: vite de' pittori bolognesi tomo terza*, Rome, 1769, 343 (Indice): "Pittori manieristi peggiorano con l'età." Crespi applied this precept in the life of Ercole Graziani (p. 278): "In tutti i professori di pittura certamente siamo costretti a compiangere la debolezza dell'età, nelle loro ultime operazioni, allora quando essi giungono a decrepitezza: ma egli è ancor fuori d'ogni dubbio, che maggiormente manifestasi la debolezza in quei pittori, che manieristi s'appellano, i quali decadono nell'operare, anche prima della decrepitezza, e che sotto debole direzione hanno avuto il loro incamminamento, nè mai hanno saputo prendere un'altro volo, e scostarsi da quel nido, in cui nella loro piccolezza, e miseria si trovarono a principio." See also for old-age mannerism, ibid., 217; and letter from Crespi to Bottari in Giovanni Gaetano Bottari and Stefano Ticozzi, eds., *Raccolta di lettere sulla pittura, scultura ed architettura*, 8 vols., Milan, 1822–25, III, 444–45.

87 Roland Fréart de Chambray, *Idée de la perfection de la peinture démonstrée par les principes de l'art et par des exemples conformes aux observations que Pline et Quintilien ont fait sur les plus célèbres tableaux des anciens peintres mis en parallèle à quelques ouvrages de nos meilleurs peintres modernes, Léonard de Vinci, Raphael, Jules Romain et le Poussin*, Paris, 1662, 119–20: "Le pauvre Dominquin, le plus sçavant de tous les Eleves des Caraces, et peut etre le seul digne du nome de Peintre, a esprouvé fort long-temps cette disgrace; quoy que presque tous ses Competiteurs luy fusent extremement inferieurs, et tres-indignes de venir en concurrence avec luy: car si nous en exceptons le Guide, qui fut veritablement plus favorisé que luy de la Nature pour le Talent de la Grace qui la rendu

singulier dans tout son siecle, mais qui ne luy estoit aussi aucunement comparable dans celuy de l'Expression, et moins encore dans l'intelligence de la regularité perspective; que pourra on dire de l'aveuglement des Peintres de nostre temps qui luy prefererent des Iosepins, des Lanfrancs, et d'autres semblables manieristes, dont les Ouvrages n'ayant que le faux esclat d'une je ne sçay quelle nouveauté que ceux d'aujourdhuy appellent une furie de Dessein, et une franchise de pinceau, que l'ignorance des veritables beautez et des principes de l'Art leur fait admirer, n'ont eu aussi de reputation qu'autant qu'a duré cette faveur passagere de la Fortune." For a discussion of Fréart's debt to and influence on Italian art criticism, however, without reference to Mannerism, see P. Barocchi, "Ricorsi Italiani nei trattatisti d'arte Francesi del Seicento," in *Il mito del classicismo nel seicento*, Florence, 1964, 129–47.

88 Sohm, *Style in the Art Theory of Early Modern Italy*, 31–33.

89 Sohm, *Style in the Art Theory of Early Modern Italy*, 87–97.

90 Giovanni Battista Passeri, "Della pittura degli Etrusci: dissertazione," *Nuova raccolta d'opuscoli scientifici e filologici*, 16 (1768), 121–24.

91 For the French on the Italians in the late seventeenth and early eighteenth centuries, see Franco Venturi, "L'Italia fuori d'Italia," in *Storia d'Italia vol. III, Dal Primo Settecento all'Unità*, Turin, 1973, 985–1481; and Françoise Waquet, *Le Modèle français et l'Italie savante: conscience et soi et perception de l'autre dans la République des Lettres, 1660–1750*, Rome, 1989.

92 Dominique Bouhours, *Les Entretiens d'Ariste et d'Eugène*, Paris, 1671, 312: "le siècle passé estoit pour l'Italie un siècle de doctrine et de politesse; il luy a plus fourni de beaux esprits qu'elle n'en avoit eu depuis le siècle d'Auguste. Le siècle présent est pour la France ce que le siècle passé estoit pour l'Italie; on diroit que tout l'esprit et toute la science du monde soit maintenant parmi nous, et que tous les qutres peuples soient barbares en comparaison des Français."

93 Fontenelle, "Digression sur les Anciens et les Modernes," in *Œuvres complètes*, ed. G.-B. Depping, 3 vols., Geneva, 1968, 362. For a thorough review of French–Italian literary relations, see Waquet (*Le Modèle français et l'Italie savante*), who also supplies some suggestive quantifiable evidence that indicates some truth behind the prejudices. Of the foreign books listed in French book store inventories, from 1700 to 1710, only 8 percent were Italian, of which, on average, half were published in the sixteenth century, a third between 1600 and 1660 and only 15 percent published after 1660. A total count of books reviewed in French journals of the 1720s and 1730s places the Italians at the same level as the Swiss, and below the English, Dutch, German, and Spanish. French publications were avidly purchased, read, and reviewed in Italy, unlike their counterparts in France. In the 1670s Italy's primary literary journal, the *Giornale de' letterati*, reviewed 520 books, 450 of them foreign, and, of those, 365 were French. In the 1680s and 1690s, with changes in editors, more Italian books were reviewed and articles published than previously but the French maintained a proportional representation of about 70 percent. By the turn of the century it was conventional for Italians to refer to France as "the learned nation" and "the new Rome." Political events, most notably the War of Spanish Succession (1700–13), confirmed Italy's marginal status. These troubled years reminded one of Muratori's friends of the foreign invasions in the early and mid-sixteenth century. "A total extermination," he thought, referring to the economic and social consequences.

94 Paul Fréart de Chantelou, *Diary of the Cavaliere Bernini's Visit to France*, ed. A. Blunt and G. Bauer, trans. M. Corbett, Princeton, NJ, 1985, 182 and 192.

95 L. A. Muratori, "A' generosi letterati d'Italia," in *Raccolta delle opere minori*, Naples, 1757, I, 3 (lecture delivered on 2 April 1703). He refers to *ozio* as "quel mostro che poco avvelenò le menti, e le distolse dal faticoso cammino della virtù." For more on laziness and decadence, see Waquet, *Le Modèle français et l'Italie savante*, 335–43.

96 Letter of 16 March 1668; published by Giovanni Previtali, "Introduzione," in Giovan Pietro Bellori, *Le vite de' pittori, scultori et architetti moderni*, ed. Evelina Borea, Turin, 1976, XXXII: "Le Vite de' Pittori che io vado scrivendo, non sono queste né di Romani né d'altra particolar Regione, ma ne ho scelti alcuni pochi secondo il mio debile giudicio. Dubito nondimeno nel poco numero di essermi troppo accordato [?] Per la scarsità [?] de' nostri tempi; e la mediocrità cosí nella pittura come nella poesia non deve essere in istima. . . ." For Dati's views, see *Discorso dell'obbligo di ben parlare la propria lingua*, Florence, 1657, 9–10. He laments the careless attitude of Florentines toward their linguistic patrimony: so little esteem do they feel toward this precious treasure, mixing ancient jewels with new mud, barbarous expressions/phrases, strange and affected words, unruly and deformed styles and syntax. See also Carlo Dati, *Delle lodi del Commendatore Cassiano Dal*

Pozzo: orazione, Florence, 1664, n. p. Dati remembers Dal Pozzo declare many times (and here he quotes Pozzo in italics): "Gran vergogna dell'età nostra, che quantunque sempre rimiri si belle idee, e norme tanto capriccio d'alcuni professori, i quali si vogliono di partir dall'antico, l'architettura alle barbarie faccia ritorno! Non così fecero il Brunellesco, il Buonarruoti, Bramante, il Serlio, il Palladio, il Vignola, e gli altri restauratori di si grand'arte . . ." For discussion, see G. Perini, "Disegno romano dall'antico, amplificazioni fiorentine, e modello artistico bolognese," in *Cassiano dal Pozzo. Atti del Seminario Internazionale di Studi*, ed. F. Solinas, Rome, 1989, 203–19.

97 Bellori, *Le vite*, ed. Borea, 628: "i giovani allettati da tali dottrine volentieri abborriscono gli studii e le fatiche, e s'allontanano da quel fine che piú dovrebbero seguitare; onde la pittura in vece della sua forma naturale prende apparenza di larva e di fantasma, lontana in tutto dalla verità che ci obbliga ad una buona e perfetta imitazione. Invano però si querela il nostro secolo che non vi siano o sgorghino dalle scuole buoni pittori, e che si veggano sí mal condotte le maggiori e piú cospicue opere, restando affatto in abbandono i buoni studii ed i buoni principii." Compare Maratta's "onde la pittura in vece della sua forma naturale prende apparenza di larva e di fantasma, lontana in tutto dalla verita . . ."to Bellori's Idea: "Laonde quelli che senza conoscere la verità il tutto muovono con la pratica, fingono larve in vece di figure. . . . Rassomiglia Platone quelli primi pittori alli Sofisti, che non si fondano nella verità, ma nelli falsi fantasmi dell'opinione" (ibid., 21). This statement is preceded by formal quotations and is followed by paraphrases ("Carlo cautions . . . Carlo abhors . . ."), so Bellori's intention is clearly to report Maratta, not to provide personal commentary.

98 Giovanni Pietro Zanotti, *Nuovo fregio di gloria a Felsina sempre pittrice nella vita di Lorenzo Pasinelli, pittor bolognese*, Bologna, 1703, 3.

99 Panciatichi, letter from Paris to Magalotti, 2 January 1671; published in *Scritti vari di Panciatichi*, 266–67: "Noi altri italiani siamo al di sotto in quasi tutti i generi di letteratura, vedendo per esperienza che le belle arti hanno passato i monti, e son venute a stanziare in quei paesi che altre volte si chiamavano barbari, ed ora sono i più gentili: sicchè le scienze, gli studj, l'erudizioni sono allignate, e fanno prova miracolosa in questi terreni oltramontani, ed i nostri, di dove elleno sono state transpiantate, sono sfruttati quasi del tutto."

100 Francesco Bianchini, "Dissertazione recitata nella radunanza degli Aletofili di Verona," *Nuova raccolta di opuscoli filologici e scientifici*, 41/1 (1785), 36 (lecture given in the late 1680s); quoted by Brendon Dooley in *Science, Politics, and Society in Eighteenth-Century Italy: The Giornale de' Letterati d'Italia and its World*, New York, 1991, 16.

101 Benedetto Menzini, "Discourse by Euganio Libade at the Meeting in the Parrhasian Woods in the Year 1692"; in *Prose degli Arcadi*, ed. Giovan Mario Crescimbeni, Rome, 1718, I, 112–25. For Menzini and Christina of Sweden, with a discussion of Menzini's sources, including Bellori, who is presented as a classicist with a preference for French art, who influenced writers on literature (Menzini, Gravina), see R. Stephan, "A Note on Christina and her Academies," in *Queen Christina of Sweden: Documents and Studies* (Analecta Reginensia, I), ed. M. von Platen, Stockholm, 1966, 365–71. Menzini dedicated *Arte poetica* (Rome, 1688) to Cardinal Decio Azzolini, a friend of Christina.

7 Turning Points: Micro-Macrohistories of Aging

1 R. Starn, "Historians and 'Crisis'," *Past and Present*, 52 (1971), 3–22.

2 Francesco Niccolò Maria Gabburri, *Vite di pittori*, n. d., IV, 1803–04 (Firenze, Biblioteca Nazionale, MSS Palatini E. B. 9. 5): quote. This passage was misrepresented by Ugo Procacci ("Di uno scritto di Giovanni Bottari sulla conservazione e il restauro delle opere d'arte," *Rivista d'Arte*, 30 (1955), 235–36) as Gabburri's invention when, in fact, Gabburri is quoting Baldinucci (3 December, par. 1; secolo 5.0 a p.7). Gabburri's text seems to stand behind J. V. Hugford (*Vita di Anton Domenico Gabbiani pittor fiorentino*, Florence 1762, 10–11). The upper-case emphasis given to *ammanierato* by Gabburri might suggests its use as a period or school label, yet for Baldinucci and many eighteenth-century writers *ammanierato* was only one of many stylistic qualities that defined Mannerism; For the Bamboccianti as "a Gothic plague," see Francesco Albani's letter to Andrea Sacchi in Carlo Cesare Malvasia, *Felsina pittrice: vite de' pittori bolognesi divise in duoi tomi*, Bologna, 1678; edition cited: ed. G. P. Zanotti et al., 2 vols., Bologna, 1841, II, 180–81. G. P. Zanotti (*Le pitture di Pellegrino Tibaldi e di Niccolo Abbati esistenti nell'Istituto di Bologna*, Venice, 1756, 9 and 36) described affectation, a form of mannered art, as

"a modern plague" and as "a plague [that] has not yet ceased to grow." Francesco Milizia, *Dizionario delle belle arti*, Bassano, 1797, I, 113–14; 1827, II, 164, s.v. Borromini: "Borromini in Architettura, Bernini in Scultura, Pietro da Cortona in Pittura, il Cavalier Marini in Poesia, sono peste del gusto. Peste ch'ha appestato un gran numero di artisti. Non v'è male, da cui non si possa trarre del bene." For the divergence between the critical condemnation of Cortona and the artistic emulation of his painting in the eighteenth century, see G. Perini, "Appunti sulla fortuna di Pietro da Cortona nel Settecento europeo," in *Pietro da Cortona. Atti del convegno internazionale*, ed. C. L. Frommel and S. Schütze, Rome, 1998, 17–28.

3　Niccola Passeri, *Del metodo di studiare la pittura e Delle Cagioni di sua decadenza, Dialoghi*, Naples, 1795, 14 and 127.

4　Giorgio Vasari, *Le vite de' più eccellenti pittori scultori e architettori nelle redazioni del 1550 e 1568*, ed. P. Barocchi and R. Bettarini, Florence, I, 43: "ecci un'altra specie di lavori, che si chiamano Tedeschi, i quali sono di ornamenti e di proporzione molto differenti da gli antichi e da' moderni. Né oggi s'usano per gli eccellenti, ma son fuggiti da loro come mostruosi e barbari, dimenticando ogni lor cosa di ordine, che piú tosto confusione o disordine si può chiarmare; avendo fatto nelle lor fabriche, che son tanto ch'hanno ammorbato il mondo, le porte ornate di colonne sottili et attorte a uso di vite, le quali non possono aver forza a reggere il peso, di che leggerezza si sia."

5　For a discussion of Vasari on Raphael's death, see K. Weil-Garris, "La morte di Raffaello e la Trasfigurazione," in *Raffaello e l'Europa*, ed. M. Fagiolo and M. L. Madonna, Rome, 1990, 177–87; and Paul Barolsky, *Why Mona Lisa Smiles and Other Tales by Vasari*, University Park, PA, 1991, 38–39. For Anton Raphael Mengs, who modelled his death on Raphael's just as he did his art, see [Gian Lodovico Bianconi], *Elogio storico del cavaliere Anton Raffaele Mengs con un catalogo delle opere da esso fatte*, Milan, 1780, 74–78.

6　Pliny, *Natural History*, trans. H. Rackham, Cambridge, MA, and London, 1952, vol. lx (xxxv 40.145). Bartolomeo Facio applied this to Gentile da Fabriano: see M. Baxandall, "Bartholomaeus Facius on Painting: A Fifteenth-Century Manuscript of the *De Viris Illustribus*," *Journal of the Warburg and Courtauld Institutes*, 27 (1964), 90–107 (especially 100–01).

7　In Paolo Pino's *Dialogo di pittura* (Venice, 1548; edition cited: P. Barocchi, ed., *Trattati d'arte del Cinquecento*, 3 vols., Bari, 1960–62, I, 124–25) the Florentine painter "Fabio" renders his verdict on old age: "gli intelletti nostri sono impediti dall'imperfezzione corporea, a tal ch'aggiugniamo prima alla morete ch'al termine dell'intendere. [Lauro:] questo è ch'il nostro Pino scrive nell'opere sue 'faciebat'. [Fabio:] è ben fatto. Il medesimo scriveva il dio della pittura Apelle, volendo farsi intendere che sempre scorgea maggior profondità nel sapere, e quanto più s'impara, tanto più vi riman da imparare." This confession that "our intellects are hindered by corporeal imperfection so that we add our intentions [to the painting] before death," that physical decline may prevent the realization of painters' intentions, is moderated by the belief that painters (at least good painters like Pino himself, then around 40 years old) grow wiser with age. For Pino's age, see V. Mancini, "In margine a un volume monografico su Paolo Pino, artista e teorico dell'arte," *Arte veneta*, 46 (1994), 83–91.

8　Francesco Scannelli, *Il microcosmo della pittura*, Cesena, 1657, 197 (on Barocci, *Lamentation*, Milan Cathedral).

9　Giovanni Battista Armenini, *De' veri precetti della pittura*, Ravenna, 1586; edition cited: ed. Marina Gorreri, Turin, 1988, 154: "Il che si è veduto benissimo accader nell'ultime e maggior opere fatte da alcuni di molto nome, sí come già fu in quelle di Pietro Perugino, dipinte di Fiorenza, e da Domenico Beccafumi nella capella del Duomo di Siena sua patria e piú in quella di Iacomo da Punterno in S. Lorenzo pur di Fiorenza, poiché ad essi, in luoghi cosí onorati e grandi, le loro pitture riuscirono peggio assai di tutte l'altre fatte di prima. E certo nel considerar queste cose non posso se non meravigliarmi di coloro (che pur ce ne sono) che, dandogliene nelle mani, pensano farsi lodar per ispeditini e belli inventori e facitori d'istorie, con darle presto finite; nelle quali, quando si vien poi misurando, riescon novi maestri delle confusioni, perché avend'apena ricevuto il sogetto, si danno a formarlo con l'ammucchiar di molte figure, senza riguardo de' termini della composizione, usandoli i modi proprii, che si disse che essi solevan fare nel trovar l'invenzioni e cosí te le piantano in opera e vengano pure come si voglia."

10　Giorgio Vasari, *Le vite de' più eccellenti pittori scultori e architettori nelle redazioni del 1550 e 1568*, ed. P. Barocchi and R. Bettarini, Florence, 1984, V, 176.

11　For an introduction to Borghini, see the foreword by Mario Rosci to his edition and reprint of the

Riposo (Milan, 1967, 11). For a discussion of Borghini's ideas on decorum, see Thomas Frangenberg, *Der Betrachter: Studien zur florentinischen Kunstliteratur des 16ten Jahrhunderts*, Cologne, 1990, 77–102; T. Frangenberg, "The Art of Talking about Sculpture: Vasari, Borghini and Bocchi," *Journal of the Warburg and Courtauld Institutes*, 58 (1995), 115–31; and Robert Williams, *Art, Theory, and Culture in Sixteenth-Century Italy: From Techne to Metatechne*, Cambridge, 1997, 94–96.

12 Detlef Heikamp, "Federico Zuccari e la cupola di Santa Maria del Fiore: la fortuna critica dei suoi affreschi," in *Federico Zuccari: le idee, gli scritti*, Milan, 1997, 139–57.

13 Raffaello Borghini, *Il riposo in cui della pittura e della scultura si favella*, Florence, 1584, 196: "Hora se noi voremmo partitamente considerare nella cappella le molte figure di Iacopo da Puntormo, mi dubito che il tempo non ci venga meno. Voi havete ragione, soggiunse tosto il Michelozzo, percioche si può dire piu volte, che non vi sia artificio, non colorito, non ordinanza, non gratia; e l'attitudini quasi tutte ad un modo disconvenevoli, e dishoneste, e solamente buoni alcuni muscoli; ma le figure di sotto di mano del Bronzino molto buone, e bene intese." And ibid., 485: "Ultimamente gli fu dal Gran Duca Cosimo allogata la Cappella di San Lorenzo, sopra la quale egli stette undici anni, & avanti che l'havesse del tutto finita si morì d'anni 65; e di questa Cappella (perche non si veggo ne inventione; ne dispositione, ne prospettiva, ne colorito, che vaglia, se ben vi è qualche torso buono) non ne parlerò altramente, confessando, ò non intender quel che egli si habbia voluto fare, ò non vi haver dentro gusto alcuno. Dal che si può giudicare che quando gli huomini vogliono strafare fanno peggio: e che le persone quando cominciano à esser d'età vagliano più nel dar consiglio, che nell'operare." (For Pontormo in San Lorenzo, see chapter 6).

14 Borghini, *Il riposo*, 82: "ha fatto un gran monte di corpacci, sporca cosa à vedere, dove alcuni mostrano di risuscitare, altri sono risuscitati, & altri morti in dishonesti attitudini si giacciano; e di sopra ha fatto alcuni bambocci con gesti molto sforzati, che suonano le trombe, e credo che egli voglia, che si conoscano per Agnoli."

15 Vasari, 1550, 9–10 and 27 (proemio).

16 Giorgio Vasari, *Le vite de' più eccellenti pittori scultori e architettori nelle redazioni del 1550 e 1568*, ed. P. Barocchi and R. Bettarini, Florence, 1976, IV, 7. For a discussion of this passage in relation to the frontispiece, see Leonard Barkan, *Unearthing the Past: Archaeology and Aesthetics in the Making of the Renaissance Culture*, New Haven, CT, and London, 1999.

17 For a history of the frontispiece and endpiece woodcuts, see Patricia Rubin, *Giorgio Vasari. Art and History*, New Haven, CT, and London, 1995, 111–15; and Carlo Simonetti, *La Vite delle "Vite" vasariane. Profilo storico di due edizioni*, Florence, 2005, 71–72, 75–76, and 84–85.

18 Armenini, *De veri precetti della pittura*, 80. Armenini also describes how he overheard debates amongst artists in front of Michelangelo's *Last Judgment*, "engaged in subtle disputations upon some little bone or highlight."

19 G. A. Gilio da Fabriano, *Due dialoghi . . . degl'errori de' pittori*, Cesena, 1564; edition cited: P. Barocchi, ed., *Trattati d'arte del Cinquecento*, II, 46. Federico Borromeo (*De pictura sacra*, Milan, 1625; edition cited: *Della pittura sacra*, ed. B. Agosti, Pisa, 1994, 35–36) objected to painters who display muscles in such detail that their paintings appear more like medical charts than art. Luigi Lanzi (*Storia pittorica dell'Italia dal risorgimento delle belle arti fin presso la fine del XVIII secolo*, Bassano, 1789; in the edition of 1809: I, 124–25; in M. Capucci, ed., Florence, 1968–74, I, 124–25) included Pontormo amongst the *Michelangelisti* working in the "anatomical style" (a category he borrowed from Anton Raphael Mengs).

20 Borghini, *Il riposo*, 177.

21 For the social and religious contexts for these "renovations," see Marcia Hall, *Renovation and Counter Reformation: Vasari and Duke Cosimo in Santa Maria Novella and Santa Croce, 1565–1577*, Oxford, 1979.

22 Borghini, *Il riposo*, 91–123.

23 For the reception of Borghini, see below on Pietro da Cortona and Giandomenico Ottonelli. *Il riposo* was reissued in 1734 by Francesco Maria Niccolo Gabburri with a preface by Giovanni Gaetano Bottari. For Gabburri's project in the context of his other art historical work, see F. Borroni Salvadori, "Francesco Maria Niccolo Gabburri e gli artisti contemporanei," *Annali della Scuola Normale Superiore di Pisa*, ser. III, 4/4 (1974), 1503–53 (on 1517–18). Plans for publication might date from the mid-1720s when Giovan Maria Ciocchi addressed its content in *La pittura in Parnaso*, Florence, 1725. The late 1720s and 1730s were a retrospective moment in art publication, when art writers become self-conscious of their past: Benvenuto Cellini, *Vita di Benvenuto Cellini: testo critico con introduzione e note storiche*, ed. Orazio Bacci, Florence, 1901 (first published without a date, probably in 1728); Carlo Dati, *Le vite dei pittori antichi*,

Florence, 1730; Baglione, *Le vite de' pittori scultori et architetti*, Rome, 1733 and 1739; Leonardo, *Trattato*, 1731 (first edition: Paris, 1651); Dolce, *Dialogo*, ed. Nicolas Vleugels, Florence, 1735; B. Cellini, *Due trattati . . . oreficeria . . . arte della scultura*, 1731 (first edition 1568). For the death of art coming with the death of Raphael, see references above in the preceding sections; and Antonio Franchi, *Trattato della teorica pittoresca: la "Teorica della pittura" riveduta e corretta sul manoscritto degli Uffizi*, ed. Antonio Torresi, Ferrara, 2001, 22: "dopo la morte del gran Raffaello, usciti il più dei pittori da ogni buona regola, andava [la pittura] in precipizio."

24 Carlo Ridolfi, *Le maraviglie dell'arte, overo le vite de gl'illustri pittori veneti*, Venice, 1648; edition cited: ed. D. von Hadeln, Rome, 1956, II, 204: "Nel cadere in fine del Palma, diede anco un grave crollo la Pittura, essendo mancato dopo di lui il buon gusto della maniera Venetiana, così bene esercitata in tante delle opere fatte da questo eccellente Artefice, le quali condusse con buono studio, usando belle ammaccature de' panni, & una dilettevole e fresca maniera di colorire, che si appressa con facile modo al naturale, e le pitture sue verrebbero maggiormente desiderate & ambite, se in manco numero ne havesse operate." Quoted in part by Domenico Calvi, *Effemeride sagro-profano di quanto di memorabile sia successo in Bergamo*, Milan, 1677, III, 182.

25 Giovan Maria Ciocchi, *La pittura in Parnaso*, Florence, 1725, especially 48–51. For Ciocchi, see S. Rudolf, "Ciocchi, Giovan Maria," in *Dizionario biografico degli italiani*, Rome, 1981, XV, 656–57.

26 For Gabburri's involvement with *Il riposo*, see F. Borroni Salvadori, "Francesco Maria Niccolo Gabburri e gli artisti contemporanei," 1517–18.

27 Gabburri sent *Il riposo* to A. M. Zanetti, who, in turn, loaned it to Antonio Balestra: letter of Balestra to Gabburri, 26 October 1730; in Giovanni Gaetano Bottari and Stefano Ticozzi, eds., *Raccolta di lettere sulla pittura, scultura ed architettura*, 8 vols., Milan, 1822–25, II, 256–57.

28 Letter by Balestra to Gabburri, 9 November 1730; in Bottari and Ticozzi, ed., *Raccolta di lettere*, II, 259–61: "Pur troppo VS. ill. la discorre bene in proposito della pittura che in oggi vediamo andar declinando al maggior segno; pur troppo è vero che non si veggono nè dall'accademie di Roma, nè di Bologna, e nè anco di queste parti, risorgere successori alli celebri maestri antepassati; quandochè li pittori d'oggi dì hanno maggiormente largo campo, e dovrebbero di necessità superare di gran lunga gli antecessori."

29 Giandomenico Ottonelli and Pietro Berrettini [i.e. Pietro da Cortona], *Trattato della pittura e scultura, uso ed abuso loro, composto da un Theologo e da un Pittore, per offerirlo al Sigg. Accademici del Disegno di Firenze*, Florence, 1652, 175: "Non elegga l'Artefice il tempo della sua vecchiaia, per condurre un'opera, con che stimi di poter universalmente piacere; perche la Pittura, e la Scultura, dice un Savio, sono difficilissime, e ricercano giuditio fermo, vedere acuto, e mano pratica, e salda, le quali cose il tempo indebolisce, e consuma. Perciò l'Artefice, che in gioventù hà studiato, e nel'età virile hà lodevolmente operato, doverebbe nella vecchiezza ritirarsi dal far opere di publica mostra. A questo rispetto di vecchiezza attribuiti sono gli errori, che si veggono in S. Lorenzo di Fiorenza in un'opera del Puntormo, che fù si valente, e che fatte haveva tante figure comendate da ciascuno; & in quell'opera par, che si perdesse. [new paragraph] Della pratica di questo Avvertimento hebbe necessità per sentenza d'un giuditioso Professore il celebre Cavalier Giuseppino in riguardo dell'ultime parti, che vecchio d'età, e difettoso di vista, distinse nella sala del Romano Campidoglio, le quali sono differenti non poco nell'eccellenza, e perfettion dell'Arte, da quelle, che giovane vigoroso condusse nella stessa sala, ove si veggono eccellentissime, e s'ammirano da tutti, come continue memorie del suo primiero, e gran valore." Based on the conclusions by Vittorio Casale (1997, 107–16) regarding Cortona's contributions to the *Trattato* in general, I have assumed that this section was written by Berrettini instead of Ottonelli; see also J. Connors, "Chi era Ottonelli?," in *Pietro da Cortona*, ed. Frommel and Schütze, 29–35. For a more restrictive view, that Ottonelli was the primary (and almost exclusive) author of the *Trattato*, see Donatella Sparti, *La Casa di Pietro da Cortona*, Rome, 1997, 91–93. Although Casale makes no reference to the passage quoted above, it does fit into his criteria for attribution, that is, it reports an opinion of an artist well known to Cortona personally. Cortona's co-author, a 68-year-old theologian and art patron, witnessed the last years of Fabrizio Boschi, a Florentine painter who painted reluctantly in old age and then only to support his family. Ottonelli served as Boschi's spiritual adviser during his last years (he died in 1642) and helped him to accept his mortality by having him make drawings of dying men (Filippo Baldinucci, *Notizie de' professori del disegno dal Cimabue in qua*, 3 vols., Florence, 1681–1728, ed. P. Barocchi, Florence, 1975, III, 646–47).

30 Ottavio Rossi, in a letter of 1621 to the painter Pietro Marone (published by Herwarth Röttgen, *Il Cavalier Giuseppe Cesari d'Arpino: un grande pittore nello splendore della fama e nell'incostanza della fortuna*, Rome, 2002, 170): "non ardirei di sottomettere il Carraccio e Michel'Angelo da Caravaggio, al Cavalier d'Arpino, ma vi dirò bene che questi tre formano il Triumvirato nella pittura. é vero, che 'l più stimato dalla Fortuna è il Cavaliero, perché egli partecipa più che non fan questi due (che son l'un Bolognese, e l'altro Lombardo) del felicissimo ascendente di Roma."

31 Bellori's marginalia in Baglione, from the life of Cesari d'Arpino, published variously but most recently by Röttgen, *Il Cavalier Giuseppe Cesari d'Arpino*, 210–11: "in questa battaglia non vi è alcuno che combatta, senza espressione ma per una bella confusione et gratia di maneggiare i colori a fresco hà avuto grandissima fama." Also, on d'Arpino's last works, Bellori writes: "che all'animo suo più non rispondevano le forze; e per l'accrescimento de gli anni mancavagli il valor del pennello. . . . questo vuol dire essere pittore di spirito, et non di scienza. La scienza s'accresce, e li spiriti mancano quando si diventa vechio, essempio ne siano le mirabili opere di Petro da Cortona Vecchio e di Monsù Poussin vecchio, et altri vecchi." Further down: "Il Cavaliere era astuto, et sapeva dar martello, et vendere la sua mercanzia è stato la ruina di molti belli ingegni, che l'hanno seguitato, havendo corrotto, et fatto cadere affatto la Pittura, che non sarebbe più risorta se Dio non mandava al mondo Annibale Carracci." Bellori's last remark: "La maniera di questo pittore cioè del cav. Giuseppe come quella del Pomaranci et altri Pittori di spirito e non scienza adesso non è più seguitata."

32 Ottonelli and Berretini, *Trattato della pittura e scultura*, 175–76, citing Ridolfi as his source.

33 For a history of these frescoes, see Maria Elisa Tittoni Monti, ed., *Gli affreschi del Cavalier d'Arpino in Campidoglio: Analisi di un'opera attraverso il restauro*, Rome, 1980; and Röttgen, *Il Cavalier Giuseppe Cesari d'Arpino*, 62–67, 74–79, 145–48, 188–91, 395–96, and 481–85.

34 Giovanni Baglione, *Le vite de' pittori scultori et architetti*, Rome, 1642, 373–74: "Et ultimamente con tre historie diede compimento alla Sala del Campidoglio, che già, quarant'anni sono, haveva ad esser finita; ma stanco d'haver faticato, e ridottosi nel tempo, che doveva prender riposo, poiché indebolita era la natura, e gli spiriti raffreddati, non ha sì appieno corrisposto al suo nome, & appagato il gusto de' Professori, e come in queste tre historie ultime, della fondatione di Roma, delle Vergihni Vestali, e del rapimento delle Sabine, così anche nelle vicine sopra narrate mostrò, che all'animo suo più non rispondevano le forze; e per l'accrescimento de gli anni mancavagli il valor del pennello."

35 Tittoni Monti, ed., *Gli affreschi del Cavalier d'Arpino in Campidoglio*, 51.

36 I have translated from Lodovico Domenichi's translation of 1547 (*La pittura di Leon Battista Alberti*, Venice, 1547, 32r) because he clarifies the artist's failure of showing front and back simultaneously by evoking the bad manners of exposing chest and buttocks ("si veggono il petto & le natiche sotto una vista sola").

37 For d'Arpino as a *di maniera* painter, see Vincenzo Giustiniani, *Discorsi sulle alti e sui mestieri*, ed. Anna Banti, Florence, 1981, 43. For d'Arpino as *ammanierato* and as the last Mannerist and end of the "romana scuola, alquanto decaduta," see Baldinucci, *Le vite*, IV, 15–16. For d'Arpino as one of the Italian *manièristi*, see Fréart de Chambray, *ldée de la perfection de la peinture demonstrée par les principes de l'art*, Paris, 1662, 119–20.

38 For this story in the context of other seventeenth-century versions, see Sohm, "Caravaggio's Deaths," *Art Bulletin*, 84 (2002), 449–68. Sandrart's version took root only in France where Roger de Piles (*Abregé de la vie des peintres*, Paris, 1699, 341–42) has Caravaggio murder Tommaso Ranuccio as a surrogate for the Cavaliere d'Arpino before challenging d'Arpino directly to a duel.

39 Matteo Pagani, *Dialogo della vigillanza*, Rome, 1623, 32: "Aurelio: Franche sono quelle figure, lì trà quelli alberi, che mirandole mi rapiscono, tanto sono bene tinte, e affituate; ma parlando hora veramente senza velo di animo appassionato, chi non confessarà con me, e che questo è il vero modo di dipingere, questi, questi vincono il naturale, e pure sono fatti senza il naturale, qui non vi si vede quelle oscurità che il vivo mai lo dimostra, nè anco certi muscoli infilzati con la setola come si vedeno certe maniere di hoggi giorno." For notice of Pagani's *Dialogo*, see Z. Waźbiński, "Il cavaliere d'Arpino ed il mito accademico. Il problema dell'autoidentificazione con l'ideale," in *Der Künstler über sich in seinem Werk*, ed. Matthias Winner, Weinheim, 1992, 317–63.

40 Pagani, *Dialogo della vigillanza*, 32: "Licino: Ma molti disminuiscono la gloria di questo huomo [d'Arpino], con dire che tiene lunghe le sue opere . . . Aur. O questo peccato non è in Giuseppe, perche lui è velocissimo in operare, e di questo non me dibisogna havere testimonij."

41 Pagani, *Dialogo della vigillanza*, 41: "Aur. E quello che più importa senza la diffultà che trovano alcuni Pittori [i.e. naturalists], quali non ponno fare un dito, disegnare un occhio, mettere insieme una testa, senza havere attaccato il naturale al fianco con lumi artificiosi, pariete tinte, quadri graticolati, che avanti si mettono all'ordine per lavorare, questo havrebbe di già fatto l'opera, e questo è che le loro pitture, non hanno poi quello spirito come hanno queste di Giuseppe; pigliamo per esempio uno che tenga una mano atteggiata, secondo il vostro pensiero, ò bisogno; quella mano in quel primo atteggiare mostra non è dubbio la sua verà vivacità, ma che ipso fatto perde lo spirito, perche non pole il naturale resistere à quell'offitio, e così sono anco le figure, tal che conviene che il Pittore non vadi mendicando questo bel d'intorno di vivacità, altrimente restano le sue opere come huomini abbandonati sovragiunti da qualche infermità."

42 Giovan Pietro Bellori, *Le vite de' pittori, scultori e architetti moderni*, Rome, 1673, 230.

43 Scannelli, *Il microcosmo della pittura*, 11–25. In the introduction to the first edition of Giovanni della Casa's poems, Severino uses a body metaphor to analyze Casa's poetry. Like Scannelli, Severino was trained as a physician. Of the scant literature on Scannelli, see Denis Mahon, *Studies in Seicento Art and Theory*, London, 1947, 48–53; Giubbini's introduction to the Milan reprint of *Microcosmo* of 1966; and Elizabeth Cropper, "Ancients and Moderns: Alessandro Tassoni, Francesco Scannelli, and the Experience of Modern Life," in *Perspectives on Early Modern and Modern Intellectual History: Essays in Honor of Nancy S. Struever*, ed. J. Marino and M. W. Schlitt, Rochester, NY, 2001, 303–24.

44 For discussions of Lomazzo's stylistics, see Robert Klein, "Les 'sept gouverneurs de l'art' selon Lomazzo," *Arte lombarda*, IV (1959), 277–87; M. Kemp, "'Equal Excellences': Lomazzo and the Explanation of Individual Style in the Visual Arts," *Renaissance Studies*, I (1987), 1–26; Williams, *Art, Theory, and Culture in Sixteenth-Century Italy*, 123–35.

45 For discussion of Boschini's "boat of painting," see Philip Sohm, *Pittoresco: Marco Boschini, his Critics and their Critiques of Painterly Brushwork in Seventeenth- and Eighteenth-Century Italy*, Cambridge, 1991, 97–98.

46 For Scannelli on "l'estremo scoglio dell'abbominevole siccità" of the quattrocento, "infette dal vitio dell'esecranda seccaggine," see *Il microcosmo della pittura*, 88 and 123. He used similar

terms to describe Alessandro Allori (201): "non poco infetto del solito vitio della snaturata seccaggine."

47 Scannelli, *Il microcosmo della pittura*, 9–10: "[D]a primi restitutori [Cimabue, Giotto, etc.] sino a tali Maestri [of the sixteenth century, especially Raphael, Titian, and Correggio] del continuo aumentandosi, allhora solamente esser osservata al colmo della maggior perfettione, e dopo la perdita di questi primi, e supremi soggetti [i.e. Raphael, etc.], ha fatto conoscere la stessa esperienza, fino a tempi de gli studiosissimi Carracci, non succedere, che la continua declinatione, e cosi del pari osservarsi proportionatamente a nostri giorni, non poco la mancanza da' primi, e maggiori vigori, e del continuo languendo si vede pur troppo cadere."

48 Scannelli, *Il microcosmo della pittura*, I, cap. XVII, 107: "Dal buono intelligente essere riconosciute le qualità necessarie alla degna Pittura, ed insieme l'inganno de' volgari. Ricercandosi la cagione, perche i migliori hodierni vengano a mutare in più chiara la propria maniera, e si discorre per riconoscere la migliore." The following summary of Scannelli on contemporary painters (*hodierni*) comes from this chapter (ibid., 107–16).

49 Richard Spear (*The "Divine" Guido: Religion, Sex, Money, and Art in the World of Guido Reni*, New Haven, CT, and London, 1997, 275–320) has written the definitive account of Reni's late style as seen through the eyes of his critics. To his fundamental account, I hope only to bring out the medicalized views of Scannelli and how he saw Reni precipitating a decline of art into a state described in terms of senescence.

50 Scannelli, *Il microcosmo della pittura*, 114; translated by Spear, *The "Divine" Guido*, 294.

51 Scannelli, *Il microcosmo della pittura*, 108–09: "Laonde si può sufficientemente conoscere, quanto si ritrovino lontani alcuni Professori de' nostri tempi alla necessaria compitezza di buona Pittura, ancorche da varj di poca cognitione venga pensato altrimenti, e sia ancora tal volta contrario il senso di quelle persone, che per ritrovarsi raccolta di Pittori hodierni ad essi per ogni parte cari, e perche non vogliono, ò non sanno riconoscere sopra la vaga chiarezza de' colori, non cessano di palesare simili dipinti per li più belli, e migliori, che si possono osservare. . . . che buona parte de gli Artefici hodierni, ancorche si dimostrino alquanto manierosi, ed anco dotati di buone qualità, si ritrovino però nell'essential fondamento, e vera naturalezza di longa mano inferiori a primi moderni, e più perfetti Maestri, nè tampoco del tutto eguali a primi loro seguaci, e più sodi ante-

cessori. . . . dove n'appare fra l'opere di molti la chiara differenza, e però direi con pace di così fatti humori non generarsi altronde opinioni cotanto erronee, che dalla violenza del di loro affetto, il che offuscando il conoscimento deprava anco ad un tempo l'immaginatione in modo tale, che simili soggetti come per se stessi ordinariamente poco intelligenti, e malamente impressi vengono poscia molto più col senso, che mediante la ragione a palesare reveal gl'imperfetti, e guasti lor gusti, ne meno mi posso dar'a credere, che Professori di tal sorte facilmente assai più proveduti di fortuna, che di sufficienza vengano pel troppo affetto di loro stessi ad ingararsi in credere di soprastare a quel valore, che al dicerto come lontani possono bene ammirare, & in qualche parte imitare, ma non già emulare col pensiero d'uguagliarsi."

52 Scannelli, *Il microcosmo della pittura*, 110: "e però dandosi a questi meritamente la gloria si verrà a tralasciare altre soverchie escrescenze come superflui mai sempre vitiose, ed abbominevoli."

53 Scannelli, *Il microcosmo della pittura*, 110–11: "Onde potrà scoprire il giudicio versato nella Pittura quanto s'abbaglj alla giornata copia de' volgari nel vedere alterati dipinti, i quali rappresentano indifferentemente fucate bellezze, che resi sodisfatti del primo cognito, ne valendo per inoltrarsi col giudicio alla debita intelligenza dell'opera, stimano solo per ultimo termine di buona Pittura una mera rappresentatione di più chiare tinte, che palesano ordinariamente lascive vaghezze, prive della necessaria proportione, e prospettiva, dipinte bene spesso a fine di palesare un'idea casualmente fabbricata, & un'effigie, se bene ad un tal vero in qualche parte rassomigliante, priva nondimeno del sufficiente fondamento riesce poi anco da quello, che pretendono esprimere, non poco lontana. E per il campo loro apportano tantosto il esempio del famoso Guido Reni, il quale, come questi asseriscono, fù ricolmato de' più eccelsi pregi, e mediante la sua straordinaria vaghezza tirò a sè a guisa d'incanto gli occhi de' maggiori regnanti. . . . Ma io professando aderire molto più al sodo de' buoni intelligneti, che all'apparenza de' volgari, dirò in tal caso, che il più, e meno del bianco, e nero non si considera nella Pittura che per accidente, e solo in ordine al debito compimento esterno del corpo naturale . . ."

54 Scannelli, *Il microcosmo della pittura*, 114–15.

55 Scannelli, *Il microcosmo della pittura*, 107: "Al presente però frà viventi Artefici di questa Scuola pare, che venga a prevalere non poco Pietro Beretino da Cortona, massime nelle grandi operationi d'histo-riati sopra muri dipinti a fresco, e tal'è il volto della gran Sala, che si vede nello straordinario Palazzo de' Barberini. . . . [cites also Cortona's frescoes in Palazzo Pitti] Havendo poscia ancor'esso in conformità d'altri primi Pittori della nostra età declinato la propria maniera nella maggior chiarezza, e l'operationi di tal sorte sono quelle, che si vengono ad osservare nella Cuppola della Chiesa nuova di S. Filippo Neri, e l'altre della Galeria Pamfilia in Piazza Navona, perche in effetto declinando l'età non può insiememente, che dimostrarsi declinanti gli effetti delle conseguenti operationi."

56 Scannelli, *Il microcosmo della pittura*, 117–18. Cardano, *De subtilitate*, Basel, 1560; edition cited: ed. Elio Nenci, Milan, 2004, bk. 4, chapter on "luce e lume". Scannelli also quotes Alberti in *De pictura* and attributes the same sentiment to the Carracci.

57 Scannelli, *Il microcosmo della pittura*, 115: "Perche sicome una volta essendo mostrato un dissegno a Francesco Albani Maestro soprastante all'Accademia di Bologna da soggetto, che per mancanza di sufficiente vista pareva col troppo chiaro haver sodisfatto ad ogni altra parte, li disse al primo incontro con la sua solita prudente argutia, per dar'ad intendere la bianchezza superflua, che era nevato fuor di stagione; così potrassi ancora verisimilmente credere, che l'inverno dell'età, sia la principale, e più potente causa di simil neve; per esser il proprio anco della prima vechiezza il debilitare parimente in parte col corpo gli stessi spiriti."

58 Scannelli, *Il microcosmo della pittura*, 116.

59 Scannelli, *Il microcosmo della pittura*, 113.

60 Carlo Ratti, *Delle vite de' pittori, scultori, ed architetti genovesi*, Genoa, 1768, II, 104: "fiachezza di tinte e meschinità ne' dintorni."

61 Francesco Saverio Baldinucci, *Vite di artisti dei secoli XVII–XVIII*, ed. Anna Mattedi, Rome, 1975, 265. For languid coloring as a universal property of old painters, see Antonio Lupis, *Il Chiaroscuro di pittura morale. Abbozzato da Antonio Lupis*, Venice, 1685, 532 (in a chapter on the insults visited by old age on different professions): "Il Pittore, che sarà languido nel colorito."

62 Carlo Cesare Malvasia, *Felsina pittrice: vite de' pittori bolognesi divise in duoi tomi*, ed. G. P. Zanotti et al., Bologna, 1841, II, 32–33; translated by C. and R. Enggass in C. C. Malvasia, *The Life of Guido Reni*, University Park, PA, 1980, 87. For possible stylistic effects of Reni's gambling, see Spear, *The "Divine" Guido*, 38–43 and 212–13.

63 Malvasia, *Felsina pittrice*, ed. Zanotti et al., II, 59; translated by Spear in *The "Divine" Guido*, 293–94.

64 L. Marzocchi, ed., *Le carte di Carlo Cesare Malvasia: Le "Vite" di Guido Reni e di Simone Cantarini dal manoscritto b. 16–17 della Biblioteca Comunale dell'Archiginnasio di Bologna*, Bologna, 1980, 33; L. Marzocchi, ed., *Scritti originali del Conte Carlo Cesare Malvasia spettanti alla sua Felsina pittrice*, Bologna, n. d., 208; Malvasia, *Felsina pittrice*, ed. Zanotti et al., II, 32–33 and 58.

65 Malvasia, *Felsina pittrice*, ed. Zanotti et al., II, 58–59; translation by Spear, *The "Divine" Guido*, 295.

66 Marzocchi, ed., *Le carte di Carlo Cesare Malvasia*, 33: "Questa sua [Reni] maniera ultima non incontrò; tenuta per troppo debile e fiacca (ove egl pretese) quella che più tosto era una delicatezza non più usata e nuova, nuova dico ma non però così lontana dal possibile . . ." Following this (on p. 34) Malvasia discusses the age following the "secolo perfetto" (Julius II to Leo X) when such artists as Vasari and Sabatini left the practice of "il caricare di colori" in favor of "le meschie più piacevoli e bianche." Before time blackened them, they were "dilavato, languido e fievole, troppo scostandosi dal [naturale] vero" not only in the coloring, which had "a certain leaden jumble" (*un certo piombicio faragineo*) that is not found in nature: "[C]he perciò lasciando il caricare di colore di Michelangelo, Raffelle, Frà Bastiano e simili fecero ben sì le meschie più piacevoli e bianche come che il tempo le dovesse annerire ma diedero poi nel dilavato, languido e fievole, troppo scostandosi dal (naturale) vero non solo nel tingere (che aveva) di un certo piombicio faragineo che non si trova nel naturale. . . . Con queste riflessioni dunque prevalesse non nella comune opinione in quella certo de'gl'intendenti quest'ultima maniera di Guido e nella quale si osserva (non lo strapazzo e troppa facilità della prima ma una nuova) de' mede[s]mi, tante galanterie, tante mezze tinte, lividetti . . . e simili gentilezzze oltre la giustezza del dissegno. . . . e conclusero la prima maniera di Guido per un certo ché di più rissoluto e vigoroso essere stimabile ma quella (poi più impareggiabile) come più perfetta, studiosa ed erudita . . ." Malvasia then (pp. 34–35) comments on the sixteenth-century Venetian practice of using delicate, light colors to compensate for the darkening with time: "[S]i scostarono [Venetian sixteenth-century painters] da que'scuri troppo fieri e cercarano (in più) questo delicato moderno osservato da . . . il gran Paolo Veronese che a poco a poco scostandosi da quel nericcio più tosto peccando, per così dire in troppo bianco, fece così delicato in certe deità femine ma in particolare in quella che finge

Venezia sovra la quale Giunone tante corone d'oro, di alloro e tante ricchezze perché non solo nella divinità dell'aria, ma nella pastosità, bianchezza e morbidezza come ciò più anche si osserva nel bel ritratto di quel vecchione col puttino in casa Grimani che assolutamente pare impasto di Guido." In the *Felsina pittrice* itself, the two important passages on Reni's late style are:

II, 32–33: "La Natività di N. Signore per Germania, e l'altra principiata per la Certosa di Napoli, e simili infinite fatte negli ultimi anni, ne' quali osservasi mancare il primiero valore in ogni gran maestro, e dare nella fiachezza. Attribuiremo dunque questo, che chiamano abbassamento di maniera, primieramente all'età, che assai avanzatasi, indebolendo le forze e lo spirito, potessero anco render fiacche le sue operazioni; secondariamente all necessità; il perchè datosi in quest'ultimo fieramente al giuoco, prendendo denari anticipatamente, per soddisfare alle perdite frequenti, bisognasse poi strapazzare i lavori, ed operare assediato più dal debito, che per istimolo di gloria; e finalmente perchè riflettendo continuamente a tanti obblighi ed impegni, soffocato il buon gusto dalle passioni dell'animo, non potessee portarsi sulle opre col solito brio ed ardire."

II, 58: "Quindi è, che temendo sempre i danni dell'età, per non s'indebolire in queste pratiche col tempo, e mantenerne fresca e pronta la memoria (come si legge anco facesse Tiziano ridotto alla decrepità, e appena vedendo lume) studiava negli ultimi anni più che mai s'avesse fatto, riducendosi ogni sera, mentre gli scolari attorno al nudo, o a' rilievi a concorrenza si travagliavano, a disegnare per tre, quattr'ore intere, teste in varie vedute, e d'ogni sesso, d'ogni età, mani, piedi, pensieri di storie . . .

"Affatticavasi anche, non mai saziandosi, come dissi, nell'ultime sue pitture, mostrandocele sempre più erudite, e con nuovi ricerchi, e mille galanterie, con certi lividetti, e azzurrini mescolati fra le mezze tinte, e fra le carnagioni; come poi forse troppo arditamente volle anche usar il Cagnacci suo allievo, il Castiglione, il Maffei, e altri; quali si osservano nelle carni delicate, che rendono un certo diafano, ma più poi, e evidentemente, qualora il lume cade sopra di esse, passando in particolare per finestre chiuse, massime di vetro, come ciascuno può molto bene osservare; non essendo queste su invenzioni chimeriche, ideali, e senza appoggio, come ebbe a dire Don Fabio della Cornia, testimonio intelligente anch'egli bensì, e dell'arte, ma sospetto, come parziale del suo Caravaggio; ed ha creduto qualcuno in altri come il

Cavalier Ridolfi nella vita di Giorgione, lodando tanto quel pittore (che fu dei primi che trovarono il buono sì, ma non ancor raffinato) di que' suoi semplici colori; ma nuove osservazioni dagli antichi trasandate, che in altre professioni ancora vediamo tutto di scaturire dalle più feconde, e spiritose miniere de' moderni ingegni, con invidia de' passati; come a dire nelle nuove stelle scoperte, anzi nelle vecchie tanto mutate, e sparite; ne' composti anatomici sempre più scrutinati, ed ampliati; nelle sposizioni legali maggiormente spremute, e sottilizzate; nelle proposizioni Aristoteliche insin negate, e all'evidenza dello sperimento ridotte.

"E questa è quella, che chiamano seconda maniera di Guido, che come perciò incognita anche, e forestiera, non giungerà che col tempo ad addimesticarsi, a farsi ben conoscere, e finalmente ad assodarsi nella comune affezione e concetto. Strillino pure a lor voglia i malevoli, che si conosceranno un giorno queste finezze per inimitabili, ed io già ne pronostico sicuro il successo da sterminati compimenti, ch'oggi usano il Bellotti in Venezia, un Carlin Dolci in Firenze, un Cignani presso di noi, che tanto sono accetti e graditi."

67 For some good general studies of this complex exchange, see A. Cottignoli, "'Antichi' e 'moderni' in Arcadia," in *La Colonia Renia: profilo documentario e critico dell'Arcadia bolognese*, Modena, 1988, II, 53–69; E. Graziosi and M. G. Accorsi, "Da Bologna all'Europa: la polemica Orsi-Bouhours," *Rassegna della letteratura italiana*, 93 (1989), 84–136; S. Gensini, *Volgar favella: percorsi del pensiero linguistico italiano da Robortello a Manzoni*, Florence, 1993, 51–97; C. Viola, "Muratori e le origini di una celebre 'querelle' italo-francese," in *Studi di letteratura italiana in onore di Francesco Mattesini*, ed. E. Elli and G. Langelli, Milan, 2000, 63–90.

68 G. G. Orsi, ed., *Considerazioni sopra la Maniera di ben pensare ne' componimenti, già pubblicata da Padre Domenico Bouhours*, Modena, 1735, I, 196: "Anzi stimo, che scuoprasi nelle Tavole con maggior diligenza finite, come sarebbero quelle del nostro Guido Reni, e principalmente della sua seconda Maniera; allorchè lasciata quella prima forza, e quella robustezza, che fu propria della Scuola de' Caracci, s'invaghì d'una tale Dilicatezza, la quale il rendè forse inferiore a lui stesso nell'ultime sue fatture." Zanotti claimed that Orsi misinterpreted Reni's delicate (*delicato*) style as weak (*debole*): in ibid., I, 275. Anon., "Lettera," in ibid., II, 29: "Pure in un luogo [in Orsi's essay] la dove mirabilmente ei n'insegna contenere in se la maniera ultima di Guido una estrema delicatezza; e pur noi tutti prima di giugnere a questo lume, l'avremmo detto solo snervata; in paragone però di se stessa, e del primiero suo se; dilavata, languida, stracca, parla di lui come di suo Paesano, onde s'io bene avviso, se non nella stessa, non sarà egli per lo meno lontano dalla Patria di Guido gran paralleli, e gran climi." In his response, Baruffaldi explains that the author of this anonymous letter mistook Guido's second style as "languida, stracca, e snervata," when he should have perceived it as delicate: "S'io userò forme tenere, soavi, proprie, e tiranti al natural modo d'acconciamente parlare, nella semplicità dell'Argomento . . . nessuno mi contradirà il nome di dilicato nel dire."

69 Giovanni Pietro Zanotti, "Dialogo in difesa di Guido Reni," in Giovan Gioseffo Orsi, *Considerazioni sopra la maniera di ben pensare ne' componimenti già pubblicata dal padre Domenico Bouhours*, Modena, 1735, II, 227.

70 Passeri, *Del metodo di studiare la pittura*, 127.

Index